LIVING
MATERIALS

LIVING MATERIALS

A Sculptor's Handbook

Oliver Andrews

UNIVERSITY OF CALIFORNIA PRESS / Berkeley · Los Angeles · London

University of California Press
Berkeley and Los Angeles, California
University of California Press, Ltd.
London, England
Copyright © 1983 by The Regents of the University of California
First Paperback Printing 1988

Library of Congress Cataloging in Publication Data

Andrews, Oliver.
 Living materials.

 1. Sculpture—Technique. 2. Modeling.
1. Title.
NB1170.A63 731'.2 77-71057
ISBN 0-520-06452-6 AACR2

Printed in the United States of America

08 07 06 05 04 03 02 01
12 11 10 9 8 7 6 5

The paper used in this publication meets the minimum
requirements of ANSI/NISO Z39.48-1992 (R 1997)
(*Permanence of Paper*). ∞

Contents

Foreword

The hunger–need for form comes before the work to sculpt and realize the vision. The vision and desire come before the work. Driving us deeper into the species' dreams (as artists we are the living moving antennae to the dreams of all our fellow humans) are music, poetry, and the contemplation of night's stars. Because sculpture is the connecting link between night stars and music, we are more tuned in, honed sharper by poetry.

To make the vision real is the substance of this book, and I urge you not to be fooled by critics' words and afterwords about your works, your sculptures—for sculpture deeply and basically *is*. To hide from the truth (it is there: in the sculpture), to *not* see what is there, to cover it with afterwords, is to fall in the great dilemma of the contemporary world: the glib hook, the critics'/emperors' new clothes of words.

We are all different, and Art not only accepts but glorifies our differences, so long as we do not hide it from ourselves. In sculpture the realization of the vision may have as its way the most accurate reproduction of that vision, or it may be interactive with the materials so that the materials suggest and the aim-vision changes and the work that results is less controlled by the origin-vision and is more itself. Whichever is your way the materials of modern sculpture are so expanded, space-time, light, world-surface, new steels, new chemicals, that there is a freshness here, and a deep real-thing need in our society that makes sculpture one of the youngest and most vital fields alive now.

Human prehistory begins with sculpture and the photohistory of human sculpture is bound into us as some kind of actual memory so that we have behind us an immense joy of shaping, wisdom of techniques, and brilliancy of realized form. It should encourage us to meet this puzzle world of newness with machine and communication forms so that we too can shape that *true* sculpture to be deep-felt in fellow humans' fellow-beating hearts: the singing knowledge of the form. Photography changed painting radically; the Impressionists made the first step (and first steps are the hardest ones to take—and the most rewarding, but only later): the step toward abstraction. When holograms first appeared in the sixties I expected equivalent radical changes in sculpture. Perhaps only participation allows that aspect of reality to pass beyond the hologram threshold.

Brancusi's great body of work is an example for all of us, so that his phrase becomes more powerfully true for all of us: "It is not hard to work, it is hard to *begin* to work." Just as in psychoanalysis there is resistance to the probe into the id-libidinal level, the struggle for sculpture (those living symbols of maximal energy, spirits' bones, song transfixed) is not easy, resists us the more deeply, more meaningfully we search. But the rewards are always more, for art is deeply entwined with life-source, somehow purely an expression of life-energy, so that the ever-true law of art is: You get out more than you put in. This deep generosity of art is so health-incredible that as you change reality (make your sculpture) you become changed: you come into the fullness of health, sunflower in sunlight; and your sculpture shall tell you who you are.

To know the industrial processes we must participate in those places (factories, yards) where the everyday application of modern technology is normal. To learn the normal control of industry is to achieve the freedom of being a free modern artist. As the secret of learning is practice practice practice, the secret of sculpting is sculpture.

The essentiality of visual form is only known by the recently blind, and we do not need to go to a hospital to know how dependent we are on physical form. From this essentiality and existential need we give expression to the formal hunger that humanity faces in the eternal questions of death, love, and eternity. But what is sadder than to see a great feeling or a terrific idea obliterated by the ineptness of control over materials? For in this continuum of existence, materials yearn toward a shape, and only by turning our antennae (i.e., to steel's tension or water's shimmer-flow) can we achieve what we dream. We can achieve only what we aim at: and poetry and music are the sculptor's aim-shapers. Few people talk of the joy of sculpture, yet that is the heart of it, the tongue to every word of sculpture, the joy of seeing the sculpture come into shape and do its space-time dance together with you. Be brave, here are your wings, in this book ancient secrets become known ways. The work is often hard and lonely and dirty but when it comes, the shining, the wonder given to you from your own work—then there is nothing like it in this world!

Let the stars sing their music through your hands.

Mark di Suvero

Publisher's Preface

On 30 September 1978 the world at large lost one of its most important teachers and sculptors—the author of this book—in a skin-diving accident off the California coast. As head of the sculptor area of the Department of Art at UCLA, Oliver Andrews influenced countless numbers of students in the philosophy and techniques of his medium, a medium he himself excelled in as a creative artist. During his tenure at UCLA from 1958 to his death, Andrews planned and organized the best sculpture studios to be found anywhere in the world. Colleagues claim that these studios were his special kingdom, that he worked in them, spent most of his time in them, and from them shared his knowledge of, and enthusiasm for, sculpture, its history, and its unlimited possibilities. Through his writing, films and videotapes, exhibitions, lectures, symposia, and media interviews, Andrews made important contributions to the history of sculpture and helped bring about new attitudes regarding the sculptural arts.

He was born in 1925 in Berkeley, California, and attended the University of Southern California and Stanford University. He held his first exhibit in 1950 at the Santa Barbara Museum of Art, beginning a long and successful career producing works of unusual beauty and technical skill which always showed strong imagination and independence of mind.

With twenty-four one-man shows, and participation in numerous group shows in museums and galleries across the country, Andrews drew international attention. He created sky fountains for the cities of Los Angeles, San Diego, and Cincinnati, and giant mylar sculptures that filled Grand Central Station, Shea Stadium, and the World Trade Center in New York; many commissions for sculptures were not completed owing to his untimely death. His design for a 14-foot-high stainless steel sculpture for downtown Glen Cove, New York, was selected from a field of 187 entrants from around the world. His passing brought an end to his own great creative activity, but it is hoped that his last contribution as a teacher, this book, will continue to influence those who are interested in the work he was so very much dedicated to during his lifetime. It would be his wish.

The University of California Press should like to express its thanks to Victoria Franklin Dillon for her help in assembling a very large and complicated

manuscript and lending her expertise in the absence
of its author. It owes a similar debt to Oliver's son
Christopher, who furnished information that made it
possible to proceed with the production of this
book.

Spring 1983 J. K.

Note on the Paperback Edition:

Because of the untimely death of the author,
the Bibliography and Sources of Supply sections
of LIVING MATERIALS have not been updated
for the paperback edition.

Introduction

Whether quarried, mined, harvested, or manufactured, all materials are expressions of the forces of nature. The artist encounters these forces in his work, as do architects, road builders, and scientists. Both the artist and the scientist are aware that the difference separating the hard, sharp, and distinct from the soft, blurred, and fuzzy, is a matter of viewing distance, rather than a difference between organic and inorganic. The embryo begins life with a pattern of organization like a galaxy. Crystals under the microscope seem to multiply like organisms. The understanding of all materials as "living" gives us, on the one hand, a sense of the continuity of nature, and, on the other hand, makes us aware of the great variety of ways in which materials assert their character. In this book I try to show how this assertiveness of materials interacts with the will of the artist in the complex process called "making a sculpture."

Some familiarity with the concepts underlying contemporary artistic and technological forms is essential to anyone who wishes to venture into sculpture today. In other words, *what to make* is inextricably bound up with *how to make it*. Somehow the idea still persists that one learns methods from one kind of book, and the aesthetics of art from another. In this book I have attempted to provide a unified approach by showing how processes are actually employed by contemporary sculptors to achieve their creative objectives. I hope that the illustrations and their captions will help to show how processes affect the way sculptures look.

I have been as down-to-earth as possible in describing ways and means. Much of the information a sculptor needs today is to be found only in scientific or industrial literature, where the presentation is likely to be technical and complex. Furthermore, the results obtained by industrial processes are not always those desired by the sculptor. What the sculptor really needs is engineering principles translated into rules of thumb. Over the past few years a body of knowledge has been brought into being by a number of imaginative contemporary sculptors who have, with great ingenuity, learned to adapt the tools of industry to the needs of sculpture. We are also seeing a renewed interest in methods of the near and ancient past.

This manual, in keeping with the American tradition of the kitchen-laboratory and the backyard-

studio, draws on many household methods of doing things, especially when they have proved to be the most widely used and efficient. I hope some of these practices will recommend themselves to students and artists of moderate means. As well as drawing inspiration from the kitchen cupboard, the book also makes use of the practices of the garage, the machine shop, the factory, and the scientific laboratory. Many of the fascinating and elaborate craft practices of former times have been eliminated, not without a twinge of nostalgia, in favor of more practical methods. I have explained some ancient trade secrets in everyday terms and shown why they became secrets in the first place. Some aspects of the interactions of materials are, however, still mysteries, and are likely to remain so for a long time.

A final chapter on planning and equipping the studio will, I hope, bring into focus an overall view of the various methods described earlier. Proper disposition of equipment and space are crucial in ensuring that the functions of the studio contribute harmoniously to the total rhythm of work.

1

Living Materials, Living Forms

The concept of "living materials" acknowledges that every material has an active presence, a character, a capacity for change, that entitles it to be considered "alive." Any piece of wood, though no longer part of a growing tree, has a grain pattern and a resiliency that causes it to respond characteristically when struck, bent, or cut. Every stone has its structure, granular or crystalline, flawed or sound, which will make it chip or split in certain ways, but not in others. Steel has its rusty willingness, silver its penetrating molten fluidity.

To understand and work with these living qualities, and occasionally to counter and transcend them, is the task of every artist and craftsman. It is a lifelong task, one that can never be completed because no one can master the temperaments of all the materials the earth has to offer, or which human ingenuity can invent. Indeed, who would want to? It is difficult enough to master just one material.

The other side of the question "how much technique do you want to know?" is the question, "how much do you want to be changed?" For if materials are alive, they return the pressure when they are pressed. As the artist cuts and trims and finally gives a presence to his work, the work in turn changes the artist. The person who finishes is not quite the same person who began.

Much of this interplay is physical, based on the slicing of the chisel through wood, or the stitching of molten metal along the weld. Much of what goes into a work of art is intelligence and will, imposing their concepts on what we have assumed to be the "obedient" substance of the "outside" world. But the world in which we artists work is neither obedient nor outside. If the earth is seen as an extension of ourselves, living and breathing as we are, the consequences for art are far-reaching. Not only does this view show us that making a work of art is a two-way proposition but it also implies that all actions are potentially art-actions, since all actions eventually affect the highest sensibilities of which we are capable. All spaces, too, become crucial, and therefore art-spaces.

The desire of contemporary artists to work in spaces outside of traditional museums and galleries is demonstrated by art that takes place in the sea, the sky, the mountains, and the desert, or which makes use of the particular characteristics of cities, farms, dumps, and swimming pools. The realization that space is as alive as matter makes it possible for actions, words, and ideas to be the materials of art,

and therefore performance art and conceptual art are recognized as art forms.

SCULPTURAL FORM

The present situation where a great variety of materials offer themselves to the artist is a recent phenomenon. In the past there were relatively few materials available to each culture. Artists had to achieve the utmost expressive range from each medium. Today's extensive inventory of materials has encouraged the proliferation in every direction of the types of forms that an artist can make. An artist can work with thin metal wires, with massive concrete, with projected light, or with sheets of transparent glass, as well as with the older materials, clay, stone, wood, or wax.

Is there an order to all these possibilities? If we can show how one kind of form grows out of another by a process of expansion, or contraction, or division, we will have a valuable conceptual tool for visualizing related types of forms. These families of forms will provide a basis for discussing which materials are most suitable for making different types of sculptures.

The *Form Wheel* is a device that displays seven different types or families of forms, arranged with six forms in a circle and one in the center. The six outer families of form are symbolized by the *Maze*, the *Screen*, the *Cube*, the *Landscape*, the *Relief*, and the *Tree*. The sculptures represented by these symbols are shaped by the action of six "ways to form": enclosure, perforation, contraction, division, flattening, and expansion.

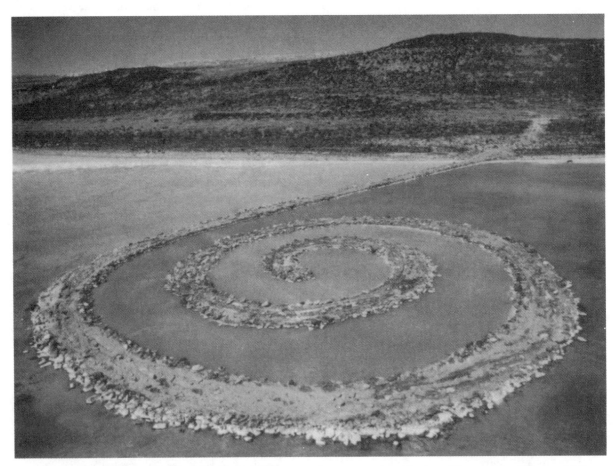

Plate 1.1. Robert Smithson, *Spiral Jetty*, 15′ × 1500′, 1970. Great Salt Lake, Utah (photo by Gianfranco Gorgoni). Bulldozers and dump trucks were the main tools for constructing this piece. The water level rises and falls, leaving deposits of salt crystals on the rocks.

In the center of the wheel is the figure of a human, representing the Source form, the most common of all sculptural forms, the Monolith. This Monolith has at different times and in different cultures been made of a tree trunk, a reindeer horn, a walrus tusk, a stone, a column of clay, a stuffed leather bag, a bundle of feathers, or a polished column of metal, to name but a few of the materials with which men and women have formed their images.

It will be noticed that of the six outer forms, three are solid—the Cube, the Landscape, and the Relief—and three are open—the Tree, the Maze, and the Screen. Also, two are flat—the Screen and the Relief—and four are volumetric—the Cube, the Landscape, the Tree, and the Maze. For each of these types of forms there are certain materials better suited than others. As one gets to know a material, one begins to sense that each material has a certain "feeling" because of the kind of form it seems to be suited for. This contest between the potential of the material and the will of the artist often has a role to play in the way a new style is born. Just as the establishing of a reliable supply of paper and the invention of movable type gave birth to novels and newspapers in the seventeenth century, so the development of metal rolling mills and the invention of the welding torch provided the means to make new forms of open sculpture in the twentieth century. Both the technique and a new vision had to exist at the same time. Perhaps that is why the Chinese produced more fireworks than cannons when they invented gunpowder in the ninth century A.D.

The Cube

The Cube represents the type of sculpture that is the result of form reduced to its bare essentials, stripped of excess ornaments or protrusions. A sphere could as well represent this type of sculpture. Sculptors such as Robert Morris, Don Judd, and Ronald Bladen have worked toward this extreme simplification. The whole idea is summed up in Mies van der Rohe's famous dictum: "Less is more." The game is to see by what restrained inflections of sculptural sensitivity one can bring into existence a sculptural entity rather than a mathematician's problem. Suitable materials would be stone, plastics, metal—particularly sheet metal.

A few observations that can be made about this rather forbidding type of sculpture is that the Egyptians were among the first to achieve monumentality

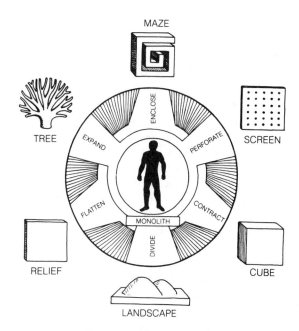

Figure 1.1. The Form Wheel.

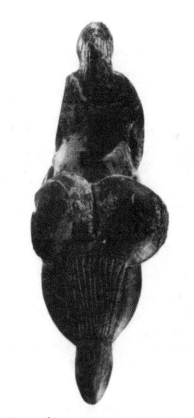

Plate 1.2. *Venus of Lespugue*, ivory, 4¾" high, Neolithic period, 20,000–18,000 B.C. Collection Musée de l'Homme, Paris (photo by Oster). This is one of the earliest sculptural expressions of the human figure.

through drastic simplification. Another observation is that Giacometti and Brancusi both came a long way in this direction, but kept their simplification from going beyond the limits that would allow them to represent human or animal states of being.

Some artists of the Minimal school of the middle sixties sought to make sculptures so bare that traditional meanings and interpretations would not cling to them. Looking at these works today emphasizes how difficult it is to avoid reading symbolic interpretations into even the most basic geometric forms.

When minimal sculpture is successful it has a timeless austerity and inevitability which go beyond its position as a once-fashionable style.

The Landscape

When two or more forms are set on a base or on a horizontal plane in relation to each other, a landscape situation is created. This can be small in scale, such as a multiple unit work in stone by Henry Moore, or the concept can take in a whole city. Models of landscapes, gardens, and theater sets are included here too. The models for parks or city projects by Isamu Noguchi and Claes Oldenburg have convincing presences as small sculpture. Plaster, clay, wood, and bronze lend themselves to small "Landscape" works. To create gardens and earthworks, the materials of the earth itself are carved and molded, and sometimes combined with timbers and reinforced concrete.

Relief

A high Relief is similar to a Landscape placed vertically. As the Relief becomes shallower and flatter,

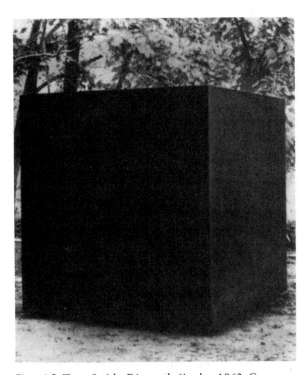

Plate 1.3. Tony Smith, *Die*, steel, 6' cube, 1962. Courtesy of Fourcade, Droll Inc., New York. *Die* was ordered by the artist from his fabricator over the telephone. The artist supposedly did not see the work until it was finished.

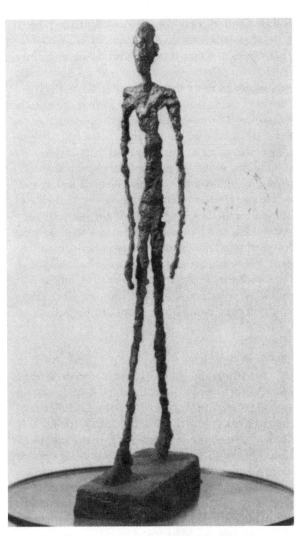

Plate 1.4. Alberto Giacometti, *Walking Man*, bronze, 27" high, c. 1946–1948. Courtesy Smithsonian Institution, Washington, D.C. The sparseness of the sculpture evokes feelings of aloofness and isolation.

the separate forms projecting into space flatten and are absorbed into the surface. We see an extreme of this tendency in Egyptian incised reliefs, in which the figures are not raised from the background but separated from it by a modeled line. Reliefs have been made from almost every conceivable material, including stone, wood, clay, concrete, metal, and plastic.

The consummation of this flattening in Relief sculpture is the blank wall—an undifferentiated surface extending in every direction. In this realm are all forms that are as flat as they can possibly be while still existing as real objects. The painter's canvas, for example, is perfectly flat but still possesses texture, edge thickness, and a definite shape. It is only very recently in the history of painting that artists have

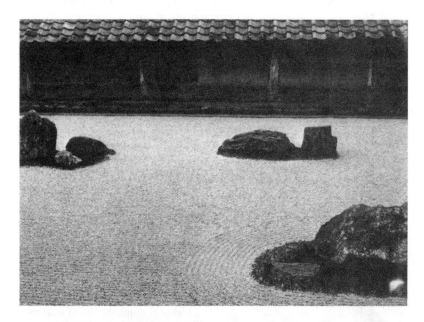

Plate 1.5. *Rock Garden at Ryo-Anji Temple*. Courtesy of Japan National Tourist Organization. The Japanese rock and sand garden is a horizontal relief in which freestanding groups of rocks are united by swirling patterns drawn in the sand with a wooden rake. The permanency of the rocks contrasts with the natural growth of moss around their bases and the immediacy of the constantly redrawn sand patterns.

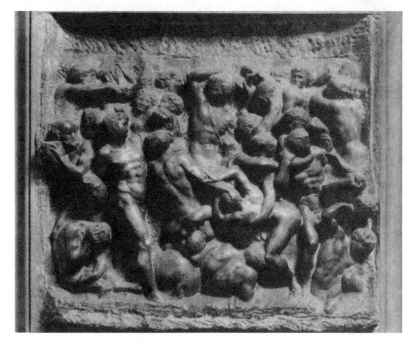

Plate 1.6. Michelangelo, *Battle of the Centaurs*, marble, 33¼″ × 35 5/8″, c. 1492. Casa Buonarroti, Florence (photo credit Brogi-Art Reference Bureau). The figures merge with the background, but the parts projecting into space are fully modeled.

begun to look around the edges of the canvas to realize they are painting on a thing, rather than making a window opening into an imaginary world.

The Tree

The open, treelike sculptural form evolved with the appearance of such materials as welded steel, metal wire, and plastic tubes and filaments. A more solid type of "Tree" sculpture is typified by the beams and girders of David Smith, Anthony Caro, and Mark di Suvero. As the extensions of this form become more attenuated, their "branches" multiply until the whole achieves a weblike radiance perhaps best exemplified in the work of Richard Lippold. Undoubtedly, sculpture of this kind will find an even more monumental expression in the future, as artists become involved in the design of cityscapes, highways, and bridges. Steel is the prime material for extension because of its tensile strength. Beams and rods when stretched become ribbons and wires. The step from materiality to immateriality replaces steel with light (lasers). At this point the Tree is transformed into the Sun.

The Maze

At the apex of the Form Wheel we have the Maze, symbolizing forms that result when the branches of open treelike sculptures are closed in. As the branches come together, they build the enclosures, corrals, and jungle gyms of contemporary sculptors like Sol Lewitt and Forrest Myers. Further enclosure produces the box, a form that has interested many sculptors of our day.

Boxes and mazes can be made of plastic or metal sheets, or more traditionally of thin pieces of wood with panes of glass and perhaps metal screening. Some masters of the box are Joseph Cornell—artificer of compartmented shrines for nostalgic fragments—and also Lucas Samaras and H. C. Westermann.

Plate 1.7. Mark di Suvero, *Nova Albion*, wood and steel, 18½' high × 14' wide × 28' long, 1964–65. Irvine, California (photo credit Richard Bellamy and James L. Monte). The extension into space of heavy beams is achieved through the use of steel cables in tension. Strength, lightness, and movement are combined.

Plate 1.8. Richard Lippold, *Variation Within a Sphere, #10; The Sun*, 22-karat gold-filled wire, 11′ high × 22′ wide × 5½′ diameter, 1956. Courtesy of the Metropolitan Museum of Art, New York, Fletcher Fund. This sculpture displays the shimmering and fragile elegance that can be attained when an artist stretches the possibilities of contemporary materials to their outermost limits. It is a good example of the type of sculpture achieved by expansion. Compare this to Tony Smith's *Die* (pl. 1.3).

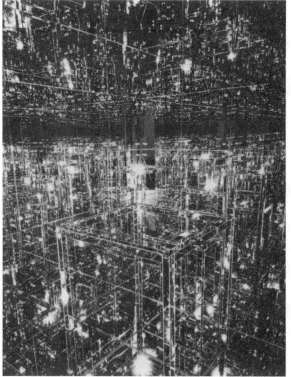

Plate 1.9. Lucas Samaras, *Mirrored Room*, mirrors, 8′ × 8′ × 10′, 1966. Courtesy of Albright-Knox Art Gallery, Buffalo, New York, gift of Seymour H. Knox. Although this sculpture is actually an enclosure, it creates the illusion of infinite extension.

The ultimate state attained by boxes and packages as they approach their final degree of enclosure is represented by the Maze or labyrinth. The three-dimensional form of the Maze, the Chinese puzzle, contains an infinite number of boxes within boxes. Appropriately enough, this serves as a symbol of the city of yesterday, which grew inward and became constantly more congested at the center. Conversely, the Ideal City is symbolized by the opposite image on the Form Wheel, the Landscape, in which living spaces are harmoniously ordered in relation to existing earth forms.

The Screen

As the Tree is the open version of the closed Cube opposite it across the Form Wheel, so the Screen or lattice is the open version of the Relief. The Screen stands not only for physically perforated planes (such as the stained-glass window) and flat webs but also for video and cinema projection screens that, by means of light, become windows into another world of movement and action. The artists working in this form are too numerous to list, but the work of Nam June Paik and Bruce Nauman is representative. Typical materials include glass, fiberglass, plastic sheeting, and wire mesh, plus light and electricity.

This abundance of materials and forms makes us wonder what will come next. Are there new, undiscovered forms of expression that will need to be added to the Form Wheel? Perhaps, but it would seem that, while every conceivable type of art is being practiced somewhere today, art has expanded into areas—such as performance and conceptual art—that are not comfortably contained by our traditional ideas of what sculpture is supposed to be. Still, while the older art forms may be temporarily eclipsed by newer ones, this does not mean that there can be no further original and moving work in conventional media. On the contrary, there is as much mystery in, say, a stone carving by Isamu Noguchi as there was when a Paleolithic hunter drew the shoulder of a bison around a musclelike projection on the wall of his cave.

BIBLIOGRAPHY

Alberts, Joseph. *Interaction of Color*. New Haven: Yale University Press, 1963.

Arnheim, Rudolf. *Entropy and Art*. Berkeley, Los Angeles, London: University of California Press, 1970.

Bachelard, Gaston. *The Poetics of Space*. Boston: Beacon Press, 1969.

Birren, Faber. *Color, Form and Space*. New York: Reinhold, 1960.

Borissavlievitch, Miloutine. *The Golden Number and the Aesthetics of Architecture*. New York: Philosophical Library, 1958.

Burnham, Jack. *The Structure of Art*. New York: George Braziller, 1971.

Fuller, Buckminster, in collaboration with E. J. Applewhite. *Synergetics, Explorations in the Geometry of Thinking*. New York: Macmillan, 1975.

Giedion, Sigfried. *Space, Time, and Architecture*. Cambridge, Mass.: Harvard University Press, 1947.

Greenbie, Barrie. *Design for Diversity*. New York: Elsevier North-Holland, 1976.

Kubler, George. *The Shape of Time*. New Haven: Yale University Press, 1962.

McLuhan, Marshall. *Understanding Media: The Extensions of Man*. New York: McGraw-Hill, 1964.

Mumford, Lewis. *Art and Technics*. New York: Columbia University Press, 1952.

Needham, Joseph. *The Grand Titration, Science and Society in East and West*. London: Allen & Unwin, 1969.

Thompson, D'Arcy Wentworth. *On Growth and Form*. 2d ed. Cambridge: Cambridge University Press, 1963.

Waddington, C. H. *Behind Appearance*. Cambridge, Mass.: M.I.T. Press, 1970.

White, Lynn, jr. *Machina Ex Deo, Essays in the Dynamism of Western Culture*. Cambridge, Mass.: M.I.T. Press, 1968.

2
Clay

Clay is an exceptionally weatherproof but breakable and heavy material. It is unsurpassed for recording the expressive gesture of the human hand. It is easy for beginners, but difficult to master. It is inexpensive to buy and process, and possesses a wide range of colors. It is good for models and maquettes, portrait busts, outdoor sculpture, architectural sculpture, and reliefs.

THE NATURE OF CLAY

There are many past civilizations whose entire production of artifacts has practically disappeared except for the fragments of a few clay objects. When these objects have been reconstructed, they tell us a great deal about the life and customs of the people who made them. They also tell us something about the nature of clay itself. What is this substance that is so abundant that it has been used by virtually every civilization, so impressionable that it records the imprint of fingers, leaves, cloth, and writing, and yet so durable that it survives the elements for thousands of years?

Clay is of course part of the earth's crust, a product of the erosion of rocks, the flow of rivers, and the decay of vegetable matter. Its appeal to the potter and sculptor is its capacity to be molded by the hands into forms that will retain their shape. In an elemental way, this is the essence of the "sculpturability" of any medium. The question is: "Is there a way to make an impression upon the medium which will endure long enough for us to contemplate it?" In the case of clay, once an object has been formed, its durability can be ensured by baking it so it becomes hard and waterproof. However, unfired or "green" clay makes an excellent study medium.

The plasticity of the clay does have its limitations. While it is easy to make small simple objects, ventures into larger scale and extensions into space bring a realization of clay's heaviness and sogginess, which tend to make energetic forms collapse and crispness degenerate into lumpishness. It is to overcome this inertia that the forming methods of wheel-throwing, coil building, and slab construction have been developed. Expertise in these methods can reach a degree of sophistication that transforms clay from a beginner's delight into a medium of great refinement. An arduous apprenticeship lies between.

To understand how the forming methods are used, one must first know something about the different types of clay in common use.

TYPES OF CLAY

Residual Clay (Primary)

Residual or primary clay is clay that has remained near the area where it was formed by the erosion of silica-bearing, or *feldspathic*, rock formations. This clay is fairly coarse and is relatively unmixed with other minerals and particles of debris. *Kaolin* or *china clay*, the principal ingredient of porcelain, is of this type.

Sedimentary Clay (Secondary)

As the action of wind and water carries primary clay away from its original source, it becomes refined in particle size and also picks up impurities in the form of organic material and minerals. The basic clay particle is a silicate of alumina ($Al_2O_3\ 2SiO_2\ 2H_2O$). Under the microscope, the particle has the form of a platelike shingle. As these platelets are refined by rubbing over one another they become smaller,

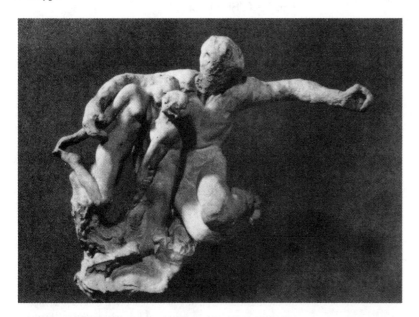

Plate 2.1. Auguste Rodin, *God Protecting His Creatures*, terra-cotta, 8″ × 10½″ × 4½″, c. 1910. Collection of the Musée Rodin, Meudon, France (photo credit Musée Rodin). Clay can be modeled swiftly and intuitively. In this small model or *maquette*, Rodin improved on a theme he was to treat many times on a larger scale.

Plate 2.2. Reuben Nakian, *Rock Drawing*, study for *The Rape of Lucrece*, terra-cotta, 10″ × 14¼″ × 6″, 1957. Museum of Modern Art, New York, fund given in memory of Philip L. Goodwin (photo credit the Museum of Modern Art). This artist explores the effects of squeezing and slashing the damp clay in a gestural fashion.

smoother, and more aligned with one another, producing that combination of elasticity and cohesion termed "plasticity." By contrast, minerals have an angular, crystalline structure even when ground very fine.

The organic elements in sedimentary clay are decayed vegetable matter and mold growing therefrom. They can color the clay blackish or greenish, and tend to give it a particular pungent odor. Actually, clay is always changing. Even in the studio, if kept damp it will continue to mold and ferment. A certain amount of organic material in clay makes it more plastic and gives it a slick, slippery feel which is an advantage in throwing on the wheel.

Minerals in the clay add a range of qualities that affect color and firing characteristics. The most common mineral, red or brown iron oxide, colors the clay and acts as a flux, reducing the firing temperature. A common type of sedimentary clay is *ball clay,* which is very plastic. Ball clay added to less plastic clays imparts the ability to hold a shape while being formed.

Stoneware Clay

A single primary or secondary clay is hardly ever used by itself, but is usually mixed with other clays to make a "body," or ready-to-use clay, which has a balance of qualities such as plasticity, green (unfired) strength, porosity, and texture, which suit it to a particular use. Stoneware clay is a rugged clay that fires in the range from cone 6 to 10 or about 2200°F to 2400°F. At this temperature the silicates in the clay fuse or *vitrify,* so that the minute spaces between the particles of clay, which had made the body porous, are filled with glassy fused silicates. The resulting body is strong and waterproof and has a ringing sound when struck. The colors of stoneware are rich browns and grays. It is used extensively for sculpture as well as pottery.

Fireclay

Fireclay is a very *refractory* (heat resistant) brownish clay often used in stoneware bodies to help their resistance to heat. If the process of vitrification goes too far without sufficient refractory materials, a stoneware body will begin to sag and, ultimately, will melt. There is a point where vitrification has occurred throughout the body, but has not caused distortion. This temperature is called the "maturing point" of that particular body.

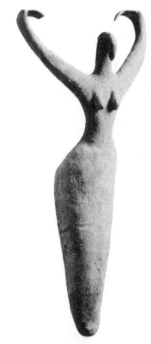

Plate 2.3. *Bird Deity,* terra-cotta, 11 7/16″ high, predynastic Egypt, c. 4000 B.C. Collection of the Brooklyn Museum, New York (photo credit the Brooklyn Museum). The affinity of clay for the human hand is exemplified by the curvilinear grace of this ancient figure.

Plate 2.4. John Mason, *Dark Relief,* ceramic clay, 11′ × 6′, 1961. Collection of the Tishman Company, New York (photo credit Frank J. Thomas). Stoneware is particularly suitable for architectural purposes because of its strength, hardness, and rugged texture. This sculpture was made in sections mounted on a steel framework bolted to the wall.

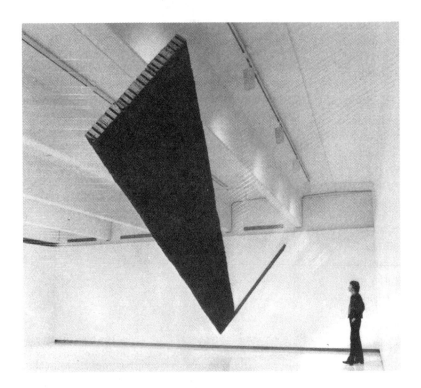

Plate 2.5. Loren Madsen, *L For Walker*, ceramic bricks and stainless steel wire. Room size: 40′ × 60′ × 15′ high (sculpture filled room). Size of brick section: 44′ long × 12′ high. Installation for Walker Art Center exhibition, Minneapolis, Minnesota, sculpture made in place, 25 April–6 June 1976 (photo credit Walker Art Center). This sculpture is made of ceramic bricks purchased from a building materials supplier, suspended in midair with stainless steel wires. When the exhibition was over, the sculpture was disassembled.

Because of the stability and extremely high melting point of fireclay it is used to make firebricks, which are used to line kilns and furnaces.

Ball Clay

A large portion of organic material makes ball clay unusually plastic, so it is added to many clay bodies, especially those intended for throwing. Dark gray in its unfired state, ball clay fires white, at which point it is chemically similar to kaolin.

Bentonite

Another plasticizer, bentonite has a finer particle size than any other clay. Small quantities of bentonite added to a body will greatly increase its workability.

Porcelain

Bodies composed mostly of kaolin can be fired until they are almost completely vitrified without losing their shape. The result is a very hard translucent glasslike material known as porcelain. It is fired up to cone 20, or about 2800°F. True porcelain pottery is exacting and expensive to produce. Most of it is made by professional potters working in their own studios. Commercial mass-produced "china" is made by adding fillers and fluxes to the body so it will resemble porcelain without requiring such a high temperature. Real porcelain is manufactured commercially in the form of electrical insulators and laboratory equipment.

Procelain has a relatively unexplored future as a material for sculpture, particularly as a vehicle for colored glazes. It should also prove useful in musical sculptures and in components for sculptures that incorporate electricity. Porcelain is an excellent medium where refined detail is sought.

Earthenware

At the opposite end of the firing scale from elegant procelain we find homey and soft earthenware, or *terra-cotta*. This is the material of primitive and folk pottery. It has been produced in wood and turf-fired kilns as well as in gas and electric kilns. Since it is not vitrified, it has a warm porous feel and is not waterproof. When struck it makes a "plunk" sound rather than the "ring" of stoneware or the "ting" of porcelain. Fired earthenware ranges from a light pink to a deep "terra-cotta" red. It is excellent for beginners and for thick, simple shapes of modest size.

Earthenware clays melt at stoneware temperatures. In fact they form the bases of some stoneware

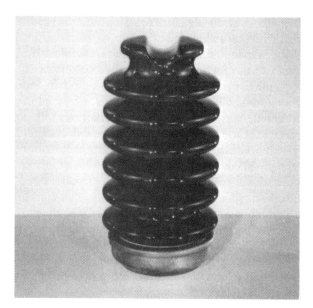

Plate 2.6. 34.5 kv line post insulator, glazed porcelain. Courtesy of Imperial Corporation, Victor Insulators Div., Victor, New York. The elegant form of this porcelain electric insulator is the result of the purity of a design response to a specific utilitarian demand.

glazes. It is important, therefore, not to inadvertently put an earthenware piece in a stoneware firing.

Aggregates

A clay can be so plastic that it is sticky and difficult to work. A very plastic clay also tends to be dense, so that it takes a long time to dry and is likely to crack. The clay then needs to be "opened up" by the addition of other ingredients. While a coarser, less plastic clay will help do this, other materials as well as raw clay are often used. The most common of these is *grog,* clay that has been fired and then ground and sifted to the desired particle size. Firebrick is much used for grog, but other types and colors of clay may be used. Since the particles of fired clay remain intact in the body they are mixed into, they have the effect of making the body more porous and allowing it to dry with less warpage and shrinkage. The thicker and larger the work to be made, the coarser and more open the body must be. Of course the character of the grog affects the feel and appearance of the clay.

Nonceramic aggregates such as sand may also be added to the body. Particularly useful are lightweight granular materials such as pumice and vermiculite, or expanded mica. They are used extensively in making

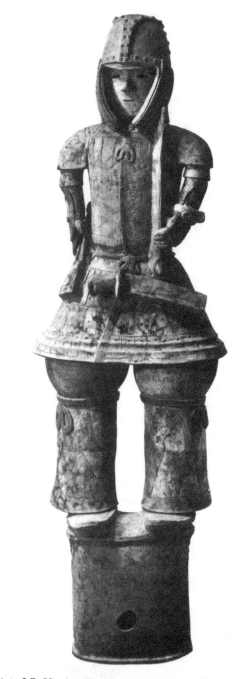

Plate 2.7. *Haniwa Warrior*, pottery, 41½″ high (cylinder 12½″), late Tumulus period, 6th century A.D. Excavated at Otu-Shi, Gumma prefecture, Japan. Eugene Fuller Memorial Collection, courtesy of the Seattle Art Museum. A good example of the monumentality that can be achieved even in small sculptures through the repetition of similar forms. The artist has made effective use of the technical choice to work with a limited shape, the tapered or flared cylinder, which will produce a hollow sculpture with uniform wall thickness.

large-scale, thick-walled objects like planters and outdoor sculpture. Shredded plastics of various kinds may also be used. They have the same effect of lightening the clay and, in addition, burn out in the firing, creating a porous body.

PREPARING CLAY

Prepared clay can be purchased packed in plastic bags ready for use. If extra aggregates or other ingredients are to be added, they can be "wedged" into the clay by kneading the clay and pounding it against a plaster slab or other hard surface.

One can, however, search out one's own natural deposits of clay, dig them up, screen out the debris, and mix in the ingredients that testing will show to be necessary to make a suitable modeling body.

More economical is the practice of buying large quantities of dry individual clays, then combining them in the studio. In a studio where considerable ceramic sculpture is made, the general situation is that there are cans or bins of used clay in various states of hardness, sacks of dried powdered clay of different kinds, and vats of pulverized clay soaking in water to prepare it for remixing. Finally, the freshly prepared clay is stored in airtight bins, ready for modeling.

Used clay, too stiff for further use, must be allowed to dry until it is brittle, then pounded up so it can be soaked in water to make it soft again. If the pieces of used clay are not too large, they may be dropped immediately into the water vat, thus bypassing the drying and pounding step.

To prepare the wet clay for use it is mixed with dry clay and grog until it is the desired consistency for modeling, or it can be placed on plaster bats for drying. In small amounts the clay may be wedged or pounded on a hard surface. Larger quantities will require the use of a *pug mill* or ceramic extrusion machine, which mixes the clay, extracts excess air, then pushes the clay through a die that forms it into a cylinder or rectangular bar, ready for use or storage.

Dough-mixing machines, such as those used in large bakeries, are often available secondhand. Though they do not extrude the clay nor de-air it, they make excellent clay-mixing machines, especially for sculpture bodies, which do not have to be as refined as conventional pottery bodies.

FORMING METHODS

Most of the techniques for hand building with clay have been known for hundreds of years. They are practical methods for overcoming the sogginess and shrinkage inherent in clay while extending its plasticity.

Simple Modeling

Pick up a handful of prepared clay. Smack it with your hand, squeeze it, pinch it, pat it, slice it with a sharp tool. These are the basic modeling gestures.

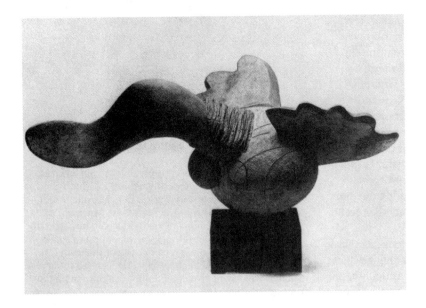

Plate 2.8. Jerry Rothman, *2001*, brown-black, zero-shrinkage clay with stainless steel reinforcement, 3′ × 5′6″ × 7′6″, 1974. Courtesy of the artist (photo by George Meinzinger). Zero-shrinkage clay, developed by the artist, combines ceramic clay with other refractory materials, firing at about 2200°F to produce a tough concretelike material. The appendages are reinforced with stainless steel mesh and the center form was modeled over a Styrofoam core.

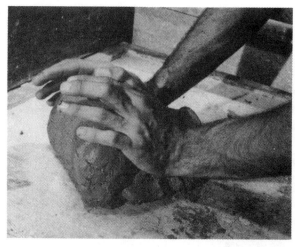

Plate 2.9. Wedging clay. The clay is kneaded and pounded on a solid table with a thick plaster top. Additional grog or other materials may be mixed in at this time.

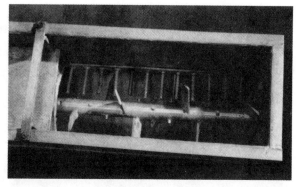

Plate 2.11*a*. View into hopper of pug mill. When the drive shaft rotates, the vanes, or blades, push the clay to the left into the vacuum chamber and out through the extrusion die at the front of the machine.

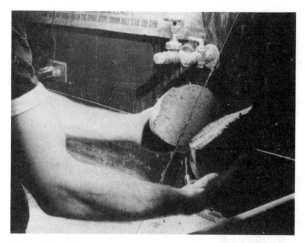

Plate 2.10. Slicing clay with wire. A taut wire at the side of the wedging table is handy for slicing the clay to aid in wedging and to determine uniformity.

You can quickly appreciate the different effects possible. Much will depend upon the consistency of the clay. When leather is hard it can be cut and scraped in a more precise way than when it is soft. If the clay is belabored too much it becomes crumbly and distraught. If handled too swiftly and dexterously it gets the bravura look of affected gesturing. It is important to remember too that much of the moist delicacy of fresh clay is lost in the shrinking and coarsening that takes place in the kiln.

When modeling clay, if it is to be fired, you cannot leave any rigid materials inside the clay for

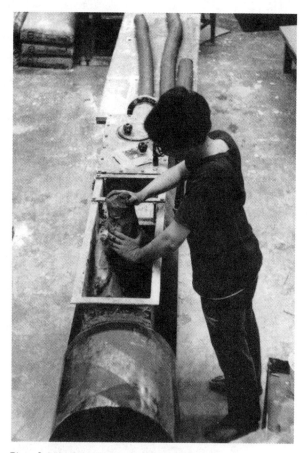

Plate 2.11*b*. Operator and pug mill. The operator feeds the ingredients for the clay body into the hopper of the pug mill. The clay is mixed by rotating blades, passed through a vacuum chamber to remove excess air, and extruded at the far end in the form of a cylinder. Other extrusion dies may be used to produce bars or slabs.

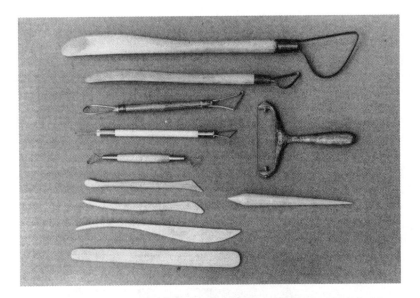

Plate 2.12. Clay modeling tools. They come in all sizes, with wire ends for slicing, wood for cutting and pressing. Each leaves its particular mark in the clay. Tools may be modified by the artist to suit a particular need.

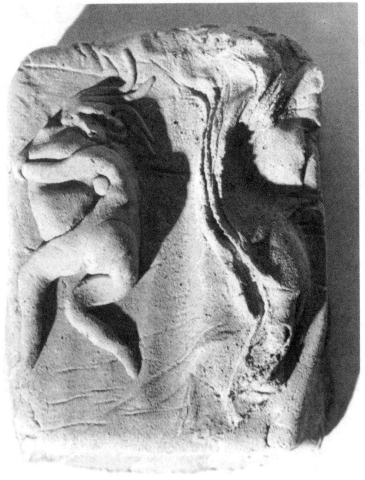

Plate 2.13. Constantino Nivola, *Untitled*, terra-cotta, 2¼″ × 5½″ × 7″, 1977. Courtesy of Gallery Paule Anglim, San Francisco (photo credit Christopher Brown). Nivola has captured the freshness of damp clay rapidly modeled with a sure hand.

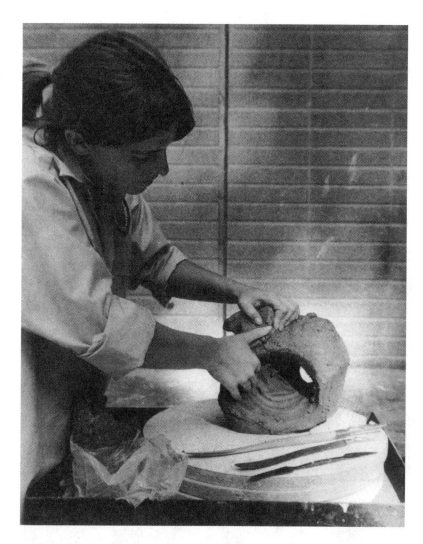

Plate 2.14. Simple modeling. Clay is modeled by pushing it into shape with the hands, pressing on pieces to build up the form, and cutting away with wood or metal tools.

support because the clay will shrink in drying and crack away from them. You can, however, use braces supporting the exterior of the form if you provide a means for the supports to move as the sculpture itself shrinks. Wads of paper or clay can be used, or the supports themselves may be made of partially hardened clay which can still shrink.

Slab Building

One way to get the clay to stand up and hold its shape is to construct the form with slabs and strips. Roll the clay out to the desired thickness over a piece of plastic or cloth so it will not stick to the table. If you use cloth, one side of the slab will be imprinted with the texture of the cloth. A rolling pin can be used to roll out a smooth slab, or it can be slapped or pounded by hand to an undulating "handmade" surface. Another method is to make a slab several inches thick and slice it into sheets with a taut wire. Each of these methods will produce slabs of a different character.

After the slabs are made, they may be cut into shapes and assembled as desired, care being taken to press all the joints firmly together so they will not come apart later under the stresses of firing. If the slabs are allowed to become leather hard before assembling, greater extensions and spans can be achieved with less sagging. Each part will then appear more distinct and separate than when the slabs are merged and modeled into each other. For joining leather-hard clay a slip of liquid clay is applied to the moistened and scored joints. A little vinegar or sodium silicate increases adhesion.

One advantage of the slab method is that a form of consistent wall thickness is produced. Such a shape will dry out and fire more safely than one with marked differences in thickness.

Coil Building

The technique of forming hollow shapes by building up coils of clay has been used from ancient times, and is still used by many potters, including the American Indians. Although a simple principle, it is capable of producing works of great precision, strength, and subtlety. One advantage of coil build-

ing is that the lower part of the work can be allowed to stiffen, supporting the upper region where the actual working of the coils is taking place, Hence, if the artist has plenty of time, each day a new ring of clay can be built above the previous day's work. Very large pieces may be made by this method.

Usually the building starts from a base slab from which the coils are wound and progressively pressed together. A paddle can be used to smooth the outside and make it more uniform. The Hopi Indian potter uses two polished stones that are worked against each other from the inside and the outside of the pot. A collection of pairs of smoothing stones

A

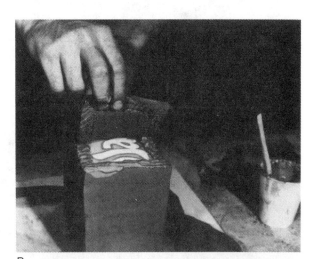

B

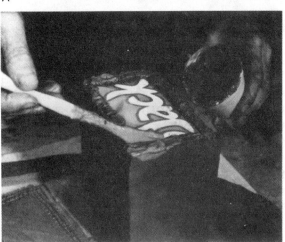

C

D

Plate 2.15*a*. Joining slabs. The edges are scored. This cube is constructed over a cardboard support that will crumple as the clay shrinks. Openings must be provided for the escape of smoke during firing; *b*. Slip is applied to both surfaces to be joined. *c*. The slabs are joined while the slip is still moist. *d*. The slabs are pressed together and the edges smoothed.

has been handed down from mother to daughter for many generations.

Supports

Mention has already been made of the use of external supports to hold up parts of a clay form which are liable to sag before they stiffen. Support may also be used within the form itself, if the support material is flexible enough to compress as the clay walls around it shrink in drying. Since clay sections more than an inch or so thick are likely to crack, forms that are more than about an inch in cross sections must be built hollow. One way to build large hollow forms rapidly is to use slabs formed over compressible materials like crushed newspapers, foam rubber or, if you prefer natural materials, bunches of leaves, grass, or corn husks. If the bottom of the form is open the stuffing can be pulled out when the clay is stiff enough to support itself, but if not, the stuffing must remain inside to burn out in the firing. So that the smoke from this burning material can escape without creating undue pressure, vent openings must be provided in the walls of the sculpture. A bed of granular material such as sand or vermiculite will allow lateral movement of the base.

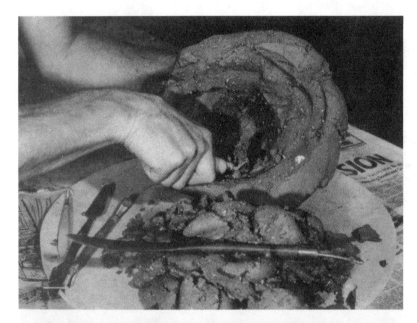

Plate 2.16. Hollowing out clay sculpture. When leather-hard, the clay form may be hollowed out to a uniform wall thickness, using wire-end tools or scrapers of wood or metal.

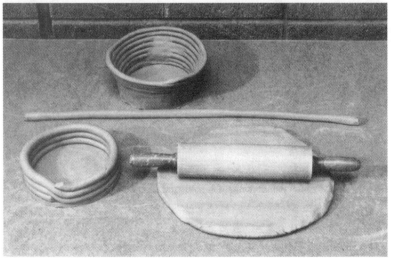

Plate 2.17. Coil building. A slab is formed by pounding or rolling. Then a coil of clay is wound around the edge of the slab, each layer on top of the coil beneath it. Finally, the coils are smoothed with finger, scraper, or paddle.

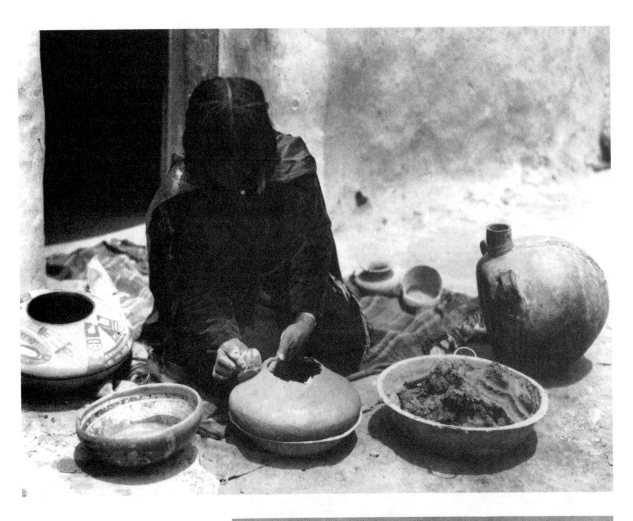

Plate 2.18. *Nampaya, Hopi Pottery Maker.* Courtesy of American Museum of Natural History, New York (photo credit Rodman Wanamaker). Forms of accuracy and refinement may be produced by the coil method when a skilled artisan works within a highly developed tradition.

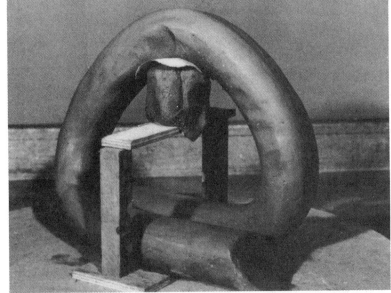

Plate 2.19. External supports for clay. As the clay shrinks in drying the pad of supporting clay shrinks also, helping to avoid shrinkage cracks.

The rounded pillowlike forms of much pre-Columbian sculpture were produced in this way, using shaped bundles of dried grass as supports to model over. Some early Iranian sculpture also made use of this technique.

Interlocking

Forms made by any of the above methods may be fitted together to make a larger sculpture. The balancing of the separate parts and the design of their joints is best planned in advance, using models. These parts can be cemented together with epoxy glue or cement mortar. Alternatively, they can be provided with jointing devices such as tennons, dowels, and cleats which will allow the parts to interlock in such a way that the sculpture can be disassembled and reassembled. This is an advantage when moving large ceramic pieces, which are usually heavy and fragile. Even if the sculpture is eventually

assembled permanently with glue or mortar, the interlocking joints will provide an extra measure of strength and safety.

Throwing

Thrown forms may also be shaped after removal from the wheel by cutting, pressing, or striking.

The technique of *throwing,* or forming a cylinder of clay on the potter's wheel, is primarily used for making bowls and vessels. Although it is fairly easy to make simple squat shapes, real skill on the potter's wheel requires several years of practice and some knowledge of the traditions of this ancient craft.

Throwing techniques for making sculpture have been demonstrated by several ceramic sculptors, as the accompanying illustrations show. Forms created on the wheel may be joined, or combined with slab, coils, or bars.

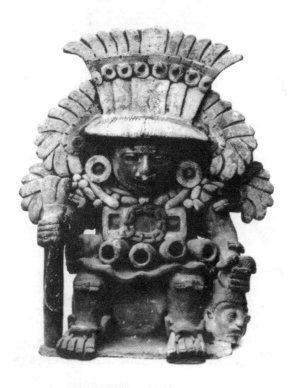

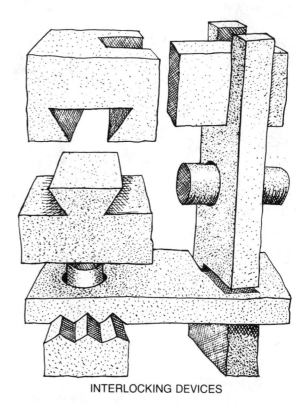

INTERLOCKING DEVICES

Plate 2.20. *Clay Urn, Zapotec,* terra-cotta, 20½″ × 17¾″ × 13½″, 3d century B.C. Monte Alban II, courtesy of the National Institute of Anthropology and History, Mexico City. Pre-Columbian ceramic sculptors achieved great variety and vitality in their handling of the basic types of handbuilding units: slabs, coils, strips, and tubes.

Figure 2.1. Interlocking devices. Slots and bars, or grooves and projections (mortices and tenons) may be used to join parts that can be disassembled, rearranged, or set in motion. Interlocking also makes glued joints stronger.

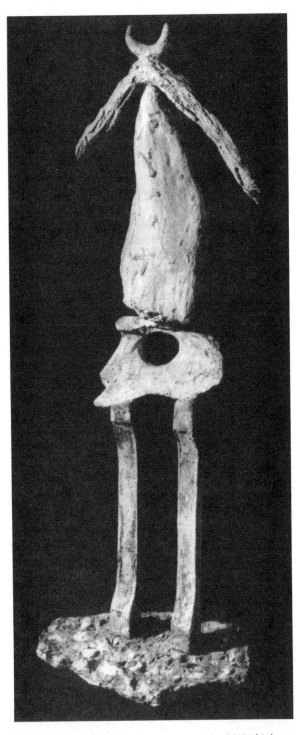

Plate 2.21. Joan Miró, *Personnage*, ceramic, 39½″ high, 1956. Courtesy of Collection Pierre Matisse Gallery, New York (photo credit Eric Pollitzer). A sculpture too delicate to be modeled in one piece is executed by joining previously shaped sections.

Plate 2.22. Stephen De Staebler, *Standing Man with Brown Knee*, high-fired clay, 82½″ × 31½″ × 9¼″, 1975. Courtesy of James Willis Galleries, San Francisco (photo by Susan Felter). This piece is too large to be made in solid clay. The slicing into sections, which was necessary for moving and firing, has been incorporated as an expressive aspect of the whole work.

Casting

Clay plays an important role in the casting of sculptures. It is molded over an armature to be used as the original model from which a cast is taken. Clay in the form of *slip,* a liquid, creamy clay solution, provides a widely used casting medium. For details see chapters three and four.

FIRING

Drying and Loading

Before being fired in the kiln, clay must be absolutely dry. The last bit of the "water of plasticity" may be driven off by placing the work in a heated closet, or on a rack near where the kiln is being fired. When ready the work is carefully loaded into the kiln. In a *bisque* firing, where there are no glazed pieces, edges

may touch, and you can even pile simple forms on top of one another. Glazed ware must be arranged in the kiln with enough separation between pieces to prevent the glazes from running together.

Loading a kiln with sculpture often presents problems because of the sculpture's weight and irregular shape. A forklift is a great help in moving heavy pieces. Often a wooden pallet will help in handling the piece so it will not be broken where it must be gripped. The pallet can be designed so it can be left in the kiln to be burned out, instead of having to be pulled out from under the sculpture.

Once in the kiln, the sculpture is often further dried by turning the kiln on very low and leaving it for several hours, or even days, with the doors and dampers open. In general sculpture requires a much slower rise in temperature than does pottery during

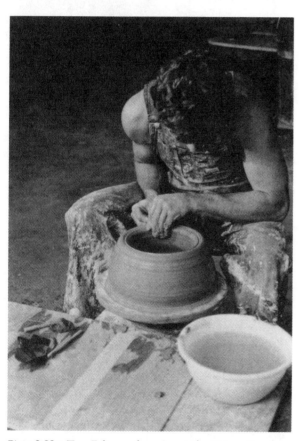

Plate 2.23*a*. Tres Feltman throwing at the University of California at Los Angeles. First the lump of clay is centered on the wheel, then opened up into a low, thick-walled drum.

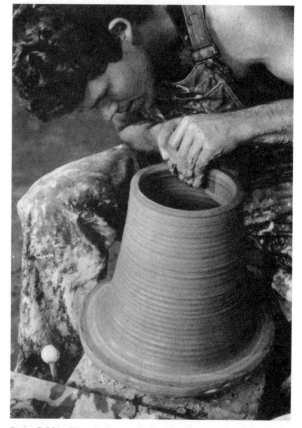

Plate 2.23*b*. Tres Feltman throwing at the University of California at Los Angeles. The sides of the cylinder are drawn upward with the fingers into a taller, thinner shape. This basic cylinder can then be closed, or opened out into a bowl form.

the early stages of firing because of the thicker wall sections used. If moisture is trapped inside the clay it will turn to steam and blow up the sculpture.

Kilns

Pottery can be fired with almost any fuel that will burn, including gas, oil, coal, wood, leaves, brush, turf, pine needles, and animal dung. Today heat is generally supplied by natural or bottled gas and electricity.

Electric kilns create accurate temperatures for firing small pieces and for testing samples. Large electric kilns are expensive to operate, and because there is no fuel, it is difficult to produce the reducing atmosphere required for most stoneware firing.

A modern kiln is essentially a rigid box lined with insulating brick. The higher the temperature to be reached, the more refractory the brick must be. A gas kiln must have burners, entrances for air, and a flue or flues equipped with dampers to control the passage of air through the kiln. There must be a door for loading the kiln. The door is always a problem. It must fit accurately and be easy to open even though it is made of heavy bricks. It must also be securely

Plate 2.24. Peter Voulkos, *5000 Feet*, fired clay, 46″ × 21″ × 13″, 1958. Collection of Los Angeles County Museum of Art, Los Angeles (photo credit Los Angeles County Museum of Art). The parts of this sculpture were individually thrown on the potter's wheel, then joined together and further modified by striking with a paddle, slicing, and scoring.

Plate 2.25. David Cressey, *Earthcells*, stoneware, 32″ high, 1958. Private collection, Architectural Pottery L.A. (photo credit Jim Goss). Typical wheel-thrown pottery shapes are assembled in a sculptural column, then sliced to reveal walls and inner cavities.

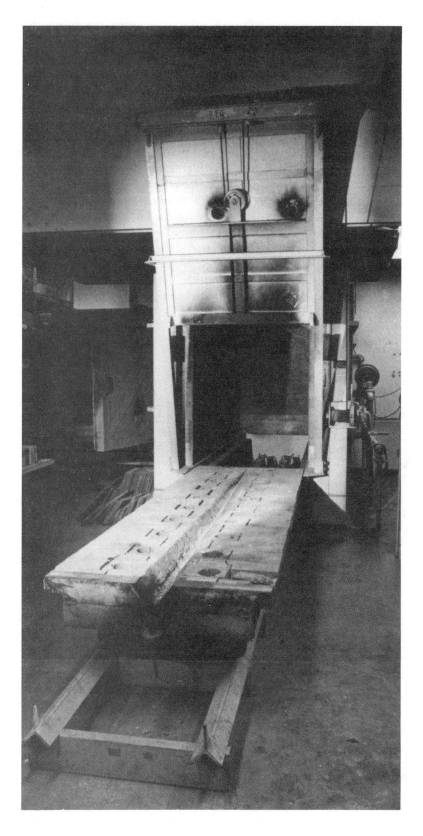

Plate 2.26. Shuttle kiln. The floor of the shuttle kiln is loaded, then pushed on tracks into the kiln itself. The guillotine door is lowered into place by a winch and cable. In the background is a smaller kiln with hinged door.

braced by the frame of the kiln so that it does not cause the frame to twist out of alignment. Some homemade kilns bypass this problem by simply using firebrick to brick up the entrance to the kiln before each firing. The main problem encountered in making your own kiln, besides the door, is to achieve an even flow of hot gases through the kiln so that the temperature will be even throughout the kiln at all stages of the firing cycle. A good way to begin is to make your first kiln a near-copy of an existing one that you know fires well.

The Firing Cycle

Once the clay is thoroughly dried out, the doors are closed and the temperature is gradually raised, keeping the dampers open. The speed of temperature rise depends upon the thickness of the sections of the sculpture and the composition of the body. Many stresses take place within the body at this time as the different materials go through their particular stages of transformation.

The temperature within the kiln is measured by a pyrometer gauge connected to a sensor inserted into the kiln, or by pyrometric cones placed within the kiln before the door is closed. Through a peep hole in the door, the cones can be observed to bend over when they reach their rated temperature. At around cone 012, or 1600°F, the molecular water chemically bound within the clay has been driven off. At this point the clay has been rendered permanently hard; it can never be softened by water.

If the body being fired is earthenware, it is taken to about cone 06 for full hardness and color. Clay that is being *bisqued,* or preglaze fired, is also terminated at about cone 06, even if the piece will later be fired to a higher temperature after it is glazed. The

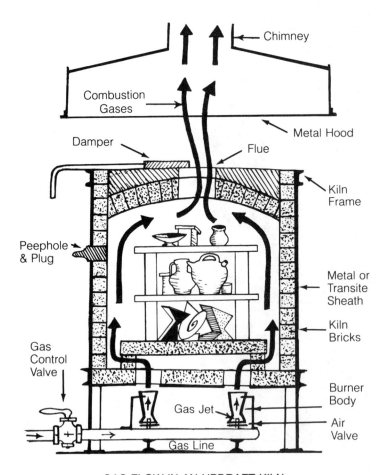

Figure 2.2. Gas flow in an updraft kiln.

GAS FLOW IN AN UPDRAFT KILN

porosity left in the clay at this temperature enables the body to absorb water and to receive the liquid glaze smoothly.

When the firing is finished, the kiln is turned off and the dampers closed to avoid sudden cooling from cold air entering the kiln. The kiln may be unloaded the next day, or after cooling for about twenty-four hours (or even longer if there are large pieces).

Reduction

When firing stoneware, a process known as *reduction* is begun as soon as the clay has lost its molecular water. The normal atmosphere within a kiln is an *oxidizing* one, which means that there is enough oxygen present to consume the fuel. By contrast, a *reducing* atmosphere indicates the opposite—an inadequate oxygen supply and an excess of fuel, hence an excess of carbon.

The process of reduction involves driving carbon into the body of the clay, where it combines with the oxygen carried by the metallic oxides within the clay. This leaves some metallic molecules free of oxygen, and the free metals impart their color to the clay. The metal most abundant in clay is iron, which has a dark gray color. If you break open a piece of reduced stoneware clay you will see that the inner part is, in fact, dark gray. The layer near the surface is dark brown because the oxygen entering the kiln after it has been turned off reoxidizes the surface of the clay to a certain extent. Actually the effect of reduction is not only to darken the surface but also to enrich it

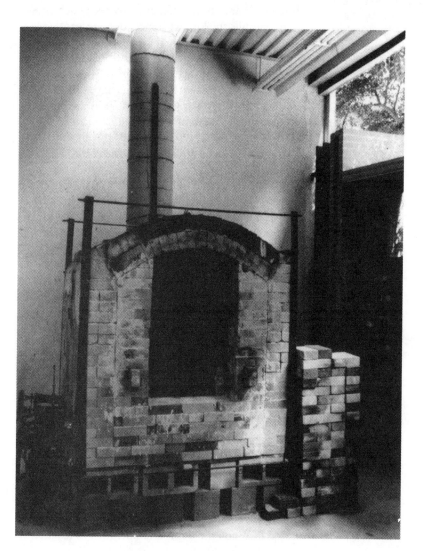

Plate 2.27. Homemade sidedraft kiln. The door is constructed for each firing by bricking up the entrance to the kiln. Note barrel-vault kiln roof.

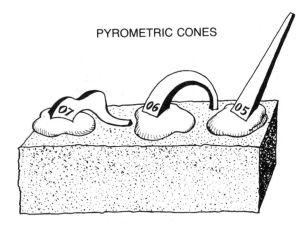

PYROMETRIC CONES

Figure 2.3. Pyrometric cones. The cones are set in dabs of clay on a firebrick, or mounted in a base designed to hold them at an angle of 60°. When a cone bends over so that its tip is even with its base, the temperature has been reached for which the cone is rated.

with a mottled effect more variegated than the uniform color of clay that has been fired in a normal oxidizing atmosphere. The amount of iron oxide present in the body will determine how much free iron will become available during reduction to color the body.

If there is a glaze on the object being fired the reduction will have a similar effect on the metallic oxides present there. Iron glazes will become gray, for instance, and copper glazes, which would be greenish when oxidized, will turn red or brown. The glazes will also become more mottled and mat in texture than they would if fired in an oxidizing atmosphere.

To reduce the kiln the dampers are partially closed at about cone 012. This impedes the rush of hot gases through the kiln and creates a back-pressure that fills the kiln with incandescent gas. Since the kiln is denied sufficient circulation for complete combustion, free molecules of carbon circulate in the kiln and are absorbed into the porous body of the clay works within. Some kilns have provision for adding jets of raw gas to the flow from the burners, so that the gas content within the kiln can be increased even more. On other kilns the air shutters of the burners can be adjusted to achieve the same effect.

As the reduction builds up, the kiln will begin to smoke. A reduction kiln should have a tight door and an efficient hood and venting system. A blower on the flue will help to pull the fumes out of the kiln room. On no account should the smoke and gas fumes be allowed to accumulate in the kiln room as they contain toxic carbon monoxide.

A person experienced in ceramic firing will be able to judge the character of the reduction by the color and length of the flames coming out the kiln flues. They should be greenish-orange but not too smoky. There is no advantage to overreducing and covering the kiln with soot.

When the clay in the kiln begins to vitrify at stoneware temperatures, starting at about cone 1, or 2120°F, the chemical reactions between the carbon and the iron oxide take place at the same time as the melting and fusing of the silicates which transform the porous clay into stoneware. The reduction may be tapered off after cone 1, or continued strongly right up to the maturing temperature of the clay, somewhere between cone 6, 2246°F, and cone 10, 2382°F. When the desired temperature is reached

TABLE 2.1 End Point Temperatures of Pyrometric Cones

The End Point Temperature is that temperature at which the tip of the cone has bent until it touches a point level with the base of the cone. Rise in temperature = 302°F (150°C) per hour.

Cone #	Degrees C	Degrees F		Cone #	Degrees C	Degrees F	
022	605	1121		1	1160	2120	
021	615	1139		2	1165	2129	
020	650	1202		3	1170	2138	
019	660	1220	Luster and overglaze	4	1190	2174	Stoneware, floor tile
018	720	1328		5	1205	2201	
017	770	1418		6	1230	2246	
016	795	1463		7	1250	2282	
015	809	1481		8	1260	2300	
014	830	1526		9	1289	2345	
013	860	1580		10	1305	2381	
012	875	1607		11	1325	2417	
011	895	1643		12	1335	2435	
010	905	1661		13	1350	2462	Porcelain
09	930	1706		14	1400	2552	
08	950	1742	Bisque and earthenware Terra-cotta	15	1435	2615	
07	990	1814		16	1465	2669	
06	1015	1859		17	1475	2687	
05	1040	1904		18	1490	2714	
04	1060	1940		19	1520	2768	
03	1115	2039		20	1530	2786	
02	1129	2057					
01	1145	2093					

the kiln is shut off and all dampers and peepholes closed.

FINISHES AND GLAZES

White earthenware and porcelain tend to look pale and incomplete until they are glazed. Stoneware has a warm and natural quality just as it comes from the kiln. However, every type of fired clay is potentially an excellent base for many kinds of finishes. Ceramic sculpture can be painted, stained, varnished, waxed, fiberglassed, and even metal-sprayed. It can be mended with epoxy glue and patched with plastic wood.

The most traditional finish for a ceramic sculpture is a glaze, permanently fused to the ceramic body. The glaze not only adds color, but provides a smooth waterproof surface which is easy to clean, a significant consideration for outdoor sculpture.

All the glazing techniques suitable for pottery are applicable also to sculpture, but the intricacies of glaze chemistry are beyond the scope of this text. Information on glazes will be found in the books listed at the end of this chapter. There are many mat, stony-looking glazes available for the sculptor who wishes his ceramic work to have a subdued earthy appearance. There are also many other possibilities for experiment: brilliant primary colors, glossy and reflective surfaces, and even lustrous metallic glazes resembling gold, silver, and chrome.

SAFETY

One might suppose that as gentle a craft as ceramics would be relatively free of health hazards, but this is not the case. Ceramics is actually quite hazardous. The principal danger is inhaling dust that contains

free silica (SiO_2). Free silica causes silicosis, a damaging and irreversible lung disease. Many ceramic products, including most clays, contain significant amounts of free silica. What is dangerous is not silica or silicon that is chemically combined with other elements, but silica that floats in the air in its uncombined form.

Therefore the precautions to take are: daily wet mopping, cleaning up with wet cloths, keeping bags and barrels of clay covered and in repair, and in general, anything that will eliminate dust. At all times when there is dust in the air, dust masks should be worn. As is true for many other sculpture processes, you should become used to wearing your dust mask, so that it is not felt as an imposition, but as a welcome protection.

You should avoid eating in the place where you work. Actually, there is no hazard in eating free silica, but there is considerable danger in eating some of the ingredients of ceramic glazes. Never point your brush by putting it in your mouth!

Some of the more hazardous of the metals and metallic compounds used in glazes are:

Barium carbonate ($BaCO_3$). It is both toxic and soluble until fired.

Cadmium compounds. All cadmium compounds are toxic. Find out if red, orange, or yellow glazes you are using contain cadmium.

Chromium. Dichromates, such as potassium dichromate, are corrosive and irritating to the skin.

Cobalt compounds are toxic. They are often found in blue and green glazes.

Lead is poisonous. It should not be used in any form for ceramic purposes. One of the problems with lead is that it accumulates in the body, owing to its slow elimination rate. Not only is lead dangerous to workers but it is also dangerous to consumers, since it can dissolve into food and drink from many types of lead glazes.

Manganese carbonate is the ingredient in many dark glazes, especially blacks, browns, and purples. It is toxic and can also produce respiratory irritation.

Many other compounds can produce irritations in certain people who are sensitive to them. Therefore, the following precautions should always be taken:

1. A dust mask should be worn when mixing glazes or powdered ceramic ingredients.
2. All glazes and powders should be kept in sealed containers.
3. There must be adequate ventilation in ceramic work spaces, either naturally or by means of fans and vent hoods. More information on ventilation in chapter fifteen.
4. Also in chapter fifteen will be found information on spray booths and other methods of isolating

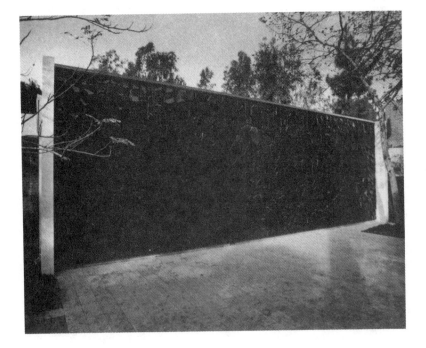

Plate 2.28. Alberto Burri, *Grande Cretto Nero*, fired and glazed ceramic, 16½′ × 50′, 1976–1977. Collection of University of California, Los Angeles, gift of the artist (photo by the author). Each piece of this relief was made and fired separately, then given a key number. The pieces are nailed into the concrete wall through metal traps cemented into the hollow backs of the pieces. The entire relief is finished with a black glossy glaze.

hazardous areas from open areas.
5. Glazing should be done in such a way that wasted glaze can be immediately discarded. Disposable paper or plastic work sheets are an aid in accomplishing this.

Many power-tool operations take place in the ceramic studio, particularly grinding and sawing. The same precautions apply here as to the use of power tools in wood- or metalworking:

1. Face and eye shields must be worn.
2. Loose clothing and hair must be carefully bound so they will not be caught in the machine.
3. Adequate footwear should be worn.
4. Ventilation must be adequate. Dust respirators and noise protectors must be provided.
5. All equipment guards and shields must be in place.
6. Equipment must be inspected often. Shut-off switches must be quickly accessible.
7. Lighting must be adequate.
8. Students should be taught to focus their attention before turning on any power tool.

BIBLIOGRAPHY

A. Studio Books

Ball, F. Carlton, and Janice Lovoos. *Making Pottery Without a Wheel*. New York: Reinhold, 1965.

Bitters, Stan. *Environmental Ceramics*. New York: Van Nostrand Reinhold, 1976.

Conrad, John W. *Ceramic Formulas: The Complete Compendium*. 5th printing. New York: Macmillan, 1976.

Ford, Betty D. *Ceramic Sculpture*. New York: Reinhold, 1964.

Fraser, Harry. *Glazes for the Craft Potter*. New York: Watson-Guptill, 1973.

Hamilton, David. *Architectural Ceramics*. London: Thames & Hudson, 1978.

Kenny, John B. *Ceramic Design*. Philadelphia: Chilton, 1963.

———. *Ceramic Sculpture*. Philadelphia: Chilton, 1953; 9th printing, 1974.

Leach, Bernard. *A Potter's Book*. 12th printing. New York: Transatlantic Arts, 1970.

Nagrimo, Ryu. *Creative Ceramics*. Tokyo: Japan Publications, 1974.

Nelson, Glen. *Ceramics, A Potter's Handbook*. 3d ed. New York: Holt, Rinehart & Winston, 1971.

Norton, F. H. *Ceramics for the Artist Potter*. Reading, Mass: Addison-Wesley, 1956.

———. *Elements of Ceramics*. Reading, Mass.: Addison-Wesley, 1952.

Rado, Paul. *An Introduction to the Technology of Pottery*. New York: Pergamon, 1969.

Rhodes, Daniel. *Clay and Glazes for the Potter*. Philadelphia: Chilton, 1957.

———. *Kilns*. Philadelphia: Chilton, 1968.

———. *Stoneware and Porcelain*. Philadelphia: Chilton, 1959.

Ryan, W. *Properties of Ceramic Raw Materials*. New York: Pergamon, 1968.

Tyler, Christopher, and Richard Hirsch. *Raku*. New York: Watson-Guptill, 1971.

Wildenhain, Marguerite. *Pottery Form and Expression*. New York: Reinhold, 1962.

Winterburn, Mollie. *The Technique of Handbuilt Pottery*. New York: Watson-Guptill, 1969.

B. Historical Books

Bliss, Robert W. *Pre-Columbian Art*. London: Phaidon, 1959.

Cameron, Elizabeth, and Philippa Lewis. *Potters on Pottery*. New York: Vanguard, 1954.

Hazashiza, Seizo, and Hasebe Gakuji. *Chinese Ceramics*. Rutland, Vt.: Tuttle, 1966.

Kidder, J. *The Birth of Japanese Art*. New York: Praeger, 1964.

Leach, Bernard. *Hamada*. Tokyo: Kodansha International, 1975.

———. *Kenzan and His Tradition*. London: Faber & Faber, 1966.

Miki, Fumio. *Haniwa*. Rutland, Vt.: Tuttle, 1960.

Richardson, Emeline Hill. *The Etruscans*. Chicago: University of Chicago Press, 1964.

Robbins, Warren. *African Art in America's Collections*. New York: Praeger, 1965.

Slivka, Rose, and Peter Voulkos. *A Dialogue with Clay*. Boston: Little, Brown, 1978.

Wilkinson, Charles K. *Iranian Ceramics*. New York: Abrams, 1963.

C. Periodicals

Ceramics Monthly, 4175 North High Street, Columbus, Ohio 43214. Oriented toward the amateur, many useful articles.

Craft Horizons, 44 West 53d Street, New York, N.Y. 10019. Covering all craft fields, with many articles on contemporary American and foreign ceramics.

Journal of the American Ceramic Society, Columbus, Ohio 43200. Technical articles, usually slanted toward industrial ceramics but occasionally of interest to the sculptor.

Crafts, 28 Haymarket, London SW1Y4SU, United Kingdom. All craft fields including ceramics, ceramic sculpture, etc.

SOURCES OF SUPPLY

A. Clay and Glazes

L. H. Butcher Co., 15th and Vermont Streets, San Francisco, CA 94107.

Garden City Clay Co., Redwood City, CA 94064.

Hammill and Gillespie, Inc., 225 Broadway, New York, NY 10007.

Interpace Corp., 2901 Los Feliz Blvd., Los Angeles, CA 90039.

Kentucky-Tennessee Clay Co., Mayfield, KY 42066.

Mandl Ceramic Supply Co., RR 1, Box 369A, Pennington, NJ 08534.

Pottery Arts Supply Co., 2554 Greenmount Ave., Baltimore, MD 21218.

Trinity Ceramic Supply Co., 9016 Diplomacy Row, Dallas, TX 75235.

United Clay Corp., Trenton, NJ 08606.

S. Paul Ward, 601 Mission St., South Pasadena, CA 91030.

Westwood Ceramic Supply Co., 14400 Lomitas Ave., City of Industry, CA 91744.

Jack de Wolfe Co., Inc., 724 Meeker Ave., Brooklyn, NY 11222.

B. Ceramic Tools and Equipment

Robert Brent Corp., 128 Mill St., Healdsburg, CA 95448. Electric wheels and tools.

L. H. Butcher Co., 15th and Vermont Streets, San Francisco, CA 94107. Tools, utensils, equipment.

Craftools, Inc., 1 Industrial Rd., Woodridge, NJ 07075. Tools and wheels.

DeVilbiss Co., 300 Phillips Ave., Toledo, OH 43601. Spray equipment.

M. Flax, 10846 Lindbrook Dr., Los Angeles, CA 90024 and 250 Sutter St., San Francisco, CA 94108. Tools.

Sculpture Associates, 101 St. Marks Place, New York, NY 10009. Tools and equipment.

Sculpture House, 38 E. 30th St., New York NY, 10016. Tools and equipment.

Paul Soldner, Box 917, Aspen, CO 81611. Kick and electric wheels.

Standard Ceramic Supply Co., P.O. Box 4435, Philadelphia, PA 15205. Tools and wheels.

Tepping Ceramic Supply Co., 3517 Riverside Dr., Dayton, OH 45405. Tools and equipment.

C. Kilns

A. D. Alpine, Inc., 353 Coral Circle, El Segundo, CA 90245. Gas and electric.

W. H. Fairchild, 712 Centre St., Freeland, PA 18224. Electric.

Nordstrom Kiln Co., 9046 Garvey St., South San Gabriel, CA 91777. Gas.

Paragon Industries, Inc., Box 10133, Dallas, TX 75207. Electric.

Skutt and Sons, 2618 S.E. Steel St., Portland, OR 97202. Electric.

Smith Engineering Co., 1903 Doreen Ave., South El Monte, CA 91733. Gas.

Unique Kilns, 530 Spruce St., Trenton, NJ 08638. Electric.

West Coast Kiln Co., 635 Vineland Ave., La Puente, CA 91746. Gas.

D. Extrusion Machines and Mixing Machinery

Bonnot Co., P.O. Box 390, Canton, OH 44701. Extrusion machines.

Essick Manufacturing Co., 1950 Santa Fe Ave., Los Angeles, CA 90021; 850 Woodruff Lane, Elizabeth, NJ 07201; 350 E. Irving Park Rd., Wood Dale, IL 60191. Cement and plaster mixers, useful also for clay.

Fernholtz Machinery Co., 8468 Melrose Place, Los Angeles, CA 90069. Extrusion machines and ball mills.

C. O. Fiedler, Inc., 553 N. Mission Dr., San Gabriel, CA 91778. Extrusion machines.

Patterson Foundry and Machine Co., East Liverpool, OH 43920. Extrusion machines.

U.S. Stoneware Co., Akron, OH 44309. Ball mills.

Walker Jamar Co., Inc., 365 S. First Ave., East, Duluth, MN 55806. Small extrusion machines (pug mills).

3

Plaster Building

Plaster is an extremely versatile material. In a fluid state it can be poured into molds to make sensitive impressions of textures. It can also be used as a mold material. When mixed to a buttery consistency plaster is excellent for modeling, and can then be carved when it has hardened. It can also be poured into a mold, accompanied by aggregates if desired, and carved like a block of soft stone when hard. The shortcoming of plaster is its weakness: it sacrifices strength to ease of forming, breaks easily, and deteriorates on exposure to the weather.

HISTORY

The appealing characteristics of plaster as an accommodating and abundant sculpture medium were early appreciated. A plaster mask was found in the Step Pyramid at Saggara in Egypt dating from 2400 B.C. Numerous casts of parts of the body were made at El Amarna around 1370 B.C., and plaster seems to have been in constant use in the ancient world up until the fall of Rome, both for making casts and for carving small objects.

In the Renaissance a revived interest in anatomy prompted artists to again use this naturally excellent mold material. Vasari credits Verrocchio with being the first Renaissance artist to calcine and refine gypsum for the purposes of sculpture.

One might assume that *plaster of Paris* (as common plaster is sometimes called) got its name from the hundreds of plaster casts of antique sculptures and their fragments, which filled every museum, academy, and studio in Paris during the nineteenth century. Actually the countryside around Paris abounds in fine quality gypsum rock that was extensively mined for plaster maufacture. Although it is this more prosaic source that gave plaster of Paris its name, sculpture in the nineteenth century looked to Paris, and also to Rome, for its inspiration, and plaster was its everyday material. The apprentice sculptor was expected to master plaster casting, plaster modeling, and plaster carving. Drawing was learned by sketching plaster casts made in plaster molds taken from original Greek and Roman sculptures in marble. These "originals" were often Roman copies of long-lost Greek originals. Only after thoroughly mastering plaster was the apprentice allowed to try his skill with marble and bronze. His overalls were always white.

The reaction against these years of whiteness took a long time to subside. Today we are beginning to

appreciate plaster for its own engaging qualities of softness and adaptability, and our more relaxed attitude about permanence allows it to be used as a final medium. It is still an excellent study material for beginners, and an economical material for small molds and patterns.

THE NATURE OF PLASTER

Common plaster is produced from an abundantly occurring rock-hard mineral called gypsum. Gypsum deposits were formed in the earth during the millennia of its early history by the evaporation of sea water. Natural gypsum is composed of crystallized salts of calcium, mainly calcium sulfate, $CaSO_4.2H_2O$, mixed with silicates and carbonates. It is mined, cleaned, pulverized, and then baked in a kiln at about 350°F, until three-quarters of the water is driven off, converting the gypsum to the fine white powder known as plaster of Paris, $2CaSO_4.H_2O$.

When the water lost in this heating, or *calcining*, process is mixed back into the plaster, the plaster sets up in about twenty minutes to a solid mass similar to its original mineral state. While it is setting the plaster gives off an amount of heat equivalent to the heat necessary to calcine it. The process of giving off heat is termed the *exotherm*. The setting of plaster is reversible. Plaster that has set can be pulverized and recalcined. If water is added to this recalcined plaster, it will set up again. This is not usually done to save plaster in the studio since it would not be worth the trouble and expense. If plaster is stored for a long time in a damp place it can become *hydrated* (take on water) so slowly that it is converted to its crystalline state without actually setting up into a hard mass. Its appearance resembles usable plaster, but it will not set. It is therefore a good precaution, before using plaster that has been in storage, to mix a small test cupful. Plaster that has become hydrated is usually thrown out.

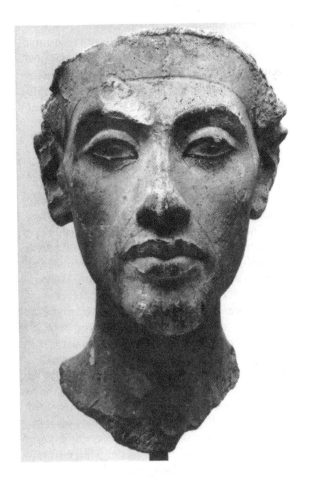

Plate 3.1. King Akhnaton, from the studio of sculptor Tuthmosis at Akhetaton (El-Amarna); gypsum, partly painted, 10″, 1364–1347 B.C. Courtesy of Staatsbibliothek, Berlin. This plaster model was intended as a guide for carving in stone. It was probably cast from a clay original.

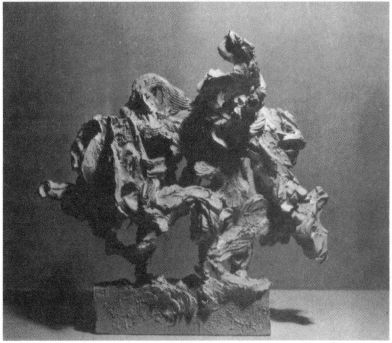

Plate 3.2. Old Boston museum interior as seen in Back Bay in 1889. Courtesy of Museum of Fine Arts, Boston (photo credit Museum of Fine Arts, Boston). Plaster casts have been used over the past 200 years as an aid in studying the sculpture of Greece and Rome.

Plate 3.3. Peter Agostini, *Ariel #2*, plaster, 1956. Courtesy of the artist. Agostini is a master of the different ways to use wet plaster.

TYPES OF PLASTER

Gypsum Casting Plaster or Plaster of Paris

This is the common type of plaster for all-around use in the studio. It is sold by building materials companies in 100-pound paper sacks for use by the building trades in plastering the inside walls of houses. It weighs about 70 pounds per cubic foot when dry and is easily carved, sawed, and filed. It sets in twenty to thirty minutes. A sculpture made of this plaster will begin to deteriorate after about a year out-of-doors and it will almost certainly break apart if it falls over.

Surgical and Dental Plasters

These plasters are similar in composition to casting plaster but they set up much faster, in five or ten minutes, and are harder. Surgical plaster is available sized into strips of gauze. The gauze may be dipped in water and wrapped around an object, creating a quick, light, molded shell. The mold must be cut off with a sharp tool, or with the special cutter used by surgeons for this purpose. Surgical plaster cost two to three times as much as ordinary plaster and is usually sold in small packages. It is available from some art suppliers.

Super-Strength Plasters

These denser, tougher, heavier plasters are manufactured for industrial use where ordinary gypsum plaster would break down or wear out. They are used for long-run ceramic molds, foundry patterns, industrial model making, and as binders in the investment molds used for aluminum and bronze casting. Three typical varieties manufactured by the U.S. Gypsum Company are Hydrocal, which is white or gray, Hydrostone, which is off-white, and Ultracal, which is light green. They are all much tougher than ordinary gypsum plaster and cost two to three times as much. They contain strengthening ingredients besides gypsum. If used for built-up sculpture they will be more difficult to carve back into and, incidentally, much more difficult to scrape off working areas. They will still deteriorate if used out of doors.

Most super-strength plasters have low expansion rates on setting, as they are designed for applications where the .20 percent expansion rate of common casting plaster would result in a tight mold or an inaccurate part. However, there are special plasters with expansion rates up to 2 percent for enlarging

work. All these plasters are available with setting times from fifteen minutes to one hour.

Homemade Super-Strength Plaster

Where an economical, tough, and weather-resistant plaster is required, and the composition need not be especially exact, Portland cement may be added to the plaster in amounts of 10 to 20 percent. More cement turns the composition into a form of concrete, for the behavior of which see chapter five. The cement is mixed with the plaster before adding water. Setting time is accelerated.

MIXING PLASTER

For every type of plaster there is an exact proportion of water which will produce a complete chemical reaction and result in maximum hardness and minimum setting time. The optimum proportion of water for most applications is usually a small amount in excess of the minimum chemical requirement. The idea is to have a workable fluidity and setting time without appreciably diminishing the hardness. The manufacturer lists this optimum working proportion by weight for each type of plaster. If the proportion is followed or exceeded, a certain extra amount of uncombined water will remain in the plaster after it sets. This water may be dried out if necessary. Too much water in the mix results in weak plaster.

When mixing common plaster in the studio, it is usually not weighed out on a scale unless the consistency desired is critical. Instead, some rule-of-thumb method is usually followed. A standard procedure is as follows:

Fill a clean container about two-thirds full of clean, cool water (warm water accelerates, cold water retards the setting). Gradually sift the plaster into the water by hand or with a flour sifter, breaking up any lumps. Continue sifting until the plaster rises to the surface of the water and forms small islands above the surface. The amount of plaster in the water will be in a proportion of about 100 to 70 by weight, or roughly 1 pound 7 ounces of plaster to 1 pound of water.

By the time the plaster has been put into the water, the water level will rise close to the top of the container. It can then be mixed by hand, with a paddle, or with a propeller shaft on a portable drill, depending on the size of the mix. Large mixes can be handled with a portable mixer mounted on a raising

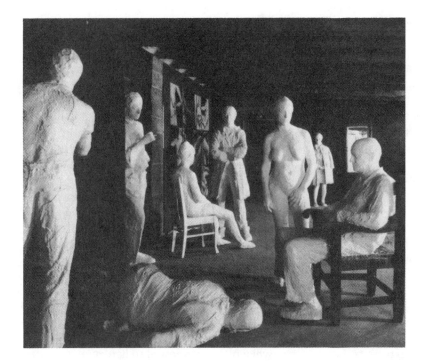

Plate 3.4. George Segal's studio (photo credit Hans Namuth). Plaster-soaked fiber and cloth, originally developed to make casts of broken limbs, is used by George Segal to mold figures directly over living subjects.

TABLE 3.1 Properties of U.S. Gypsum High-Strength Plasters

	Normal consistency: parts water to 100 parts gypsum cement by weight to make a pourable slurry	Setting range in minutes	Typical setting expansion: inches per inch	Average compressive strength: pounds per square inch dry*	Reaction
High expansion Hydrocal	40–42 35–37	25–35	1/4 5/16	800 wet 1700 dry	acid
Medium high expansion Hydrocal	48–50 44–45	25–35	1/8 3/16	1000 wet 2100 dry	acid
Industrial molding pattern shop Hydrocal	64–66 54–56	25–30 20–25	.0018 .0015	2000 3200	neutral neutral
Hydrocal B-11	46–49	20–25	.0005	3800	alkaline
Hydrocal B-11 (slow set)	46–49	45–55	.0004	3800	alkaline
Hydrocal A-11	40–42	20–25	.0005	4500	alkaline
Industrial white Hydrocal	40–43	20–30	.0030	5500	neutral
Ultracal "30"	35–38	25–35	.0003	7300	alkaline
Ultracal "60"	36–39	75–90	.0002	7300	alkaline
Ceramical	30–32	18–23	.0005	11000	alkaline
Hydro-Stone	28–32	20–25	.0020	11000	alkaline

*Figure for wet strength is about half dry strength.

and lowering device. Some ways of doing this are illustrated in the drawing.

Whatever the technique of mixing, there is no better way of finding out if the mix has been thorough than to feel around in it for lumps with the hand. A bucket of water can be kept nearby to wash off the hand afterward. While thorough mixing is necessary for a smooth mix, if the action is too vigorous, air bubbles will be beaten into the plaster. If the mixing is prolonged after the lumps have been removed, the beginning of crystallization will be disturbed and the plaster will not reach its ultimate hardness upon setting.

After the plaster has been mixed it may be immediately poured into a mold, or it may be allowed to thicken for modeling purposes. Experience will show how much to mix for a given job so that it can all be used before it sets.

Many aggregates can be blended with raw plaster during the mixing phase to enhance its appearance, change its texture, or increase its strength. In particular, powdered pigments for color, or texturizers—such as sand, pumice, Zonolite (expanded mica), or grog (fired and pulverized clay)—can be mixed with the dry plaster before water is added or during wet mixing. Liquid additives—paints, dyes, stains, and emulsions—must be blended in after the water.

Cleanup

It is much easier to clean up tools and work surfaces before the plaster sets than after. Excess plaster should be scraped off into a trash can and then the equipment should be washed in a settling barrel with a small brush. Plaster down the sink means trouble, even where heavy duty traps are installed. Dried plaster can be stripped off with a stiff scraper or strong knife and a wire brush. Plaster rusts tools if not removed, and ruins electric motors if it gets inside.

In the classroom, the first working days with plaster usually result in splattered floors and equipment, and stopped-up sinks. Concentrated attention to plaster discipline at the outset is a must if decent working conditions are to be maintained. Once the correct procedures are established, many people can work efficiently with plaster in the same room.

Safety

Plaster is a relatively safe, nontoxic material. However, when plaster is allowed to harden on the skin it can be painful to remove, particularly if hair is stuck in it. Wet plaster should therefore be washed off the skin before it sets. Gloves and protective creams are advisable. After prolonged exposure to wet plaster the affected areas should be treated with skin cream

Plate 3.5a. Mixing plaster. Plaster is dumped into barrel half full of water.

Plate 3.5b. Mixing plaster. The plaster is thoroughly mixed with a portable drill and mixing blade.

Plate 3.5c. Mixing plaster. The plaster is poured into a mold as soon as it is mixed to a smooth consistency.

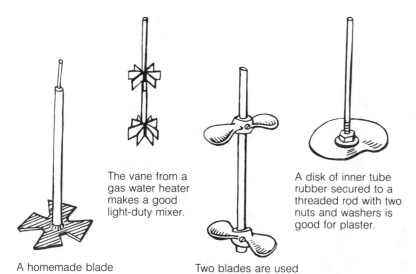

The vane from a gas water heater makes a good light-duty mixer.

A disk of inner tube rubber secured to a threaded rod with two nuts and washers is good for plaster.

A homemade blade can be cut from sheet metal and welded to a shaft.

Two blades are used for mixing in deep containers.

Figure 3.1. Plaster mixing devices. These devices are attached to drill motors to mix plaster or other thick liquids.

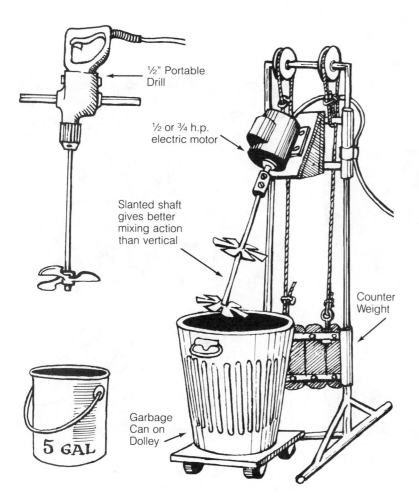

½" Portable Drill

½ or ¾ h.p. electric motor

Slanted shaft gives better mixing action than vertical

Counter Weight

Garbage Can on Dolley

5 GAL

Figure 3.2. Methods for mounting plaster mixers. The mixing blade may be mounted in a portable drill if the amount to be mixed is around five to ten gallons. A drill press may be used for larger amounts. A homemade mixer hoist can be made of welded pipe. A counterweight helps to raise the mixer out of the barrel.

Plate 3.6. Plaster mixing setup. The ideal setup for mixing large batches of plaster is a powerful mixer mounted on a forklift and connected to a variable speed control (shown here next to the electrical outlet).

to restore natural oils and prevent chapping. When working with large amounts of dry plaster a respirator should be worn to avoid breathing plaster dust.

THE ARMATURE

Owing to its great range of consistency, plaster can be applied in dribbles, in icinglike flows, in buttery slabs, in smooth mounds, or in brittle crusts. Offsetting this pliability is that plaster is not very strong. Fortunately it expands slightly on setting, rather than shrinking like clay, so rigid supports may be used to reinforce the interior of plaster forms. Armatures for plaster work generally consist of two parts: the rigid skeletonlike support that provides structural strength to hold the sculpture together, and the sheets of wire mesh or cloth that give contour to the sculpture and provide a surface to receive the layers of plaster. The predominance of one type of armature over the other in any particular sculpture will depend a great

Plate 3.7. Settling barrel. Hands and tools are washed in the settling barrel so as not to clog up sinks. The plaster that sinks to the bottom must eventually be cleaned out.

Plate 3.8. Sink trap. The unit in the foreground has been disassembled to show the top, inner bucket, and straining screens.

deal on the kind of sculpture to be made and whether it is linear or volumetric in nature.

Suggested materials for the skeleton are lumber, branches, metal rods, pipe, tubing, also cardboard tubing and wire for small pieces. Attached to this structure with wire, string, staples, and tacks are pieces of wire mesh, chicken wire, metal lath, or window screen. The plaster can be applied directly to the mesh, or further reinforced with burlap, paper, rope, fiberglass, or other kinds of cloth. Silk stockings work well. The cloth may be stretched tautly over the mesh, or draped loosely in folds.

A material widely used in applying the first layers of plaster is sisal, or hemp, fiber. This strong long-fibered material is smoothed and flattened, then dipped in the bowl of plaster. The saturated mat of fibers is then smoothed into place over the mesh. The fibers prevent the plaster from falling through the mesh and greatly increase the strength of the plaster. The saturated sisal fiber can also be wound

Plate 3.10. Skeleton of herring gull. Courtesy of Life Picture Series, © Time, Inc. (photo credit Andreas Feininger). The skeleton provides a structural framework for the bird's muscles just as a metal or wood armature provides support for a plaster sculpture.

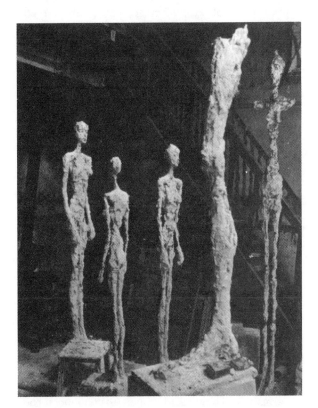

Plate 3.9. Giacometti's studio, 1958 (photo credit Inge Morath). Plaster permits repeated carving away and building up until the desired contour is attained.

Plate 3.11. Types of wire mesh. Expanded metal lath, hardware cloth, window screen, and chicken wire.

ARMATURE FOR PLASTER

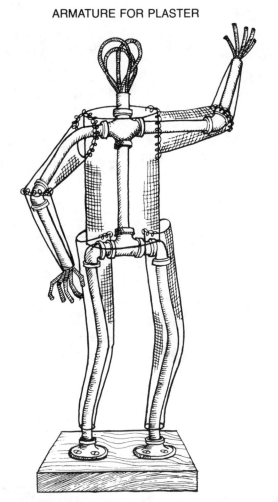

Figure 3.3. Pipe and mesh armature. Wire mesh is secured to a rigid pipe support with short lengths of flexible wire. Galvanized metal should be used so it will not rust through the plaster.

like a bandage around joints to reinforce them. The layer of fiber is usually covered with a layer of pure plaster so that the surface may be worked without exposing tufts of fiber. If the fiber does become exposed, it can be burned off and covered with plaster. Sisal is available in bales from building materials suppliers.

An alternate use for armatures is as a support for clay modeling when the piece modeled is not the final version of the work, but will be cast later in another material. In the case of water-base clay, the clay must be kept wrapped with moist cloths and plastic coverings so that it will not dry out and crack off the armature. Oil-base clay or "plasticene" may be left exposed to the air. In either case usually a simple skeletal armature is used without elaborate wire mesh extensions.

Styrofoam is another material that is useful for making armatures. It is light, easily formed, and can be nailed and stapled for the attachment of wire and cloth. Actually, Styrofoam can serve both as a structural support and as a contoured surface for the application of plaster. When applying plaster directly over Styrofoam it is best to use a coarse open-surfaced foam to provide a texture that the plaster can cling to.

All kinds of objects such as branches, rocks, junk machinery parts, and the like, may be used as part of the armature. They may be used for structural reasons because of their shape, or they may be included because they add a symbolic gesture to the meaning of the work. In this latter case the objects might protrude nakedly from the work or perhaps be covered with a thin layer of plaster that would reveal their form.

Some points to consider when making an armature:

1. If the sculpture is to stand up by itself, it must either have a shape that is naturally stable, or it must be securely fastened to, or embedded in, a base.
2. Do not count on the plaster to reinforce the armature. Unless the armature is strong and rigid, it will provide even less support when the weight of the plaster is added to it. Cracks will result.
3. The joints are the crucial parts of the structural armature. They must be rigid. Overlap metal rods and wrap them tightly with wire or use cable clamps. Welding is the most secure. Pipe is convenient (though expensive) because it provides a

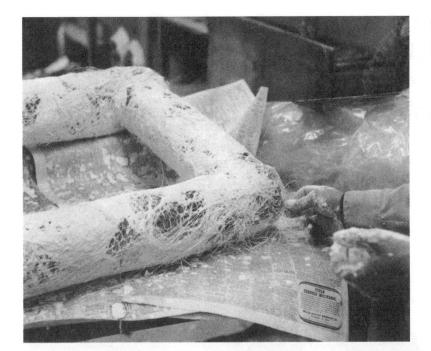

Plate 3.12*a*. Sisal fiber provides a strong support for applying the first layers of plaster to the wire mesh.

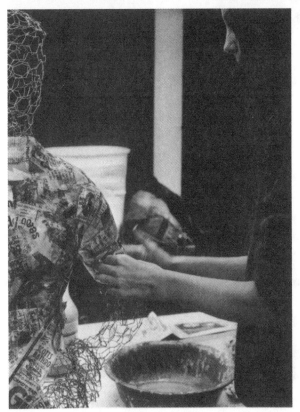

Plate 3.12*b*. Newspaper is applied to a wire mesh armature with wheat paste. Then the form may be built up using more paper, plaster, or fiberglass.

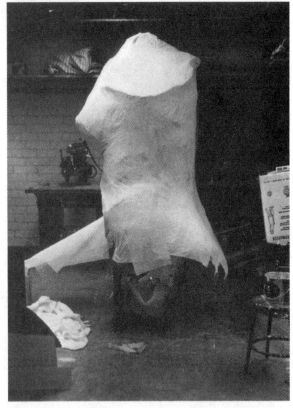

Plate 3.12*c*. Cloth is smoothed with starch or thin plaster over a wire armature to provide the basis for thicker layers of plaster.

Plaster Building / 43

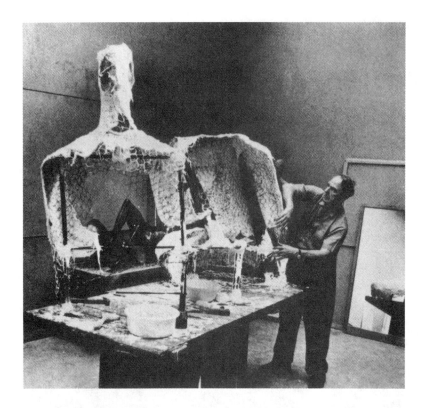

Plate 3.13. Henry Moore working on the armature for the model for the UNESCO reclining figure, 1957. Courtesy of the artist. Henry Moore applies plaster and fiber over a traditional armature of steel pipe and chicken wire.

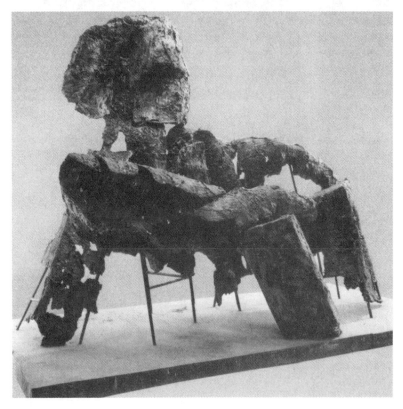

Plate 3.14. Reuben Nakian, *Birth of Venus*, plaster for bronze, 10'11" long, 1963–1966. Courtesy of the Museum of Modern Art, New York (photo credit Thor Bostrom). Edges of fabric and handfuls of fiber are left exposed to emphasize the ragged surface of this work.

Plate 3.15*a*. A Styrofoam core is carved to shape with saws and rasps before adding plaster.

Plate 3.15*b*. Plaster is applied directly to the Styrofoam and modeled or carved to shape. Wood or metal paste or fiberglass may also be applied to the Styrofoam core.

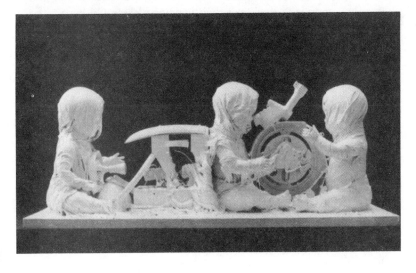

Plate 3.16. Paul van Hoeydonck, *Big Mutants with Gun*, mixed media, 18½″ × 50½″ × 21½″, 1966. Courtesy of Studio Modern Art, Milan. Found objects are used as the basis for further development with plaster and cloth.

TYPES OF BASES FOR PLASTER ARMATURE

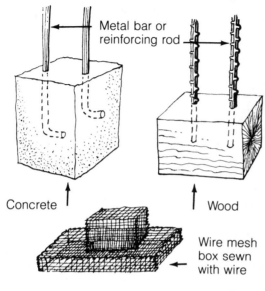

Metal bar or reinforcing rod

Concrete

Wood

Wire mesh box sewn with wire

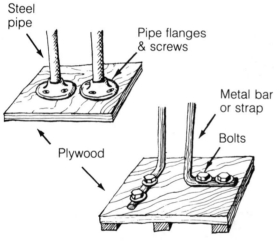

Steel pipe

Pipe flanges & screws

Plywood

Metal bar or strap

Bolts

Cleats provide space for nuts on under side.

Figure 3.4. Types of bases for plaster armature.

ready-made joining system that provides for changes of direction. A pipe bender extends this versatility even farther.

4. The heavier the plaster gets, the more strain there is on the armature. A well-planned armature will help in achieving a light, strong sculpture. Sometimes the sculpture changes a great deal during construction and parts have to be cut away, new extensions of armature added, and soon. It is one of the advantages of plaster construction that additions and subtractions can go on indefinitely until the desired effect is achieved.

SURFACE TREATMENT

The final form of the sculpture can be achieved by building up a surface of modeled plaster, or by cutting away. The resulting surface may be left showing the marks of fingers or tools, or it may be smoothed down and made very precise. Granular aggregates such as sand or Zonolite may be mixed with the final layers to give a more textured surface.

Plaster can be finished with all types of paints, stains, and varnishes. Because of its bland nature it can be treated to resemble many other materials such as stone, bronze, wood, and clay. The imitation of other surfaces is not always used for fakery but also to gain some idea of the appearance of a full-scale sculpture represented by a plaster model.

Plaster can be fiberglassed to protect it from the weather. When the fiberglass is built up thickly it begins to assume a strength and surface of its own and the plaster acts merely as a core to build upon.

Water-base paints such as acrylic or latex can be applied safely over slightly damp plaster. Oil-base paints and polyester or epoxy resins require that the plaster be completely dry from the inside out.

CARVING PLASTER

A block of cast plaster can be carved with wood or stone chisels and behaves very much like tufa or soft stone. In fact, carving plaster is an excellent way to get the feel of carving before going on to concrete and stone. Aggregates such as pumice, Zonolite, grog, or sand may be mixed into the plaster before casting, as well as mineral coloring agents. A plaster and Zonolite mixture will be light, porous, and carvable with wood chisels. Small pieces can be carved with a pocket knife.

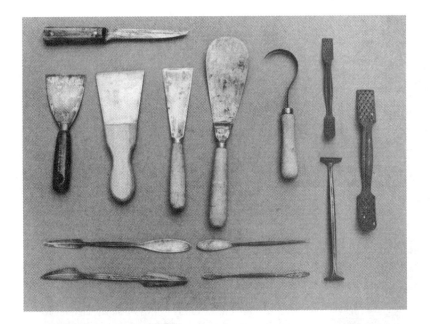

Plate 3.17. Plaster tools. The knife and the two scrapers on the left are multipurpose tools, whereas the others are specifically made for shaping plaster. The two rasps on the right are perforated so they will not become clogged with plaster.

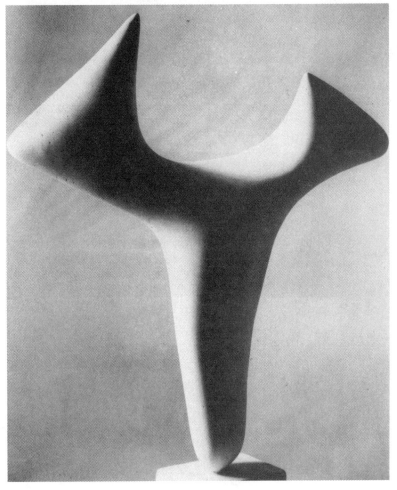

Plate 3.18. Alberto Viani, *Il Pastore Dell' Essere*, plaster, 63″ high, 1963. Courtesy of Alberto Viani (photo credit Riva Carbon). An example of the smooth contours which can be attained by filing and sanding plaster. A bronze cast from such an original could be highly polished.

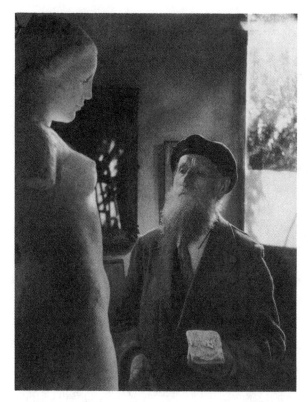

Plate 3.19. Aristide Maillol in his studio at Banyuls-sur-Mer in 1943, working on *Harmonie*. Courtesy of Galerie Diana Vierny, Paris (photo credit Karquel). The adaptability of plaster makes it a preferred medium for the initial execution of works which are later to be cast in metal.

Sand mixed in the plaster produces a heavier, grittier composition that is best cut with a toothed stone chisel. Proceed as described in chapter six.

Pure carved plaster has an inimitable quality of pristine coolness, reflecting light like no other material. In its presence one realizes that, accommodating and changeable as plaster is, it has yet an aloofness and purity of its own.

BIBLIOGRAPHY

Meilach, Dona H. *Creating With Plaster*. Chicago: Reilly & Lee, 1966.

Rich, Jack C. *The Materials and Methods of Sculpture*. New York: Oxford University Press, 1947; 9th printing, 1973.

Chapters on plaster will be found in most of the comprehensive books on sculpture techniques listed in the Appendix.

See also the bibliography in this book for chapter four, Mold-Making and Cold-Casting.

SOURCES OF SUPPLY

A. Plaster

Plasters and aggregates used in building construction are obtainable from building materials companies throughout the United States. High-strength plasters and special molding plasters are available through the ceramic materials suppliers listed for chapter two.

Several manufacturers of plasters and aggregates are listed below:

Crystal Silica Co., Oceanside, CA 92054, subsidiary of Ottawa Silica Company, Ottawa, IL 61350. White silica sands, graded for mesh size.

Georgia Pacific Gypsum Corp., Box 311, Portland, OR 97207. Denscal high-strength industrial plasters.

W. R. Grace and Co., Zonolite Div., 758 Colorado, Los Angeles, CA 90039; Cambridge, MA 02140; Newark, NJ. Zonolite expanded mica plaster and concrete aggregate.

Redco, Inc., 11831 Vose St., North Hollywood, CA 91605. Permalite pumice aggregate.

U.S. Gypsum Co., 300 W. Adams St., Chicago, IL 60606. Largest manufacturer in the U.S. of industrial and building plasters.

B. Plaster Tools

The same chisels, files, and scrapers that are used for clay, wood, and stone are used for plaster. See the tool listings for chapters two, six, and seven.

4

Mold-Making and Cold-Casting

A good sculpture material should possess two contradictory qualities: the capability to be formed and, at the same time, durability. Tough, long-lasting materials like metal and stone require considerable energy to shape them. Materials that are easier to work, such as wood and plaster, usually are subject to deterioration. Throughout history artists have attempted to develop processes by which a material that is easy to shape can be transformed into something strong and lasting.

The first step toward this goal was the discovery that clay could be hardened by baking it in a fire. Once the techniques for concentrating and directing fire had been mastered, it became possible to smelt, forge, and cast metals. These advances gradually brought about the development of metal implements that extended the artist's command over stone, wood, and clay. For the first time the breaking down of nature into its components was practical; no longer were materials restricted to those lying about on the surface of the earth.

The casting process is a refined way of forming a durable and predictable product by substituting cleverness—that is, technology—for repetitive labor. The method can be as timeless as scooping a hole in the earth or as up-to-date as computer-controlled mold-making. The essence of casting is the creation of an empty space. This space can be filled with a choice of materials to create an object. As long as the mold, the container of the space, remains intact, you can produce a continuous series of almost identical objects. As the details of the mold wear away, the faithfulness to the original becomes less exact.

CASTING, MEANS OR END?

Originals and Reproductions

Conventional casting processes enable the artist or manufacturer to work with a pliable and convenient material, such as wax or clay, and then to cast the final object or objects in another material, perhaps metal or plastic, that has the desired qualities of strength, weight, and color. There are two different objectives toward which casting can be directed: it can be viewed as a series of creative steps culminating in a work of art or, conversely, as a system for making copies of an existing object, in either the same or different materials. When casting is used for copying, the process is reproductive rather than innovative.

The distinction between an "original" cast and a reproduction becomes confused when a number of originals are cast from the same mold. Ever since the latter part of the nineteenth century, many sculptors have cast their work in bronze in *editions* ranging from two or three to nine or more. Sculptors who have worked in this manner include Auguste Rodin, Aristide Maillol, and Jacques Lipchitz. Today it is generally agreed that casts made under the supervision of an artist during his lifetime are originals, while those made after his death are reproductions. Reproductions may, however, be authorized by the artist's estate, in which case they are legitimate. Such casts are supposed to be made from the original plaster or clay models worked on by the artist. The size of this authorized edition is generally limited to fewer than one hundred pieces, after which the mold and clay or plaster model should be destroyed. It is not considered acceptable practice to take a new mold off an existing bronze, but a "replica" in some

other material is sometimes made in this way for study purposes.

Many materials can be used as a final casting medium; clay, plaster, concrete, fiberglass, polyester resin, and epoxy are some of the most common. Metal casting is discussed in chapters eleven and twelve.

Multiple Casts

The desire to make more than one cast from an original presents the problem of preserving the mold from one cast to the next. If the original form is a complicated one, a complex mold will probably be required. Usually, the mold must be made in several pieces, or must be flexible, or both. Designing a form for production by casting most often means simplifying it so that it can be cast with as few mold sections as possible and a minimum of special finishing after it leaves the mold.

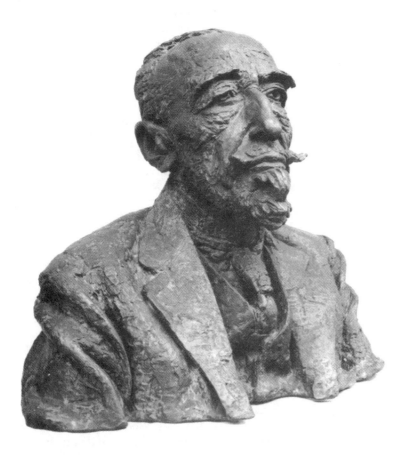

Plate 4.1. Jacob Epstein, *Bust of Joseph Conrad*, bronze, 19″ × 23″, 1924. Collection of the City Museum and Art Gallery, Birmingham, England (photo courtesy of same). Though this sculpture is made of bronze, its rough and scored surface retains the evidence of the sculptor's struggle with the original clay.

Plate 4.2. Auguste Rodin, *Drawer of Plaster Casts from the Artist's Studio at Meudon* (photo credit Leni Iselin). These casts of body parts he had sculptured were used by Rodin for the study of gesture and proportion.

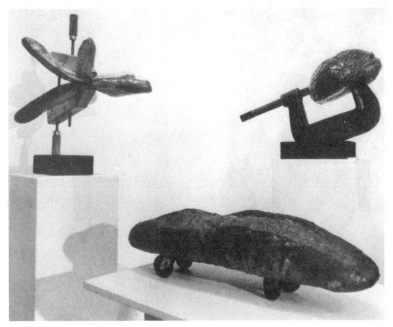

Plate 4.3. John Fischer, 1. *Large Clamp with Pumpernickel*. 2. *Bread on Wheels*. 3. *Parallel Clamp with Three Loaves*, bronze, 1964. Collection of Allan Stone Gallery (photo credit Nathan Rabin). Actual loaves of bread were used to make the patterns for this sculpture. The bread was consumed by the flames of the burnout furnace.

In some cases, such as metal casting from plaster investment molds, the mold is destroyed with each cast, so a new one must be made from a master pattern for each subsequent cast. In industry, this process is often semiautomatic.

While it might seem that the methods just described have more to do with manufacturing than with creating original works of art, it should be remembered that there is no essential contradiction between large numbers and originality. If a mass-produced object copies a particular work, then the product is obviously a reproduction. If, however, the artist's intention calls for a work consisting of one thousand identical objects made in a certain way, then those one thousand pieces made in that way constitute the artist's original work. Whether casting is done by hand or by machine is irrelevant, as long as the artist's purpose is fulfilled.

TYPES OF MOLDS

Waste Molds

A waste mold is used only once; the process of freeing the final cast destroys the mold. The advantage of this system lies in its simplicity. The mold need not be divided into many pieces, nor must it be flexible in order to pull away from the sculpture, and therefore it can cast even very complex shapes.

Plaster waste molds. In the typical plaster waste mold, the plaster is kept thin enough so it can be chipped away from the surface of the sculpture within. The material cast into the mold should be harder than the mold to prevent damage during mold removal. This process is suitable for casting Hydrocal, magnesite; concrete, fiberglass, and casting resin. Plaster and clay, because of their relative softness, are better cast in a piece mold. Often the first layer

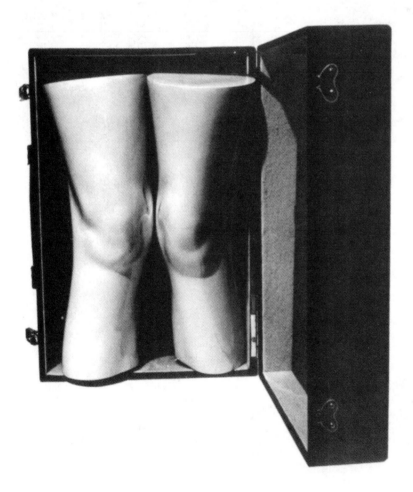

Plate 4.4. Claes Oldenburg, *London Knees*, 15″ high, 1966. Multiple edition of 120 by Editions Alecto, London, with Galerie Neuendorf, Hamburg, 1968. Painted later. Packed in case containing postcards, notes, drawings and photos. Courtesy Editions Alecto, London. Contemporary industrial casting techniques permit the casting of large editions which retain excellent fidelity to the artist's intentions. This multiple casting was made from a mold taken directly from live knees.

of a plaster waste mold, the layer next to the surface of the sculpture, is made of colored plaster, to mark the proximity of the sculpture beneath.

Sand waste molds. One of the easiest ways to cast forms of plaster or concrete is to go to the beach and dig hollows in the sand, filling them with freshly mixed casting material. You must use only fresh water for plaster and concrete mixing, because sea water retards setting and causes *efflorescence*—a white powdery mineral coating. Beach sand included as an aggregate will also produce a certain amount of efflorescence.

By digging interconnecting tunnels, you can create complex forms. If the casts are turned over after they have been pulled from the sand, an additional cast can be made on the flat side that was originally the surface. Thus, the method permits a range of forms from shallow reliefs to completely three-dimensional shapes.

The face of the mold can be lined with rocks, shells, mosaic tiles or other textural materials, and these will be picked up as an embedment in the surface of the cast. Many forms—bottles or parts of the body, for example—can make impressions in the mold face.

While this type of sand casting is primarily a school-project technique, it has been used quite successfully by professional artists and is well suited for the creation of architectural murals. To gain the degree of control over the technique required for more serious work (and to escape from the vagaries of the tides), you can build a sandbox at the studio. Complex forms often are managed by stacking a series of frames one above the other. The sandbox can be adapted for casting fiberglass and resins. In this case, the surface of the sand should be covered with polyethylene sheeting to provide a moisture barrier. Dry sand can be sprinkled over the surface of this sheeting if a sandy surface is desired.

Damp earth and clay make excellent mold materials. Clay is especially good for molding small and delicate plaster casts.

Styrofoam waste molds. Blocks of Styrofoam, which are easy to carve, make excellent molds; the cavity can then be filled with plaster, concrete, or casting resin. Remember that polyester resin dissolves Styrofoam, but epoxy resin is compatible with it. Urethane foam can be used with polyester resin, or Styrofoam can serve as a mold if it is coated with epoxy. After the casting material has set, you can

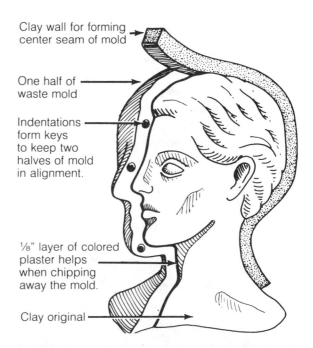

Figure 4.1. Waste mold. One half of the mold is shown in place. When the clay is stripped away, the second half of the mold is formed against the center edge of the first half. A ⅛″ layer of colored plaster is applied to aid in stripping the mold.

Labels on figure:
Clay wall for forming center seam of mold
One half of waste mold
Indentations form keys to keep two halves of mold in alignment.
⅛" layer of colored plaster helps when chipping away the mold.
Clay original

BEACH CASTING MOLD IN DAMP SAND

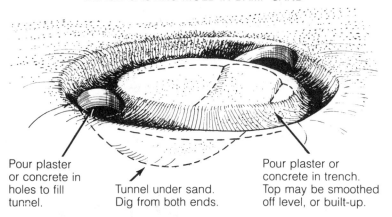

Pour plaster or concrete in holes to fill tunnel.

Tunnel under sand. Dig from both ends.

Pour plaster or concrete in trench. Top may be smoothed off level, or built-up.

Figure 4.2. Beach casting mold in damp sand.

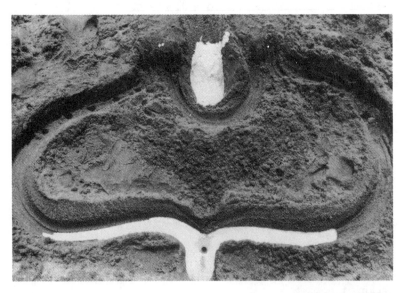

Plate 4.5a. Beach cast. Plaster has just been poured in the part of the mold that tunnels under the sand. Reinforcing bars should be placed in this section to connect it to the horizontal section about to be poured.

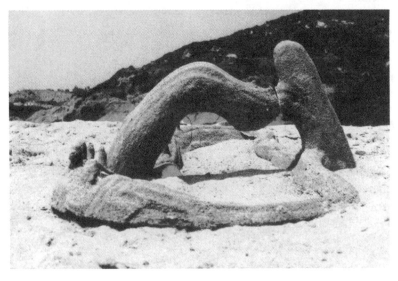

Plate 4.5b. Beach cast. The cast is lifted out of the sand and turned over. There is a separation where reinforcing bars should have been placed.

either carve the foam mold away or dissolve it with acetone.

A variation of this technique involves carving a positive shape or pattern of Styrofoam. Then, plaster is cast around the foam and the foam is dissolved with acetone. The mold is then filled with plaster, concrete, or resin.

Fabric, plastic sheeting, and inflatable molds. If you can imagine a suit of clothes filled with plaster, you will begin to see the possibilities inherent in fabric molds. They can be made of cloth on a sewing machine, or of polyethylene or vinyl sheeting, with glued, taped, or heat-sealed seams. Inflated forms are particularly useful for making negative spaces or cavities within the boundaries of a sculpture. When the casting material has hardened, the forms can be deflated and withdrawn easily. Inflatable molds are adaptable to architectural applications.

One-Piece Molds

When more than one cast is to be made from a mold, the cast must be removed from the mold without damaging it. The more complicated the shape of the object, the more difficult this becomes. Even the simplest mold, if it is to survive, must have a certain amount of *draft*—or slanting outward of the mold's walls. Draft enables the object cast to be pulled out easily. If the casting material expands when setting, there must be enough draft so that the cast does not become wedged in place. Also, one-piece molds preclude undercuts or indentations, for

Plate 4.6. Constantino Nivola, *Mural Facade of the Covenant Mutual Insurance Building,* sand cast relief, 30′ × 110′, 1957, Hartford, Connecticut. Courtesy of Covenant Mutual Insurance Company. Nivola cast this concrete relief in 132 sections in beds of sand. The surface of the relief retains the sandy texture of the molds.

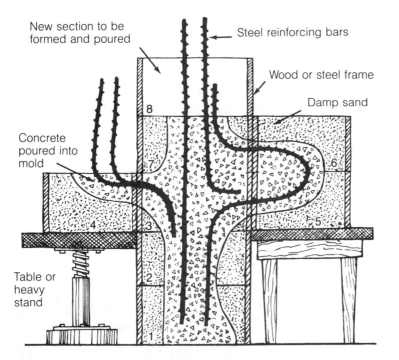

New section to be formed and poured

Steel reinforcing bars

Wood or steel frame

Damp sand

Concrete poured into mold

Table or heavy stand

CASTING CONCRETE WITH SAND-BOX MOLDS

Figure 4.3. Casting concrete with sandbox molds. The frames of the sandboxes are stacked on top of each other as the work proceeds. Damp sand is packed to make a negative mold and concrete is poured and tamped in place. When one box is poured, another may be added, using reinforcing bars to hold the sections together.

Plate 4.7. Piotr Kowalski, *Wall for Housing Project in Viry-Chatillon*, concrete cast in elastic molds with timber bracing, 120′ long, 1962. Courtesy of Piotr Kowalski (photo credit Pierre Joly-Vera Cardot). The concrete was poured into molds made of inflated plastic sheeting held in place by wood beams. The forms can be reused with the beams in different patterns.

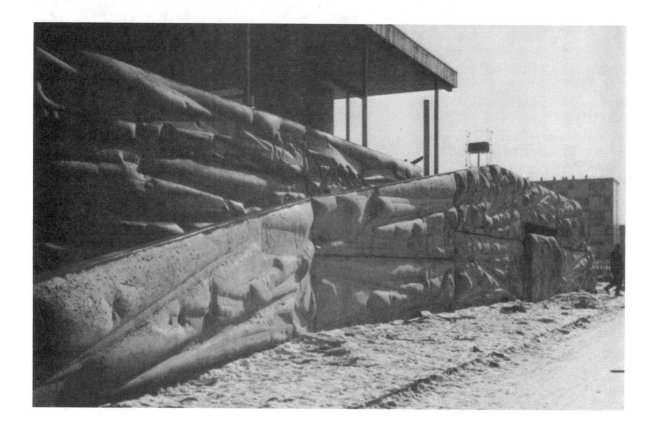

such features can cause the cast to lock itself into the mold.

So far we have been discussing the negative type of mold, a concavity in which a material is cast so that the final outside surface of the cast results from contact of the cast material with the interface or contact face of the mold and will have the same texture. Sometimes a concave mold will be made from a convex or positive mold, alternatively called a *pattern*. (In conventional usage concave molds are often referred to as "female," convex molds as "male.")

Occasionally a final sculpture will be made over a positive mold, rather than within a negative mold. In this case, the artist creates the final surface of the sculpture as he builds up material. The mold provides only the inner shape of the sculpture. This type of mold should properly be called a *form,* since it is a shape over which another shape is built up. When the piece is finished, the sculptor slips it off the form if possible; otherwise it may be necessary to cut the sculpture apart, remove the form, and reassemble it.

Multiple-Piece Molds

A two-piece mold—two one-piece molds assembled face to face—can handle simple symmetrical shapes. But the casting of more complicated shapes requires multiple-piece molds. The art of mold-making consists of dividing up a shape, no matter how complex, into a number of one-piece molds that, when assembled, will fit over the original shape. With experience, the mold-maker learns to arrange the divisions in such a way that the mold needs the least number of pieces. This is accomplished by taking into account all the undercuts and by making sure that each piece has enough draft to be pulled, or released, from the casting.

The mold-maker divides the work to be cast into sections and then, using a barrier of clay to contain the plaster, builds each section of the mold separately. Alternatively, if the original is made of clay, the barrier can be constructed of squares of thin sheet metal stuck into the clay. Each new section is cast against the edges of the preceding ones. Adjacent sections are keyed by means of small indentations in the edges, so the mold will have a good *register,* or alignment, when it is assembled. If there are many pieces, they should be numbered.

When all the pieces have been made, there may be so many that it is necessary to make another mold, sometimes called a *mother mold,* over the first set of pieces, to contain them. If the mold has become large and heavy, handles are cast into the backs of the pieces, with devices provided for clamping or tying the whole mold together.

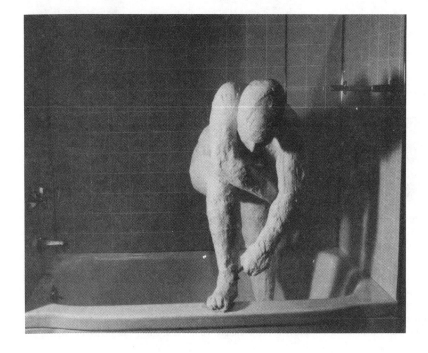

Plate 4.8. George Segal, *Woman Standing in Bathtub,* plaster cast figure and linoleum tile around porcelain tub, 64″ × 64½″, 1963. Courtesy of collection of Mrs. Robert B. Mayer, Chicago (photo credit Rudolf Burckhardt). The figure looks heavy and lumpy because the sculpture was made *over* the actual body of a person. The surface, therefore, was formed by the hand of the artist, not by the skin of the woman.

After completion, the mold is disassembled, freeing the original sculpture within. At this point any imperfections can be corrected. Before the casting material is poured in, the interface should be coated with an appropriate release agent—usually wax or petroleum jelly. The mold is then reassembled and it is ready to be *charged* with the casting material. If the sculpture has a bottom, this area should be left open to serve as the charging entrance. Otherwise, some portions of the mold must be left open for filling. After the mold has been removed, this area of the casting may have to be refinished so that its surface matches the surface of the rest of the sculpture. If the mold is filled with a solid material like concrete, it will need tamping or vibrating to ensure that the material fills all parts of the mold.

It is also possible to make a hollow sculpture by the piece-mold method. Small molds can be rotated as the liquid plaster or wax is poured inside to give them an even coating. Larger molds must have enough room inside to enable you to *lay up,* or apply, materials such as clay, fiberglass, wire-reinforced concrete, or plaster reinforced with swatches of burlap. Such molds may be cast partly disassembled. The cast sections are then taken from the mold and joined to form the final intact cast. This system works particularly well with a material like fiberglass, because the separate sections can be joined with fiberglass tape and the outside surface sanded smooth.

Once the material in a mold has hardened, the mold is stripped off, cleaned, and set up for the next cast. The resulting sculpture or reproduction can be worked over extensively after it leaves the mold, or it may be left relatively untouched. Aggregate-filled materials—such as concrete, filled plaster, or filled

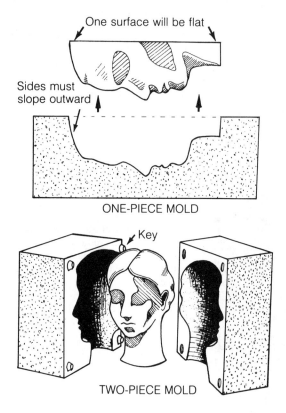

Figure 4.4. One-piece and two-piece molds. The surfaces of the one-piece mold must be slanted outward from the center. If a surface is vertical or leans inward ("overhang"), the cast will be difficult or impossible to withdraw from the mold. A two-piece mold is like two one-piece molds joined to produce a fully rounded object.

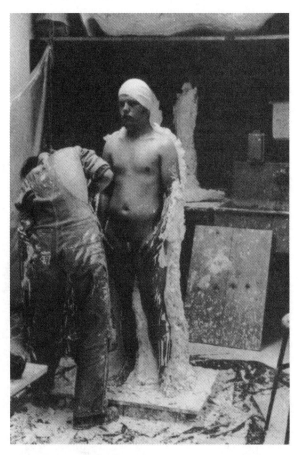

Plate 4.9a. Full body cast. By correctly positioning the parting line, the entire back section can be made in one piece.

resins—will form a surface skin of the finer components of the aggregate mix. If the particles of the aggregate are to show on the surface, this fine-grained skin must be ground through to reveal the matrix. Terrazzo concrete is a good example: the marble chips in the mix are ground flush with the surface and add a contrasting pattern to the matrix in which they are embedded.

If you want to retain the surface skin texture, you must take care not to penetrate it in making repairs, for the cast surface is difficult to simulate once it has been broken. If the surface of the cast is left just as it comes from the mold, it will have fine ridges corresponding to the joints of the mold sections. When the mold wears down, the ridges it produces become more pronounced. Since the divisions of the mold are originally laid out along the prominent crests of the forms composing the sculpture, the ridges on the cast tend to define these forms. Some sculptors allow these casting ridges to remain, as an indication of the method by which the sculpture was made.

Flexible Molds

Plaster records surfaces faithfully, but it has many drawbacks as a mold material, particularly for larger molds. It is heavy, rigid, and fragile. A large plaster piece mold is cumbersome. For certain types of work, lightweight flexible molds provide the best solution.

Latex. Latex is a natural unprocessed rubber that dries in the air to a tough, elastic film. This elasticity enables it to record surface detail with considerable undercutting, while retaining its ability to pull free; thus, molds can be constructed of a minimum number of pieces when they are lined with latex. Since latex is very soft, it must be backed up by a shell or

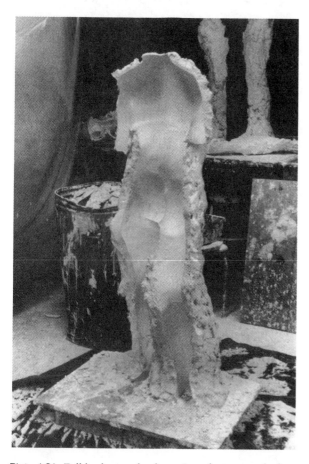

Plate 4.9*b*. Full body cast, back section after removal of model. This part will be cast in one section of fiberglass.

Plate 4.9*c*. Full body cast, showing extremely accurate skin texture and parting line carved to a smooth contour.

case of plaster or fiberglass. Natural latex dries slowly and should be applied in a succession of thin layers. In the past few years latex compounds have been developed which set by catalytic action, so they cure evenly throughout and do not need to be built up gradually.

Latex is irritating to the skin and it is also inflammable.

Various grades of silicone rubber molding compounds, or *cold molding compounds,* are available as alternatives to latex as a mold liner. These are synthetic rather than natural rubbers and are also referred to as RTV (room-temperature-vulcanizing) compounds. They set by catalytic action, so they are faster to use than natural latex, have better shelf life, and can be formulated with different degrees of elasticity. Widely used by industry, silicone rubber molding compounds are still fairly expensive for the average sculptor, unless used in small works.

Glue and agar. Animal glue derives from boiling

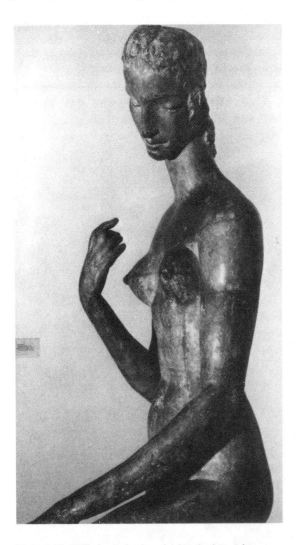

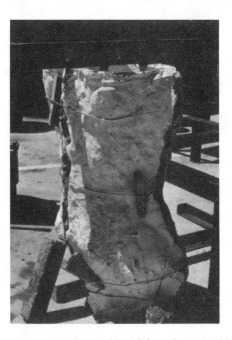

Plate 4.10. Wilhelm Lehmbruck, detail of *Kneeling Woman,* cast stone 69½″ high, at base 56″ × 27″, 1911. Collection of the Museum of Modern Art, New York, Abby Aldrich Rockefeller Fund (photo credit Museum of Modern Art). Visible on the surface of this concrete ("cast stone") sculpture are the ridges left by the joints in the piece mold from which it was cast.

Plate 4.11*b.* Piece mold with latex liner. Mold assembled, leveled, and ready to be poured.

down animal bones and hooves; *agar* is a product of the processing of seaweed. Both of these substances have been used for many years as cheap, flexible mold compounds. They are less flexible and strong than latex, but they work well for many medium-size, not-too-demanding casting jobs. Because they are organic compounds, glue and agar have odors and are subject to decay. Unlike latex and synthetic cold molding compounds, agar and glue can be reused by being broken up and remelted.

Fiberglass. Fiberglass is light, strong, and slightly flexible. A good material for mold-making, it is easier to remove from a cast than is plaster. In addition, the sections can be much thinner, resulting in a more compact mold. Fiberglass molds can be constructed

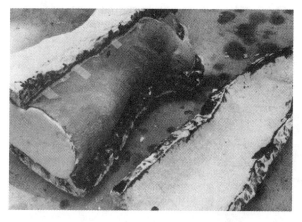

Plate 4.11*c*. Poured mold with one plaster section removed.

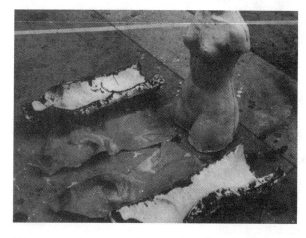

Plate 4.11*d*. Plaster cast after removal of two sections of mold with latex liners.

according to the same principles as plaster molds. Because of the thinness and flexibility of the fiberglass sections, it is generally possible to use fewer pieces than would be necessary for a plaster piece mold.

The first layer of resin in a fiberglass mold can be thickened with a thixotropic agent so that it will record surface detail. For more details on fiberglass, see chapter seven and also below under Cast Fiberglass.

CASTABLE MATERIALS
Casting Clay

The two methods by which clay can be cast are *pressing* and *pouring*. Both can produce either solid casts for models and study purposes or hollow casts with walls of uniform thickness suitable for firing. In any case the inside surface of the mold must be prepared by lightly dusting with talc or French chalk (a talclike substance) to ensure easy removal of the cast.

For the pressing method, a piece of clay should be placed on the inner surface of the mold and pushed down, working it outward to produce an even layer. If additional clay is required to cover the mold, it should be carefully worked into the already placed clay so that the two will be bonded together firmly. Fill each piece of the mold in this manner, then assemble the mold, joining the seams with the clay-joining technique discussed in chapter two. If the cast is large and the walls require strengthening, add on clay "ribs" or "honeycombs." Wrap the mold in cloth and place it on an open-shelf rack to permit even circulation of air. When the clay has reached the leather-hard stage, the pieces of the mold can be removed; the completed cast can then be refined and smoothed. If the cast is to be fired, it must be allowed to dry thoroughly.

The technique of pouring clay into a mold requires that the clay be in the form of slip. *Casting slip* is a liquid mixture of clay and water that contains a wetting agent, such as sodium silicate, to render the clay fluid with the least possible amount of water. This mixture will shrink less upon drying than slip containing a larger percentage of water. For slip formulas, consult the ceramics books listed in the bibliography for chapter two.

When the slip reaches the consistency of heavy cream, it can be poured into an already assembled,

talc-dusted mold. The pouring should be done slowly, so that the slip covers all portions of the interior of the mold in an even coating. If you vibrate the mold as you pour, coverage will be more complete and uniform. The vibration will also force out any trapped air bubbles. When a wall of the required thickness has been built up, the remaining slip should be poured away. Allow the piece to set, observing the same procedure as for pressed-clay casts.

Casting Plaster

Plaster can be cast solid or hollow. While solid casts are stronger, they are quite heavy, and are generally avoided in making large-scale works. Hollow casts can be strengthened by building up an inside layer that contains sisal fiber, pieces of burlap, or both.

Plaster waste molds perform well in casting plaster, provided that a layer of the mold near the interface has been colored. When you begin to chip the mold away, this layer of color will warn you that you are approaching the surface of the cast.

Solid casting should proceed as follows. Apply soap or petroleum jelly to the inside of the mold pieces, then clamp the sections together to form the complete mold. Mix the plaster and pour it into the mold. (It is a good idea to vibrate the mold gently as you pour, for this will release air bubbles.) When the plaster reaches the consistency of hard cheese, level it off at the mold opening. Do not turn the mold right side up until the plaster has set. It should then stand for about an hour. If you are using a waste mold, carefully chip it away with a chisel and mallet. Never attempt to remove it all at once, or severe damage to the cast will occur. Chip away, working from the high points down to the lower ones, using the colored layer of the mold as a guide. When the mold has been completely removed, make any necessary refinements or repairs. Blunt chisels can be used as wedges to remove a piece mold, taking care not to crack the mold.

To cast hollow forms, prepare the mold in the same manner as for solid casting. Then pour in enough plaster to make a layer about one-fourth

Plate 4.12. Peter Agostini, *Carousel*, plaster, 7½' high. Courtesy of Zabriskie Gallery, New York. Cloth umbrellas, inflated inner tubes, and balloons provide the original patterns from which the many molds were cast that went into the making of this fanciful sculpture.

inch thick, rotating the mold to allow for even coverage. For small casts you can pour in a second layer about one-half inch thick, mixed with chopped fiber or burlap. Larger casts require that layers of fiber-reinforced plaster be built up from the inside. The remaining procedures are the same as for solid plaster casts.

Casting Concrete

Concrete is occasionally termed "cast stone" when used for sculpture. Most people today recognize that concrete need not be ashamed to carry its correct name.

It is possible to cast concrete in all types of conventional molds. In the process of casting, the cement presses through the aggregate to make con-

tact with the interface of the mold; thus, accurate casts can be made of delicate surface features, even with a fairly coarse mix. As discussed in the previous section, however, once the thin cement surface skin has been broken through, the aggregate beneath is exposed, making casting errors in concrete difficult to repair.

When casting thin or extended shapes, reinforcing rods and/or wire mesh will greatly increase the strength of the finished work.

Successful concrete casting depends upon using the right consistency of concrete for the shape involved. If the shape is intricate, the concrete must be soft enough to fill the details of the mold; however, if the mixture is too watery, the cast will be weak. Thorough mixing of the concrete before pouring and

Plate 4.13*a*. Cloth forming of concrete. A piece of carpet is suspended between tables, and a one-inch layer of mortar and mesh is applied over it. In the foreground a tube (denim pant-leg) is filled with concrete and bound with rope.

Plate 4.13*b*. Cloth forming of concrete. The finished casts show the textures and bulging forms produced by cloth casting.

thorough tamping of the mold will produce dense casts with a minimum amount of water.

As described earlier, cloth molds work well with concrete. Bag and tube shapes can be made of strong cloth or canvas and charged with concrete. Textures and wrinkles in the cloth will be rendered in the concrete when it is set. Ropes can be used to tie and squeeze the cloth forms or to suspend them from supports.

Shell-like forms can be made by smoothing concrete over suitable mesh reinforcement in swagged and draped cloth. You can also cast in earth and sand, but unless the surface of the mold is lined with polyethylene sheeting, the concrete will pick up some of the mold material.

Styrofoam is an excellent material for concrete molds of all kinds, including reliefs and hollow forms. The interface should be coated with silicone PVA mold release or pancake syrup to facilitate removal of the set concrete.

Casting Plastics

To work with any plastic you must become familiar with its properties, as well as with its catalysts, promoters, solvents, and mold-release agents (parting agents). Much of this information is provided in chapter eight, but material of a more technical nature can be found in the references listed in the bibliography or, in some cases, by contacting your plastics supplier or manufacturer directly. Be sure to read over the safety precautions discussed in chapter eight; unless these instructions are followed carefully, working with resins can be extremely hazardous.

Cast polyester. The plastic most frequently cast in the sculptor's studio is polyester. It is usually worked

Plate 4.14. Paolo Soleri, *Earthhouse at Arcosanti: Silt Form-work.* Courtesy of Coasanti Foundation (photo credit Ivan Pintar). Concrete is poured over an earth mound to form a dome. Ribs have been carved into the mound and steel reinforcement is embedded as the work proceeds. After the concrete has cured, the earth is removed, leaving the shell of the building.

Plate 4.15a. Parts for resin mold. The plywood sides are covered with ½ mil Mylar to produce a smooth surface and easy release. Note the beveled edges.

Plate 4.15b. Mold ready for pouring in resin tent. The polyethylene tent makes an airtight compartment to prevent escaped resin fumes. The fan exhausts the fumes to the outside. In populated areas a vent pipe may be necessary to carry away the fumes.

with power tools and is relatively expensive compared to plaster or concrete but less expensive than bronze. Polyester resin can be left in a clear state or mixed with a variety of fillers and coloring agents before it is cast in a solid form.

There are two main types of polyester resin for casting: *crystal clear* and *mass-cast*. Crystal clear is truly clear but cannot be used for pieces more than a few inches thick, though the area of this thickness can be quite large, as in a wall plaque. It is used commercially to fabricate small decorative items and embedments.

Mass-cast resins will allow quite large casts—up to about 20 gallons (200 lbs.)—to be made with normal procedures and a little care. The large cast sculptures pioneered by California artists during the late sixties are made of mass-cast polyester resin poured under highly controlled conditions. In addition to the critical amounts of catalyst and promoter required, factors affecting the cure are: the temperature of the resin and the mold, the temperature and humidity of the room, the material of the mold lining, and the type and quantity of the pigments used. As a rule, follow the manufacturers' sug-

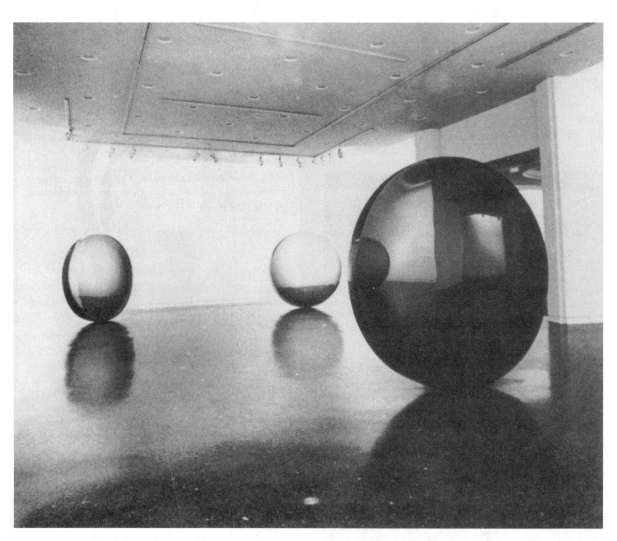

Plate 4.16. DeWain Valentine, *3 Concave Circles*, cast polyester resin, 8' diameter, 1970. Installation view, Pasadena Art Museum, courtesy of Pasadena Art Museum, California. These large disks were cast with mass-cast resin suffused with finely-ground transparent red pigment. The unusual degree of optical clarity is achieved through exacting techniques for grinding and polishing.

gestions concerning the amount of catalyst (methyl-ethyl-ketone, MEK) to be mixed in. With experience, you will be able to adjust these amounts as you see fit. The promoter generally will be already combined with the resin. Your workroom should be relatively dry and kept at a temperature close to 70°F.

In addition to crystal clear and mass-cast resins, there are flexible casting resins that can sometimes be mixed with mass-cast to make it more flexible when curing. Flexible resins can also be used alone, suggesting a considerable range of sculptural possibilities.

Molds for small pieces can be made of plate glass caulked with silicone sealant. For all sizes, wooden molds lined with ½ mil aluminized Mylar are standard. Plaster or fiberglass molds serve for casting nongeometric shapes, with intricate details and undercut relief entrusted to RTV silicone rubber. The most widely used mold release agent for polyester casts is polyvinyl alcohol (PVA).

Resins to which fillers have been added are easier to cast than clear ones; the fillers strengthen the resin and absorb some of the heat released in curing. Metal powders and other aggregates can be combined with the resin to produce solid cast materials resembling bronze, aluminum, iron, marble, granite, concrete, and wood, to name just a few. The surface of the cast is usually sanded after its removal from the mold to reveal the texture and color of the filler material.

All the types of molds described above can be used for casting filled resin compounds. When pouring an intricate mold, you must take care that the molding compound is not too stiff; it must be able to fill in the details of the mold. In larger casts, the piece is often cast hollow and the fillers mixed in with the surface layer of resin. Sometimes the cavity is filled up later with polyurethane foam for added rigidity.

Cast epoxy. Since epoxies are more expensive than polyesters, there is little reason to use them for casting, except in situations in which their superior strength and adhesiveness make them necessary. Epoxies will accept a higher percentage of filler material without weakening than will polyester, and have greater resistance to impact. Epoxies are used by the electronics industry for encapsulating small components; anyone working with electric sculptures might find them valuable for this purpose. A variety of

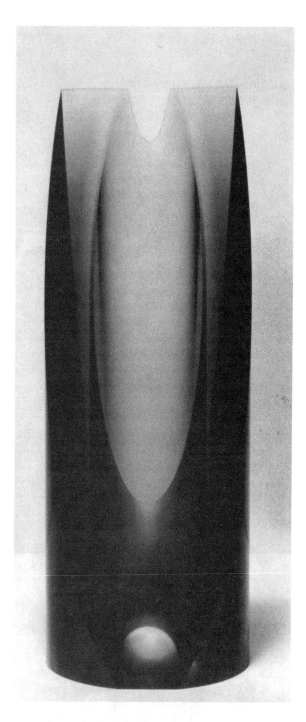

Plate 4.17. Fred Eversley, *Untitled*, polyester resin, 20½″ × 7½″ × 7½″, 1970. Collection of Whitney Museum of American Art, New York (photo credit Whitney Museum). This casting shows layers of transparently pigmented resin. Each layer must be poured at exactly the moment when it will fuse with the curing layer beneath it. After the whole block has cured, it is cut and polished.

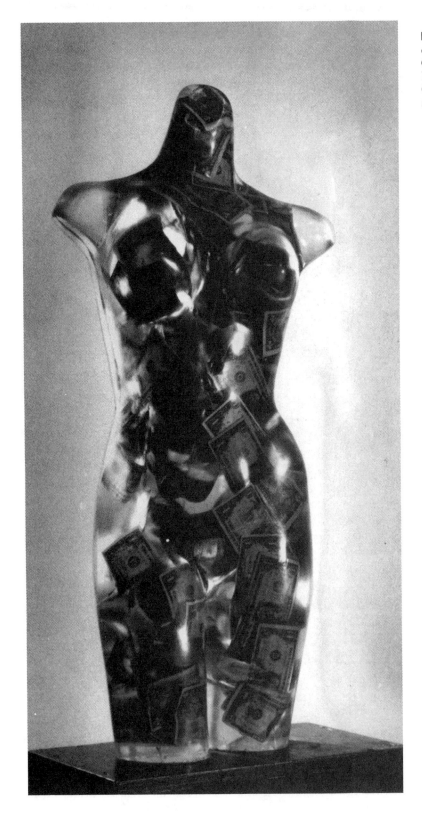

Plate 4.18. Arman, *Venu$*, cast polyester with money, 35″ high, 1970. Collection of Andrew Crispo Gallery, New York (photo credit Andrew Crispo Gallery). Arman combines dazzling wit with technical legerdemain.

epoxies are manufactured for casting in rigid and flexible formulations.

Cast fiberglass. As discussed in chapter seven, fiberglass is made from glass fiber, matting, or cloth that has been impregnated with polyester resin. Epoxy can be substituted for the polyester. The two methods by which fiberglass is molded are *hand layup* and *spraying*.

In hand layup, the face of a nonporous mold is sealed and coated with a mold release such as polyvinyl alcohol, so that the polyester resin will not adhere to the mold. When a fiberglass shape is cast in a negative mold, the final surface can be created within the mold without the necessity of further finishing. This is accomplished by a *gel coat*, available already prepared in several types, which is applied to the surface of the mold before any layers of glass fiber are built up. The gel coat usually contains a thixotropic agent such as silica flour which enables it to form a thick, even coat over the mold instead of running down the sides. The gel coat may contain some chopped strands of glass for added strength, and it is usually applied "hotter"—that is, with more catalyst—than are the following layers of resin. Layers of glass and resin are built up by lamination (see chapter seven) until the cast form is completed.

When you are using a positive mold or fiberglassing over a core, the process is the same, except, of course, that a gel coat is unnecessary since it does not represent the final surface. The final surface must be achieved by sanding and hand-finishing the laminated fiberglass.

Plate 4.19*a*. Fiberglass cast in plaster mold. The cloth is cut to shape and fitted to the mold contours.

4.19*b*. Fiberglass cast in plaster mold. In sequence apply 1) gel coat, 2) color coat, 3) glass and resin, and 4) final resin coat.

Plate 4.19c. Fiberglass cast in plaster mold. The finished cast is pried from the mold. After cleaning the mold, additional casts may be made.

Plate 4.20. Fiberglass boat hull. Courtesy of Burson Marsteller, Public Relations, New York. This boat hull was produced by laminating several layers of glass cloth resin over a gel coat applied to the inner surface of the mold. The mold can be reused many times.

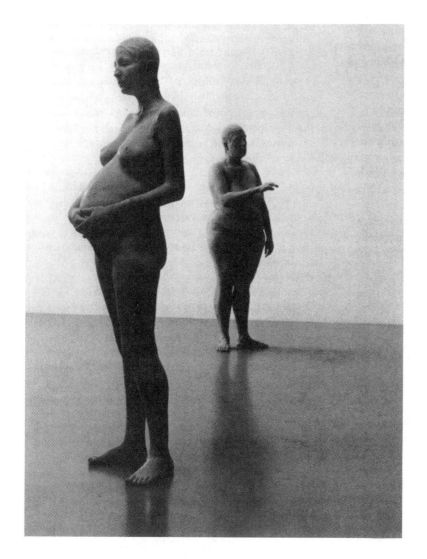

Plate 4.21. Robert Goulart, *Laura and Leah*, fiberglass, 5'2" and 5'1" high, 1974. Courtesy of Robert Goulart. These figures were built up of fiberglass in molds made of plaster lined with RTV silicone rubber molding compound. The pieces were then formed with thickened polyester resin and glass tape.

TABLE 4.1 Release Agents

Material	Consistency	Application	Use
Vaseline	greasy	brush, fingers	general clay & plaster
Soap	liquid	brush, several applications	plaster fine detail
Wax	paste	brush, cloth	plaster & plastics fine detail
Lard	soft	brush	general clay & plaster (cheap)
Polyvinyl Alcohol (PVA)	paste	brush	plastics, good release
Pancake Syrup	sticky	brush	concrete

To seal porous molds for fiberglass layup, two coats of lacquer or shellac should be applied to the interface. Following this, the surface should be paste waxed and buffed *twice* before a coat of PVA is put on.

Spraying fiberglass requires a power spray machine that premixes measured amounts of resin and chopped fiber and feeds them through a wide nozzle into a mold or onto surfaces. Used primarily by industry, these power outfits can often be rented from local manufacturers. When spraying plastics, extreme safety precautions should be taken to prevent skin and eye contact. It is advisable to wear a full face mask connected to an external source of fresh filtered air. The effects of breathing resins are drastic and may include irreversible damage to the nervous system.

BIBLIOGRAPHY

Chaney, Charles, and Stanley Skee. *Plaster Mold and Model Making*. New York: Van Nostrand Reinhold, 1973.

Hochfield, Sylvia. "Problems in the Reproduction of Sculpture," *Art News* 73, 9 (November 1974), 20.

Johnson Atelier. 743 Alexander Road, Princeton, NJ 08540. Information and slide sets on casting processes.

Mills, John W. *The Technique of Casting for Sculpture*. New York: Reinhold, 1967.

Percy, H. M. *New Materials in Sculpture*. London: Alec Tiranti, 1969.

Chapters on molds and casting will be found in most of the comprehensive books on sculpture techniques listed in the Appendix.

SOURCES OF SUPPLY

Adhesive Products Corp., 1660 Boone Ave., Bronx, NY 10460. Silicone rubber, Kwikmold latex compound, mold release, cold-casting compounds.

L. D. Caulk Co., Milford, DE 19663. Jeltrate alginate molding compound.

Dow Corning Corp., Midland, MI 48641. Silicone rubber.

M. Flax Artists Supplies, 10846 Lindbrook Dr., Los Angeles, CA 90024. General sculpture and casting supplies.

General Latex & Chemical Corp., Box 35l, Ashland, OH 44805. Denscal high-strength industrial plasters.

B. F. Goodrich Industrial Products Co., 500 S. Main St., Akron, OH 44318. Latex rubber.

Hastings Plastics Co., 1704 Colorado Ave., Santa Monica, CA 90404. Silicone rubber and other molding compounds.

Sculpture Associates, 101 St. Marks Place, New York, NY 10003. General sculpture and casting supplies.

Sculpture House, 38 E. 30th St., New York, NY 10016. General sculpture and casting supplies.

Shell Chemical Corp., Synthetic Rubber Div., 19253 S. Vermont, Gardena, CA 90247. Latex rubber.

Smith & Co., 1220 S. 49th St., Richmond, CA 94804. Silicone rubber.

Alec Tiranti Ltd., 72 Charlotte St., London W-1, United Kingdom. Sculpture equipment and cold-casting compounds.

U.S. Gypsum Co., 300 W. Adams St., Chicago, IL 60606. Casting and mold-making plasters.

Local building materials companies. Plaster, cement, sand, sisal fiber, and burlap for reinforcement.

5

Cement and Concrete

The composite nature of concrete determines its particular character. It is made from a selection of different mineral ingredients that interact with one another to produce a stonelike mass with a controllable range of properties. Concrete can be a heavy, coarse material resembling sandstone or limestone; a smooth, carvable, polishable mass similar to marble; or a light and porous material like tufa or volcanic rock. Yet concrete used as a thin, flexible shell will yield forms impossible to achieve in any type of stone, the nearest equivalent being the delicate and highly engineered webbing of a Gothic cathedral. Like clay and plaster, concrete can be cast; while not as plastic as clay, it is much stronger than plaster. As a sculpture casting material, concrete is sometimes called "cast stone," but it would be a mistake to think of it exclusively as a kind of imitation stone, since it has its own unique properties. Its qualities of strength and durability—plus the low cost and ease of working—make it ideal for large outdoor structures and architectural works.

THE NATURE OF CONCRETE

Concrete is prepared somewhat like plaster, by mixing dry ingredients with water and allowing a setting process to take place. The two basic components are the *cement* or binder and the *aggregate* or granular material that the cement holds together. The aggregate·can be sand, gravel, pumice, ceramic fragments, or almost any other granular material. Often a third element, a *reinforcement,* will be added to increase the tensile strength of normally brittle concrete and make it more elastic, so that it can flex without cracking. *Ferroconcrete,* the most widely used building material of the twentieth century, consists of steel rods and steel mesh laid inside concrete to strengthen it. This results in a *two-phase* material that has properties combining the virtues of each component. (Another two-phase material is fiberglass, discussed in chapter seven.)

Actually, any combination of a binder with an aggregate can be considered a kind of "concrete"— for example, asphalt paving, a mixture of oil and gravel; "plastic wood," a combination of glue and sawdust; or "putty," a blend of linseed oil and white lead. Generally speaking, however, the term *concrete* refers to a mixture of sand and gravel with a water-setting mineral cement derived from limestone and clay. This chapter deals with such concretes; further

Plate 5.1. James Wines, *Notch Project Showroom* for Best Products Company, Sacramento, California, concrete block construction 36′ × 202′ × 164′, 1977. Courtesy of Best Products Company (photo credit Michelle Stone). This building was constructed on concrete blocks bonded together with mortar, over a steel frame. The corner is 14′ high and moves on tracks in and out of the "notch" to close or open the building, which is a showroom for many kinds of merchandise.

information about composite materials based on wood and plastics will be found in chapters six and seven.

COMPONENTS OF CONCRETE

Cements

Portland cement. The most common cement is Portland, named for a city in the south of England where there is a naturally occurring grayish limestone called Portland stone which the cement resembles in its "set" or hardened state. When mixed with water,

Portland cement begins to set in about an hour. Under normal conditions damp cement reaches 80 percent of its ultimate hardness in about seven days. If kept damp, it will complete its curing cycle and reach maximum hardness in twenty-eight days, but heat and accelerators can speed the process. Because it requires water to set, cement is said to be a *hydraulic* material.

Unlike plaster, which sets completely in under half an hour but can later be returned to its original state, cement, once set, can never be reconverted to its precast condition. Cement also differs from plaster in its imperviousness to water after curing.

Plate 5.2. Eduardo Torroja, *Hipódromo de la Zarzuela*, Spain, concrete reinforced with steel mesh, 1935. Courtesy of Instituto Eduardo Torroja, Madrid. Concrete rein- forced with steel mesh was cast as a thin shell for these cantilevered roof canopies.

Plate 5.3. Le Corbusier, *Chapel at Ronchamp*, 1954. Courtesy of French Government Tourist Office (photo credit Lucien Hervé). The rough, massive quality of cast concrete is forcefully expressed here.

Plate 5.4. Le Corbusier, *Chapel at Ronchamp*, photographed under construction (photo credit Lucien Hervé). The steel reinforcing bars and wire mesh are wired in place before the concrete is poured.

Moisture and exposure to weather will not deteriorate it. Furthermore, whereas the setting of plaster involves a relatively simple chemical action, cement setting is a complex interlacing of fast- and slow-growing crystals of silica, alumina, calcium carbonate, and calcium silicate—the chemical constituents of the limestone-clay mixture from which cement is made.

The raw materials for Portland cement are mined in areas where natural deposits of limestone and clay occur in the proportions required to produce good cement. These raw materials must be pulverized and heated in large rotating kilns to drive off about half the water content. The product, called *clinker,* is then ground to a fine powder and packaged as Portland cement. Additions of 10 to 15 percent fireclay produce a relatively plastic cement suitable for wall stucco, mortar, or any application that requires a stickier mix. To make *high-early-strength* cement, calcium chloride and calcium oxychloride are added as accelerators.

Further refinement and bleaching of Portland cement produce white cement, used to make tile mortar, *terrazzo,* and white stucco. White cement mixes well with bright pigments; the gray of standard Portland dulls colors mixed with it. Sculptors combine white cement with white silica sand, alum, and marble dust to produce clean, sparkling concretes resembling white marble. White cement costs about twice as much as ordinary Portland cement.

Magnesite. Magnesite is an oxychloride cement. The two principal types are a mixture of magnesium oxide with magnesium chloride and a mixture of zinc oxide with zinc chloride. Magnesite cement produces a very hard concrete that takes a superior polish. Sometimes poured as a floor material where a high finish is desired, this concrete presents the dual drawback of brittleness and lack of complete water resistance. If used outside, it must be kept waxed or otherwise protected. For this reason, terrazzo, a mixture of cement and ground marble, serves more often for high-polish floors today. Although expensive, terrazzo is both luxurious and durable.

Refractory cements. Starting in the 1950s several families of *refractory* or heat-resistant concretes have been developed. These *castable refractories* contain high-alumina cements and magnesite cements in combination with alumina, chrome ore, and magnesia aggregates. Once set, refractory cements can withstand temperatures up to 2800°F for the alumina-based concretes, to 4000°F for all-magnesia materials. In terms of their density these cements offer a range from very lightweight to heavy, impervious, and abrasion-resistant.

The interest to artists of these refractory materials lies not so much in their suitability as sculpture media (except for sculptors working with fire) as in the possibilities they present for the sculptor or potter who wants to build his own kiln or metal-casting furnace. The artist-builder, once limited to

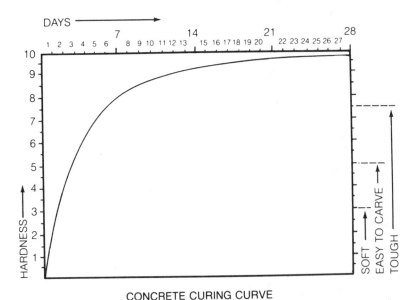

CONCRETE CURING CURVE

Figure 5.1. Concrete curing curve. If concrete is kept damp it will reach 75 percent of its maximum hardness in five days. When continuous dampness is maintained, it will reach 98 percent of maximum hardness in 28 days. Concrete that is allowed to dry out after pouring will attain only 30 percent to 40 percent of the potential hardness of properly cured concrete.

shapes that could be constructed of bricks, can now cast furnaces, furnace lids, flues, and kiln doors in one piece.

Aggregates

The aggregate in concrete can vary from a fine powder to large boulders. Very large aggregate protrudes from the mix and is obviously visible, whereas a fine aggregate will impart color, texture, and its own strength or weakness to the mix. In a particular concrete there may be one or more types of aggregate. *Mortar* is a smooth, buttery mix of sand and cement used between stones and bricks. In terrazzo several aggregates are combined with cement: mineral colors, sand, and several sizes of marble chips.

The strongest concrete results from a mixture of sand and gravel screened in such a way that the particles of one aggregate size fit into the voids or spaces between particles of the next larger size. Such an exactly graded concrete may include four or five or more steps in particle size. The quantity of cement in this ideally dense mix is the amount necessary to coat all the particles in the mix, and to fill the voids between them from the finest sand to the largest rocks.

Most concrete mixes contain a certain amount of sand. There are hundreds of varieties of sand, often identified by the localities from which they come. Sharp, angular sands that are newly ground feel harsh and gritty. These produce a stronger concrete than the rounder sands, like beach sand, in which the corners have been worn off by the tumbling action of waves and erosion.

Table 5.1 lists some of the more commonly used concrete aggregates and their properties. As one would expect, the stronger the aggregate material, the stronger the resulting concrete will be. Softer, more porous materials yield lighter concretes that are easier to carve.

In general, if the aggregate is softer than the surrounding matrix of cement, the concrete will carve smoothly and aggregate particles can be cut flush with the surface. But when the particles are harder than the cement, they will either protrude from the surface or become detached when struck with a chisel, leaving a pit. Thus, the surface of a carved block containing coarse flint gravel, for example, would be rough and pitted.

MIXING CONCRETE

The major consideration in mixing concrete for a particular application is achieving the optimum proportions of water, cement, and aggregate. Theoretically, the sculptor should add only enough water to moisten the entire mixture and start it setting. Excess water weakens concrete, because any amount of water beyond that which can enter into

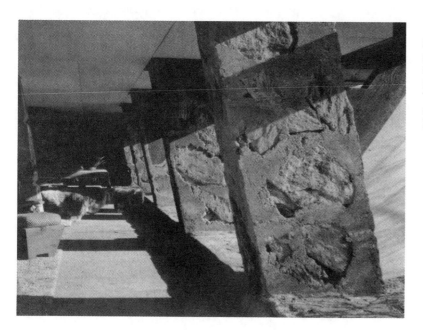

Plate 5.5. Frank Lloyd Wright, *Taliesin West*, Scottsdale, Arizona, 1938. Concrete was poured into wood forms around boulders from the site. The boulders were placed one on top of another as the column grew in height.

SAND AND GRAVEL PARTICLES
IN CONCRETE MIX

Figure 5.2. Sand and gravel particles in concrete mix. In a well-graded mix of gravel and sand, there is a variety of particle sizes with a selected quantity of each. Size the mixture so that the smaller particles fit in the spaces between the larger particles in an evenly dispersed pattern. Each layer should be coated with a layer of moist cement. The particles illustrated have the sharp edges characteristic of freshly crushed sand and gravel.

chemical combination with the cement forms small voids or empty spaces when it evaporates. If a sculpture is placed outside and water enters these voids, cracks can develop when the temperature drops below freezing.

Minimum water yields a concrete that not only requires an inordinate amount of mixing but is difficult to handle and tamp into place. In practice, most sculptors add just enough water to make the concrete plastic. Where powerful mixers are available, along with power tamping or vibrating equipment, the mix can be denser. Certain forming methods, however—such as the *gunite* process, in which concrete is blown through a hose—demand an almost liquid solution. To compensate for added water, the cement content must be increased. Such a mix, then, contains a higher than standard proportion of water and cement to aggregate.

In building moderate-size sculptures, the artist's primary concern is usually with the appearance and handling qualities of the concrete, rather than with extreme strength or economy of material. He or she usually works out the proportions by making a few test samples. Large architectural works, however, may require a series of carefully controlled tests and perhaps even the services of a concrete engineer to calculate the exact quantities of each ingredient.

Table 5.2 provides average quantities of the various ingredients for certain typical mixtures. These can be varied by making tests to determine ideal proportions for a particular project.

Small batches of concrete can be mixed in a tub or wheelbarrow. Combine all the dry ingredients first, then add water and mix thoroughly with a hoe or large trowel. On small jobs that call for standard mortar or concrete mixes (or formulations based on these), you can buy the dry ingredients premixed in bags, then simply add water and mix to the desired consistency.

A cement mixer offers by far the best way to mix large quantities of concrete. In this case, you can either combine the dry ingredients and then add water, or put the water in the mixer first and then gradually add the cement, coloring materials, and other ingredients. The latter method helps to prevent the mixer blades from becoming caked with clods of uncombined material. Very large projects may warrant the purchase of concrete delivered in a *transit-mix* truck. This requires planning, however, for

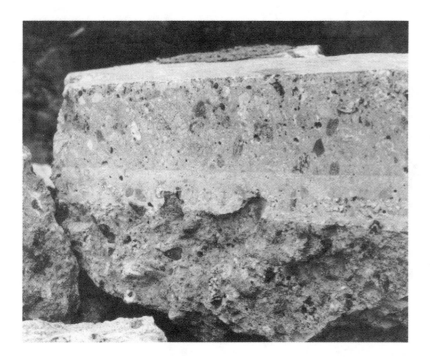

Plate 5.6. Broken paving blocks. The structure of the concrete aggregate is plainly visible.

TABLE 5.1 Concrete Aggregates

Name	Origin	Character
Beach sand	beaches	soft, flowing, fine
River sand	river banks	sharp, contains range of particle sizes
Silica sand	beach, desert, building supply	white, screened for consistent particle size from No. 12 coarse to No. 90 superfine
Pea gravel	natural	rounded particles
Flint gravel	gravel crusher	flat, angular particles
Pumice	volcanic	light, porous, carves easily
Tufa	volcanic	light, porous, brittle
Marble chips	marble manufacturers	luminous, carves, many colors
Marble dust	marble manufacturers	fine, smooth, brilliant
Vermiculite	expanded mica	soft, superlight
Perlite	pulverized plastic	white, superlight
Metal filings	machine shop or manufacturer	strong, impart character of particular metal
Carborundum	manufacturer	superhard, glitters
Grog	ceramic manufacturers	pulverized ceramic: black, red, buff
Brick chips	make yourself or builders supply	coarse crushed ceramic: porous, red, buff
Mineral colors	ceramic or builders supply	inert coloring material
Sawdust	lumberyard	light, porous
Microballoons	plastic manufacturers	exact graded sizes, lightweight, expensive
Pulverized seashells	make or from manufacturers	colorful, light-reflective

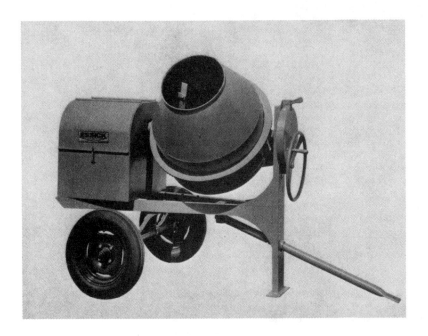

Plate 5.7. Concrete mixer, Mold 93. Courtesy of Essick Manufacturing Company, Los Angeles, California. This concrete mixer can be towed behind an automobile, and can be powered by either a gasoline or an electric motor.

CONCRETE TOOLS

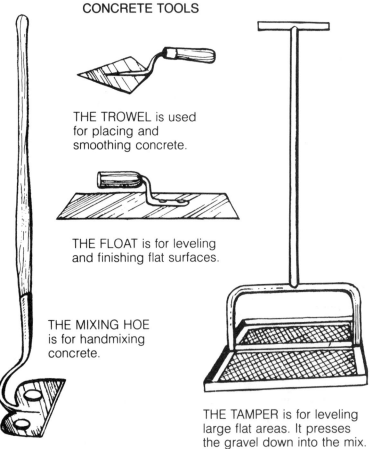

THE TROWEL is used for placing and smoothing concrete.

THE FLOAT is for leveling and finishing flat surfaces.

THE MIXING HOE is for handmixing concrete.

THE TAMPER is for leveling large flat areas. It presses the gravel down into the mix.

Figure 5.3. Concrete tools. The trowel is used for placing and smoothing concrete. The float is for leveling and finishing flat surfaces. The tamper is for leveling large flat areas; it presses the gravel down into the mix. The mixing hoe is for hand-mixing concrete.

TABLE 5.2 Proportions for Concrete

Type of concrete	Cement	Sand	Gravel	Other
Common construction	1 Portland	3 sharp	4 sharp or pea	stones as desired
Mortar	1 Portland or plastic	3 sharp		
Casting	1 Portland	3 sharp	2–4 as desired	color, etc.
White casting	1 white	3 white silica		marble chips, color, pumice, etc.
Modeling	1 Portland or plastic	2–3 silica		up to 1 part clay for plasticity; color, Zonolite, etc.
Quickset modeling	1 Portland	2–3 silica		up to 4 parts plaster; up to 1 part clay; color, etc.
Wet carving	1 Portland, plastic, or white	2–3 silica	1–2 fine gravel in larger works	color, Zonolite, pumice, etc.
Dry carving	1 Portland or white	2–3 silica or sharp	1–4 fine gravel in larger works	color, Zonolite, pumice, marble chips, etc.

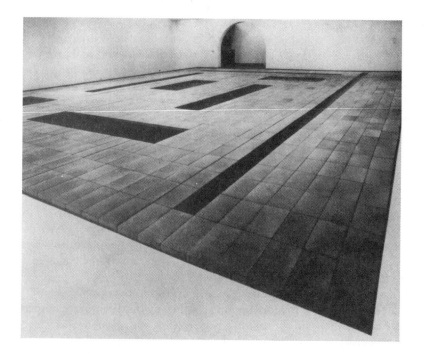

Plate 5.8. Carl André, *Cuts*, concrete blocks, 2″ × 30′ × 42′, 1967. Installation at Divan Gallery, Los Angeles (photo credit John Weber Gallery, New York). In this installation the artist has created the sculpture by placing precast concrete blocks on the floor. The blocks were cast by a factory for use in building construction. No mortar or other adhesive was used, and the installation was removed after the exhibition.

when the truck arrives, you have less than an hour in which to place several tons of concrete.

Safety and Cleanup

Concrete is caustic to the skin. The sculptor must take precautions to protect hands, eyes, clothing, and tools—also nearby live plants, which it will damage. Gloves should be worn for handling concrete, although protective hand creams may be adequate in cases of very light contact. When mixing large batches of concrete or transferring dry ingredients from bags to bins, it is imperative to wear a respirator to avoid dust inhalation.

Once concrete has set, it is very difficult to remove from surfaces. (For instance, it will ruin the finish of an automobile.) Wash all tools and machinery after use—never in a sink but in a settling barrel, as for plaster. Concrete stains can be removed from bricks and tiles with hydrochloric acid.

FORMING METHODS

Casting

Casting serves a variety of purposes in concrete work. It can be used to form solid blocks intended for carving, to approximate the ultimate shape of a sculpture that will be further refined by carving, or simply to cast a finished sculpture. Concrete lends itself to casting in all manner of conventional molds. Full instructions are given in chapter four.

Carving

After it has set, concrete can be carved by the same general methods that apply to stone carving (see chapter six). It can be chiseled, chipped, ground, and polished. Wood tools will cut concretes made from from softer aggregates, such as vermiculite and pumice, although this type of carving is hard on the tools.

Concrete presents an excellent material for the beginning carver. First cast a block large enough to be stable, using any of the methods described in chapter four. As soon as the block sets, you can begin to carve. If the surface is kept damp during the carving process, it will help to keep down the dust.

Preliminary drawings help in visualizing the form of the sculpture, but you experience the true nature of carving more directly if you proceed to carve the block without any drawings at all. As Michelangelo said, "Carving the figure is simple. You have only to go down to the skin and then stop." After the method of direct carving has been mastered, the sculptor may wish to employ pointers and diagrams for guides.

As mentioned above, concrete permits the sculptor to cast a preliminary shape approximating that to be carved. A shortcut method involves removing the forms from the casting mold while the concrete is only partially set. Carving then proceeds immediately with trowels, knives, spoons, and woodcarving chisels. Within a few hours you can achieve a form that would take days or weeks to cut with stone chisels from completely hardened concrete. This system also permits the shaping of much more delicate projections and tunnels than would be possible in brittle and resistant hardened concrete. Of course, care must be taken not to jar or shock the partially cured material. After the basic form has been realized, surfacing and finishing are carried out while the concrete approaches its final hardened condition.

Modeling over an Armature

It is possible to apply concrete directly over an armature in much the same way as you would use plaster. The same types of armatures are used for concrete modeling as for plaster (see chapter three) except that expanded metal lath often replaces chicken wire or hardware mesh, since the lath provides a better grip for wet concrete. Because concrete modeling generally involves building up only (rather than the build-up-and-carve-away process typical of plaster), the mesh usually remains fairly close to the surface of the sculpture. However, when softer aggregates such as vermiculite are included in the mix, the concrete will remain carvable after setting.

A straight mortar made from sand and Portland cement will not have sufficient plasticity to model well, so plastic cement is preferred for modeling. The plasticizing effect can be increased by adding fireclay to the mortar mix. Because clay shrinks as it dries, a piece built up from concrete with fireclay must be kept damp until the cement sets if you want to prevent cracks from forming. After a time, a fine network of cracks will appear in the surface anyway, but these will not be too noticeable if the concrete has been well cured.

Occasionally, you may wish to work over an armature rapidly, building up one layer over another in succession as in modeling with plaster. To accelerate setting so the concrete will be ready to receive another layer, you can combine 20 to 50 percent

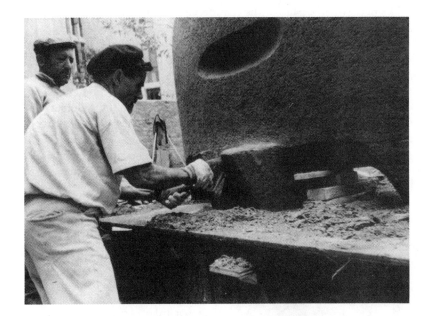

Plate 5.9. Constantino Nivola carving concrete sculpture at Yale University, 1962 (photo credit Robert Galbraith). The concrete is still soft enough to be carved with a mason's trowel, making it possible to complete the sculpture in hours, rather than in days or weeks.

Plate 5.10. James Wines, *Cobra*, steel and concrete, 5′ × 12′ × 4′6″, 1966. Courtesy of Marlborough Gallery, New York. Sections of concrete are formed over a welded steel framework.

plaster with the concrete. Then it will set like plaster in fifteen to twenty minutes, but afterward the mix will gradually harden to a true waterproof concrete. Once the plaster has set up on its own, it remains to function as another aggregate in the cement bond.

Stressed Concrete

When concrete is reinforced with steel to strengthen a casting or to provide an armature for modeling, the reinforcing joins the concrete to create a two-phase material, with the attendant advantages of strength and flexibility that such processes offer. The effectiveness of the two-phase principle depends upon the design of the reinforcement; that is, the degree to which it is continuous and coherent, completely embedded in the concrete, and strategically placed in regard to the stresses that will be present.

The advanced concrete sculptor can take advantage of the further refinements this method offers, by post- and pre-tensioning the reinforcing system. When high-strength steel rods serve as the reinforcement, they can be tensioned before or after the concrete sets to provide a tremendous increase in strength. This permits the construction of thin beams that will span long distances between supports, or of extended arches and curves. Stressed

Plate 5.11. Guniting a "W" panel. Courtesy of Gunite Contractors' Association, Los Angeles, California. Gunite, or air-sprayed concrete, is here applied over reinforcement to make building panels. "W" panels are formed over a foamed plastic center core lined with curtains of welded wire fabric.

Plate 5.12. Pre-tensioned concrete beam. Courtesy of Portland Cement Association. Tension is applied to the reinforcing bars, which are made of high-tensile steel so they will maintain their tension while the concrete around them sets.

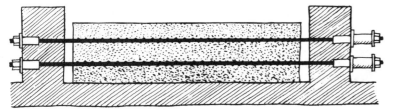

PRE-TENSIONING

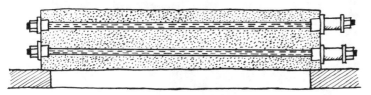

POST-TENSIONING

PRE- AND POST-TENSIONING

Figure 5.4. Pre-tensioning and post-tensioning. Pre-tensioning a concrete beam involves stretching high-stress steel rods on cables between two immovable beams, then pouring concrete around them. When the concrete has set, the tension is released, compressing the concrete. The rods of cables must have some kind of pattern on their surface for the concrete to grip. Post-tensioning a beam employs pouring cement around tubes containing slack rods or cables. After the concrete has set, the rods or cables are tensioned by taking up the jacks at the ends.

concrete would seem to offer many possibilities for large-scale architectural and landscape-oriented sculptures.

FINISHES

The surface of untreated concrete is dry, hard, dull and cold. For works of an austere nature these qualities may be just right. Anything done to modify the surface will inevitably obscure the record of how the sculpture was made, as expressed by chisel marks, troweling, or casting lines. Since concrete is by nature a straightforward, common, and unpretentious material, often the best way to finish it is to leave it as is.

Many methods exist, however, for finishing concrete. One of the simplest is to impregnate the surface with a penetrating oil stain that will alter the color without changing the texture. When the concrete has already been dyed by pigments in the mix, a stain can intensify this color. Stains also help to make the surface impervious to water and to bind together small particles that—particularly with rough concrete—tend to keep dusting off.

Other helpful surface binders include the various armoring or hardening preparations. Any work that will be out-of-doors in a freezing climate should be treated with a hardener so that water will not soak in and then freeze, chipping flakes off the surface. These preparations—most of them based on sodium

silicate or magnesium fluosilicate—are also available in formulations that can be added directly to the concrete during the mixing process.

After setting, concrete can be painted with most conventional finishing materials—enamels, epoxies, and acrylics, for example. Artist's oil paints work well, because they impart a richness and gloss to the surface. The sculptor must take care, however, that the concrete is absolutely dry, for otherwise it will *effloresce*, or produce a white, limy surface residue that can interfere with the coating.

Smoothing and polishing will transform the normally coarse concrete texture into something glossy and sensuous. The aggregate must be fairly fine—or if large, grindable—to make this possible. Most sculptors use an emery block or a carborundum wheel with water for such polishing. If the concrete is flushed with water as the grinding proceeds, the result will be an open, slightly porous surface that exposes the interior aggregate. The sculptor can, however, also smooth the paste produced by grinding into the surface and augment it with fresh cement, thereby filling in pores and pits to achieve a smooth satin texture. The amount of aggregate that remains visible will depend upon how far this process is carried. After the "closed" coat has set, it can be further smoothed with emery cloth, then waxed to a high luster.

Concrete offers the sculptor a wide range of effects, combined with exceptional durability and

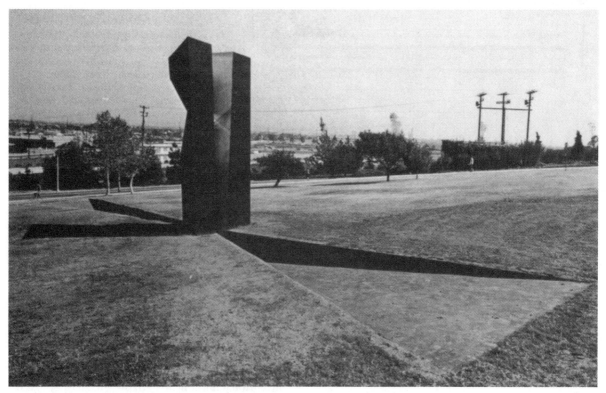

Plate 5.13. Kosso Eloul, *Hardfact*, concrete and stainless steel, 21′ × 135′ with concrete-lined trench at base, 1965. Made during the Sculpture Symposium at Long Beach State College in the summer of 1965 and installed on campus. Courtesy of California State University, Long Beach. The upright form was cast in one continuous pour with black iron-oxide pigment mixed in the concrete. The metal section lining the slot is ⅛″ stainless steel sheet.

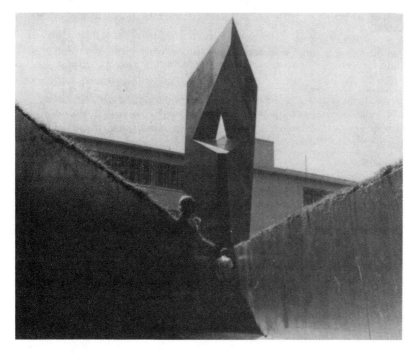

Plate 5.14. Kosso Eloul, *Hardfact* (detail). This view shows the front of the sculpture from the trench. The poured concrete walls of the trench are painted with red epoxy.

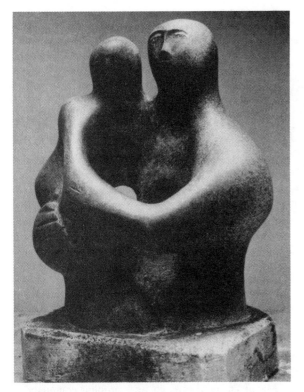

Plate 5.15. Henry Moore, *Mother and Child*, concrete, 7″ high, 1930. Collection of Ian Phillips (photo courtesy of the artist). Concrete was built up and then carved away to make this small sculpture. The outer surfaces were smoothed, but the marks of the scraping tool are visible on the hollowed parts.

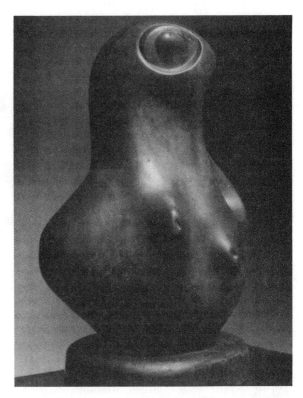

Plate 5.16. Henry Moore, *Composition*, carved concrete, 24″ high, 1933. Collection of British Council (photo courtesy of the artist). After carving, the concrete was ground down to a smooth finish. A network of fine cracks runs across the surface.

strength. Its surface can vary from rugged coarseness to high polish. In terms of mass and ability to cover space, concrete ranges from stony solidity to the webbed airiness of thin shells.

BIBLIOGRAPHY

A. Books

Mills, John W. *Sculpture in Concrete*. New York: Praeger, 1968.

Moore, Clairl E. *Concrete Form Construction*. New York: Van Nostrand Reinhold, 1977.

Parker, Charles, and Merrick Gay. *Materials and Methods of Architectural Construction*. 3d ed. New York: John Wiley & Sons, 1958.

Tucker, Walker, and Swenson. *The Physical Properties of Cast Stone*. R.P. 389, Supt. of Documents, Government Printing Office, Washington, D.C., 1932.

Witt, J. C. *Portland Cement Technology*. New York: Tudor, 1947.

B. Articles in Periodicals

Lin, T. Y. "Prestressed Concrete," *Scientific American* 199, 1 (July 1958), 25.

Slayter, Games. "Two-Phase Materials," *Scientific American* 206, 1 (January 1962), 124.

Spring, Bernard, and Donald Canty. "Concrete. The Material That Can Do Almost Anything," *Architectural Forum* 117, 3 (September 1962), 78.

SOURCES OF SUPPLY

A. Cements

American Cement Co., 2404 Wilshire Blvd., Los Angeles, CA 90057. Information on cement.

Atlantic Cement Company, Inc., 25 Crescent St., Glenbrook, CT 06906. Information on cement.

California Portland Cement Co., 612 S. Flower St., Los Angeles, CA 90017. Information on cement.

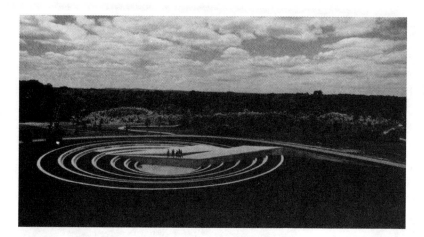

Plate 5.17. Beverly Pepper, *Amphi-sculpture*, concrete, 200′ diameter, 70′ extension, 14′ deep, 8′ above ground, 1974–1977. Courtesy of André Emmerich Gallery, New York (photo credit Gianfranco Gorgoni). This work was cast in place with removable concrete forms. It is a place as well as a monument, a setting for human interaction.

The Joseph Dixon Crucible Co., Jersey City, NJ 07300. Refractory cements.

Harbison-Walker Refractories Co., Pittsburgh, PA 15222; 6444 Fleet St., Los Angeles, CA 90022. Refractory cements.

Local building materials company. The place to make all routine purchases of cement, sand, aggregate, coloring materials, and concrete finishing tools.

Medusa Portland Cement Co., 104 East 40th St., New York, NY 10016. Information on cement.

H. K. Porter Refractories, 300 Park Ave., New York, NY 10022. Refractory cements.

Red-E-Crete Pre-Mixed Products. Premixed dry concrete and mortar, available at local building and hardware stores.

Sakrete Dry-Mixed Products. Premixed dry concrete and mortar, available at local building and hardware stores.

B. Aggregates

The Carborundum Co., 26 Kennedy Blvd., East Brunswick, NJ 08816. Information on silicon carbide abrasives as aggregates.

Ceramic grog: see listings under chapter two.

Crystal Silica Co., Oceanside, CA 92054. Subsidiary of Ottawa Silica Co., Ottawa, IL 61350. White silica sands, graded for mesh size.

S. L. Fusco, 3110 Harcourt St., Compton, CA 90224. Abrasives in powder form.

Local building materials company. For all routine purchases of cement, sand, aggregates, coloring materials, and concrete finishing tools.

Owens-Corning Fiberglas Corp., Fiberglas Tower, Toledo, OH 43659. Fiberglas cloth and fibers. BlocBond glass-reinforced concrete.

Redco, Inc., 11831 Vose St., Los Angeles, CA 91605. Permalite lightweight pumice aggregate.

Speed-D-Burr Div. of Industrial Compounds Co., 2609 Maceo St., Los Angeles, CA 90065. Abrasives.

Zonolite, Div. of W. R. Grace & Co., Newark, NJ; 7237 E. Gage St., Los Angeles, CA 90039. Vermiculite (expanded mica) lightweight aggregate.

C. Additives

Anti-Hydro Waterproofing Co., 271 Badger Ave., Newark, NJ 07100. Manufacturer of concrete waterproofing compounds.

Evercrete Corp., 315 W. 39th St., New York, NY 10018. Manufacturer of concrete waterproofing compounds.

Hunt Process Co., Inc., 12767 E. Imperial Highway, Santa Fe Springs, CA 90670. Curing and waterproofing compounds, form release agents, air-entraining agents.

Howard G. Ridley, 6621 Clara Street, Bell Gardens, CA 90201. Flor-Kur curing and waterproofing compounds, coloring agents.

D. Concrete Mixing and Finishing Tools

Concrete may be carved with stone and wood tools, which are listed with chapters eleven and twelve. Trowels, hoes, wheelbarrows, and other mixing and forming tools will be found in local building materials and hardware stores. The following sources are for electric and gasoline-powered concrete mixers.

Challenge Cook Brothers, Inc., 15421 E. Gale St., City of Industry, CA 91745. Concrete mixers sales and services.

Construction Machinery Co., 26 Broadway, New York, NY 10004. Concrete mixers sales and service.

Essick Manufacturing Co., 1950 Santa Fe Ave., Los Angeles, CA 90221; 850 Woodruff Lane, Elizabeth, NJ 07201; 390 E. Irving Park Road, Wood Dale, IL 60191. Manufacturers of concrete and mortar mixing and spraying equipment.

Rex Chainbelt, Inc., 7601 Telegraph Road, Los Angeles, CA 90022. Manufacturer of Rex concrete mixers.

Sears Roebuck & Co. stores in principal cities. Sales of economical portable cement mixers.

6

Stone Carving

The basic structure of our planet is formed of stone. Earth is, in fact, a sphere of molten rock covered with a thin skin, or mantle, of solidified rock, two-thirds of which supports a layer of water—the oceans. Over geologic time, this mantle of rocks is constantly folding, breaking apart, thrusting itself up into peaks, and plunging down again into the molten heart of the earth. We are made aware of this process occasionally when a volcano erupts, when a new island appears, or when we are shaken by an earthquake.

Less spectacular than these dramatic events but equally important in changing the face of the earth is the slow but relentless wearing away of the mountain ranges by wind, rain, and ice action. As old ranges become worn down by erosion, they produce the sand and clay that eventually become soil, enabling plants to take root and grow. These plants in turn help produce the oxygen-rich atmosphere necessary for higher forms of life on our own planet. Some artists, such as Henry Moore, see the earth's ridges of stone as providing a bonelike structure for the landscape as they press up through the fields and slopes that are the earth's living flesh.

Every piece of stone is a document of its long history as part of the earth's mantle. Its character, soft and crystalline like marble, gritty and coarse like sandstone, or dense and hard like granite, will suggest the use to which it may be put in making sculpture. Whether polished or left rough, the inner structure of the stone is evident in the final work. Stone and concrete, though superficially resembling each other, are very different materials. Concrete has character as mass; every stone has a personality.

ORIGINS, TYPES, SOURCES

Stone may be classified in three general categories, depending upon its origin: igneous, metamorphic, or sedimentary.

Igneous Stone

This is the most basic form of stone, produced by the cooling of molten rock from beneath the earth's mantle as it is pushed up into the cooler layers near the surface. Igneous rock tends to be dense, tough, and heavy. It is one of the most durable materials on earth. The Egyptians and the Mayans, who had eternity in mind, have left some of our best examples of granite and basalt carving. Obsidian is a black

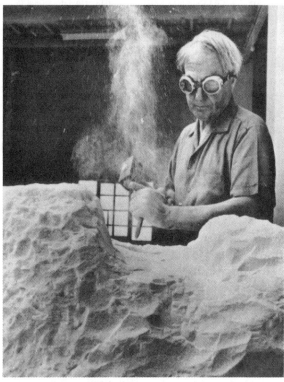

Plate 6.1. Henry Moore carving stone. Courtesy of the artist. In stone carving, the artist experiences direct contact with the work.

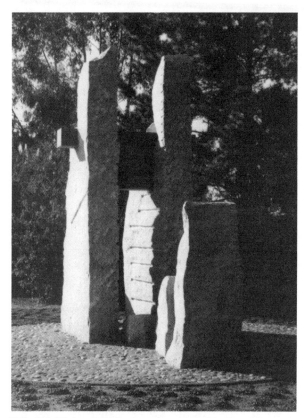

Plate 6.3. Richard O'Hanlon, *Sunstones*, black granite and white granite, 12' high, 1974. Courtesy of the artist (photo credit Pirkle Jones). The drill holes and split face made in quarrying those blocks are retained as elements of the finished sculpture. It is designed to indicate the solstices and equinoxes during the year.

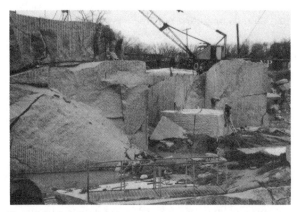

Plate 6.2. Quarrying granite in Minnesota. Courtesy of Cold Spring Granite Company, Cold Spring, Minnesota (photo by the author). Granite of sculptural and architectural quality is found in several locations in the United States.

Plate 6.4. Granite outcropping near Cold Spring, Minnesota. This uncut stone is about twenty feet high by a hundred feet long. It obviously extends far down into the earth.

glassy igneous stone of volcanic origin, much used by early man for weapons and tools.

Pumice rock is also of volcanic origin. This solidified volcanic froth is very light and easy to carve. Since it is porous throughout it is impossible to give it a smooth surface or to shape fine details. It is sold under the name Featherock and is employed extensively for pools, waterfalls, and patios. It is economical to purchase and it is often used in beginning carving classes.

Sedimentary Stone

As mountain peaks are worn down by erosion, sands, clays, and rock fragments are washed down the mountain slopes. Some of this material is carried down rivers and eventually reaches the sea. Much remains in the valleys, building up in layers. The top part of these beds mixes with decayed vegetable matter and becomes soil. The bottom part is compacted more and more densely and eventually,

Plate 6.5. Sandstone in riverbed (photo by the author). Sandstone forms the riverbed in Malibu Canyon, California. The water has cut deeply into the stone and has carried large boulders downstream.

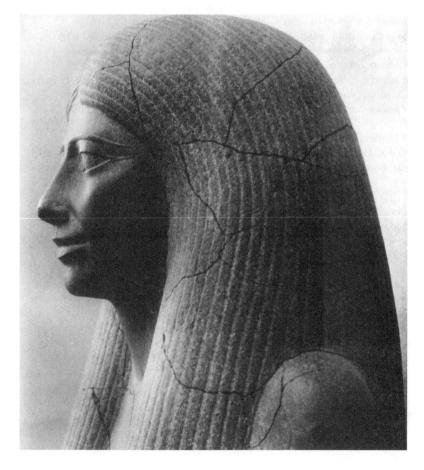

Plate 6.6. *Lady Sennuwy*, granite, detail from figure, 67½″ high, from Kerma in the Sudan, dynasty XII, c. 1950 B.C. Courtesy of the Museum of Fine Arts, Boston, Harvard-Boston Expedition Fund. Egyptian carvers understood how to work with the hardness and weight of granite.

TABLE 6.1 Common Types of Stone

I. Igneous Stones
1. *Granite*. Crystalline, hard, dense, formed of quartz, feldspar, and mica. Use tungsten carbide chisel points and diamond wheels. Wide range of colors, many whites, blacks, reds. Worldwide distribution, particularly: Africa red, Brazil blue and black, California (Raymond) black and white, Canada red and gray, Minnesota (Cold Spring) black and white, Egypt (Aswan) red, India (south) beige and gray, Labrador green and blue, Sweden red and dark green, Tennessee black, Texas red and beige, Vermont white.
2. *Basalt*. Smooth textured, dark gray or black, weathers brown. Hard, work with granite tools. Origin from lava flows, found in India, Iceland, Alaska, Hawaii, Oregon.
3. *Diorite*. Similar to granite, but no silica, sometimes called "black granite."
4. *Obsidian*. Glassy and hard. Flakes under pressure. Black or brown, found in volcanic areas.
5. *Pumice rock*. Light, soft, porous, volcanic origin. Can be worked with wood tools. Abrasion produces sharp, glassy particles; protect skin. Variegated shades of gray.

II. Sedimentary Stones
1. *Limestone*. Formed by deposition of skeletal remains, mostly marine, and/or precipitation of calcium carbonates from water. Pure limestone is white but most is colored from impurities such as iron oxide (yellow and red), carbon (gray), sulphides, pyrites (blue), or chlorites (green). Wide range of hardness from soft to tough, can be cut with steel tools. Usually not hard enough to polish. Large deposits in France, Italy, England, and Egypt. The pyramids were built of yellow limestone. In the United States a fine dense variety is found in Indiana.
2. *Sandstone*. Composed of fine grains of sand (quartz or silica) cemented into a solid mass. Sandstone cemented with quartz is tough and durable, but other varieties are soft and wear easily. Sandstone is porous, therefore does not weather well in cold, wet climates. Can be worked easily but wears down tools because of hard grains.
Red sandstone is quarried in Central India, buff sandstones in France, England, Canada. In the United States, "brownstone" came from Connecticut, a fine-grained sandstone is found in Rowan County, Kentucky, and other varieties come from Pennsylvania, Wisconsin, and California.
Stratified sandstone is called "flagstone."
3. *Slate*. Highly stratified and dense form of shale, a geologically compacted mixture of clay, sand, and organic materials. Because of its brittleness it is best worked with files, rasps, and abrasive tools.

III. Metamorphic Stones
1. *Marble*. A crystallized form of limestone, takes high polish, fine-grained varieties excellent for details. Can be cut with light steel tools with fine edges. Worldwide distribution. U.S. types include Alabama cream, Georgia white with gray veins, Tennessee pink, Vermont green and white. Colorado Yule is a fine white marble that is no longer quarried commercially.
2. *Onyx*. Translucent marble with bands of yellow, brown, or red.
3. *Soapstone*. Talc, or steatite, is a soft black or green stone with a slick feel. Can be cut with a knife or wood tools. It is composed of magnesium silicate, as is serpentine.
4. *Serpentine*. Noncrystallized, soft, easily polished, has a slick feel like soapstone. Softer varieties can be cut with a knife. Use marble tools on harder varieties. Flaws limit sculpture applications. Popularly called "green marble," "Verde di Prato" in Italy, "Epinal" in France. Green through blue.
5. *Alabaster*. A sulphate of lime, very soft, can be carved with wood tools or marble tools, takes a high polish. One of the attractions of alabaster is its translucence, but it is not durable out-of-doors. Commercially available in yellows, pinks, and white.

through the crystallization of silicates and other minerals present in underground water, these deposits harden and form what we call sedimentary stone.

These stones are generally not as hard as igneous or metamorphic stones, though some limestones are harder than marble and can be polished. Most sedimentary stones, however, are gritty and chip fairly easily. They are good for architectural works where the treatment is broad and fine detail is not a requirement.

The famous *pietra serena* used for many buildings and sculptures during the Italian Renaissance is a gray-blue limestone. Some limestones formed by deposits that were at one time covered by the sea contain the shells and skeletons of ancient sea animals.

Sandstone, like limestone, has a soft and warm quality which makes it appealing as a building stone. The denser varieties can be carved cleanly without crumbling, are relatively inexpensive, and are available almost everywhere.

Metamorphic Stone

Stone that has been originally produced by the cooling of molten material from within the earth may be subjected to further processes of transformation while it is still within the earth's crust. Extreme pressures and temperatures generated there produce some of the most useful stones for carving, as they are not quite as tough as igneous stones but still strong enough to support the carving of fine details.

Metamorphic stone may also be produced by the transformation of sedimentary stone. Marble, which is crystallized limestone, is the best example of this process.

Marble is one of the most popular stones for carving. It exists in a great variety of colors and textures. From the sixth century on, the Greeks quarried marble for sculpture and building from a number of different sites. Two of the marbles most in use were a gray marble from the island of Naxos and white Parian marble from the island of Paros. The Parthenon is constructed of honey-colored Pentelic marble from Mount Pentelikon near Athens. Michelangelo personally directed the quarrying of the marble for most of his sculptures from the peaks near Carrara and Pietrasanta in northern Italy. These quarries are still in use today. Excellent marble is quarried in the United States in Alabama, Georgia,

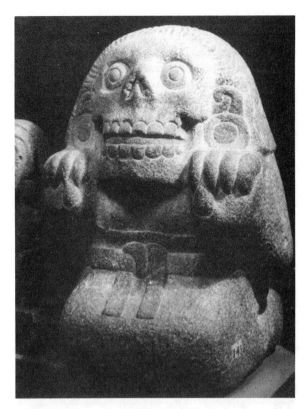

Plate 6.7. *The Goddess Mictlancihuatl*, basalt, 28″ × 18½″ × 17¾″, Nahua Culture, 15th century. Courtesy of National Institute of Anthropology and History, Mexico City. The simple forms and low relief of this carving emphasize the solidity of the stone.

Plate 6.8. Masayuki Nagare, *Moon Tray*, black Swedish granite, 35″ × 17″ × 14″, 1964. Collection of Mr. and Mrs. David Steine, Nashville, Tennessee (photo credit Staempfli Gallery, New York). Ancient and modern approaches to stone carving meet in this two-part granite sculpture by one of Japan's leading contemporary sculptors.

Tennessee, and Vermont. The lighter-colored marbles have a high degree of luminosity, or ability to reflect light, especially when polished.

Other metamorphic stones are soapstone or *steatite* and alabaster. Usually available from supply houses in large cities, these stones are recommended for beginners. They are easy to carve and finish and are soft and lustrous in appearance.

TOOLS FOR STONE CARVING

Hand Tools

The hammers and chisels used to carve stone have changed little from those that have been used for centuries, except that we have steels that are tougher than those available in the past. The hammer should be of soft iron rather than steel, because iron is more resilient and therefore less tiring to work with. Chis-els can be retempered by a blacksmith when they have been worn and resharpened beyond the tempered part of the point and into the shank of the tool, which is left untempered so it will not be brittle. You can retemper your own tools with a welding torch if a blacksmith is not available.

One modern innovation in stone-carving tools is the use of tungsten carbide chisel tips welded or inserted in the standard tool-steel shank. Tungsten carbide stays sharp five to ten times as long as tempered tool steel.

The two main types of carving tools are those that are held at right angles to the surface to pulverize or abrade the stone, and those that are held at an angle to cut or chisel away small pieces.

A *boucharde* or *bushhammer* is really two tools in one—a combination hammer and cutting tool. It is shaped like a sledgehammer, with a number of points

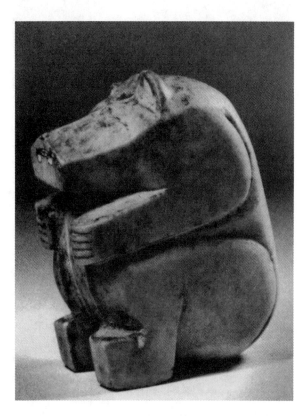

Plate 6.9. *Bear*, white marble, 4½″ high, Shang Dynasty, 1523–1038 B.C. Collection of Dr. Paul Singer (photo credit O. E. Nelson). Merely a handful in size, this ancient carving has a feeling of monumentality and power.

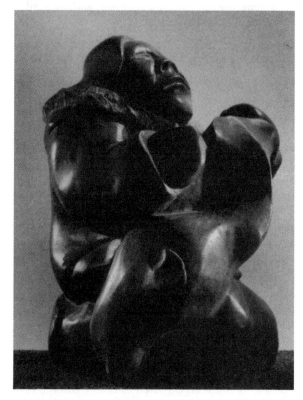

Plate 6.10. Ningeoseak, *Woman with Fish*, soapstone Cape Dorset, 14″ high. Courtesy of Waddington Galleries, Montreal, Canada. Though it is easy to carve details in soapstone, this artist has kept the forms restrained and uncluttered.

projecting from the striking end. The weight of the hammer provides force, while the pointed surface removes the stone. Just how much stone will be cut away depends upon the number and sharpness of the pyramidal points of the hammer. By going from a relatively gross boucharde to a relatively fine one, the sculptor can nearly complete a work, switching to other tools only for fine detail. The action of the boucharde pulverizes the top layer of stone, and the dust created should be brushed off between strikes. Essentially, this tool abrades, compacts, and bruises the stone, rather than slicing or breaking it. A boucharde can also be used to create a roughened surface and give a chisel more "purchase" or grip on the stone.

A *point* can also accomplish the roughing-out process, but with a different effect. Instead of many impact points (as on the boucharde), there is only

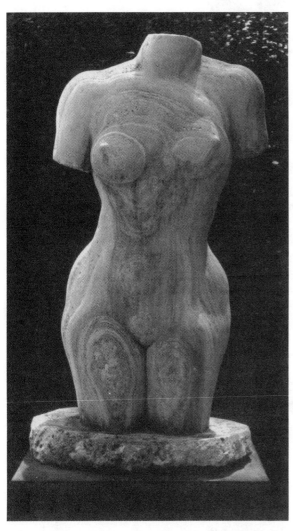

Plate 6.11. Bernard Reder, *Torso*, French limestone, 45″ × 23¾″ × 17″, 1938. Collection of the Museum of Modern Art, New York, gift of J. van Straaten. The organic patterns in the limestone follow the generous contours of this torso.

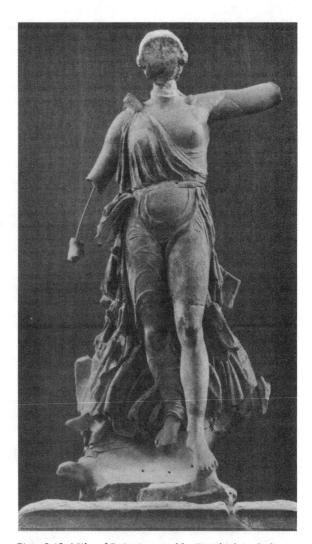

Plate 6.12. *Nike of Paionios*, marble, 7′1″ high including the base (estimated to be originally 9′6″ to tips of lost wings; 421 B.C., found at Olympia in 1875). Now in collection of the Munich Olympia Museum, Greece (photo credit Hirmer Fotoarchiv., BRD). The excellence of marble for the carving of flowing drapery was developed to an unparalleled degree by Greek artists of the 5th century.

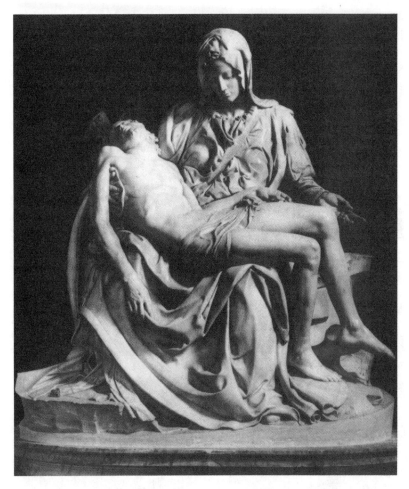

Plate 6.13. Michelangelo, *Pietà*, marble, 69″ high, 1498–1499. St. Peter's, Rome (photo credit Art Reference Bureau, Inc., New York). Michelangelo was 24 when he finished this sculpture. It exhibits the high degree of complexity and finish characterizing his youthful work.

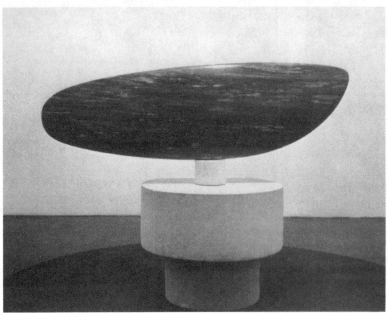

Plate 6.14. Constantin Brancusi, *Fish*, gray marble, 21″ × 71″, 1930. Three-part pedestal of a marble cylinder and two limestone cylinders totaling 29½″ high (second and largest stage of *Fish*, 1922). Collection of the Museum of Modern Art, New York, acquired through the Lillie P. Bliss bequest. Simplicity is the result of refinement.

Plate 6.15. Eduardo Chillida, *Homage a Kandinsky*, alabaster, 10″ × 14″ × 14″, 1965. Courtesy of Galerie Maeght, Paris (photo credit Claude Gaspari). The luminous surface of the alabaster is enhanced by the clearly defined forms and precision of workmanship.

Plate 6.16*a*. Stone hammers. The first two are iron, the next two steel, the fifth bronze. The two on the right end are a boucharde and a pick, for striking the stone directly.

6.16*b*. Stone chisels. Toothed chisels, straight chisels, and points.

Stone Carving / 97

one. Points generally are used on denser stones such as granite and hard marble, with a relatively blunt point serving for the first, a sharper one for the second. These tools remove large amounts of stone by making deep grooves, which causes large pieces of stone to fall away. The size of the groove, of course, relates to the size of the point. Some types of sculptures can be brought to their ultimate forms with points only, but more often the carver switches to chisels or abrasives for finishing.

The point can be driven directly against the stone to break up the surface, or it can be directed at an angle so that it will cut more like a chisel. Chisels themselves are always used at an angle and cut a path across the stone, leaving the marks of their edge-shape.

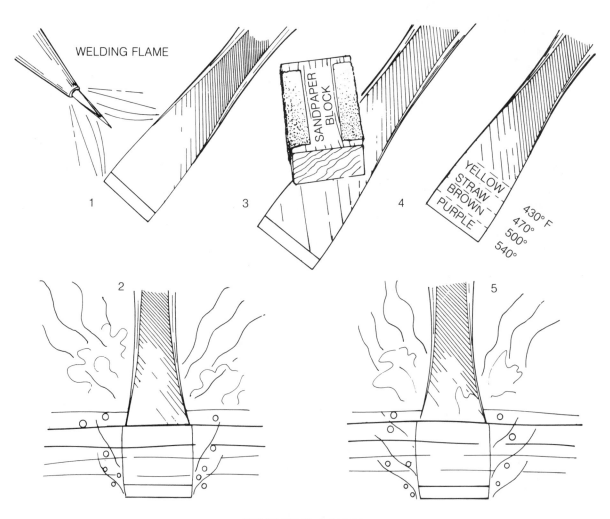

TEMPERING A CHISEL

Figure 6.1. Tempering a chisel. (1) Heat about 2″ of the end of the chisel to a red-hot temperature with a welding flame or in a forge. (2) Plunge about 1½″ of the end of the chisel into cool water only long enough for the submerged portion to turn dark. This portion has now been *hardened*. It is very hard, but brittle. (3) Remove the chisel from the water and quickly sand the end until it is bright. (4) Watch the colors form on the end of the chisel as the heat remaining in the shank flows down and removes some of the hardness, or *tempers* the end of the chisel. (5) When the edge turns purple, after being blue, it has the right *temper* or combination of hardness and toughness. The chisel is then plunged back into the water, or quenched, until it is cool.

Toothed chisels do their work by means of several pointed projections along the cutting edge; therefore, the action is more that of a number of points breaking up the stone progressively along a plane, rather than the slicing action characteristic of a wood chisel. A series of toothed chisels can serve for the entire roughing-out process on softer stones, such as limestone and some marbles. The carver moves progressively from the clawed chisel with a few large, sharp teeth to a blunter, many-toothed instrument.

Flat chisels have no teeth but simply a straight cutting edge. They come in several widths and act as finishers to create a smooth surface following the use of points, bouchardes, or clawed chisels. Many sculptors find the surface left by a flat chisel to be satisfactory, but a more refined finish can be achieved with abrasives.

The basic stone-carving equipment is completed by a pair of gloves of cotton or soft leather (light enough so you can feel what you are doing) and a pair of goggles or a face shield. A small brush is handy for brushing away chips.

Power Tools

Power tools for stone carving do not provide the sense of touch that hand tools do, but they are useful for removing large amounts of material. With practice one can attain a high degree of sensitivity in the use of power tools.

Electric hammers and grinders can be used to work stone, but pneumatic (air-driven) tools are more satisfactory. They will stand up to the rough usage of stone working and do not heat up when used for several hours at a stretch. There is bound to be lots of stone dust produced when using power tools and this is very damaging to electric motors.

Of recent development is equipment for the flame cutting and shaping of stone. While it is expensive, at least for an individual sculptor, this equipment may offer some exciting possibilities for speeding up large-scale stone cutting projects.

SAFETY

Stone dust is damaging to human lungs and eyes. Continued breathing of silica-bearing dusts will result in *silicosis*, a progressive disease accompanied by the buildup of scar tissue in the lungs. Goggles and respirators should *always* be worn when working

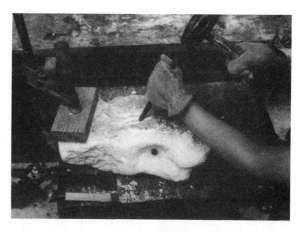

Plate 6.17*a*. Ways to hold chisels. The point cuts grooves and is held at an angle of from 60 to 80 degrees.

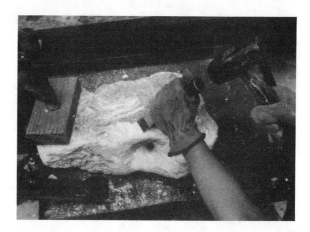

Plate 6.17*b*. Ways to hold chisels. The straight chisel cuts a flat plane. It is held at about 45° to the surface of the stone.

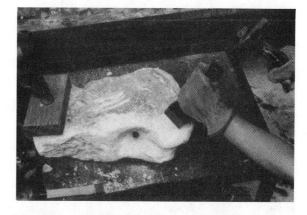

6.17*c*. Ways to hold chisels. The toothed chisel cuts rapidly, but roughly. It is held at an angle of about 45 degrees.

stone with power tools. The work area should be well ventilated and separated from equipment or materials that could be damaged by the infiltration of stone dust. The use of wet grinding and polishing techniques will cut down the dust problem considerably.

CARVING TECHNIQUES

No complete set of instructions will tell the beginner how to become an accomplished stone carver; however, these are a few basic principles to be observed.

The most strenuous part of stone carving may be getting the block of stone into a position that will enable you to work on it. This usually means a platform or table of some kind, which brings the sculpture to a comfortable working level. Overhead rails and hoists can be a great help with larger stones. Lacking such an arrangement, you can gradually raise the stone by building up wood blocks on alternate sides until the desired height has been reached.

The stone must be securely fastened to the working surface. Small stones can be clamped to a sturdy work bench; alternatively, you can let them rest on a

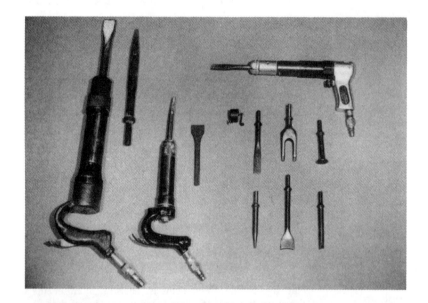

Plate 6.18. Pneumatic tools. Air-driven tools are powerful and not so easily damaged by stone dust as electric tools. The bits may be reshaped with a welding torch to make them more suitable for stone carving.

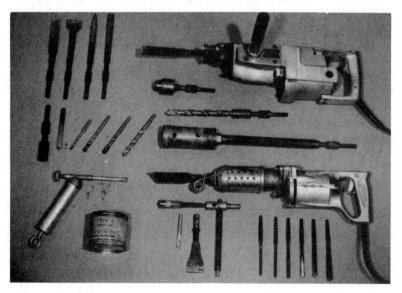

Plate 6.19. Electric hammers. These tools drive a variety of bits for stone and concrete work. A switch converts the Roto-Hammer (top) to rotary action for turning drills.

sandbag or place them in a barrel of sand. Larger pieces may require that beams and blocks of wood be nailed or bolted around them to hold them in place.

Before beginning the actual carving, you should try to visualize as clearly as possible the form you plan to carve. A few reference marks will help, but it is impossible to draw the finished shape on the outside of the stone. You must rely on your ability to project your visualization of the form into the stone as you work.

The first carving stage involves reducing the stone to approximately the correct size, unless the size and shape of the stone will determine the contours of the sculpture. You can split large blocks of stone by driving wedges into notches that have been cut into the stone. You can also cut stone with a stone saw or a wire that has been coated with tungsten carbide or diamond abrasive powder.

Grasp the chisel and hammer firmly but without tension, allowing the weight of the hammer to do the work, rather than your muscles. Since stone carving is a long process, you should cultivate a state of relaxed awareness. Patience will allow the action

of stone carving itself to teach you what you need to know.

Broad, blunt tools are driven against the surface of the stone to wear it down by abrasion. The sharper and thinner the tool, the more cutting action it will have, and the more it can be directed at an angle to the surface.

Whenever possible, you should direct the chisel toward the central mass of the stone to prevent breaking off extremities. As the sculpture becomes more developed, this type of action assumes greater importance, especially if thin sections are to be carved.

In direct carving the stone generally is worked from all sides toward the form that has been visualized within. But some carvers prefer to work the stone from virtually one plane—the "figure-in-the-bathtub" method. Many sculptors find it easier to visualize the figure emerging, bit by bit, from the water (represented by the block of stone), as the level of water is lowered.

A model or maquette enables you to make choices and mistakes before confronting the stone. But when models or maquettes are used as guides in

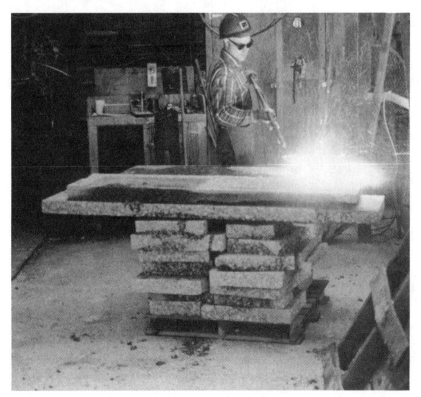

Plate 6.20. Flame-finishing granite. Courtesy of Cold Spring Granite Company, Cold Spring, Minnesota. Extensive areas of stone can be shaped rapidly with the stone-cutting torch.

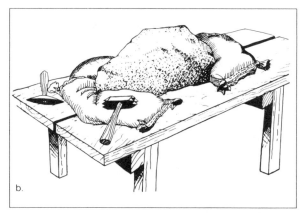

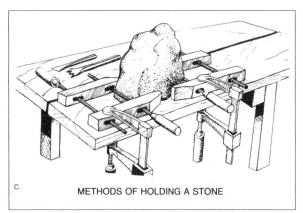

METHODS OF HOLDING A STONE

Figure 6.2. Methods of holding a stone. *a.* Small pieces of stone that are not too irregular in shape can be clamped to a sturdy bench with standard woodworking clamps. *b.* Stones of an irregular shape can be held in place by sandbags made of burlap or heavy cotton duck. The sandbags can be formed to fit the stone. *c.* Larger stones can be held by nailing or bolting 2″ × 4″ and 4″ × 4″ blocks around them. The blocks have to be repositioned when turning the stone. Double-leaded nails make removal easier.

Plate 6.21. John Jebb, *Soft Touch*, white marble, 24″ × 12″ × 12″, 1978 (detail). The paths cut in the stone by the tooth chisel and the point can be seen in this photograph.

stone carving, they will provide a truer representation of the problems to be dealt with if they themselves have been carved rather than modeled. Ordinary casting plaster makes a good carving material, as does damp but stiff (leather-hard) clay. Styrofoam can be carved rapidly and is light enough so that even large models can be moved without difficulty around the studio.

A somewhat different approach is followed by professional stonemasons who must reproduce in stone a sculpture that has already been given its final form in some other medium, such as clay or plaster. A pointing machine, which transfers measurements from the model to the block of stone, serves as a guide for enlarging or reducing the scale as necessary.

Holes are then drilled in the stone to correspond with the measurements, and the excess stone is chipped away to the depth of the holes. Sculptures produced entirely by this method tend to look mechanical and stiff. Nevertheless, pointing can be a valuable technique for roughing out large stone blocks, especially if the sculptor employs assistants.

FINISHING

Many works in stone are finished when the sculptor puts down his chisel and hammer and somehow decides that he has done enough. Some pieces require further refining with rasps and small curved files called *rifflers* (see pl. 7.17). Some stones are polished with varying degrees of sandpaper, wet or dry, wet especially for the finer grades from 220 on. Finally, the surface is buffed with a cloth buffing wheel and abrasive. Tin oxide, stannic oxide, and aluminum oxide are some of the fine abrasives for stone polishing. The more finely-textured stones such as granite and marble will take a high polish,

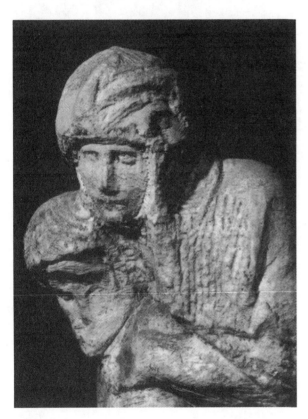

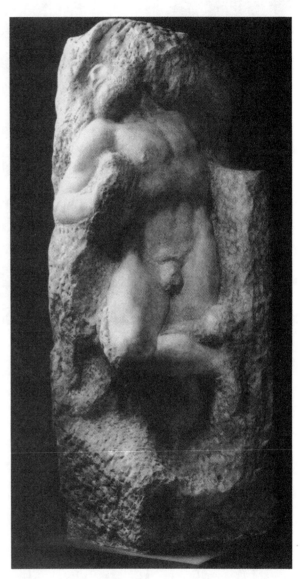

Plate 6.22. Michelangelo, *Rondanini Pietà*, marble, 6′3″ high, 1564 (detail). Castello Sforzesco, Milan (photo credit Anderson-Art Reference Bureau, Inc., New York). In the upper head one sees how drastically Michelangelo was able to change direction in the midst of his work.

Plate 6.23. Michelangelo, *Fourth Captive from the Boboli Gardens: The Awakening Giant*, marble, 9′ high, c. 1527–1528. Academia di Belle Arti, Florence (photo credit Alinari-Art Reference Bureau). Michelangelo began to work on this block of marble from the front and sides, though it is believed he intended it to become a figure in the round. He carved directly into the stone with a point and tooth or "claw" chisel, not using drill holes as guides.

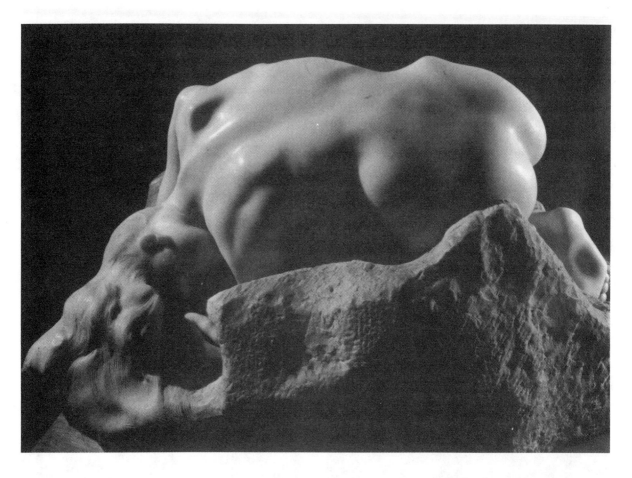

Plate 6.24. Auguste Rodin, *The Danaide*, white marble, 13¾″ × 28½″ × 22½″, 1885. Collection of Musée Rodin, Meudon, France (photo credit Photographie Bulloz). The concept of a nude figure emerging from the unfinished stone, invented by Michelangelo, becomes a device in the hands of the stone carvers employed by Rodin to translate his works into marble.

PROPORTIONAL DIVIDERS AND CALIPERS

Figure 6.3. Proportional dividers. To enlarge or reduce a sculpture, measurements may be taken from the original work and transferred to the new one. Dividers are also useful in taking measurements when transposing a sculpture from one medium to another, as from clay to stone.

whereas a coarse stone such as sandstone cannot be polished at all.

The coarser stones have a more open texture than the denser ones. If they are to be placed out-of-doors in a climate where there are freezing temperatures in winter, they can absorb moisture and then fracture and *spall* (flake off) when the absorbed water expands upon freezing. This can be avoided to a certain extent by impregnating the stone with masonry sealer before placing it outdoors.

Unfortunately, the hydrochloric acid and sulfuric acid present in the air of modern cities is very damaging to stone. Limestone sculptures in London, Paris, and Rome are beginning to show signs of deterioration although heretofore they have remained almost unchanged for centuries.

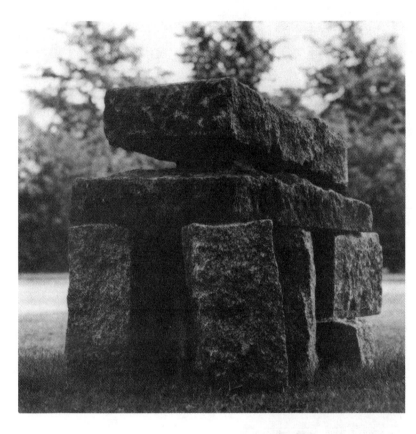

Plate 6.25. Shamai Haber, *De Grote Poort*, granite, 34″ × 54″ × 35″, date unknown. Collection courtesy of Stedelijk Museum, Amsterdam, Holland. A rough-hewn work reminiscent of Bronze Age monuments such as Stonehenge.

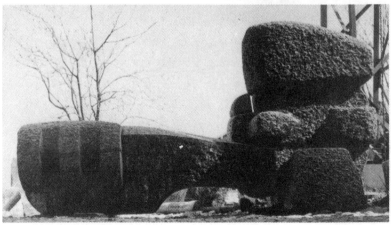

Plate 6.26. Andrea Cascella, *Jupiter*, granite, 114″ × 55″ × 43″, 1964. Collection of Joseph Pulitzer, Jr., St. Louis (photo credit Antonia Mulas). The separate members of this sculpture fit snugly together with matched joints.

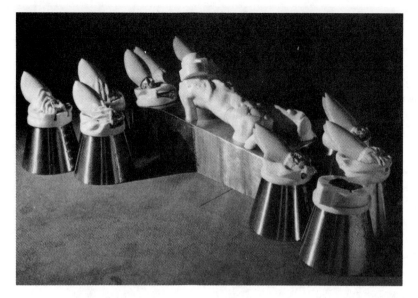

Plate 6.27. Jean-Robert Ipousteguy, *La Mort du Père*, marble, 20′ × 10′4″, 1968. Collection of National Gallery of Victoria, Melbourne, Australia, courtesy of Galerie Claude Bernard. The pristine quality of highly-polished marble is played against the shine of metal in this contemporary work.

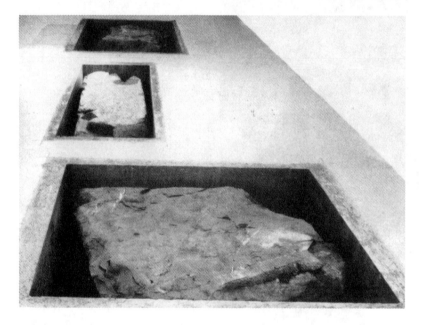

Plate 6.28. Michael Heizer, *Displaced/Replaced Mass*, granite and concrete, 29′ × 49′ (pits are 4′ deep), 1977. Courtesy of Ace Gallery, Venice, California. The unhewn strength of these blocks of granite is emphasized by their placement and the space around them.

Stone has been used for sculpture for thousands of years. Although it may seem today to be eclipsed by the dazzling array of modern materials, it still holds a fascination for some of the most creative contemporary sculptors.

BIBLIOGRAPHY

Adam, Sheila. *The Technique of Greek Sculpture in the Archaic and Classical Periods.* London: Thames & Hudson, 1966.

Batten, Mark. *Stone Sculpture by Direct Carving.* London: Studio Publications, 1957.

Casson, Stanley. *The Technique of Early Greek Sculpture.* Oxford: Clarendon Press, 1933.

Eliscu, Frank. *Slate and Soft Stone Sculpture.* Philadelphia: Chilton, 1972.

Gill, Eric. *An Essay on Stone Cutting.* Ditchling, Sussex: St. Dominic's Press, 1925.

Grant, Colonel Maurice. *The Marbles and Granites of the World.* London: J. B. Shears & Sons, 1955.

Hoffman, Malvina. *Sculpture Inside and Out.* New York: Bonanza, 1939.

Lent, Frank A. *Trade Names and Descriptions of Stones.* New York: Stone, 1925.

Meilach, Dona Z. *Contemporary Stone Sculpture.* New York: Crown, 1970.

Miller, Alec. *Stone and Marble Carving.* Berkeley and Los Angeles: University of California Press, 1948.

Wittkower, Rudolf. *Sculpture: Process and Principles.* New York: Harper & Row, 1977. Marble carving in Greek, medieval, Renaissance, and baroque periods.

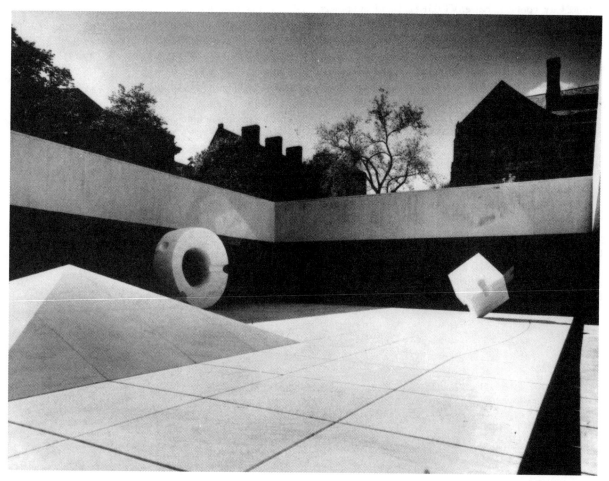

Plate 6.29. Isamu Noguchi, *Marble Garden, Beinecke Rare Book Garden, Yale University*, 1960–1964 (photo credit Ezra Stoller Associates). This ideal space, created entirely of white marble, is cool and serene. It is made to be contemplated, not occupied.

SOURCES OF SUPPLY

A. Stone-Carving Tools and Equipment

American Pneumatic Tool Co., 1201 W. 190th St., Gardena, CA 90249. Pneumatic tools.

Arrow Tool Co., 1900 S. Costner Ave., Chicago, IL 60623. Pneumatic tools.

Behlen & Brothers, Inc., 10 Christopher St., New York, NY 10014. Hand tools.

Brunner & Lay, 727 S. Jefferson St., Chicago, IL 60607. Hand and power tools.

City Tool Works, 425 Stanford St., Los Angeles, CA 90013. Blacksmithing and toolmaking.

Ettl Studios, 213 W. 58th St., New York, NY 10019. Hand tools.

Fillmore & Garber, Inc., 1742 Floradale Ave., S. El Monte, CA 91733. Abrasives, air tools, diamond wheels.

Granite City Tool Co., Barre, VT 05641. Hand and power tools.

Ingersoll Rand Co., 5533 Olympic Blvd., Los Angeles, CA 90022. Pneumatic tools.

Paul L. Kuzmik Mfg. Co., Inc., 271–279 Grove Ave., Verona, NJ 07044. Diamond wheels.

Kysor Industrial Corp., 11515 Alameda Dr., Strongsville, OH 44136. Diamond wheels and cutting machines.

Sculpture Associates, 101 St. Marks Place, New York, NY 10003. Hand tools.

Sculpture House, 38 E. 30th St., New York, NY 10016. Hand tools.

Standard Equipment Co., 3175 Fulton St., Brooklyn, NY 10456. Handling equipment (dollies, lifts, trucks, etc.).

Trow and Holden Co., Barre, VT 05641. Pneumatic tools, emery stones, and finishing materials.

Union Carbide Corp., Linde Div., 30 E. 42nd St., New York, NY 10017; 2770 Leonis St., Los Angeles, CA 90022. FSJ-6 stone-shaping torch.

U.S. Industrial Tool and Supply Co., 13541 Auburn St., Detroit, MI 48233. Pneumatic tools.

B. Sources for Stone

Bloomington Limestone Corp., 110 E. 42nd St., New York, NY 10017. Limestone.

Bruner Pacific, Inc., 843 S. Mission Rd., Alhambra, Ca. 91801. Marble and granite.

Carthage-Georgia Marble Co., 8353 E. Loch Lomond Dr., Pico-Rivera, CA 90660. Marble.

Cold Spring Granite Co., 202 S. 3rd Ave., Cold Spring, MN 56320. Also quarries in Raymond, CA; Lake Placid, NY; Marble Falls, TX; and Lac du Bonnet, Manitoba, Canada. Many varieties of granite.

Colorado Alabaster Supply, 1507 North College Ave., Fort Collins, CO 80524.

Deery Marble Co., Inc., Long Island City, NY 11101. Marble.

Elberton Granite Assn., P.O. Box 640, Elberton, GA 30635. Granites.

Glenn, Ken, 2100 Mesa St., San Pedro, CA 90733. Carrara marble, French limestone, other carving stones.

Indiana Limestone Co., 40 E. 41st St., New York, NY 10017. Limestone.

Indian Hills Stone Co., Bloomington, IN 47401. Limestone.

Marble Unlimited, 14554 Keswick St., Van Nuys, CA 91405.

North Carolina Granite Corp., Mt. Airy, NC 27030. Granite.

Stone Age, RD #1, Box 51, Smyrna, DE 19977. Soapstone, slate, marble, granite, limestone.

Stranco, Inc., 25840 Belleporte St., Harbor City, CA 90710. Alabaster.

U.S. Pumice Co., 6331 Hollywood Blvd., Los Angeles, CA 90028. Lightweight pumice stone or Featherock.

Vermarco Supply Co., 3321 Prospect Ave., Cleveland, OH 44101. Carving stones.

Vermont Marble Co., 101 Park Ave., New York, NY 10017. Marble.

Western Marble Co., 321 W. Pico Blvd., Los Angeles, CA 90015. Marble.

Western States Stone Co., 1849 E. Slauson Ave., Los Angeles, CA 90058. Granite, slate, sandstone.

7

Wood

Wood is distinguished from the other sculpture materials discussed in this book by the fact that it began its existence as a living, breathing organism.

In the past, sculptural use was made of other materials from the plant and animal world, such as bone, ivory, shell, and leather, but these materials are little in use today. Wood, probably more than any other commonly used sculpture material, carries over into its character as finished sculpture qualities that developed during biological growth. The grain pattern, color, and smell of wood tell us, if we can read these things, what variety of tree we have before us, what part of it, and sometimes the age of the tree and where it grew.

The sculptor, then, in confronting a piece of wood to be shaped, must deal with the living character of the wood. The wood will only split in the direction in which it grew. It is best carved in the direction of the grain or across it, rather than against it. You can change your mind to a considerable extent in woodworking, but never, for instance, as freely as you can in working with plaster. Part of the interest in a good piece of wood carving comes from the interaction between the wood's quiet will-to-be and the sculptor's active will-to-form.

The sculptor who cooperates too completely with the wood and tries only to "bring out the character of the grain" is just turning out driftwood. The ocean does it better.

THE STRUCTURE OF WOOD

If we think of the trunk of a tree as its body and its roots as feet, then its branches and leaves would be arms, fingers, and hair. The roots reach deep within the ground and absorb nutrients from the soil which are carried through the trunk, which is really a giant pump, to the leaves. The tree breathes with its leaves. Carbon dioxide is absorbed from the atmosphere and, through the action of sunlight, it is combined with the nutrients from the soil to form cellulose, which is the building material of trees just as calcium and protoplasm are the materials from which humans and animals are constructed. Oxygen is exhaled by the leaves of all green plants and maintains the atmospheric balance that is necessary for life on earth.

The interior of the tree is made of long fibers running in the direction of the trunk and the limbs. Between the fibers are elongated cells of cellulose

containing water. During the growing season of the year, when water is most plentiful, the cells grow larger and farther apart; during the rest of the year the cells are more dense and closely packed, making this part of the wood tougher and darker than the growth-season wood. This alternating between hard and soft layers is what gives wood its grain. Usually there is one growth season per year, so that the age of the tree can be told by counting rings; but sometimes there are two seasons, and sometimes there is a drought and the tree shows little or no growth wood.

In some trees the center part of the tree turns dark and becomes inactive while the pumping of sap continues in the outer ring of wood beneath the bark. The inner part is then called *heartwood* and the outer, lighter part is called *sapwood*.

Where a tree forks or a branch begins the grain will be turbulent and wavy. Where the branch begins there is a hornlike core, a *knot*. Wood with many knots comes from trees with many branches. Straight-grained "clear" (knotless) lumber comes from trees with tall, straight trunks that do not branch until they are near the top.

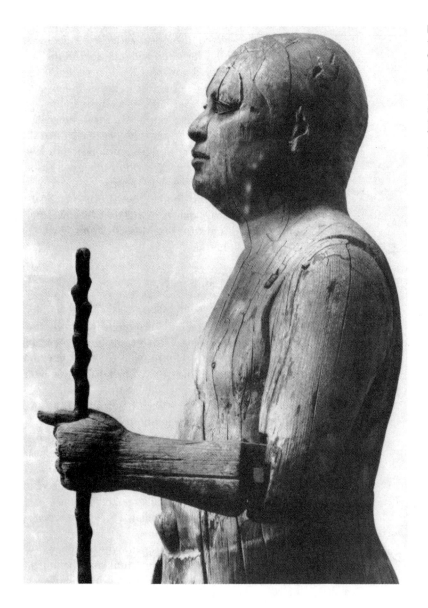

Plate 7.1. *Kaaper, "Sheikh El Beled,"* wood 3'7" high, 2900–2790 B.C.. Collection of Cairo Museum, Egypt (photo credit Hirmer Fotoarchiv., Munich). In a dry atmosphere protected from insects, this wood sculpture has survived for over 4000 years with only minor deterioration. The method of joining the parts with peg and socket joints is clearly visible.

Hardwood is produced by trees like ash, hickory, and oak, which grow fairly slowly so that their cells are thick and densely packed and their growth rings close together. Often the grain of hardwood is more complex and curiously patterned than that of the faster-growing and straighter softwood trees like pine, fir, and redwood.

The wood from fruit-bearing trees like pear, lemon, or olive is tough and close-grained like hardwood but usually has a smooth, delicate texture. It is favored for finely detailed carving and was once used extensively for handmade toys, cuckoo clocks, and the like. Nutwoods such as walnut have rich color and interesting grain pattern. They are usually classified as hardwoods.

SEASONING

When a tree falls in the forest or is felled by lumbering, it starts to dry out. The heavy, wet, green wood becomes lighter, stiffer, and springier. It also shrinks as the pocketlike cells lose their water. If the tree is allowed to lie in the open unprotected, the outer layers of the trunk will shrink faster than the inner layers, and cracks or *checks* will develop.

In commercial lumbering, the logs lie in a pond until the sawmill is ready for them. Then they are sawed into boards and stacked with spacers between each board so air can circulate. The boards are thin enough to dry evenly without much checking. Larger timbers, twelve by twelve inches or four by sixteen inches, do check some, but this does not seriously affect their strength as building materials.

Better quality wood such as hardwood or first quality softwood destined for finish carpentry is *kiln dried,* placed in a special shed where the temperature and humidity can be controlled. Then it is slowly dried or *seasoned.* Finally it is heated so that more moisture is driven out of the wood than would be the case if it were left to dry in the open. The resulting wood will be straight, free of checks, and expensive.

For the sculptor who wishes to carve large pieces of wood, seasoning is a problem. It is difficult today for an individual to find a really large tree that can be bought or cut down. Unfortunately for lovers of live

Plate 7.2. Constantin Brancusi in his studio in Paris. Courtesy of Magnum Photos, Inc., New York (photo by Wayne Miller). The artist's straightforward attitude toward wood is demonstrated by the cracks and chisel marks that remain as expressive components of the upright figure and the archway shown here in his studio.

WOOD CELLS AND FIBERS

Plate 7.3. William Turnbull, *Chief*, rosewood, 57¼″ high, 13¾″ diameter, 1962. Photo courtesy of the artist. Sensitive chisel marks add to the surface vitality of this columnar sculpture.

Plate 7.4. Split timber. The lengthwise direction of wood fibers is revealed when a piece of wood is split.

Figure 7.1. Wood cells and fibers, a magnified view. Sap flows between the cells. When the cells dry out they shrink, leaving seasoned wood lighter and springier than wet wood.

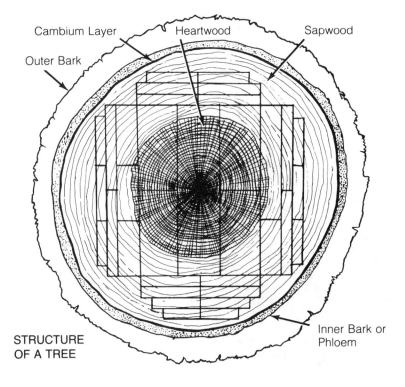

Cambium Layer Heartwood Sapwood

Outer Bark

Inner Bark or Phloem

STRUCTURE OF A TREE

Figure 7.2. The structure of a tree. The rounded outermost sections are ground up to make paper pulp and particle board. The next outer portion of the log has the fewest knots and the straightest grain, so it is used for boards and planks, while the inner part is cut into larger timbers.

trees (and fortunately for the wood sculptor) tree surgeons and firewood companies do a brisk business cutting down cypress and eucalyptus hedges, clearing away maple and hickory trees, and tearing out walnut orchards. A sound, large trunk of one of these trees can be put in a shed, covered with sacks or blankets, and painted on the ends with linseed oil or wax to slow down the drying process. In a couple of years a fine piece of wood will be ready to carve.

In an emergency, green wood can be carved by coating it immediately after each day's work with a generous layer of floor sealant. Before the piece can be left bare, however, it must still dry out if cracks are to be avoided.

Care must be taken in moving wood sculpture from one climate to another. If the new environment is drier than the former one, cracks may appear. Even when a sculpture has had many years to season it can be no drier than the prevailing atmosphere.

Plate 7.5. View of timber and grain. The growth rings can be seen with typical cracks or "checks" radiating from the center. The knot is the core of the branch that began growing early in the life of the tree.

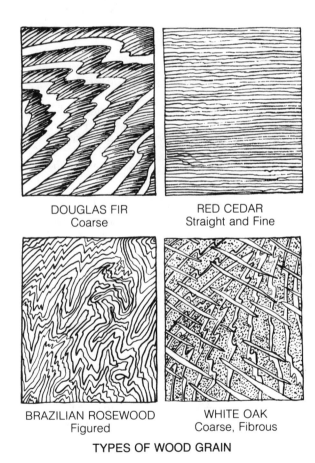

DOUGLAS FIR
Coarse

RED CEDAR
Straight and Fine

BRAZILIAN ROSEWOOD
Figured

WHITE OAK
Coarse, Fibrous

TYPES OF WOOD GRAIN

Figure 7.3. Types of wood grain.

Plate 7.6. *Death with Left Hand Raised*, Upper Rhine, German, linden wood, 10⅝″ high, c. 1600–1650. Collection of Busch-Reisinger Museum, Harvard University, Museum Associates Fund Purchase. Smooth close-grain woods can be carved with precision and refinement of detail.

TABLE 7.1 Wood Varieties and Uses

Type	Grain	Color	Character	Use
Maple	wavy	blonde	easy to carve	furniture
White oak	coarse, fibrous	white	many varieties from USA & Europe	heavy construction, furniture, flooring
Brown oak	rough	brown	robust, European	furniture, paneling
Padouk	figured	crimson to purple	exotic	paneling parquet
Brazilian rosewood	figured	black, brown	luxurious, costly	ornamental cabinetry
Teak	fine	brown	durable & smooth	furniture, marine fittings
Walnut	figured	brown	many varieties, all excellent for carving	gunstocks, cabinetry
Zebra	distinctive	brown, white	flamboyant	decorative panels & veneers
Yew	fine	brown, yellow	strong, springy	archery
Fruitwoods				
Apple	fine	yellow	easy carving	toys, clocks
Cherry	lively	golden brown	very workable by power & hand	frames, boxes, knobs
Lemon	fine	yellow	dense, strong	combs, small tools
Olive	very fine	cream	heavy, very strong	shipfittings in ancient times
Pear	very fine	reddish	light, soft	drafting, musical instruments
Softwoods				
Balsa	clear	white	lightest, softest	models
Cedar	straight	reddish	easy to carve	Indians carved, building
Chestnut	wavy	tan	checks, warps	carving
Eucalyptus	wavy	yellow-gray	stringy, large	firewood
Fir	coarse	tan	cheap, splits	construction
Lime or linden	very fine	straw	smooth carving	musical instruments
Redwood	fine	red	porous, rot-resistant	paneling, siding, fences
Sugar pine	very fine	white	smooth carving	models, patterns
Yellow pine	varies	yellow	common	construction, furniture
Hardwoods				
Ash	coarse	blonde	tough	tool handles
Coca-bola	prominent	red-brown	distinctive; beware toxic dust	knife handles

TABLE 7.1 *Continued*

Type	Grain	Color	Character	Use
Ebony	dense	black	luxurious	cabinetry, handles
Elm	crossed	brown	resists splitting	mallets, hubs
Hickory	dense	white to brown	strong	tool handles
Koa	wavy	brown	light but strong	bowls, trays
Lignum vitae	dense fibrous	yellow to green	heaviest, hardest	mallets, bearings
African mahogany	clear	light brown	Rich, durable	furniture, cabinetry
Honduras mahogany	figured	brown	rich, durable, rare	furniture, cabinetry

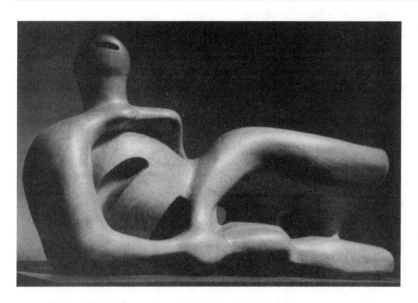

Plate 7.7. Henry Moore, *Reclining Figure*, elm wood, 75″ long, 1945–1946. Private collection, Italy (photo courtesy of the artist). This large sculpture is carved from a single block of well-seasoned English elm.

Plate 7.8. Richard Serra, *Sawing: Base Plate Measure, 12 Fir Trees*, red and white fir logs, concrete, 35′ × 50′ × 60′, 1970. Photo courtesy of Pasadena Art Museum. The timber is straight from the forest. The logs were purchased directly from the mill, and would have ended up as lumber if not diverted for the purposes of art.

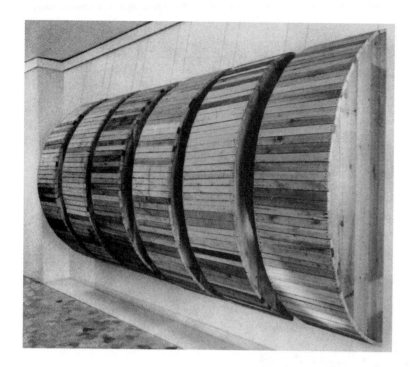

Plate 7.9. Mario Ceroli, *A Modulo Ondulatorio 10*, wood, 5′ 2⅛″ × 2′ 3⅜″ × 1′5½″, 1968. Courtesy of Galleria d'Arte del Naviglio, Milan (photo credit Bacci Attilia, Milan). The artist explores the effects of using rough lumber and exposed nails as they might appear in the everyday construction of fences, pens, or crates.

SOURCES

Aside from going out and chopping down your own tree, there are several other means of procuring wood for sculpture. Ordinary lumber yards carry fairly large timbers of pine and Douglas fir. If you are not too bothered by knots and minor cracks, this wood is cheap and easy to cut.

Most large cities have sources of fine woods. The so-called hardwood companies usually carry many varieties of fine quality woods, clear kiln-dried softwoods as well as fruitwoods, hardwoods, and exotic tropical woods. You should bear in mind that hardwood is not necessarily harder to carve than softwood. In fact, most hardwood, walnut or mahogany for instance, is perfect for carving because the dense, smooth wood holds together well as the chisel cuts through it. Most pines and firs, however, though soft, are coarse grained and tend to split or splinter while being worked.

Most hardwoods are quite expensive and do not come in very large pieces. There are a few old hardwood yards in the United States which still have whole logs and old planks. Remember that you will get more for your money if you can use a whole piece of wood rather than having your piece cut

from a larger one. If you work small, or work by laminating or joining standard-sized pieces of lumber together, lumber and hardwood yards will serve your purposes. If you want large pieces of whole wood, however, you will have to look elsewhere, or else spend a great deal of money.

As described above, you can go directly to the people who cut down the trees, but you will have a long time to wait before your wood is ready to carve. So you must find sources of large pieces of seasoned lumber. Firewood companies, at their central yards, sometimes have seasoned logs and particularly stumps that have not been split to fireplace size. If you do not mind a few cracks and insect holes these stumps are inexpensive and often the strongest and most interesting wood in the tree.

Another source is the salvage and wrecking yard. Here you may be able to locate old bridge or wharf timbers, or pilings used for street and subway construction. More than likely you will find some wonderful object that has nothing to do with the original purpose of your visit.

Finally, you can take a drive through the countryside looking for fallen trees which are still sound. A walk in the summer up a dry river bed will usually show you some trees that have fallen into the river

and thus been allowed to season slowly without cracking. It may take a chain saw and a jeep with a winch to get the piece you want onto the road.

On some of the more deserted beaches of this country, along the coasts of Oregon and Washington for instance, are hoards of magnificent seasoned tree trunks and stumps. These may be difficult to remove from the beach without heavy equipment. You will also find that this wood has sand driven deep into every crevice, which is very hard on tools.

WOOD CARVING

Cutting Tools

As can be seen from the illustration, there are dozens of shapes and varieties of wood chisels. To begin carving, you need only a narrow and a wide flat chisel and a shallow and a deep gouge. The size will depend on the size of the sculpture you are attempting. As you gain experience and feel the need of a more specialized shape of chisel you can acquire it and add it to your kit.

Many of the chisels sold as "wood-carving" chisels have weak handles meant for pushing by hand. They will not stand up under the mallet blows necessary for carving wood of any size. These chisels can still be used, if the handles are replaced with ones of hardwood or plastic.

Beginners usually start with a mallet that is too light, so that muscular effort must be exerted to drive the chisel through the wood. It is better to learn to use the weight of a slightly heavier mallet that will be less tiring once you catch onto the rhythm of using it.

The adz combines the weight and handle of the mallet with the cutting edge of the chisel. It is unsurpassed for carving large logs and timbers. All the wood carving of Pacific Oceania is done with adzes, from the hollowing out of a fifty-foot canoe to the smallest detail on a paddle handle or ceremonial staff.

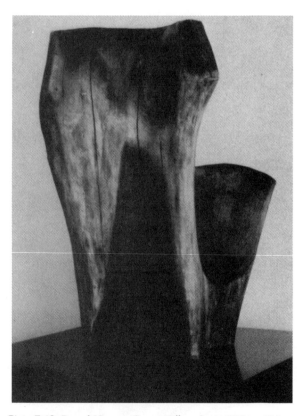

Plate 7.10. Raoul Hague, *Groeg Kill*, walnut, 60″ × 48″, 1970. Courtesy of Zabriskie Gallery, New York (photo credit John A. Ferrari, New York). The shape of the original tree crotch is retained in the finished sculpture, along with the checks and other surface imperfections of wood seasoned naturally out-of-doors.

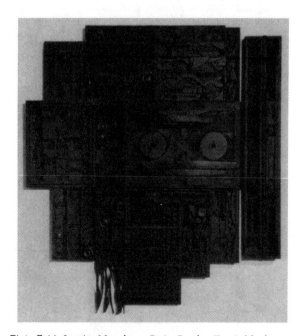

Plate 7.11. Louise Nevelson, *Rain Garden Zag I*, black painted wood, 80″ × 72½″ × 5½″, 1977. Pace Gallery, New York (photo credit Al Mozell, New York). Treasures from years of collecting old furniture and curious parts appear in the haunting and nostalgic assemblages.

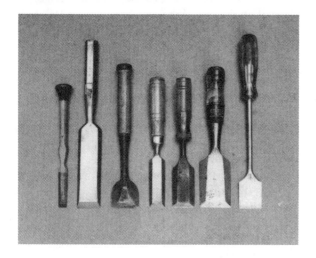

Plate 7.12. Straight chisels with integral handles of steel, or replaceable handles of wood or plastic.

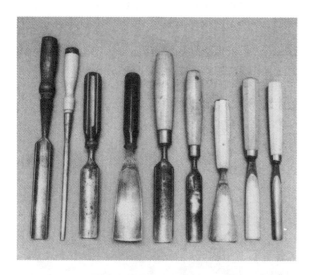

Plate 7.13. Gouges with wood or plastic handles driven onto a tang or fitted into a tapered socket.

Plate 7.14. Hatchets and adzes are useful tools for fast work. The two on the right are converted gardening tools.

Plate 7.15. Hand saws and draw knives. Draw knives, sometimes called "spoke shaves," are useful for rounding and paring with the grain.

Plate 7.16. Mallets. For driving wood chisels. Upright mallets are lignum vitae. Reclining mallets are faced with leather (l) and plastic (r).

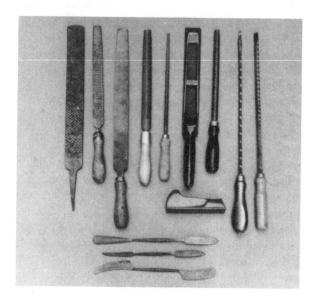

Plate 7.17. Rasps and files. Rasps have coarse individual teeth, files have fine teeth. Stanley Sureform files are perforated to allow wood shreds to pass through. Rifflers (bottom) are shaped to reach difficult contours.

Plate 7.18. Sanding blocks hold the sandpaper flat and taut, while providing a backing that the hand can grip.

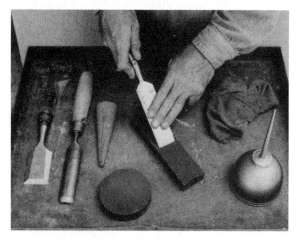

Plate 7.19a. Chisel sharpening. The straight chisel is sharpened by rubbing the beveled side evenly back and forth on a well-oiled stone. Keep bevel flat.

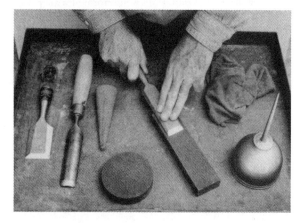

Plate 7.19b. Chisel sharpening. When the bevel of the straight chisel is sharp, the burr is removed by rubbing the back side of the chisel flat against the stone.

Sharpening

For the kind of relaxed attention needed for wood carving it is essential that the tools be sharp. This usually means that you must stop several times during the working day to sharpen your tools. This can provide a refreshing pause in the rhythm of work and a time for reflection on the progress of the piece.

Sharpening is easy if you understand what you are trying to do. The sharpening stone is made of hard abrasive particles embedded in a matrix that is fairly soft. As the edge of the tool is rubbed over the abrasive, the steel is worn down, but some of the abrasive particles are rubbed out of the matrix as well, forming a sort of paste. This paste must be washed away so it will not interfere with the cutting action of the stone. Oil performs this action smoothly while lubricating the cutting action. Water cleans the stone more thoroughly, producing faster but coarser sharpening. After using a stone it should always be wiped clean so the pasty residue does not clog the stone.

In sharpening, the worn and rounded edge of the tool is reshaped to a wedge by the coarse stone, then refined and smoothed with the fine side of the stone. Even finer stones may be used if a super-sharp edge is required, but for most wood carving the standard two-sided sharpening stone is sufficient. To maintain the correct wedge shape of the edge of the chisel, it must be sharpened on one side only. Care should be taken to keep the full width of the bevel in contact with the stone. It does not matter whether you move the edge in circles or push it back and forth, so long as you maintain the bevel in full contact with the stone. The action with a gouge is the same as with a flat chisel, except that the gouge must be rotated gradually from side to side so that the entire edge receives the sharpening action. An edge that has become rounded through incorrect sharpening, or chipped, must be restored to the proper shape on a grinding wheel.

As the sharpening of the bevel proceeds, a slight ridge, or fin, of turned-up metal will appear on the back, or flat, side of the edge. This is removed with a fine stone without rounding this side of the edge. Specially curved tapered stones are used with gouges for this purpose, as the fin develops on the inside curve of the gouge. The better the quality of the steel, the finer the edge can be sharpened before it turns over and forms a fin on the back side.

Inevitably, as a chisel is sharpened and resharpened, the edge is worn back towards the shank until it reaches a point where the steel no longer has sufficient *temper*, or hardness, to hold an edge. A chisel is hardened only at the edge. If the whole chisel were hardened it would be so brittle that it would break when struck. Usually worn-out chisels are discarded, but it is possible to have old favorites retempered by a blacksmith.

Plate 7.20*a*. Gouge sharpening. In sharpening the gouge, the bevel must be rotated from side to side while rubbing back and forth, so that the entire edge will come in contact with the stone.

Plate 7.20*b*. Gouge sharpening. The burr is removed from the inside of the gouge with a rounded stone called a "gouge slip."

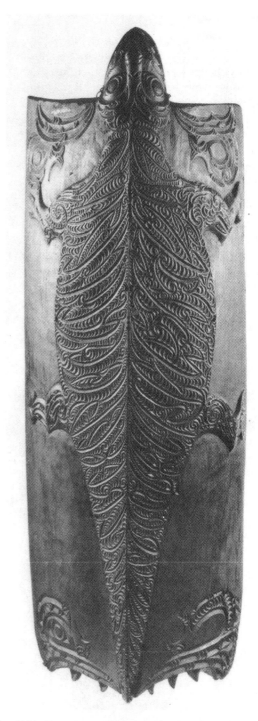

Plate 7.21. *Front View of a Bone-Chest (Waka Tupapaku) With Manaia-Headed Lizard Forming Basic Design*, wood, 48″ high. Courtesy of Auckland Institute and Museum, Auckland, New Zealand (photo credit Ross Hawkes, Auckland). These swirling light-reflective patterns are carved with a selection of small razor-sharp adzes.

Holding Devices

A large log or timber is usually heavy enough to stay put while you carve it, but smaller pieces must be carefully clamped so they will neither break nor come loose while being worked on. It is a good idea to spend some time at the beginning figuring out how to clamp your wood securely rather than having to stop constantly to make adjustments.

Beginning

As is stone carving, the art of wood carving is a gradual growth of skill and sensitivity which everyone must accomplish through direct experience. Elaborate instructions will only get in the way.

Once the wood is securely fastened down and the chisels properly sharpened, you should begin by carving in the direction of the grain, holding the chisel and mallet lightly and without strain. At first you will

Plate 7.23. Woodworking vises. M. maple bench tops, these open to 12

Plate 7.24. Bar and pipe clamps. They are available in a wide variety of sizes. Pipe clamp ends mount on standard ¾″ pipe.

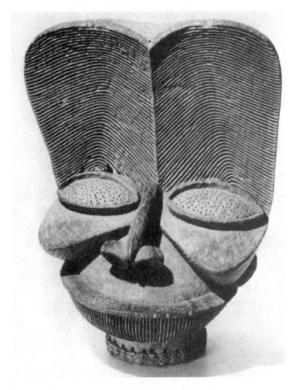

Plate 7.22. *Large Dance Mask*, Babanki, Tikar group in Bamenda, Cameroon Grasslands. Collection of Von der Heydt, courtesy of the Museum Rietberg, Zurich. The broad planes and repetitive textures of this mask create a forceful image when the mask is in motion in dim light.

Plate 7.25. Carving with chisel and mallet. The tools are held lightly but firmly.

be tense and your hands will get sore. Do not work for too long a stretch the first few days. After a while you will be able to carve all day without getting tired. Then you will realize that you have forgotten about "wood carving" and are completely absorbed in the wood and what it will become.

POWER TOOLS

Table saws, hand saws, drills, joiners, planers, routers, belt sanders, orbital sanders, disk sanders: all the tools of a fully equipped power woodshop can be useful to the sculptor. In fact, much wood sculpture today is produced with the almost exclusive use of power tools. Since a full discussion of power woodworking tools would constitute a book in itself, the reader interested in pursuing this subject further is referred to the several excellent manuals listed in the bibliography and the illustrations in chapter ten.

Some power tools are of great use to the sculptor who still works primarily from a carving point of view. The chain saw, either electric or gasoline driven, can rapidly cut logs to the approximate shape to begin final carving. There are types of sanders

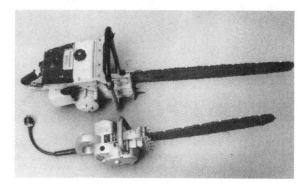

Plate 7.27. Chain saws. Top: large gas chain saw shown with 36″ blade or bar can take up to 60″ bar for cutting big timber. Bottom: electric chain saw is convenient where electric power is available. It is quieter than gas chain saw and there are no starting problems.

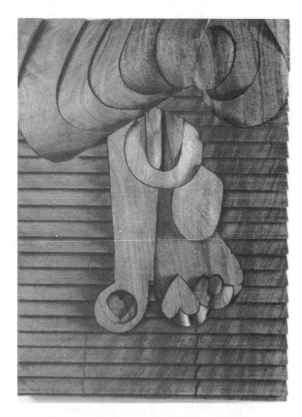

Plate 7.26. Hugh Townley, *O Western Wind When Whilt Thou Blow*, mahogany, 24¼″ × 18″, 1972. Photo courtesy of the artist. These precisely cut, close-fitting forms are shaped with power tools.

Plate 7.28. *Max oscillating vertical spindle sander*. Courtesy of Max Manufacturing Co., San Jose, California. Spindles from ¼″ to 4″ in diameter may be mounted in this machine for sanding irregular contours.

Plate 7.29*a*. Panel saw. The panel saw is mounted on a rack to facilitate cutting sheets of wood, plastic, and metal. The weight of the saw helps it to cut.

7.29b. Panel saw. Panel frames can be purchased or constructed to hold the work at any angle needed.

available which can deal with the complex curves which usually occur in hand-carved forms.

If a woodworker uses power tools and moves out into the country near the source of supply rather than bringing wood to the studio, there will be a problem if there is no source of electric power nearby. For small jobs there are battery-powered tools, but for heavier jobs one must either use gasoline-powered tools or bring along a portable source of power. At present there are two practical sources of portable power.

A portable compressor can be towed behind a car and supply air pressure to operate pneumatic tools. This setup would be the most expensive but reliable, durable, and powerful. It would still be run by a gasoline engine.

Portable electric generators powered by a gasoline motor are compact enough to fit in the back of a station wagon or pickup truck. They can be carried by two persons or mounted on a dolly with wheels. They will operate one or two portable electric tools, and, moreover, provide current for lights and heaters. If the sculptor already owns electric tools, this is probably the better solution of the two unless the work requires heavier pneumatic equipment.

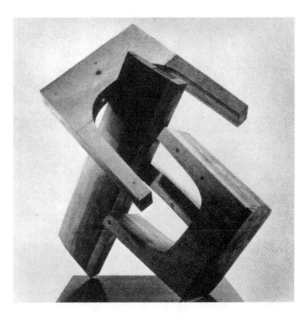

Plate 7.30. Gabriel Kohn, *Bird Keys*, wood, 39″ × 40″, 1962. Courtesy of Marlborough Gallery, New York. The band saw and drill press were employed to create this laminated and pegged sculpture. The joinery is akin to shipbuilding practice.

After thinking for a while about these options, a person might come to the conclusion that the human body is the best source of portable power.

JOINING AND LAMINATING

So far we have been discussing wood sculpture as though it were exclusively a process of shaping a form out of a single block of wood. This is far from the case. Many contemporary wood sculptures are constructions made of pieces of wood fastened together with adhesives or mechanical fastenings such as bolts, plates, dowels, or shaped and fitted joints. All the techniques of boat building and wooden architecture can be applied to sculpture. A study of African, Polynesian, and Micronesian building methods will introduce an entire system of flexible construction based on lashing and tying.

With modern adhesives, such as epoxies and resorcinol glues, layers of wood can be bonded to each other, enabling the sculptor to work with a larger, stronger piece of wood than may be otherwise available or affordable. Moreover, a deliberate emphasis placed on the layered quality can achieve striking visual effects in a carved sculpture. Lamination affords the sculptor the opportunity of bending wood

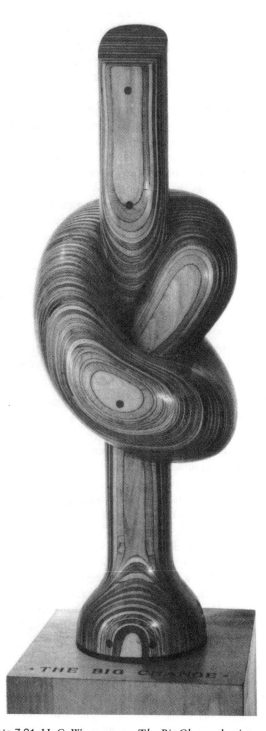

Plate 7.31. H. C. Westermann, *The Big Change*, laminated plywood, 4′8″ high, 1963. Private collection, New York (photo credit Nathan Rabin, New York). Laminated plywood displays its edge grain, intensifying the tactile sense of contour.

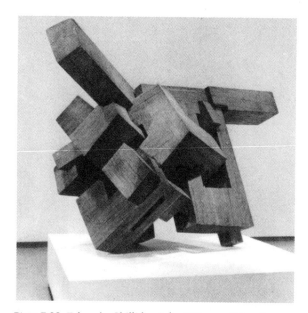

Plate 7.32. Eduardo Chillida, *Asbesti Gogora III*, oak, 81⅝″ × 136⅜″, 1962–1964. Collection of the Art Institute of Chicago, Grant J. Pick Purchase Fund (photo courtesy of the Art Institute of Chicago). Interlocking timbers in a powerful display of positive and negative forces.

Mortice Joint with Dowels

Mortice and Tenon

Tenon Joint with Bolts

MORTICE AND TENON JOINTS

Figure 7.4. Mortice and tenon joints.

into forms impossible to attain with a single thickness. After the adhesive has been applied carefully between the layers, the wood is clamped in the desired shape or held in place until the glue has dried completely. Wood can also be glued and fastened to other materials.

Wood can also be bent by steaming. To steam wood properly, you will need a loosely-covered tank, partially filled with constantly boiling water, and a support to keep the wood above the water level. Allow about one hour of steaming time for each inch of the wood's girth. The steamed wood must be removed from the tank with asbestos gloves; it should be immediately shaped and clamped in place. Steaming and laminating techniques can be combined.

SAFETY

The greatest dangers in woodworking are associated with the use of power tools. The following rules should be observed whatever the material involved, be it wood, plastics, stone, or metal.

1. Protective guards and shields must always be used over blades, wheels, and other moving parts.
2. Protective eye guards—either goggles or face shields—must always be worn when operating power equipment. Ear guards should be worn around noisy equipment.
3. Use pushing sticks or holders for small pieces of material that bring the hands close to cutting edges.
4. Do not wear loose clothing that can get caught in machines. Tie up loose hair. Wear shoes.
5. Before changing blades, grinding wheels, bits, and sandpaper, turn off power of stationary equipment. Unplug portable electrical tools, uncouple pneumatic tools.

Another considerable hazard associated with woodworking is inhaling fumes from toxic chemicals, or getting the chemicals on your skin. In all stripping operations, respirators and gloves should be worn, and forced ventilation should be in operation indoors. Remember that vapors affect not only the user but other people in the same area. Some of the solvents known to be toxic are methyl butyl ketone, carbon tetrachloride, xylene, toluene, trichlorethane, and benzene. Benzene is a cause of leukemia and

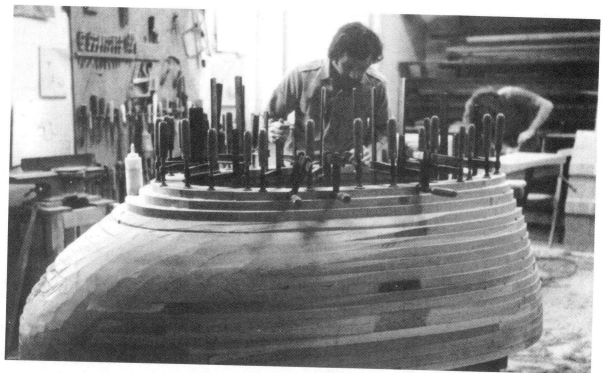

Plate 7.33. Wendell Castle in studio with laminated wood construction. Laminating thin sections allows the artist to achieve a form which fulfills preexisting drawings and dimensions.

Plate 7.34. Don Potts, *My First Car—The Basic Chassis (Body #3)*, clear spruce reinforced with brass, 27½″ × 141″ × 74″, 1966–1970. Collection of the artist, courtesy of Hansen-Fuller Gallery, San Francisco. The almost unbelievable delicacy of this vehicle chassis was achieved through joinery reminiscent of fine cabinet work or early aircraft construction.

other blood diseases. Do not use benzene under any circumstances.

Some adhesives, particularly epoxies, are irritating to the skin. Epoxies should never be allowed to touch the skin. If they do, the affected area should be cleansed with a waterless hand cleaner, then washed with soap and water. Solvents should not be used as skin cleaners! Gloves should be worn when painting or working with glues and solvents. If the hands become dry from contact with solvents (or from excessive washing) skin oils should be replenished with skin lotion.

Dusts, too, are a hazard to woodworkers, particularly those dusts produced by power equipment. Adequate ventilation and respirators are called for here, as well as dust collection hoods and sawdust bags on portable equipment.

Certain wood dusts are irritating to certain people. Some of the most allergenic are arborvitae,

boxwood, ebony, obeche, western red cedar, and even redwood. Cherry, maple, oak, pine, walnut, and most other fruitwoods and nutwoods seem to be safer.

FINISHING AND PRESERVING

While wood, like stone, may be left in its original condition, it is often given some kind of treatment to preserve it and bring out its inherent qualities. Stain, wax, linseed oil, and wood preservatives help seal the grain against moisture in the atmosphere and provide some defense against insect attack if the sculpture is to be mounted outdoors. Wood will accept every type of paint, water-based, oil-based, or resin-based, and it can be bleached with chemicals to give it a weathered appearance.

After all that has been said about the fascinating appearance of wood grain, it must be admitted that much of the great sculpture of the past was completely painted or *polychromed*. Many of the wood sculptures of medieval and Renaissance Europe which we now admire for their delicate traces of polychromy were, of course, completely painted when they were made, as were sculptures in Japan, China, Greece, and Africa.

BIBLIOGRAPHY

Beercroft, Glynis. *Carving Techniques*. New York: Watson-Guptill, 1976.

Byers, Ralph E. *Woodworking with Power Tools*. Philadelphia: Chilton, 1959.

Collingwood, G. H., and Warren D. Brush. *Knowing Your Trees*. Washington, D.C.: The American Forestry Association, 1964.

Edlin, Herbert L. *What Wood is That? A Manual of Wood Identification*. New York: Viking Press, 1969. Contains 40 actual wood specimens.

———. *Fine Hardwoods Selectorama. A Guide to the Selection and Use of the Popular Species*. Chicago: The Fine Hardwoods Association, 1956. A.I.A. File 19-E-S.

Gravney, Charles. *How to Start Carving*. New York: Van Nostrand Reinhold, 1972.

Gross, Chaim. *The Technique of Wood Sculpture*. New York: Arco, 1965.

McDonnell,.Leo P. *The Use of Hand Woodworking Tools*. New York: Van Nostrand Reinhold, 1977.

Meilach, Dona Z. *Contemporary Art with Wood*. New York: Crown, 1968; 7th printing, 1975.

Rood, John. *Sculpture in Wood*. Minneapolis: University of Minnesota Press, 1950.

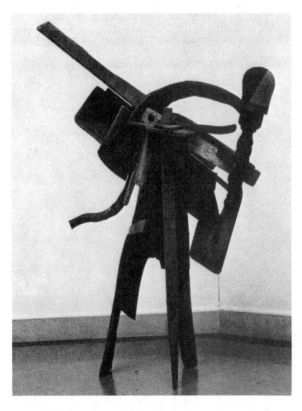

Plate 7.35. Arlo Acton, *Come One, Come Two*, wood, 84½″ high, 1963–1964. Collection of San Francisco Museum of Art, gift of the Women's Board; courtesy of San Francisco Museum of Art. An open sculpture combining many pieces of wood from different sources.

Rottger, Ernst. *Creative Wood Design.* New York: Reinhold, 1961.

Skinner, Freda. *Wood Carving.* New York: Bonanza Books, 1961.

Waller, Julian, and Lawrence Whitehead. "Health Issues: Woodworking," *Craft Horizons* 37, 6 (December 1977), 8, 77–78.

Wilcox, Donald. *New Design in Wood.* New York: Watson-Guptill, 1968.

Zim, Herbert S., and Alexander C. Martin. *Trees, A Guide to Familiar American Trees.* New York: Golden Press, 1952.

Zimmerman, Martin H., and C. L. Brown. *Trees: Structure and Function.* New York: Springer-Verlag, 1971.

SOURCES OF SUPPLY

A. Hardwood and Other Special Wood

Amherst Wood Co., North Amherst, MA 01002.

Todd E. Binford, 1303 N.W. 20th St., Lincoln City, OR 97367. Native Oregon wood.

James Burnet, 1501 Gaylord St., Long Beach, CA 90813. Imported wood.

Plate 7.36. *Religious Procession in Taxco, Mexico.* Photo by Fusco (courtesy of Magnum Photos, New York). A layer of gesso (chalk and glue) over the wood forms a ground for the painted details so necessary to the impact and symbolism of this sculpture.

Plate 7.37. *Whale Mask,* red cedar, native and commercial paint, 67½″ long × 16″ wide × 12½″ high, c. 1900. Courtesy of the Denver Art Museum, Denver, Colorado.

This painted mask is intended to be worn on the head of a dancer. The mouth, fins, and tail can be moved by hand-held strings.

Constantine's, 2050 Eastchester Rd., Bronx, NY 10461.

Craftsmans Wood Service Co., 2727 S. Mary St., Chicago, IL 60608.

Educational Lumber Co., 21 Meadow Rd., Asheville, NC 28801.

Exotic Wood Shed, 65 N. York Rd., Warminster, PA 18974.

Greenheart-Demerara, Inc., 52 Vanderbilt Ave., New York, NY 10017.

Holt and Bugbee, 243 Medford St., Boston, MA 02155. Imported and native hardwood.

House of Balsa, 2814 E. 56th Way, Long Beach, CA 90805.

House of Hardwood, 2143 Pontius Ave., Los Angeles, CA 90024.

Leitz Co., 330 Corey Way, San Francisco, CA 94080.

J. H. Monteath Co., 2500 Park Ave., New York, NY 10051.

Overseas Trading Co., 422 Natchez St., New Orleans, LA 70113.

Rare Woods, Inc., 3160 Bandini Blvd., Los Angeles, CA 90058. Large selection of tropical hardwoods.

Chester B. Stern, Inc., Grant Line Rd., New Albany, IN 47150. Rare tropical woods.

B. Woodworking Equipment

Andrews Hardware, 1610 W. 7th St., Los Angeles, CA 90017. Wood-carving tools, power tools, workbenches.

Broadhead Garret Co., E. 71st St., Cleveland, OH 44101. Wood-carving tools, power tools, workbenches.

Brookstone Co., 127 Vosefarm Rd., Peterborough, NH 03458. Hard-to-find tools.

Buck Brothers, Riverlin Works, Millbury, MA 01527. Chisels.

Craftools, Inc., 36 Broadway, New York, NY 10013. Wood-carving tools, workbenches.

Ekstrom, Carlson & Co., 1400 Railroad Ave., Rockford, IL 61110. Pneumatic drum sanders.

Ettl Studios, 213 W. 58th St., New York, NY 10019. Wood-carving tools.

M. Flax, 10846 Lindbrook Dr., Los Angeles, CA 90024; 250 Sutter St., San Francisco, CA 94108.

Garrett Wade Co., 302 Fifth Ave., New York, NY 10001. Hand tools, Inca power tools.

Leichtang, 5187 Mayfield Rd., Cleveland, OH 44124.

Max Mfg. Co., 138 Stockton Ave., San Jose, CA 95126. Spindle sanders, disk sanders, saw sharpeners.

Frank Mittermeier, Inc., 3537 E. Tremont Ave., New York, NY 10065. Wood-carving tools.

Sandvik Steel, Inc., 1702 Nevins Road, Fair Lawn, NJ 07410. Chisels and saws.

Sculpture Associates, 101 St. Marks Place, New York, NY 10009. Wood-carving tools and equipment.

Sculpture House, 38 E. 30th St., New York, NY 10016. Wood-carving tools and equipment.

The Stellhorn Co., 300 S. Summit St., Toledo, OH 43602. Woodworking tools.

J. D. Wallace and Co., 800 N. Detroit St., Warsaw, IN 46580. Woodworking machinery.

Woodcraft Supply Corp., 313 Montvale Ave., Woburn, MA 01801.

8
Plastics

During the last hundred years industrial chemists have invented a whole new range of materials called *plastics*. At first these products resembled, and were used as substitutes for, natural materials such as ivory, wood, and leather. Soon, however, plastics began to take on entirely new and sometimes unexpected qualities. Ways were found to alter their chemistry to meet changing needs. By the mid-twentieth century synthetic materials had arrived, and artists quickly began experimenting with them.

Many sculpture materials are soft and easily formed in the initial stages of working; later, they set to become hard and durable. The temperature at which this setting takes place, and the transformations that accompany it, are the keys to the behavior of the final material.

As clay dries, it stiffens but remains quite fragile. Heating in a kiln drives off more water, until irreversible molecular changes begin to transform the clay into a strong and permanent material. In the case of plaster and concrete, hardening depends on crystallization. With oil paint, drying results from the evaporation of solvents. With time, an additional process transforms the linseed oil in the oil in the paint. This process is termed "polymerization." Linseed oil belongs to a family of materials known as organic polymers.

All forms of life are based on large molecules made of carbon, oxygen, and hydrogen atoms, often combined with some nitrogen, silicon, calcium, and phosphorus. The basic "building-block" molecules, or *monomers,* often have the ability to link up with other monomers to form even more complex molecules known as *polymers.* Natural polymer materials include leather, horn, vegetable fibers, resin, asphalt, pitch, and linseed oil.

For about a century chemists have been discovering ways to select monomers and join them through the use of heat, pressure, and catalysts. The resultant *high polymers*—so called because of their high number of molecular links—resemble natural polymers in some ways, but they also have unique properties. Some exhibit glasslike transparency, others increased resistance to heat; still others are unusually slippery. Almost all are very durable.

The molecules in synthetic polymers can be made larger than those found in nature. This quality produces unusual resistance to attack by bacteria, to natural solvents, and to weathering. At first the durability of polymers was hailed as an unquestionable advantage. Today, the persistence of discarded

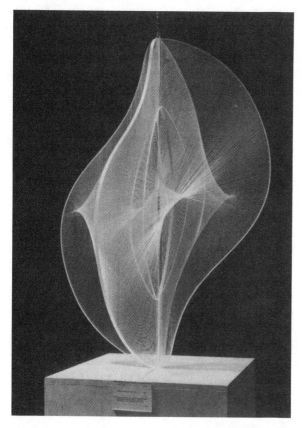

Plate 8.1. Naum Gabo, *Linear Construction #2*, acrylic plastic, 36″ high, 1949. Courtesy of the Tate Gallery, London. Gabo was one of the first artists to explore the transparency and precision of plastics.

yet indestructible synthetic material in our environment has prompted chemists to work toward development of biodegradable and naturally weathering polymers for applications where permanence is not a factor.

Not only do these materials we call "plastics" have qualities that transcend their use as substitutes for existing materials but in many ways they can augment traditional materials to give them a new role as ingredients in composite substances, such as plastic aggregate concretes and plastic laminates with wood, metal, and cloth.

TYPES OF PLASTICS

Plastics can be produced that are hard or soft, dense or lightweight, porous or nonporous, rigid or flexible, elastic or limp, transparent, translucent, or opaque, flammable or heat resistant. They can be made in the form of solids, liquids, fibers, foams, films, sheets, coatings, and adhesives. There are about fifty major families of plastics, with many varieties within each family, and new ones are being discovered almost daily.

Plastics terminology is somewhat confusing at first. A particular plastic material can have as many as three different names: its generic or family name, its chemical name, and its commercial or trade name, which will vary from one manufacturer to the next.

Plate 8.2. Curtis JN-C6, trainer aircraft, 1916. Courtesy of the Smithsonian Institution, Washington, D.C. This World War I aircraft had a wooden frame covered with fabric.

After the fabric had been fastened to the frame it was tightened and stiffened by applying several coats of cellulose nitrate lacquer or "dope."

For instance, *acrylic* is the generic name for the family of polymers made of polymethyl methacrylate. The sheets of this material marketed in the United States by the Rohm & Haas Company have the trade name Plexiglas; those marketed by the E. I. Du Pont de Nemours Company are called Lucite; in England a similar product offered by the Imperial Chemical Industries Ltd. is termed Perspex; in Japan, the Mitsubishi Rayon Company produces and exports their acrylic sheet, Shinkolite. The Modern Plastics Encyclopedia for 1978–1979 lists more than 1,400 trade names for plastics.

Polymers are made of very large molecules constructed in the pattern of a long chain. The type of bonds that hold the monomers together within a given chain determine the ultimate behavior of the plastic. When the monomers are connected with linear bonds, the plastic will relax and become formable with the application of heat. Plastics in this category are *thermoplastics*. Some common thermoplastics are:

ABS (acrylonitrile-butadiene-styrene)
acrylic
cellulose acetate
cellulose nitrate
nylon
polyethylene
polypropylene
polystyrene
fluoroethylene
vinyl

Plastics in which the monomers are connected by complex cross-linked bonds resist heat with little distortion up to the burning point; these are *thermosets,* or themosetting plastics. Some common thermosets are:

alkyd
epoxy
phenolic
polyester
silicone
polyurethane

Thermoplastics

Acrylonitrile-butadiene-styrene. An exceptionally strong plastic, acrylonitrile-butadiene-styrene, or ABS, is used increasingly in the manufacture of large objects subject to wear and abuse, such as car bodies, luggage, boat hulls, and even bulletproof armor. It is slow burning and has good heat and chemical resistance. Sold primarily in the form of molding pellets, ABS is injection molded or extruded

Atom Bond
Atom
Bond
Bond LINEAR BOND
Cubic lattice molecule
Atom

CROSS-LINKED BOND
POLYMERIZATION

Figure 8.1. Polymerization. In this schematic diagram polymerization is depicted as taking place from right to left. The spheres represent atoms of carbon, oxygen, hydrogen, nitrogen, or phosphorus. The atoms are shown linked together, with white bars to represent cubic lattice organic molecules. Then the molecules are shown linking up to each other with black bars to form polymer chains.

into finished shapes, but the intense heat and pressure required in this process demand equipment that is too expensive for most sculptors. It is expected that, in the near future, ABS will be more widely available in solid forms (sheets, bars, and tubes) that can be machined, laminated, riveted, screwed, and stapled.

Acrylic. Introduced in the 1930s, acrylic, or polymethyl methacrylate, is the most transparent of all plastics and more transparent than most glass, with 92 percent light transmission. It has the unusual property of *light piping;* that is, it transmits light from one edge to another with very little loss, even around curves. Strong, weather resistant, and slow to burn, acrylic remains, however, susceptible to scratching. It can be damaged by several household substances, including perfume, gasoline, cleaning fluid, and acetone.

Acrylic is available in more than fifty colors—transparent, translucent, opaque, and fluorescent. It is sold in the form of solid sheets, rods, and tubes, as a resin or lacquer, and in a water emulsion as a painting medium. It can be bent with heat, cut, sawed, filed, tapped, threaded, polished, and glued. In all these forms and techniques acrylic has great sculptural potential. Manufactured products include windows, skylights, aircraft canopies, lenses, and furniture. Acrylic signs are replacing neon signs in outdoor advertising.

Cellulose acetate. Developed jointly in 1927 by the Celanese Corporation and the Celluloid Company, cellulose acetate is generally encountered today in the form of thin, flexible, clear sheets of remarkable toughness. The backing material for almost all photographic film produced today, cellulose acetate is also used for drafting layout sheets and as a protective covering for drawings and photographs. Molded, it is shaped into toys, beads, and eyeglass frames. It may also be extruded to form rayon fiber. Cellulose acetate resists mild acids, oil, gasoline, and cleaning fluids, but it can be damaged by alcohol, acetone, and alkalies. Although generally easy to

Plate 8.3. Craig Kauffman, 1969 installation at Pace Gallery showing *Untitled*, sheet acrylic, 73″ × 48″ × 9″, and *Untitled*, sheet acrylic, 73″ × 36″ × 9″, 1969. Courtesy of Pace Gallery, New York. These brilliantly colored works are a good example of the thermoforming of acrylic.

work with in the studio, it must not be used in molding operations that require intense heat or pressure.

Cellulose acetate butyrate (Tenite and Urex) is a more advanced member of the cellulosic family developed by the Eastman Company. Clear and lustrous with a bluish tint, it takes pigmentation well and is extremely strong and weather resistant. Industrial applications include tool handles, lighting fixtures, and highway signs. Artists use it for vacuum molding.

Cellulose nitrate. One of the earliest of plastic materials, cellulose nitrate, *pyroxylin,* or—as it is best known—*celluloid,* was discovered in 1868 by John Wesley Hyatt. It served extensively in the 1920s and 1930s for shirt cuffs, collars, toys, teeth, and billiard balls, proving to be extremely flammable, prone to brittleness, and tending to yellow with age. Stronger, more stable plastics such as cellulose acetate have replaced celluloid in recent years. Nevertheless, it has been used by several artists seeking a new medium. Naum Gabo and Antoine Pevsner worked with sheet celluloid in their early constructivist sculptures. David Alfaro Siqueiros and Jackson

Pollock executed many of their paintings in Du Pont Duco, which at that time was a pyroxylin lacquer.

There is one celluloid material still in use by artists, model makers, and stage craftsmen: Celastic, manufactured by the Woodhill Chemical Corporation. This is a cotton flannel impregnated with pyroxylin and a flame retardant. It can be cut with a scissors, dipped in acetone until soft, and molded into any shape. When the solvent evaporates, the fabric-reinforced celluloid becomes hard, lightweight, and flexible.

Nylon. Nylon was developed by the Du Pont Company in 1940. In its original form, made from castor oil and phenol, nylon replaced silk as a hosiery fiber and was further perfected for parachutes during World War II. Today the word *nylon* (used both generically and as Du Pont's trade name) applies to a whole family of polyamide resins. Those produced in solid form are tough, long-wearing, and possessed of a slippery texture that needs no lubrication, making bearings, gears, and rollers that are quieter than metal ones. Nylon resists fuels, acids, oil, alkalies, and organic solvents. As a fiber, nylon is woven into fabrics, ropes, and cordage—all of which have excellent potential for outdoor sculptures.

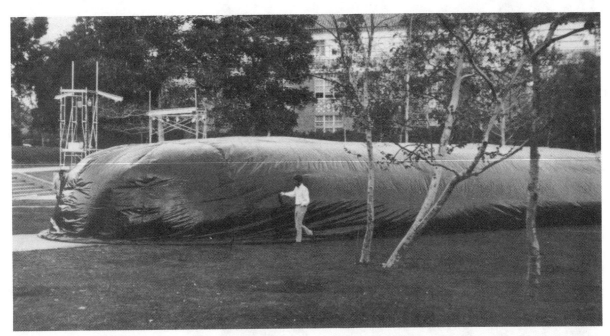

Plate 8.4. Chris Dawson, Alan Stanton, and Danny Lord, *Inflated Polyethylene Structure,* 4 mil (.004″) black polyethylene, 10′ × 16′ × 54′, 1969. University of California, Los Angeles, School Architecture and Urban Design. Polyethylene is produced in large sheets which can be taped or heat-sealed. A tube of water seals the shelter's bottom edge to the ground while a blower pumps in a constant supply of air.

Polyethylene. Discovered by the British in 1942, polyethylene was first used as an insulation material for radar cable. It appears most often today in the form of squeeze bottles, dry cleaning bags, and electrical cable covering. Polyethylene is odorless, tasteless, effective as a moisture barrier and electrical insulator, and resistant to chemicals and solvents; it has a waxy surface that cleans easily. (A stiffer, stronger, and more heat resistant variety is called high-density polyethylene.)

As a studio material, polyethylene is inexpensive and therefore useful for drop cloths, mold liners, and inflatables. Because of its resistance to adhesives, joining must be accomplished by heat sealing. Polyethylene can be produced in many colors which compensates for its resistance to paint. It is available in sheets, filaments, film, powders, rods, and tubes.

Polystyrene. The styrene family encompasses a number of copolymers in which the original qualities of polystyrene are augmented by joining them with other polymers. Such a copolymer is ABS, described above. SAN (styrene-acrylovitrile) has better outdoor weatherability and *dialectric resistance* (that is, it resists losing its insulative qualities at high voltages) than unmodified polystyrene. *Impact styrene* is a copolymer with rubber.

Polystyrene itself is rigid and crystal clear. It can, however, be dyed with transparent or opaque colors. Practical applications include battery cases, wall tiles, jewelry, lighting fixtures, and phonograph records.

Foamed polystyrene is a lightweight, rigid material manufactured in planks and beams. A common product, Dow's Styrofoam, makes an excellent sculptural substance also useful in mold-making. It comes in a variety of densities and in textures from fine to coarse, and is best worked with toothed tools such as saws, files, and rasps.

Fluoroethylene. Fluoroethylene is best known by its trade name Teflon (Du Pont). Most people recognize it as the original antistick plastic coating for pots

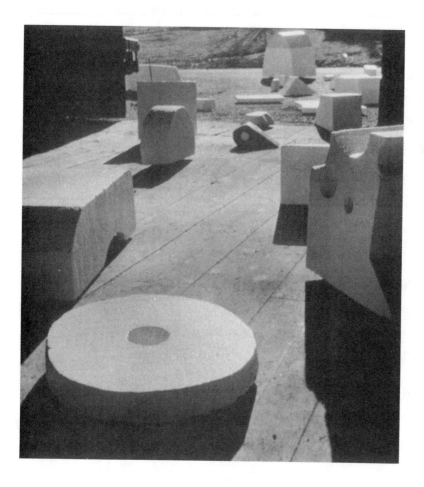

Plate 8.5. Robert Breer, *Self-Propelled Styrofoam Floats*, pointed Styrofoam forms propelled by battery-driven motors, 1965–1966. Courtesy of the artist. These simple shapes were sawed from Styrofoam blocks. Battery-powered motors driving rubber wheels are recessed into the bottom. Each motor is equipped with an inertia-activated reversing switch, so that when the float runs into something, it changes direction and backs away.

and pans. Teflon has a translucent white color, a temperature range of 425°F, outstanding resistance to chemicals, and low moisture absorption. It is used industrially for laboratory equipment, valves, stopcocks, gaskets, and seals. Teflon may have some studio applications as a high-temperature tubing or as bearings.

Vinyl. PVC, or polyvinyl chloride, is the most important of about a dozen industrially useful vinyl polymers and copolymers. Its adaptability to different manufacturing processes and its compatibility with modifying additives give it a wide range of properties. PVC can be produced as a rigid solid, as a rubbery or leathery sheet, or as the flexible and stretchy film often used as a household food wrap. Its surface can be glossy, mat, textured, or metalized, and it can be produced in many transparent or opaque colors.

In its solid or semiflexible form, PVC appears as wall and floor tile, shoe soles, electrical housings, furniture, and toys. As a sheet, or bonded to cloth, PVC is used for furniture upholstery, luggage, shoes, raincoats, simulated leather clothing, garden hoses, swimming pools, inflatable toys, and hundreds of other everyday items.

PVC in sheet form interests many artists, since it is inexpensive, comes in numerous colors and textures, and is easy to fabricate. Available in rolls six or more feet wide, PVC sheets can be glued, taped, sewed, and heat sealed, making them especially good for the creation of inflatables (see chapter fourteen). Vinyl tubing is an excellent plumbing material for sculptures involved with the transfer of liquids.

Thermosets

Epoxy. Epoxies were invented in Switzerland in 1941, but their amazing capacities as bonding and coating materials were discovered in the United States by researchers at the Shell Chemical Corporation. They encompass a broad family of resins with excellent insulating and adhesive properties, as well as great physical strength and chemical resistance. Epoxies are produced in a range of consistencies: as a thin liquid for dipping and spraying; as a viscous syrup for brushing, cementing, casting, and encapsulating; and as an adhesive paste for caulking, patching, and joining irregular surfaces. Epoxy is naturally resilient and can be made more flexible with the addition of plasticizers. It can be heavily filled with pigments and inert fillers such as sand,

sawdust, talc, marble dust, and powdered metals to produce cold-casting compounds.

Epoxy can be laminated with glass cloths and mats to produce high-strength fiberglass. Commercially, it serves for high-pressure tanks and piping, rocket cases, radar domes, space vehicle windows, electronic encapsulations, and—in liquid form—as paints, varnishes, cements, and sealants.

Uncured epoxy gives off toxic fumes and is caustic to human skin. When completely cured, it becomes chemically stable and thus safe for human contact.

Phenolic. Phenolics reach the market in several types, all based on the polymerization of phenol and formaldehyde. Among the earliest plastics (the first phenolic resin was patented by Leo Baekland in 1909), phenolics are still popular today, usually when combined with fillers such as wood flour, cotton flock, macerated fabric, asbestos, or mica. These products have an opaque brown, black, or dull red color and are very hard, rigid, and heat resistant. Phenolics are used for electrical insulators, clutch facings, brake linings, telephone handsets, and other electronic gear. As an adhesive, unfilled phenolic liquid serves as the bonding agent for plywood and particle board. Aircraft and electronic surplus stores offer many types of phenolic parts and phenolic stock that may be of interest to sculptors working with mechanical and electric art forms. The polymerization of phenolic is an industrial process that is usually not undertaken in the artist's studio.

Polyester. Artists probably use more polyester resin than all other plastic materials combined. With glass fiber reinforcement, it is the principal ingredient of *fiberglass*—a lightweight, strong, weather-resistant material that can be easily made in an assortment of shapes, textures, and colors. While polyester and epoxy resins can be used interchangeably for some of the same processes—such as laminating and cold-casting—polyester is far less expensive and much less toxic. Epoxy will adhere to most clean, dense surfaces, but polyester requires porosity for adhesion. It will not stick to metal, painted surfaces, or even to the completely cured surface of itself, though it does have excellent adhesion to wood.

Polyesters are available as fibers and films. Dacron is the trade name of Du Pont's polyester fiber that is woven into strong lightweight fabric. Mylar, Du Pont's tough polyester film, comes in a range of thicknesses from ¼ mil (.00025 inch) to 5 mil (.005

inch), available in a transparent state, in colors, and in aluminized silver or gold.

Polyester in its most common form—fiberglass—is used to fabricate car bodies, boat hulls, helmets, luggage, tool and tackle boxes, skylights, concrete forms, theater sets, swimming pools, bathtubs, storage tanks, skis, diving boards, fishing rods, and dozens of other objects that must be made of a lightweight, strong, springy material. Casting resins are available for embedment (enclosing objects),

Plate 8.6. John d'Andrea, *Two Women*, fiberglass and polyester resin, polychromed, life-size, 1971. Collection of Roger Stallaerte, courtesy of Sidney Janis Gallery, New York (photo by Eric Pollitzer). These extraordinarily lifelike figures are cast in delicately tinted polyester resin from molds taken from live models.

Plate 8.7. Eva Hesse, *Repetition 19, III*, nineteen fiberglass units, 19″–20¼″ high, 11″–12¾″ diameter, 1968. Collection of the Museum of Modern Art, New York, gift of Anita and Charles Blatt (photo courtesy of Xavier Fourcade). Eva Hesse was among the first to use raw fiberglass just as it appears when it is freshly laid-up—stringy, bumpy, pale and translucent.

cold-casting with fillers, mass-casting up to several hundred pounds, and small water-clear castings.

Silicone. Silicones are available as molding compounds, resins, adhesives, coatings, greases, fluids, and synthetic rubbers. Silastic molding compound, manufactured by Dow Corning, is an RTV (room-temperature-vulcanizing) silicone rubber with several different grades of stiffness. It provides an alternative to the emulsion of the natural latex rubber that was once the sculptor's standard flexible molding material.

Silicone lubricants, available in spray cans, make convenient mold releases, rubber preservatives, and anticorrosion protectors. Silicones maintain their properties through a wide range of temperatures,

from −100°F to +500°F.

Dow Corning and General Electric manufacture a silicone adhesive that is particularly good for sealing glass, tile, and ceramics. Artists use it for sealing the plate glass molds in resin casting.

Polyurethane. The polyurethane family is large and diverse, encompassing rigid and soft foams and coatings that range from firm to elastic. The soft foams appear in furniture, mattresses, camera cases, and many types of insulation and padding. They are excellent for packing fragile sculpture for shipping. Rigid polyurethane foam is available in densities from light (¼ pound per cubic foot) to dense and woodlike (40 pounds per cubic foot). It is supplied in boards, slabs, and blocks. Polyurethane foam is

Plate 8.8. Robert Mallary, *Fat Man*, fabric and wood impregnated with polyester resin, 72″ high, 1962. Photo courtesy of Peter Moore. Everyday articles made of fiber, such as clothing, bags, and rope, may be impregnated with polyester resin to stiffen them. Here Mallary treats men's suits with resin to create the phantom gesture of an absent occupant.

water- and vermin-proof and provides good shock resistance and sound absorption. It can be formed in place to fill cavities or cover forms. Foam is used by industry for building insulation, flotation devices, refrigerator walls, and surfboards, and by artists for molds, cores, casting patterns, models, and scenery. Polyurethane spray foam is extremely toxic and should be used only under rigidly controlled conditions.

Polyurethane coatings are particularly abrasion resistant, tough, and adhesive, so they excel wherever continuous flexibility under adverse conditions is important. They can be pigmented but are difficult

Plate 8.9. Oliver Andrews, *Skyfountain*, aluminized Mylar with red helium balloons, Mylar is 100' high × 5' wide, October 19, 1969. Photo by the author. The Mylar is ¼ mil thick (.00025″). A coating of aluminum so thin that it is translucent is applied by the manufacturer to one side of the Mylar. The lightness and strength of Mylar encourage the introduction into the atmosphere of large forms which can respond to the movement of air currents.

to sand because of their elasticity. Even the clearest urethane coatings are slightly amber in color and become more so with aging.

ADDITIVES AND MODIFIERS

Any given plastic can be tailored more exactly to meet specific needs by the incorporation of additives, or modifiers, as they are sometimes called. Some are incorporated during manufacture, others later by the user. The list of suppliers at the end of this chapter gives the names and addresses of additives manufacturers.

Antioxidants. Added to many polymers—including polyethylene, vinyl, styrene, polyester, and urethane—an antioxidant is a stabilizer that prevents oxidation, both in the process of manufacture and in the subsequent exposure of the polymer to the atmosphere. The effects of oxidation are discoloration, embrittlement, cracking, and *crazing* (the development of a network of fine all-over cracks).

Antistatic agents. Antistatic agents are usually added to plastics before forming operations in the manufacture of containers, bottles, dishes, and electronic equipment. They cut down on the accumulation of dust and lint. In some cases, a plastic object, left untreated, can build up so much static electricity that there is the possibility of an electrical discharge. Wiping dust off a statically charged surface with a dry cloth only increases its charge. There are antistatic products on the market, including convenient sprays, which can be applied after an object has been put in service.

Colorants. Colorants include organic dyes, organic pigments, as well as special-effects materials such as metal flakes and powders, pearlescent pigments based on lead and bismuth, and fluorescent pigments.

Dyes. Dyes are organic chemicals dissolved in solvents. They produce brilliant transparent colors when mixed with the clear polymers such as cellulosics, acrylics, and clear polyesters, but they tend to fade on exposure to sunlight. *Organic pigments* are dyes that have been treated chemically to render them insoluble. They exist as separate particles, even when thoroughly mixed into a polymer matrix. *Inorganic pigments* are mineral compounds, insoluble in common solvents. They are heavy, light stable, and heat resistant. Like organic pigments, inorganic pigments must be thoroughly dispersed in the poly-

mer matrix to produce even coloration. They work best for producing opaque colors. To aid in dispersion, pigments can be premixed with small amounts of resin. *Color concentrates* are premixed pigments usually in granule or pellet form; *paste concentrates* are dispersed in plasticizers compatible with specific types of resin.

Fiber reinforcements. Fiber reinforcements strengthen polyester and epoxy laminates and phenolic castings. The fibers can be woven as cloth, twisted as roving, felted or matted in random alignment, dispersed as chopping strands, or distributed as small pieces of cloth (macerated fabric). Glass fibers are the most common, but cellulose is also used in the form of cotton, jute, sisal, and rayon. Nylon, Dacron (polyester), and Orlon (polyacrylonitrile) make satisfactory reinforcements, as do metal filaments and meshes. Asbestos is an effective strengthener, whether in the form of loose fiber, yarn, felt, or cloth. One of the best known examples of an asbestos-filled plastic is vinyl-asbestos floor tile. Most artists today avoid working with asbestos because of the *extreme* care which must be taken to avoid inhaling the fiber.

Not immediately available to most artists, but interesting nonetheless, are the super-strength fila-ments of boron and sapphire used in jet engine components. Flame-polished sapphire filaments machined from solid crystals have a diameter of 20 mils and a tensile strength exceeding 600,000 pounds per square inch. The ultimate filaments are ceramic *whiskers,* single crystals of an extremely high order of symmetry. Only a few microns in diameter, they possess a tensile strength of between three and four million pounds per square inch. Needless to say, such whiskers are very, very expensive.

Fillers. Fillers were originally used to make an expensive polymer "go farther." Today, however, they modify the character of plastics in many useful ways. Fillers can add some of their own character to the mix, as sawdust makes polyester more carvable; or they may have some other effect, such as thickening and stiffening. For example, powdered silica added to polyester changes it from a syrupy to a buttery consistency.

Mineral compounds suitable for addition to polymers include sand, quartz, diatomaceous earth, silica, silicon carbide, talc, mica, asbestos, chalk, clay, cement, and plaster. Almost all forms of metal granules, chips, and powders can serve as fillers, as can plant and animal products such as sawdust, ground nutshells, seashells, and bones.

Plate 8.10. John Chamberlain, *Hua,* urethane, 32″ × 33″ × 33″, 1967. Collection of Jared J. Sable, Toronto, courtesy of Leo Castelli Gallery, New York (photo courtesy of Rudolph Burckhardt). The material is cut with a razor-sharp tool leaving slash marks in the foam. Then it is bound tightly with nylon cord.

Plate 8.11. Types of glass-fiber reinforcement. *a*. Ten ounce woven cloth. *b*. Twenty ounce woven cloth. *c*.

Heavy mat. *d*. Fine finishing mat. *e*. Rope, made of twisted roving. *f*. Chopped strands.

Microballoons and microspheres are manufactured of glass, phenolic, and other plastics for special filler applications requiring very regular aggregates.

Flame retardants. Plastics manufacturers have worked diligently to develop flame retardants that would qualify their products for continued use under federal laws concerning the flammability of fabrics and building materials. This has been a complex job, because different plastic formulations require different chemicals to slow their burning rate without interfering with their properties. Few plastics can be rendered absolutely fireproof by flame retardants; they are made to be either very slow burning or self-extinguishing. The manufacturer or supplier will provide information about whether a flame retardant was incorporated in a plastic at the time of manufacture. There are also preparations that can be applied to finished plastics and other materials to increase their fire resistance.

All artists who plan to execute works of plastics, cloth, or wood for exhibition in public places would do well to familiarize themselves with federal and local fire regulations. Exhibitions have been canceled and dismantled after the first visit of the fire inspector.

Plasticizers. Plasticizers are added to polymers while they are undergoing polymerization to give them more flexibility. A plasticizer functions much like a permanent solvent that remains within the material throughout its life. Plasticizers give vinyl (PVC) its range of flexibility and enable it to be made either hard or rubbery. Plasticizers can be added to polyester, polyurethane, or epoxy at the time it is catalyzed. An *elastomer* is plasticized polymer that is elastic as well as flexible.

A *plastisol* is a colloidal dispersion of a resin in a plasticizer. Usually prepared and applied hot, the plastisol, once it has gelled and set, becomes a thick, flexible coating. Vinyl (PVC) is the most commonly used plastisol, as seen in vinyl-coated metal and cloth.

Ultraviolet stabilizers. Although claims extolling the durability of plastics are well founded, like all organic matter, plastics are damaged by ultraviolet light. Since the chief source of ultraviolet light is the sun, all plastic objects to be mounted outdoors must be well protected, or chalking, crazing discoloration, embrittlement, and eventual disintegration will result. The most ultraviolet-resistant plastics are polyvinyl fluoride and acrylic; like all other plastics

intended for outdoor use, they are formulated with ultraviolet stabilizers appropriate to their polymeric composition.

There are many ultraviolet stabilizers and several different methods by which they screen out ultraviolet radiation or absorb its energy. In preparing epoxy, polyester, polyurethane, and acrylic coatings for outdoor use, extra ultraviolet stabilizers can be added to the mix. Lack of sufficient protection is particularly noticeable on sculptures that have a clear coating applied over a polished or ground metal surface. The appearance of the entire work may be altered as the coating darkens and crazes.

Solvents and parting agents. A *solvent* is a liquid capable of dissolving other substances. Most thermoplastics can be dissolved by solvents in their uncured state. Once a plastic has completely cured, however, its solvent is usually no longer effective except as a surface cleaner.

Solvents are indispensible for cleaning tools and working surfaces. In general, acetone or methyl-ethyl-ketone (MEK) function as cleaning solvents for epoxy, acrylic, polystyrene, vinyl, polyurethane, and polyester. There is no known solvent for polyethylene.

Before working with a particular plastic, you should familiarize yourself with its solvents. This information can be found in the manufacturer's specifications and should be available from your plastics supplier.

A *parting agent* is a substance to which a particular plastic will not adhere. Such materials are essential as mold release agents when casting plastics and are discussed more fully in chapter four.

WORKING WITH PLASTICS

Acrylics

The most transparent of all plastics and one that can be fabricated in a variety of ways, acrylic is one of the standard materials of contemporary sculpture.

Liquid forms. Acrylic sheets and other shapes are all manufactured by casting. In this process, liquid monomers are mixed with catalysts and poured into molds or between sheets of glass. The temperature and pressure must be controlled very precisely, because they are critical in the polymerization of acrylic, and variations can cause bubbling and discoloration. Thicker castings require even greater

Plate 8.12. A mold ready to be poured with acrylic, Bruce Beasley's studio, 1978. Photo by the author. Note the center section, which is made of a piece of heat-formed acrylic sheet.

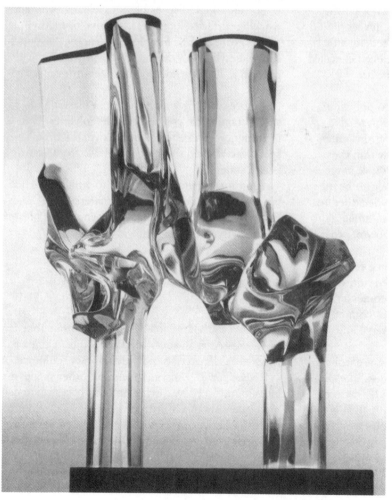

Plate 8.13. Bruce Beasley, *Stamper's Lighthouse*, cast acrylic, 28½″ × 25″, 1967. Courtesy of the artist. The brilliant light-reflective qualities of acrylic are enhanced by the convolutions of this piece. Beasley has cast larger acrylic sculptures than any other artist.

precision of temperature and pressure. For this reason, acrylic becomes increasingly expensive in thicker sections.

Acrylic monomers are available for casting, but they are very difficult to use, except for thin panels and embedments. One artist, Bruce Beasley, has succeeded in casting large works from liquid acrylic monomers. Beasley uses an *autoclave,* a giant pressure tank capable of extremely fine adjustments for pressure, temperature, and humidity.

Acrylic polymer liquid can be cast in thin layers—up to about a half inch thick—to produce embedments. Basically, this process consists of the following steps: The liquid is mixed with a few drops of a catalyst (to accelerate curing) and then poured into a mold that has been treated with a release agent. When this layer reaches the consistency of a rubbery gel, moisture-free objects are placed on its surface, and a fresh layer of liquid is poured to cover the objects. Each time a layer reaches the gel state, objects can be set in, then covered over with an additional liquid layer. When the finished piece feels cool to the touch, it is sufficiently cured to be removed from the mold. Be sure to keep your work area free from dust to avoid trapping particles in the clear acrylic as it cures. For making transparent panels and reliefs, the layers of cast acrylic can be poured into a shallow box of acrylic sheet edged with rectangular bars or strips. This will ensure that the surface and edges will be flat and undistorted. Follow the manufacturer's recommendations con-

cerning the catalyst to be used, the proportion of liquid to catalyst, and pouring procedures.

Solid forms. Solid acrylic sheets are available in two main types: *shrunk* and *unshrunk.* Shrunk acrylic will remain dimensionally stable throughout heating and bonding operations, because it is manufactured to exacting tolerances. Unshrunk forms will shrink approximately 2.2 percent in length and about 4 percent in thickness during heating and forming. Unshrunk is cheaper than shrunk acrylic, making it a good choice for projects that do not require precise dimensions. Also available are special varieties of solid acrylic, including flame-resistant, ultraviolet-absorbing types often used by museums for fabricating display cases, and solvent-receptive grades that are more easily cemented, laminated, and solvent dyed.

Sheets range from 1/16 inch to 1 inch thick; blocks 24 by 36 inches come in thicknesses up to 12 inches; rods vary from 1/16 inch to 12 inches in diameter; and tubes are available in diameters up to 18 inches.

Acrylics can be fabricated in many ways. They can be carved, sawed, drilled, sanded, heat formed (bent, vacuum formed, or blow formed), and bonded with adhesives or solvents.

Cutting. Since acrylic is easily scratched, the paper covering the sheets when they are purchased should be left on for as much of the working procedure as possible. The paper also makes a convenient surface for making guide lines. If the paper is

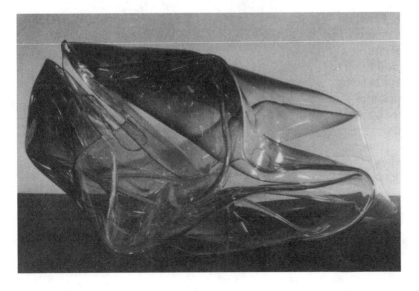

Plate 8.14. John Chamberlain, *Polacca,* metal-coated Plexiglas, 22″ × 39″ × 46″, 1970. Courtesy of Leo Castelli Gallery, New York (photo courtesy of Eric Pollitzer). The acrylic sheet is coated with iridescent colors in a vacuum deposition chamber of the type used to coat glass. While still warm, the sheet is removed from the chamber and hand-formed.

missing, the bare acrylic can be covered with brown wrapping paper or drawing paper affixed with rubber cement. Bare acrylic can be safely marked with a grease pencil.

One of the convenient aspects of working with acrylic is that it can be cut, drilled, and sanded with the same standard shop tools that are used for wood or metal. A band saw blade of 10 to 12 teeth per inch is good for sheets up to ½ inch thick; an 8-tooth blade will cut better without burning for thicker sections. Band saw blades are available with special tooth patterns for sawing plastics. Since burning or melting the material in the cut is to be strictly avoided, only sharp blades should be used. When cutting with a circular blade on the table or radial arm saw, a carbide-tooth blade will cut more cleanly than a conventional blade. Visors should be worn to guard against chips. With thicker sections it is wise to wear a respirator since acrylic fumes are particularly noxious and stinging to the nasal passages.

For cutting curved shapes in 1/16-inch to 3/8-inch acrylic a saber saw is particularly useful. Use a metal cutting blade, leave the paper on the sheet, and cut slowly to avoid heat buildup. A right-angle grinder with a coarse fiberglass disk will trim large pieces of acrylic, whereas light shaping may be done with a high-speed die grinder, air or electric, driving a carbide burr or mill at 20,000 to 45,000 rpm. These tools can be self-contained or mounted in a handle at the end of a flexible shaft. They are particularly good for carving intaglio designs into the face of an acrylic sheet. When the sheet is illuminated from the edge, the design will light up.

Forming. Heat forming operations are based on the ability of acrylic to soften within the temperature range of 250°F to 320°F. (Greater temperatures will cause it to bubble, and at 700°F acrylic will begin to burn.) The actual temperature required for bending acrylic depends on the thickness of the material—which retains heat—and the amount of bending to be done. Observe the following guidelines:

1. Allow for shrinkage of unshrunk acrylics.
2. For each 1/100 inch of thickness, allow about one minute of heat.
3. Except in the case of simple linear bends, the whole piece to be formed should be heated uniformly to avoid stresses and subsequent crazing.
4. The bending should take place in one unified operation before the plastic cools.

Kilns, ovens, kitchen stoves, hot plates, and propane torches can be used for heating. One of the best devices is an electric heat gun, which produces a column of heated air at a selected temperature. To heat a narrow area, as when making a long bend, the preferred tool is a commercial strip heater. These are manufactured for plastic and glass bending, but you can make one by welding gas stove parts or from a length of pipe. Asbestos gloves should be worn when handling the hot plastic. Jigs and forms help to shape and support the acrylic while it hardens.

Vacuum forming and *blow forming* combine heat (approximately 270°F for sheet acrylic) with air pressure. If a piece of heated acrylic is tightly clamped over a hole in a box, air pumped into the box will blow the acrylic into the shape of a hemispherical bubble. However, if the air in the box is pumped out, the vacuum created will pull the heated acrylic down into the box to form a concave hemisphere. Base templates and patterns permit the creation of a

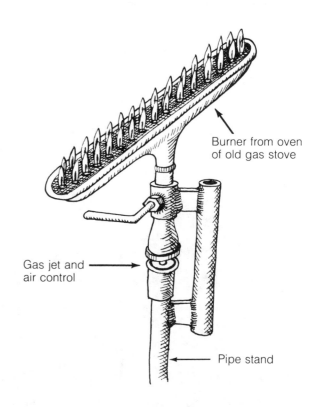

Burner from oven of old gas stove

Gas jet and air control

Pipe stand

HOMEMADE STRIP HEATER

Figure 8.2. Homemade strip heater.

Plate 8.15. Leister hot air tool. Courtesy of Brian R. White Company, Inc., Westminster, California, and Leister-Elektro-Geraltbau, Switzerland. This tool directs a column of heated air on the spot to be formed or melted.

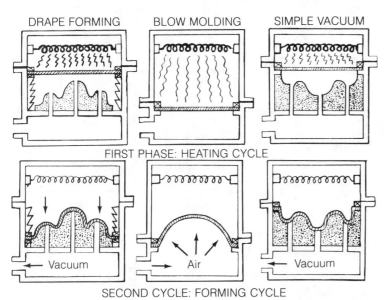

DRAPE FORMING BLOW MOLDING SIMPLE VACUUM

FIRST PHASE: HEATING CYCLE

Vacuum Air Vacuum

SECOND CYCLE: FORMING CYCLE

Figure 8.3. Vacuum forming and blow molding. The dotted shapes in the vacuum forming ovens are the patterns that form the heated plastic when it is pulled down over them. Free blowing and simple vacuum forming are adequate for small shapes in thin sheets. Larger, heavier forms require the more positive action given by the moving frame of the drape forming press.

Plate 8.16. Plasti-Vac Vacuum Press Model 406XX. Courtesy of Plasti-Vac Inc., Charlotte, North Carolina. This machine will handle vacuum and drape forming of plastic sheets from 1' × 1' to 4' × 6' × 26" deep.

variety of shapes, ranging from simple bubble forms to letters and complex reliefs. Molds of this type are not difficult to construct in a well-equipped studio, but size is limited by the problems of heating a large piece of acrylic evenly and developing adequate vacuum pressure to pull it into shape while it is still hot. The vacuum mold seems to be the most promising type for the home builder, because it can produce more versatile shapes than the blow mold, and because the blow mold cools the acrylic sheet rapidly if it is larger than a few inches across. Vacuum and blow forming can be applied to other thermoplastic sheet materials, such as ABS, Tenite or Uvex (cellulose acetate butyrate), and polyethylene.

Joining. Acrylic pieces can be joined with specific solvents or cements. The standard acrylic cementing

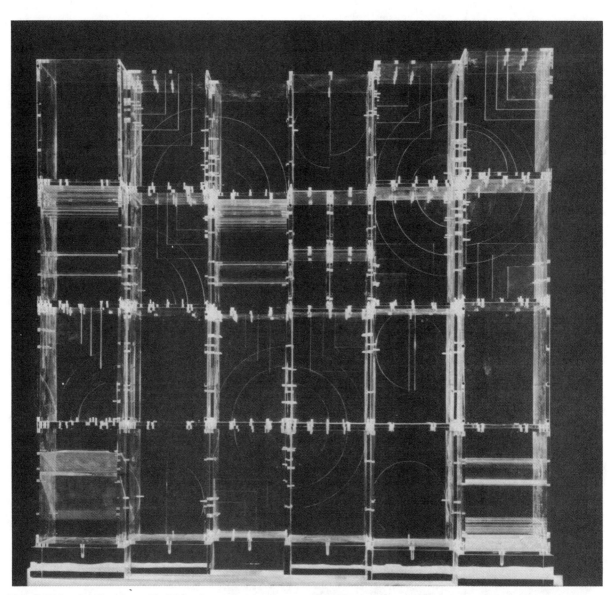

Plate 8.17. Louise Nevelson, *Model for Atmosphere and Environment: Ice Palace I*, clear Lucite, 24″ × 26″ × 12″, 1967. Courtesy of Pace Gallery, New York (photo courtesy of Ferdinand Boesch). When acrylic is edge-lit, the light traveling within the planes of plastic is emitted wherever the surface is etched or engraved. The sculpture is assembled with screws.

agent, ethylene dichloride (EDC), is a solvent, not a cement. The parts coated with EDC soften and when pressed together make a weld. EDC thickened with dissolved acrylic is used for joints where there is a space to be filled. The water thinness of EDC works as an advantage in syringe-cementing. This technique applies when an assembly of regular flat shapes is to be cemented together, as in making a box or frame. The assembly is clamped together snugly (not tensely), and the EDC is squirted into the joints with a hollow-needle syringe. The EDC fills the joints, and capillary action tends to hold it in place. Delicate tightening of the clamps presses the softened surfaces together and promotes welding.

For heavy laminates and stressed joints, a catalyzed resin cement is used. Cadillac Plastics manufactures an adhesive named PS 30 that produces a clear bond of great strength.

The clamping of acrylic laminations is an art in itself. If the mating surfaces are clean and the cement of the right consistency, sensitive tension will eliminate bubbles without squeezing out too much cement.

Finishing. Sanding and polishing are sometimes required to finish acrylic sculptures. Acrylic can be sanded easily as long as heat is not allowed to build up to the plastic's melting point, which would cause smearing of the surface and gumming of the sandpaper. Aluminum oxide or garnet sandpapers of 80 to 150 grit are the best for rough sanding, garnet and open-coat silicon carbide of 150 to 220 grit for medium sanding, and silicon carbide of 320 to 600 grit, used wet, for final smoothing. Edge trimming is often done with files. A crescent pattern auto-body file leaves a smooth plane when used to trim the edges of acrylic sheets. Polishing should be done with a sewn buff and white tripoli compound, followed by a loose buff, either dry or with a commercial acrylic polish like Meguiar's Mirror Glaze.

Flame polishing involves passing a flame quickly over edges or small parts so that the surface just barely melts. This takes some practice. It can be done with a self-contained propane torch or, more accurately, with an oxyacetylene torch with a 0 or 00 tip.

Abrasive household cleaning powders must never be used on polished acrylic, nor should alcohol, gasoline, or spray-type glass cleaner. Only soap and water or one of the commercial cleaners formulated specifically for acrylic are suitable for cleaning. Once the surface becomes dulled, the only way to restore it is by rebuffing.

Acrylic can be dyed, either before or after fabrication, by dipping or wiping with any of the acrylic dip dyes available from plastics suppliers. These are aniline dyes in a water-acetone base.

Acrylic paints. Acrylic lacquers dry very quickly, are made in a great many colors, and retain their gloss exceptionally well, even outdoors. They are excellent for painting all types of steel and aluminum sculptures where a high-gloss finish is desired. Care should be taken to use appropriate primers and thinners, as recommended by the lacquer manufacturer.

Water-soluble acrylic emulsion paints are fast-drying, highly stable, durable, and flexible. They come in a full, rich spectrum of colors; Rhoplex, a water-based acrylic manufactured by the Rohm & Haas Company, is supplied in traditional hues and also in pearlescent colors containing a reflective additive. Acrylics work as well for painting sculptures as they do on canvas, and are particularly compatible with cloth, paper, cardboard, plaster, wood, and Styrofoam (polystyrene). Stiffeners are available for building up a thick surface. Durable as acrylic paints are, however, they are not intended as protective coatings, as are epoxy or urethane enamels, which can withstand abrasion and impact.

Fiberglass

The woven or matted glass-fiber cloth reinforcement in polyester laminates is commonly described in literature by the two words *fiber glass.* The polyester-glass cloth laminate so produced is also called *fiberglass,* one word, and this is a common usage among artists, builders, and craftspersons. *Fiberglas* is a trade name of the Owens-Corning Fiberglas Corporation of Toledo, Ohio. In this book, the word *fiberglass* means glass-reinforced polyester laminate.

Glass fibers. Glass fibers are available in the form of cloth, mat, tape, rope, and chopped strands. Since the individual fibers are extremely fine, they must be twisted into thread or yarnlike roving before being matted or woven into other forms. When glass fiber is thoroughly embedded in resin, a new material results, which has the qualities of its two components but which transcends both of them in many

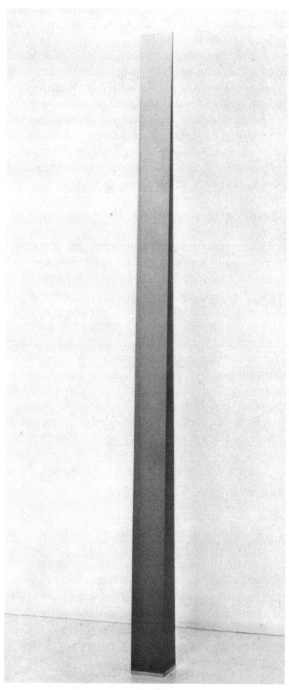

Plate 8.18. Peter Alexander, *Untitled*, polyester resin, 96″ × 8″ × 8″, 1968. Private collection, Los Angeles (photo courtesy of Frank Thomas, Los Angeles). This wedge-shaped sculpture was cast in a mold of ¼″ tempered glass and then sanded with successive grits of sandpaper, ending with No. 400 wet sandpaper. The tapered shape produces a subtle gradation of color.

respects. Such two-phase materials display great tensile strength combined with elasticity. (Steel-reinforced concrete is another two-phase material. An example of a two-phase material occurring in nature is wood, in which cellulose fibers are embedded in a matrix of lignin. In bamboo this structure is particularly clear.)

Polyester resin. Uncured polyester is a thick, syrupy liquid that can be polymerized by heat to produce a tough solid mass. The more heat applied, the faster this reaction proceeds. The standard method of heating is through the combined action of a promoter (usually a cobalt compound) and a catalyst, methyl-ethyl-ketone (MEK). Commercial resins, unless otherwise specified, are sold with the promoter already mixed in, giving the originally clear resin a pale violet or amber hue. Additional promoter can be added to make the resin set under adverse conditions, but *undiluted promoter and catalyst must never be mixed together,* or a violent explosive reaction will occur.

Each manufacturer gives resin/catalyst proportions for average conditions, but the correct amount for each application can be determined only by experiment. This is because many factors influence curing rate, including temperature, humidity, and the thickness of the section to be fabricated. Thicker sections create more heat or exotherm, so less catalyst is required. An average proportion for laminating would be about two teaspoons of catalyst to a quart of resin.

Once the catalyst has been thoroughly stirred into the resin, there will be a working period of from five to thirty minutes before the resin begins to gel and then harden. Occasionally, after fiberglass has been laid up, it is advantageous to accelerate the cure with sunlight or infrared lamps. Old resin will be slightly oxidized and therefore slow to harden.

Several types of polyester resin are manufactured, each tailored to a specific application. These include casting resins (see chapter four) and the laminating, sanding, and finishing resins used in making fiberglass laminates, as discussed below.

Laminating. Fiberglass sometimes is laid up over another material such as wood or foam, in which case it becomes a shell or protective layer bonded to a core; or it may be laid up on a mold from which it is later separated to make an independent form. Surfboards and bar tops are made the first way, car bodies the second.

Glass cloth and three types of resin are used in fiberglass laminates. *Laminating resin* has a slightly sticky surface when set, which aids in holding the next layer of cloth in place. Since the surface is not quite cured, a better bond forms with the next layer of resin as well. *Sanding resin* is brushed onto intermediate layers of forms that must be sanded to shape before a finishing coat is applied. This resin contains fillers that allow it to be sanded without clogging the sandpaper as much as laminating resin does. *Finishing resin* has an admixture of liquid wax that rises to

the surface, protecting it from the air and promoting a complete cure.

Once the initial layer of resin is laid up, laminating the cloth and resin proceeds until the required thickness has been achieved. If a thick layer is desired, glass mat can be sandwiched between two layers of cloth. Air bubbles impair the strength and clarity of fiberglass; rollers and squeegees help to push the resin through the fibers while forcing out trapped air. When the fibers have been thoroughly impregnated, they become transparent. A layer of clear acetate or

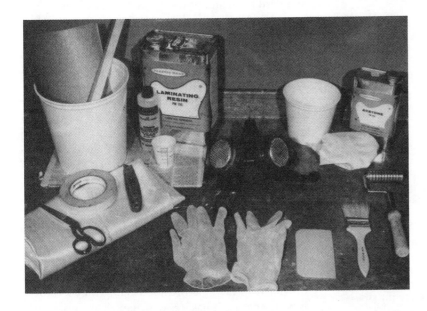

Plate 8.19. Tools and materials for laying up fiberglass. All the tools and materials, including gloves and respirator, should be ready before beginning to "lay up" or laminate the work.

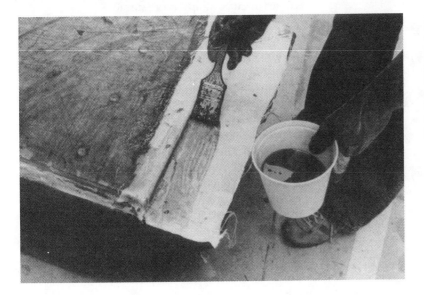

Plate 8.20. Fiberglassing wood. The wood is given a coat of laminating resin, a layer of cloth, and another coat of resin, which is worked well into the cloth with brush and roller to eliminate wrinkles and air bubbles. Several more layers of cloth may be applied if desired, and finally a coat of finishing resin.

Mylar pressed over the final coat of glass and resin helps to squeeze out the bubbles and also provides a protective barrier to promote curing.

The lamination process is essentially the same whether you make a molded form or cover a core of wood or foam. Laminating resins cannot be used for casting, however, because they produce so much heat that thick sections would crack. Mold-making and casting techniques are discussed in chapter four.

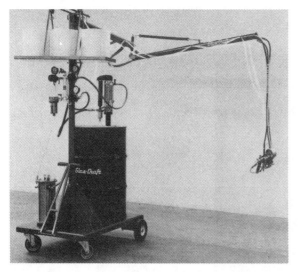

Plate 8.21. Fiberglass spray rig. Courtesy of Ransburg Corporation, Indianapolis, Indiana. Visible here are the spray gun at the end of its boom, the roll of glass fiber, catalyst metering cylinder, resin drum, and pressure pot, plus pressure gauges to adjust the flow of materials to the gun.

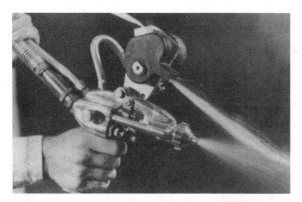

Plate 8.22. Spray gun: mixing catalyst, resin and glass filaments. Courtesy of Ransburg Corporation, Indianapolis, Indiana. The gun delivers a stream of catalyzed resin into which is blown a spray of prechopped glass fibers. Anything it is directed at will be covered with a sticky layer of fast-setting fiberglass.

In the fiberglass-to-core method, the core material must be sanded so that the resin will adhere to it. Glass cloth has a certain amount of bias give, so it will adapt itself to small bumps, but shapes with complex curves should be covered by pieces of cloth small enough to fit without wrinkles.

When cured, pieces of fiberglass can be glued together with epoxy and the joints reinforced with glass fiber tape. Holes can be filled with a paste made of resin and thixotropic silica, with chopped strands added for larger sections.

Fiberglass can be sawed, drilled, and sanded with standard hand and power tools. Glass and resin dust are very damaging to the armatures of electric motors, so motors should be cleaned by blowing air through them at the end of every work session. Glass fiber and resin dust can also damage human lungs, eyes, and skin. A respirator, face shield, gloves, and adequate clothing should be worn when using power tools with fiberglass. Plastic bands or ties at wrists and ankles help keep dust out.

Polyester resin will take a polished surface if buffed with auto buffing compound and a lamb's wool bonnet on a disk driven by a sander or polisher. High-speed grinders should be slowed down with a speed control so the resin will not be overheated. Before buffing, the resin should be wet-sanded with 320 or 400 grit paper on an oscillating sander. The preferred tool for this is an air-driven sander with an eccentric oscillating disk. For taking down flat surfaces before fine sanding, a belt sander is best, because it has less tendency than a disk sander to cut scallops in the surface.

Spraying. Several companies manufacture complete outfits for spraying fiberglass. The equipment is mounted on a movable cart and consists of a drum of resin, the catalyst container, a spool of glass filament, an air compressor, and a spray gun. The gun has controls for metering resin and catalyst, as well as for chopping the glass filament into the desired lengths as it is fed into the stream of catalyzed resin. An expensive piece of equipment, the spray rig is used to spray resin and glass into or over molds to make boat hulls, car bodies, architectural elements, and even entire buildings. No hand layup is necessary, since the gun can spray the gel coat and all subsequent layers with any mix of glass, resin, and thickener.

Working over armatures. Another method for building hollow fiberglass shapes is to work over a

form made of wire mesh. The form is constructed much like an armature for a plaster sculpture (see chapter three). It requires less bracing, however, since fiberglass is stronger and lighter than plaster. The glass cloth can be sewn onto the wire mesh and painted with resin, or pieces of glass cloth already saturated with resin can be applied directly to the armature. Unless a great deal of glass and filler is used, this method produces a somewhat lumpy, rough sculpture. It is particularly fast and easy for making trees and rocks for stage sets.

An even freer method for working with fiberglass involves constructing a sketchy armature of mesh, wire, rods, slats, or branches, and then draping pieces of resin-impregnated glass cloth over this, using the natural drape of the cloth as a condition of the sculpture. When the cloth has stiffened, the work can be positioned at a different angle for

Plate 8.23*a*. Fiberglass over mesh. The glass cloth is trimmed to shape and laid up over the mesh. Resin should be applied to the back side also unless it is impossible to reach, as in a totally enclosed form.

Plate 8.23*b*. Layers of glass cloth and polyester resin built up over form. One or more layers of glass cloth and polyester resin are built up over the form.

8.23*c*. The final surface is trimmed and sanded. If left unpainted, the fiberglass will be translucent and the mesh will show through. This method may also be used for enclosed volumetric forms.

further draping. Cloth, rope, feathers, and innumerable other materials can be incorporated as the work proceeds.

Safety and cleanup. The solvent for uncured polyester resin is acetone. It should be used to clean brushes, tools, and clothing. Cheap, disposable brushes and rollers will save cleanup time and avoid unnecessary contact with resin and acetone, as will liberal use of disposable drop cloths. Uncured resin must not be permitted to get into the mechanism of power tools or to remain on floors, shelves, or equipment, where it could contaminate unsuspecting persons. Acetone should not come in contact with skin, for it removes protective oils, causes drying, and can result in an allergic reaction. A waterless hand cleaner like Sta-Lube, followed by soap and water, will remove resin from the skin. Although polyester is not toxic to the skin, as epoxy is, it is still very caustic and difficult to remove. Anyone who does extensive work with polyester should wear disposable polyethylene or latex gloves.

Polyester fumes are quite unpleasant, and prolonged exposure to them can be dangerous to your health. Immediate symptoms may be headache and

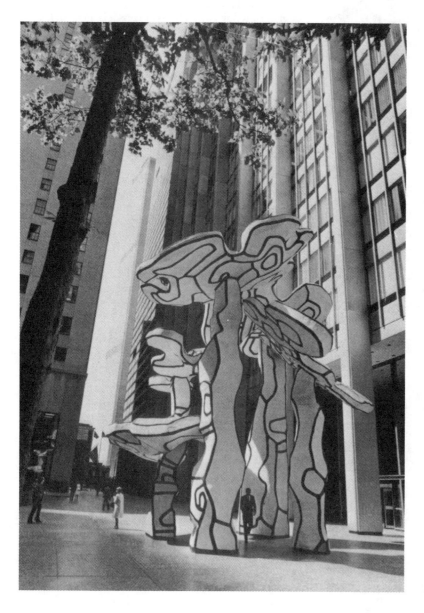

Plate 8.24. Jean Dubuffet, *Group of Four Trees*, polychromed fiberglass over concrete and aluminum core, 42′ high, 1972. Courtesy of the Chase Manhattan Bank, New York (photo courtesy of Arthur Lavine). Reinforced concrete forms the cores of these figures, which are covered with laminated fiberglass and paint. Polyester resin will adhere to porous concrete.

nausea. Indoors, a forced-air ventilation system must be used for fiberglass work. A *resin tent* of polyethylene sheeting served by a fan can be set up within the studio to isolate resin activities from other types of work. Care must be taken that the exhaust duct of the system does not pump the fumes into inhabited areas outside the building, or the victims of the fumes will oppose all resin work in your neighborhood. Do not eat or sleep in the area where you are working with polyester or other resins.

It should again be stressed that glass fiber and resin dust are damaging to the lungs. Always wear a respirator, face shield, gloves, and protective clothing when spraying or using power tools on fiberglass. Any glass fibers breathed into your lungs will remain there for the rest of your life.

Epoxies

Uncured epoxies come in a range of viscosities: water thin, syrupy, or as a thixotropic paste. They can be formulated for casting (as discussed in chapter four) or as adhesives, putties, and coatings.

Adhesives. Epoxy is an excellent adhesive for joining hard, smooth materials difficult to bond with conventional adhesives. It thus offers the best way to cement substances such as glass, metal, plastic, and ceramic. Epoxy is also a superior weatherproof adhesive for porous materials, including wood, plaster, concrete, leather, and fabric. The bonding strength of epoxy depends upon the cleanliness of the mating surfaces. If a trace of oil, moisture, or dust remains on either surface, the bond will probably fail. Acetone, ketone (MEK), carbon tetrachloride, and chlorothene can be used to prepare clean surfaces for epoxy bonding (the latter two give off toxic fumes). Metal surfaces should be ground bright if possible.

Unlike polyesters, epoxies require a certain exact amount of catalyst to produce the polymerization reaction. More catalyst does not make them set faster; in fact, too much catalyst may inhibit polymerization. Some industrial epoxies have very critical catalyst requirements. Most epoxies for general use, however, have been adjusted so that the requirement is a simple proportion, such as equal parts of resin and catalyst by volume, or two parts to one.

The polymerization of epoxy (like that of polyester) accelerates in proportion to mass. Some epoxies are allowed to cure in the pot for twenty to thirty minutes before use so that polymerization can have a

chance to get started. Epoxies do not set suddenly (as do polyesters), but rather thicken gradually and often take several days after hardening to reach their maximum strength.

When completely cured, epoxy bonds are very strong in terms of the amount of continuous stress they can withstand. However, a sudden impact can sometimes break an epoxy joint, and sustained vibrations have been known to weaken such bonds. The addition of plasticizers lowers the ultimate strength of epoxy but makes it more resistant to vibration.

The best adhesive for joining two dissimilar substances—such as wood and glass, or metal and ceramics—is flexible epoxy. It must be remembered that different materials have different coefficients of

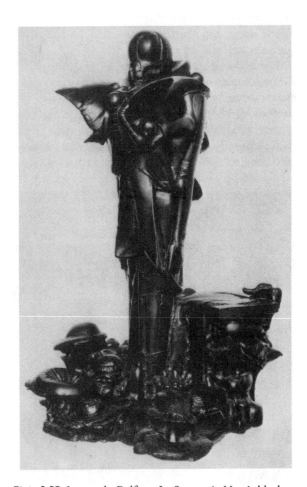

Plate 8.25. Leonardo Delfino, *Le Souverain No. 1*, black epoxy resin, 75″ × 39½″ × 43½″, 1972. Collection of the artist (photo courtesy of Galerie Darthea Speyer). Black pigment was mixed into the epoxy resin before it was cast in the forms of the sculpture.

expansion when subjected to changes in temperature. A two-material bond that has held for a long time may suddenly fail when there is an abrupt change in temperature. It is best to try to design such joints so that they combine mechanical and adhesive principles.

Putties. There are many types of joints in which the surfaces to be joined do not fit together perfectly. An epoxy putty excels in these situations, since it is both an adhesive and a filler and has physical strength when cured. Many commercial preparations of this type are available. One that allows easy preparation is a mixture of a thixotropic filler—fine silica, for example—with liquid epoxy. Coloring agents and other fillers can also be mixed in. Powdered metals, stone dust, and sawdust combined with epoxy make, respectively, plastic metal, plastic stone, and plastic wood—all useful for patching holes and making repairs.

Epoxy putties can also be used as modeling pastes for building up small sculptures over armatures and for modeling over cores of wood, foam, clay or cardboard. They are excellent for making maquettes, architectural models, and designs for the stage.

Coatings. Some general-purpose epoxies can serve interchangeably as casting materials, adhesives, and coatings, but most epoxies labeled as coatings are made specifically for this purpose and set up only when applied as a thin film. Epoxies can be sprayed, brushed, or rolled. Their adhesion to smooth surfaces such as metal is good, provided that these surfaces have been adequately cleaned. Uncured epoxy is toxic, and precautions should be taken when spraying it, as discussed in the section on safety and cleanup.

Epoxy is available in an almost clear form that will mix with transparent and opaque pigments. Many premixed epoxy "paints" are on the market. They are widely used as architectural and marine finishes.

Since most epoxy coatings are slightly flexible, they cannot be buffed and polished like polyesters and lacquers. Most epoxy paints, however, produce a high-gloss, exceptionally long-lasting surface.

Safety and cleanup. Epoxy resins and their catalysts are toxic to human tissue, so any direct contact with them must be avoided. Disposable plastic gloves should be worn at all times. When epoxy is being sprayed, the operators must leave no exposed areas of skin or hair. Any parts of the body that come in contact with epoxy should be cleaned immediately with waterless hand cleaner, then washed thoroughly with soap and water. Carelessness with epoxy carries the risk of developing a cumulative allergy that produces blisters and cracking of the skin.

Epoxy fumes are toxic. Except when you are mixing small amounts from squeeze tubes, a respirator should always be worn. Fans, resin tents, and ventilated spray booths should be set up for indoor work. When large amounts of material are involved, it is advisable to wear a respirator connected to a supply of air coming from outside the working area.

Epoxy thinners are sold by plastics suppliers for cleaning brushes and equipment and, in small amounts, for thinning epoxy paints. Lacquer thinner is cheaper than epoxy thinner and makes an effective solvent for cleanup. It should not be used for cleaning hands, however, because it is itself toxic. Waterless hand cleaner will remove epoxy from the skin. Disposable brushes and disposable paper or plastic drop cloths should be utilized whenever possible.

Do not eat or sleep in the area where you are working with epoxy or other resins.

After spraying epoxy or other resins, you must immediately clean the spray gun with solvent, or the resin will solidify inside it. After running solvent through the gun, take it apart, wash all parts with

Plate 8.26. Hand cleaner dispenser. When hand cleaner is conveniently available, it is more likely to be used. Solvents such as turpentine, paint thinner, lacquer thinner, or acetone should not be applied to the skin.

thinner, and dry them completely. Disposable gloves and a respirator should be worn for this operation.

Polystyrene and Polyurethane Foams

Although plastic foams made from cellulose acetate, epoxy, vinyl, and phenolic resins are available, polystyrene and polyurethane are by far the most common foam materials. They are supplied in two forms: solid blocks, sheets, and bars; and liquid two-part systems that can be sprayed or poured.

Solid foams. If you compare a piece of polystyrene with a piece of polyurethane of the same density and color, the two will appear to be quite similar. But there are some important differences between them. Styrofoam (the trade name of foamed polystyrene) is compatible with epoxy and dissolved by polyester; polyurethane is compatible with polyester but dissolved by epoxy. Both are attacked by acetone and lacquer thinner. This means that if you want to coat Styrofoam with a fiberglass shell, the Styrofoam must first be coated with epoxy or another protective material, or else the polyester in the fiberglass will dissolve the foam.

Both Styrofoam and polyurethane can be cut with hand saws, rasps, files, and band saws. Electrically powered carving knives work well too. Styrofoam can be cut with a hot wire kept at a constant melting-point temperature, with a hot knife or soldering tip, and even with the flame from a welding torch. A respirator should be worn to intercept the fumes. Polyurethane must never be cut with hot tools, since its fumes are highly toxic.

Although both Styrofoam and polyurethane tend to yellow and deteriorate outdoors, polyurethane is the more durable of the two.

Sculpting with foam. Styrofoam and polyurethane are frequently used as easily carved core materials over which other, harder materials can be applied as a finishing layer. Fiberglass is excellent for this purpose. Plaster and cement allow some modeling to be done in producing the final shape.

Open constructions can be made from foam boards, slabs, bars, and a variety of preformed shapes fastened together. Pins or skewers of pointed metal rod ⅛ to ¼ inch in diameter serve for holding a

Plate 8.27. Carl André, *Crib, Coin and Compound*, Styrofoam planks, each 9′ × 9′ × 18′, 1965. Installation at Tibor de Nagy Gallery (photo courtesy of Sperone Westwater Fischer Gallery, New York). These "logs" of foamed polystyrene are stacked in their "as-delivered" factory condition. The sides retain the skin left by the mold. The ends have an open texture where they were sawed to size.

construction together while adhesives are setting. Good adhesives for joining foam pieces include epoxy, aliphatic resin glue, white glue, asphalt tile cement, and resorcinol-base glues. Acetone solvent cements and putties cannot be used because of their action on the foam. For large carvings, slabs of foam can be laminated to the desired size.

Ragged, charred, flamelike forms result from Styrofoam shaped with an oxyacetylene torch, but this method so overpowers the material that all flame-carved Styrofoam sculptures tend to look much alike. This technique is not advisable with polyurethane, because its fumes are not intercepted by standard respirators.

Models and scenery. Because foams are lightweight and can be worked easily, they make an excellent material for models. Full-scale models of sculptures can be carved out of foam and set upon the intended site, enabling the sculptor to judge scale and position. For the same reasons, foam is popular for the construction of stage scenery. The open texture of the foam may be modeled over with resin paste or plaster to simulate various materials. Al-uminized Mylar can be glued to surfaces to simulate polished metal. Check with the manufacturer about flame retardants.

Liquid foams. Two liquid ingredients—polyether resin (freon) and fluorocarbon-polydiisocyanate—are mixed together to produce urethane foam. The proportion of each substance depends on the individual manufacturer and the density of the foam to be made. Both ingredients are highly toxic.

Before the ingredients are mixed, everything must be ready, including the tools (masonry trowels or wooden paddles for pushing the foam into place) and the armature or base upon which the foam is to be poured. Mixing and placing must be accomplished within about five minutes. Gloves, face shield or goggles, and a respirator with an independent air supply must be worn, and, if you work indoors, an adequate exhaust system must be operating. Polyurethane fumes are strong enough to sting unprotected eyes. They are heavy and tend to cling to the floor. The exhaust system must be able to deal with this situation.

Plate 8.28. Flame-sculpted foam. This block of Styrofoam was carved with the flame of a welding torch. Wear a respirator and work in a well-ventilated place when trying this.

Plate 8.29*a*. Foaming in place. The foam is mixed and quickly troweled over the armature. This one is made of wire mesh nailed to plywood bulkheads.

Plate 8.29*b*. Foaming in place. When the foam has set it is shaped with saws, rasps, and files.

Plate 8.29*c*. Foaming in place. When the foam has been shaped, it is usually covered with one or more layers of glass cloth and resin.

The two ingredients should be mixed quickly in a large container with a drill mixer. A malted-milk mixer can be used for small batches, or commercial mixers are available. As soon as foaming starts, placing and forming must proceed quickly. When set, the foam can be cut and sanded just like preformed foam, or, if you prefer, the billowing plastic-skin-covered surface can be retained. To produce colored foam, pigment is added to the isocyanate component before it is combined with the freon. The possibilities of using other fillers and aggregates are limited, since the mixing time is so short, and heavy aggregates interfere with the foaming process.

As it is poured, foam will adhere to most materials, including wood, cloth, plaster, and metal. To prevent sticking, a release agent—such as silicone spray, paste wax, PVA, or polyethylene film—can be applied to the surface on which the foam is poured. Liquid foam mixtures can be poured into molds for casting (see chapter four).

Recently, foam-blowing machines have been developed by the building industry. With these machines the ingredients are mixed automatically and blown out a nozzle something like a fire hose. Large structures can be formed by flowing the foam onto fabric supports or over inflated shapes.

Flexible foams. A variety of flexible urethane foams is available in sheets, slabs, and shredded pieces. These can be employed to stuff soft sculptures made of cloth, leather, plastics, and rubber. Fiberglass can be applied to urethane foam on one or both sides, forming a stiff shell. Flexible foam can also be formed and tied over another shape before glassing.

Rubber

Natural latex rubber foam is heavier than urethane and less durable, but it has some applications for sculpture where the artist desires a denser, fleshier feel. Natural latex rubber has many sculptural applications; it can be cast in molds, applied as a coating to other materials, and made into flexible sheets by adhesion to fabrics. Although not strictly a plastic in its natural state, rubber as used by most sculptors today is a highly modified or entirely synthetic material that sets through the use of catalysts, rather than by a simple drying process.

Dow Corning manufactures a silicon RTV (room-temperature-vulcanizing) rubber that is popular as a mold compound. Its use as a mold material, as well as that of natural latex, is discussed in chapter four.

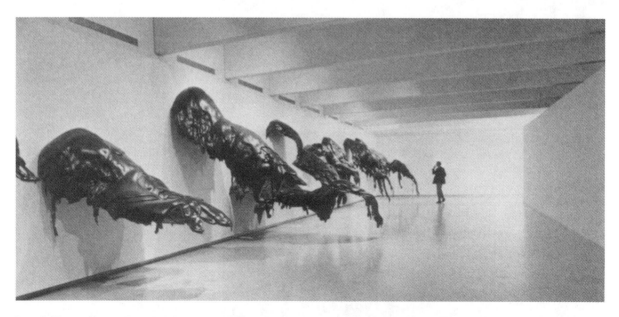

Plate 8.30. Lynda Benglis, *Adhesive Products*, iron oxide and black pigmented polyurethane, 13½′ × 80′ × 15′, 1971. Walker Art Center, Minneapolis (photo courtesy of Paula Cooper Gallery, New York). The foam is mixed by the artist and rapidly applied over an armature in a number of layers. As there is very little alteration after the foam sets, the surface skin remains intact.

There are a number of synthetic rubbers manufactured for use as containers, conveyor belts, gaskets, shock absorbers, and roofing. One of the most weatherproof and chemical-resistant of these is polychloroprene, commonly known as Neoprene, a trade name of Du Pont. Du Pont sells Neoprene in the form of a colloidal suspension to submanufacturers, who mold it into products or mix it with a foaming agent to produce Neoprene foam.

The individual CO_2 or nitrogen bubbles in Neoprene are separate from each other, or *unicellular*. Thus, foam Neoprene does not absorb water. It is used for gaskets, insulation, and skin-diving suits. Foam Neoprene can be sewn and also glued with Neoprene cement, a solution of Neoprene in the solvent Xoluol.

Plastics provide the sculptor with a wide variety of durable materials that can be worked with readily available tools. The qualities they are capable of offering range from the bright, slick surfaces we are familar with in manufactured plastic articles, to the scruffy, ragged forms that we encounter in the work of many contemporary artists.

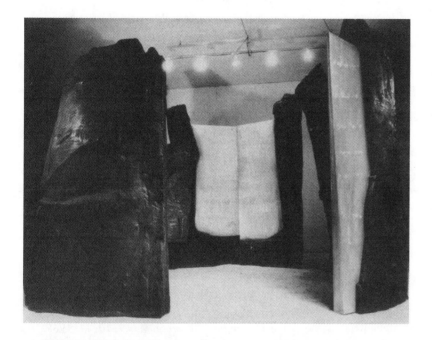

Plate 8.31. Roger Bolomey, *Sky-Gate*, polyurethane foam, 8′ × 16′ × 9′ high, 1964. Courtesy of Royal Marks Gallery, New York. The urethane components were mixed by the artist in large quantities and poured in place while still foaming. The outer skin, formed as the urethane sets, was left intact, not carved or sanded through.

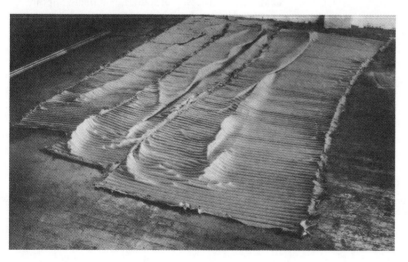

Plate 8.32. Richard Serra, *Untitled*, cast rubber, 144″ × 192″ × 6″, 1968. Collection of Mr. and Mrs. Joseph Helman, courtesy of Leo Castelli. The flexibility of latex and its ability to pick up detail are evident here. The same qualities that make latex a good mold material make it an interesting sculpture medium. It also has a sort of fleshy clamminess that is unique.

BIBLIOGRAPHY

A. Books

Baldwin, John. *Contemporary Sculpture Techniques: Welded Metal and Fiberglass.* New York: Reinhold, 1967

Bunch, Clarence. *Acrylic for Sculpture Design.* New York: Van Nostrand Reinhold, 1972.

Cagle, Charles V. *Handbook of Adhesive Bonding.* New York: McGraw-Hill, 1973.

Dombrow, Bernard A. *Polyurethanes.* New York: Reinhold, 1969.

Duffin, D. J. *Laminated Plastics.* New York: Reinhold, 1958.

Farkas, Robert D. *Heat Sealing.* New York: Reinhold, 1964.

Ferrigno, Thomas H. *Rigid Plastic Foams.* 2d ed. New York: Reinhold, 1967.

Hastings Plastic Co. *Materials and Methods for Making Plastic Molds.* Santa Monica, Ca.: Hastings Plastics Co., 1970.

——. *Polyester Resin Systems.* Santa Monica, Ca.: Hastings Plastics Co., 1970.

——. *Polyurethane Foam Systems.* Santa Monica, Ca.: Hastings Plastics Co., 1970.

——. *Silicone Rubber for Mold Making.* Santa Monica, Ca.: Hastings Plastics Co., 1970.

——. *Spectacular Dewain Valentine Mass Casting Resin for the Modern Artist.* Santa Monica, Ca.: Hastings Plastic Co., 1970

Horn, Milton B. *Acrylic Resins.* New York: Reinhold, 1960

Lawrence, John B. *Polyester Resin.* New York: Reinhold, 1960.

Lubin, George. *Handbook of Fiberglass and Advanced Plastics Composites.* New York: Van Nostrand Reinhold, 1970

Miller, M. L. *The Structure of Polymers.* New York: Reinhold, 1966.

Modern Plastics Encyclopedia 1978–79. New York: McGraw-Hill, 1978.

National Board of Fire Underwriters. *Fire and Explosion Hazards of Organic Peroxides.* New York: National Board of Fire Underwriters, 1956.

Newman, Jay Hartley, and Lee Scott. *Plastics for the Craftsman.* New York: Crown, 1972.

Newman, Thelma. *Plastics as an Art Form.* Rev. ed. Philadelphia: Chilton, 1969.

——. *Plastics as Sculpture.* Philadelphia: Chilton, 1974.

Odian, George. *Principles of Polymerization.* New York: McGraw-Hill, 1972.

Oleeskey, Samuel, and Gilbert Mohr. *Handbook of Reinforced Plastics.* New York: Reinhold, 1964.

Skeist, Irving. *Plastics in Building.* New York: Reinhold, 1966.

Roukes, Nicholas. *Sculpture in Plastics.* Rev. ed. New York: Watson-Guptill, 1978.

Simonds, Herbert R., and James M. Church. *Concise Guide to Plastics.* New York: Reinhold, 1963.

——. *The Encyclopedia of Basic Materials for Plastics.* New York: Reinhold, 1967.

Skeist, Irving. *Handbook of Adhesives.* 2d ed. New York: Van Nostrand Reinhold, 1977.

Society of the Plastics Industry. *Plastics Engineering Handbook.* 3d ed. New York: Reinhold, 1960.

——. *Plastics Safety Handbook.* New York: Society of the Plastics Industry, 1959.

Steele, Gerald L. *Fiberglass, Projects and Procedures.* Bloomington, Ill.: McKnight and McKnight, 1962.

Wordingham, J.A., and P. Reboul. *Dictionary of Plastics.* Totowa, N.J.: Littlefield, Adams, 1967.

B. Articles in Periodicals

"Annual Processing Handbook 1970–71," *Plastics Technology* 16,10 (September 1970), entire issue.

Mallary, Robert. "The Air of Art is Poisoned," *Art News* 62, 6 (October 1963), 34.

Schwartz, Louis. "Dermatitis from Synthetic Resins," *Journal of Investigative Dermatology* 6, 4 (August, 1945), 247.

Slayter, James. *"Two-Phase Materials," Scientific American* 206, l (January, 1962), 124.

C. Lectures at Conferences

National Sculpture Center. *Proceedings of the Fifth National Sculpture Conference, May 9, 10, 11, 1968.* Lawrence: University of Kansas, National Sculpture Center, 1970.

Winfield, Armand G. *One Hundred Years Young, the Twenty-Sixth Annual Technical Conference of the Society of Plastics Engineers Inc.* New York: The Society of Plastics Engineers, Inc., 1968.

D. Periodicals

Du Pont Magazine, E. I. Du Pont de Nemours & Co., Wilmington, Del. 19800.

Modern Plastics. McGraw-Hill, Inc., 330 W. 42nd St., New York, N.Y. 10036.

Plastics Technology, Hill Publications, Inc., 630 Third Ave., New York, N.Y. 10017.

Plastics World. Rogers Publishing Co., 270 St. Paul St., Denver, Col. 80206.

LIST OF MANUFACTURERS

A. Additives

American Cyanamid Co., Bound Brook, NJ 08805. U.V. stabilizers.

Eastman Chemical Products, Inc., Sub. Eastman Kodak Co., Box 431, Kingsport, TN 37662. U.V. stabilizers and Kodaflex plasticizers.

Emery Industries, Inc., Carew Tower, Cincinnati, OH 45202. Plastolein, epoxy plasticizer.

Geigy Chemical Corp., Saw Mill River Rd., Arsley, NY 10502. Tinuvin P, U.V. stabilizer.

General Aniline and Film Corp., 435 Hudson St., New York, NY 10014. Unival, U.V. stabilizer.

Hooker Chemical Co., 277 Walck Rd., Tonowanda, NY 14120. Flame retardants.

Pittsburgh Quartz Co., P.O. Box 840, Valley Forge, PA 19482. Microspheres and fillers.

Rohm & Haas Co., Independence Mall W., Philadelphia, PA 19105. Paraplex and Monoplex plasticizers.

B. Adhesives and Putties

Behr-Manning Div., Hammerhill Paper Co., P.O. Box 328, Troy, NY 12181. Cements and bonding agents for plastics, rubber, paper.

Borden Chemicals, Div. of Borden Inc., 350 Madison Ave., New York, NY 10017; 180 E. Broad St., Columbus, OH 43215. Epoxy and casein adhesives.

Cadillac Plastics & Chemical Co., P.O. Box 810, Detroit, MI 48232; 9025 Lenexa Dr., Lenexa, KS 66215; 11255 Vanowen St., Los Angeles, CA 91605. Epoxy adhesives, PS 18 and PS 30 cements for acrylic bonding.

Chemical Seal Corp. of America, 12910 Panama St., Los Angeles, CA 90066. Epoxy adhesives and caulking materials.

Devcon Corp., Endicott St., Danvers, MA 01923. Plastic Steel and Plastic Aluminum epoxy adhesives and patching materials.

Dow Corning Corp., Midland, MI 48640. Silastic RTV silicone adhesives and sealants.

Furane Plastics Inc., 16 Spielman Rd., Fairfield, NJ 07007; 5121 San Fernando Rd. W., Los Angeles, CA 90039. Epibond epoxy adhesives.

Gem-O-Lite Plastics Corp., 5525 Cahuenga Blvd., Los Angeles, CA 91603.

General Electric Co., Silicone Prods. Dept., Waterford-Mechanicville Rd., Waterford, NY 12188. Silicone RTV adhesives and sealants.

Hastings Plastics Inc., 1710 Colorado Ave., Santa Monica, CA 90404. Epoxy adhesives, cements for vinyl and Styrofoam, EDC cements for acrylic bonding.

Sculpture House, 38 E. 30th St., New York, NY 10016. Sculpmetal and Sculpsand modeling compounds.

Snow Foam Products, 9917 Gidley St., El Monte, CA 91731. Adhesive for Styrofoam.

Travaco Laboratories, Inc., 345 East Ave., Chelsea, MA 02150. Epoxy and silicone adhesives and caulking compounds for marine use.

U.S. Plywood Corp., 777 Third Ave., New York, NY 10017. Weldwood resorcinol and phenolic glues for wood.

C. Color

Carbic-Hoechst Corp., 270 Sheffield St., Mountainside, NJ 07092. Concentrates, dyes, pigments.

Columbia Carbon Co., 380 Madison Ave., New York, NY 10017. Carbon-black.

Ferro Corp., Color Div., 4150 E. 56th St., Cleveland, OH 44105. Concentrates, dyes, pigments, fluorescent and metallic pigments.

Pfizer Co., Inc., 235 E. 42nd St., New York, NY 10017. Basic and metallic pigments.

Plastic Molders Supply Co., Inc., 109 New Brunswick Rd., Somerset, NJ 08873. Concentrates, dyes, pigments, fluorescent, luminescent and metallic pigments, pearl essence.

Plastics Color Div., Crompton & Knowles Corp., Campus Dr., Somerset, NJ 08873. Concentrates, dyes, pigments, fluorescent, luminescent and metallic pigments, pearl essence.

D. Fillers and Extenders

Cabot Corporation, Cab-O-Sil Div., 125 High St., Boston, MA 02110. Cab-O-Sil, thixotropic fill.

Cadillac Plastics & Chemical Co., 15111 Second Ave., Detroit, MI 48232; 9025 Lenexa Dr., Lenexa, KS 66215; 1205 W. Beverly Blvd., Los Angeles, CA 90057. Natural and synthetic fibers and fabrics.

Englehard Minerals & Chemicals Corp., Menlo Park, Edison, NJ 08817. Silicates, chalks, and clays.

Hastings Plastics Inc., 1710 Colorado Ave., Santa Monica, CA 90404. Natural, synthetic, and metallic fillers.

Johns Manville, 22 E. 40th St., New York, NY 10016; Greenwood Plaza, Denver, CO 80217. Asbestos fabric, mat, and roving.

Mead Paper Specialty Co., Willow St., South Lee, MA 01260. Natural and synthetic laminating paper, fabric, and mat.

Metals Disintegrating Co., Box 290, Elizabeth, NJ 07207. Metal powders, granules, and flakes.

Plymouth Fibres Co., Inc., 65 Traffic Ave., Ridgewood, NY 11227. Cotton flock.

Raybestos Manhattan, Inc., 123 Steigle St., Manheim, PA 17545. Asbestos fabric, mat, roving, and flock.

Thalco Uniglass Industries, Div. United Merchants and Mfrs. Inc., 6431 Flotilla St., Los Angeles, CA 90040. Natural and synthetic fibers and flours.

U.S. Bronze Powders Inc., Route 202, Flemington, NJ 08822. Metallic fibers.

Wood Flour, Inc., 3 Howard St., Winchester, NH 03470. Wood flour, cellulose, sisal, and cotton flock.

E. Foam

American Petrochemical Corp., Lenoir Div., Box 390, Lenoir, NC 28645. Urethane foaming systems.

Cadillacs Plastics & Chemical Co., P.O. Box 810, Detroit, MI 48232; 9025 Lenexa Dr., Lenexa, KS 66215; 2305 W. Beverly Blvd., Los Angeles, CA 90057. Styrofoam boards and slabs.

Diamond Foam Co., 459 S. La Brea Ave., Los Angeles, CA 90036. Flexible foams.

Dow Chemical Co., Midland, MI 48640; 309 Crenshaw Blvd., Torrance, CA 90501. Styrofoam boards, slabs.

Durez Div., Hooker Chemical Corp., 277 Walck Rd., 1072-7 Iroquois Ave., Niagara Falls, NY 14302. Urethane foaming systems.

Flexible Products Co., Box 996, Marietta, GA 30060. Flexible and rigid urethane foaming systems.

Pacific Foam Products, 4200 Charter St., Los Angeles, CA 90058. Rigid Styrofoam and urethane boards, slabs, bars, and shapes.

Pittsburgh Corning Corp., 800 Presque Isle Dr., Pittsburgh, PA 15239. Rigid urethane foam boards and slabs.

Reichold Chemicals Inc., 525 N. Broadway, White Plains, NY 10603. Urethane foaming systems.

Sinclair-Koppers Co., 900 Koppers Bldg., Pittsburgh, PA 15219. Dylite expandable polystyrene and foam boards.

Smooth-On, 1000 Valley Rd., Gillette, NJ 07933. Urethane Casting Compound C-1500.

Upjohn Co., 7000 Portage Rd., Kalamazoo, MI 49001; 555 N. Alaska Ave., Torrance, CA 90503. Urethane foaming systems.

F. Glass Fiber

Burlington Glass Fibers, 1345 Ave. of the Americas, New York, NY 10019.

Cadillac Plastics & Chemical Co., P.O. Box 810, Detroit, MI 48232: 9025 Lenexa Dr., Lenexa, KS 66215; 11255 Vanowen St., Los Angeles, CA 91605.

Ferro Corp., Fiber Glass Div., 200 Fiberglass Rd., Nashville, TN 37211.

Gem-O-Lite Plastics Corp., 5525 Cahuenga Blvd., Los Angeles, CA 91603.

Gustin-Bacon Mfg. Co., 210 W. 10th St., Kansas City, MO 64105. Fiberglass cloth.

Hastings Plastics Inc., 1710 Colorado Ave., Santa Monica, CA 90404.

Miles Fiberglass & Plastic Supply, 4060 Wyne St., Houston, TX 77010.

Owens-Corning Fiberglas Corp., Fiberglas Tower, Toledo, OH 43659. Fiberglas cloth, mat, roving, glass flakes.

Potters Industries Inc., 377 Rt. 17, Hasbrouck Hts., NJ 07604. Glass flakes, spheres, and granules.

PPG Industries Inc. (Pittsburgh Plate Glass), Fiber Glass Div., One Gateway Center, Pittsburgh, PA 15222.

Thalco Uniglass Industries, 6431 Flotilla St., Los Angeles, CA 90040.

G. Machines and Tools

Albert Air Conveyer Corp., 2493 American Ave., Hayward, CA 94545. Dust and vapor collecting equipment.

American Petrochemical Corp., Lenoir Div., Box 350, Lenoir, NC 28645. Spray equipment for foam and fiberglass.

Cavitron Utrasonics, 11-40 Borden Ave., Long Island City, NY 11101. Utrasonic sealing and assembly equipment.

Comet International Sales Inc., 2500 York Road, Elk Grove Village, IL 60007. Heat sealing and thermoforming machines.

Cosmos Electronic Machine Corp., 114 Florida St., Farmingdale, NY 11735. Electronic sealers.

DiAcro Div., Hondaille Industries, Inc., 578 Eighth Ave., Lake City, MN 55041. Vacuum forming machines.

Dura-Tech Corp., 1555 N.W. First Avenue, Boca Raton, FL 33432. Hot-wire cutters.

Dymo Products Co., Box 1030, Berkeley, CA 94701. Vacuum forming machines.

Edemco Co., 13835 Saticoy St., Van Nuys, CA 94100. Hot-air guns.

Glas-Craft of Calif., 9145 Glenoaks Blvd., Sun Valley, CA 91352; 3939 W. 56th St., Indianapolis, IN 46254. Spray equipment for foam, fiberglass and gel-coats.

Glas-Mate Corp., Box 23730, Fort Lauderdale, FL 33307. Spray equipment for foam and fiberglass.

Hotpack Corp., 5083 Cottman St., Philadelphia, PA 19135. Strip heaters and ovens.

Master Appliances Corp., 2420 18th Street, Racine, WI 53403. Air guns and torches.

Plasti-Vac, Inc., Box 5543, Charlotte, NC 28205.

Rotodyne Mfg. Co., Bldg. 12-13, Navy Yard, Brooklyn, NY 11205. Dust and vapor collecting equipment.

Stokes Div., Penwalt Corp., 5500 Tabor Rd., Philadelphia, PA 19120. Vacuum metallizing equipment.

Vertrod Corp., 2037 Utica Ave., Brooklyn, NY 11234. Heat sealing machinery.

West Coast Plastics Equipment, Inc., 6122 W. Washington Blvd., Culver City, CA 90230. Heat sealing and thermoforming machines.

Edward L. Wiegand Co., Pittsburgh, PA 15200. Chromalox radiant heaters for use in vacuum forming and blow-molding.

H. Molding Compounds and Rubbers

Atlas Sponge Rubber Co. Inc., 1707 S. Calif. Ave., Monrovia, CA 91016. Molded and sheet sponge rubber.

Cementex Co., 226 Canal St., New York, NY 10013. Latex and polysulfide rubber.

Dow Corning Corp., Midland, MI 48740. Silastic RTV silicone molding compounds.

Du Pont de Nemours, E.I., & Co., 1007 Market St., Wilmington, DE 19898. Neoprene and synthetic rubbers.

Hastings Plastics Co., 1625 17th Street, Santa Monica, CA 90404. Haflex silicone RTV molding compounds.

Perma-flex Mold Co., 1919 Livingston Ave., Columbus, OH 43209. Silicone, urethane, and vinyl molding compounds.

Rubatex Corp., P.O. Box 340, Bedford, VA 24523. Closed-cell Neoprene foam sheet and extrusions.

West American Rubber Co., 750 N. Main St., Orange, CA 92668. Natural and synthetic rubber sheet and parts.

I. Paint

Brocour Artists Colors Inc., 552 W. 52nd St., New York, NY 10019. Aquatec acrylic artists colors.

Du Pont de Nemours, E.I., & Co., 1007 Market St., Wilmington, DE 19898. Duco synthetic enamels and Lucite acrylic lacquers.

Furane Plastics Inc., 16 Spielman Rd., Fairfield, NY 07007 and 5121 San Fernando Rd. W., Los Angeles, CA 90039. Epoxy and urethane primers and finishes.

Grumbacher, M., Co., 460 W. 34th St., New York, NY 10001. Hyplar acrylic artists colors.

Illinois Bronze Powder and Paint Co., 300 E. Main St., Lake Zurich, IL 60047. Epoxy paint.

O'Brien Corp., 6323 Maywood Ave., Huntington Park, CA 90255. Epoxy paint.

Permanent Pigments Inc., 27000 Highland Ave., Cincinnati, OH 45212. Liquitex acrylic artists colors.

Pigments & Colors, S.C.M. Corp., 390l Hawkins Point Rd., Baltimore, MD 21226. Acrylic sign finishes.

P.P.G. Industries Inc., Pittsburgh, PA 15222; 465 Crenshaw Blvd., Torrance, CA 90501. Synthetic enamels, acrylic lacquers, Ditzler automotive finishes.

Shiva Artists Colors, Tenth and Monroe Streets, Paducah, KY 4200l. Acrylic artists colors.

U.S. Paint, Lacquer, and Chemical Co., 3127 E. 26th St., Los Angeles, CA 90023. Aircraft finishes and made-to-order finishes.

Valspar Corporation, 7701 W. 47th St., Lyons, IL 60534. Epoxy and urethane marine finishes.

Zynolite Products Co., 15700 S. Avalon Blvd., Compton, CA 90224. Epoxy paint.

J. Polishing, Buffing, and Cleaning Compounds

Avecor Inc., 13596 Vaughn St., San Fernando, CA 91340. Antistatic agents.

Cadillac Plastics and Chemical Co., P.O. Box 810, Detroit, MI 48232; 9025 Lenexa Dr., Lenexa, KS 66215; 11255 Vanowen, Los Angeles, CA 91605. Cadco antistatic cleaner.

Chemical Development Co., Danvers, MA 01923. Anstac 2M antistatic agent.

Goodison Manufacturing Co., Box 128, Rochester, MI 48063. Triple A buffing compound.

Lea Mfg. Co., 239 E. Aurora St., Waterbury, CT 06720. Learock buffing compounds.

Mac's Super Gloss Co., Inc., 6040 N. Figueroa St., Los Angeles, CA 90044. Polishes, cleaners, and buffing compounds.

Mirror Bright Polish Co., 17275 Daimler, Irvine, CA 92714. Meguiars Mirror-Glaze Polish.

K. Release Agents

Axel Plastics, 41-14 29th St., Long Island City, NY 11101.

Carlisle Chemical Works, Inc., 1801 West St., Reading, OH 45215. Release waxes.

Contour Chemical Co., 4 Draper St., Woburn, MA 01801. Kraxo 1711 spray release agent.

Frekote Co., P.O. Box 825, Boca Raton, FL 33432. Frekote 33 spray release.

Miller-Stephenson Chemical Co. Inc., P.O. Box 628, Danbury, CT 06810. Fluorocarbon release agents.

Specialty Products Corp., 15 Exchange Place, Jersey City, NJ 07302

L. Resins

Allied Chemical Corp., Box 365, Morristown, NJ 07960. Epoxies and urethanes.

American Cyanamid Co., Bound Brook, NJ 08805. Polyesters and epoxies.

Cadillac Plastics and Chemical Co., P.O. Box 810, Detroit, MI 48232; 9025 Lenexa Dr., Lenexa, KS 66215; 11255 Vanowen St., Los Angeles, CA 91605. Polyesters and epoxies.

Cook Paint and Varnish Co., 2041 Broadway, Boulder, CO 30302 and Box 389, Kansas City, MO 64141. Polyesters.

Dow Chemical Co., Midland, MI 48640. Epoxies and urethanes.

Durez Div., Hooker Chemical & Plastics Corp., 1072 Iroquois Ave., Niagara Falls, NY 14302. Polyester resins.

Furane Plastics Inc., 16 Spielman Rd., Fairfield, NJ 07007 and 5121 San Fernando Rd., Los Angeles, CA 90030. Epoxies and urethanes.

Gem-O-Lite Plastics Corp., 5525 Cahuenga Blvd., Los Angeles, CA 91603. Resins.

Hastings Plastics Co., 1710 Colorado Ave., Santa Monica, CA 90404. Polyesters and epoxies.

The Marblette Co., 37-31 30th St., Long Island City, NY 11100. Resins.

Plastic Mart, 2101 Pico Blvd., Santa Monica, CA 90404. Resins.

Reichold Chemicals Inc., 525 N. Broadway, White Plains, NY 10603. Polyesters, epoxies, urethanes.

Shell Chemical Co., Polymers Div., 1 Shell Plaza, Houston, TX 77002. Polyesters and epoxies.

Taylor & Art Plastics Inc., 3011 Alvarado St., San Leandro, CA 94577. Polyesters and epoxies.

3-M Co., 3 M Center, St. Paul, MN 55101. Epoxies and urethanes.

Union Carbide Corp., Chemicals and Plastics, 270 Park Ave., New York, NY 10017. Epoxies and urethanes.

M. Sheets and Films

American Cyanamid Co., Plastics Div., S. Cherry St., Wallingford, CT 06492. Acrylite acrylic sheets.

Argo Plastic Products Corp., 7711 Grand Ave., Bldg. 6B, Cleveland, OH 44104; 417 Lesser St., Oakland, CA 94601. Acrylic sheets, rods, tubes; cellulose acetate sheets and films; polycarbonate, nylon, and phenolic sheets, rods, and tubes.

Cadillac Plastics and Chemical Co., P.O. Box 810, Detroit, MI 48232. 9025 Lenexa Dr., Lenexa, KS 66215; 11255 Vanowen, Los Angeles, CA 91605. Acrylic, nylon, phenolic sheets, rods, and tubes.

Catalina Plastics Suppliers, Inc., 1245 Flower St., Glendale, CA 91200. Acrylic, acetate, vinyl and polyethylene sheets and films.

Du Pont de Nemours, E. I., & Co., 1007 Market St., Wilmington, DE 19898. Lucite acrylic sheets, rods, tubes.

Eastman Chemical Products Inc., Box 431, Kingsport, TN 37662. Tenite cellulose acetate butyrate and cellulose acetate sheets and films.

Gem-O-Lite Plastics Corp., 5525 Cahuenga Blvd., Los Angeles, CA 91603. Acrylic, vinyl, polyester.

Industrial Plastics, 324 Canal St., New York, NY 10013. Acrylic and phenolic sheets, rods, tubes.

Pantasote Co., 277 Park Ave., New York, NY 10017; Box 1800, Greenwich, CT 06830; 4703 E. 48th Street, Los Angeles, CA 90058. Vinyl films and sheets.

Plastic Mart, 2101 Pico Blvd., Santa Monica, CA 90404. Acrylic, vinyl, polyester.

Rohm & Haas Co., Independence Mall West, Philadelphia, PA 19105. Plexiglas acrylic sheet, rods, and tubes.

Transparent Products, 1739 W. Pico Blvd., Los Angeles, CA 90006. Transparent and aluminized Mylar sheets and rolls.

Woodhill Chemical Co., 18731 Cranwood Parkway, Cleveland, OH 44128. Celastic cellulose nitrate modeling sheet.

N. Safety and Protection Products

Allied Industrial Distributors, 7800 Compton Ave., Los Angeles, CA 90001. Full line of equipment and supplies.

Ayerst Laboratories, 245 Paterson Ave., Little Falls, NY 13365. Kerodex protective skin creams.

Bel Art Co., Pequannock, NJ 07440. Emergency eye wash stations.

E.D. Bullard Co., 5586 E. Imperial Hwy., South Gate, CA 90280. Respirators and protective clothing.

Dickson Safety Products Co., 12921 W. Washington Blvd., Los Angeles, CA 90066. Full line.

Eastco Industrial Safety Corp., 26-15 123d Street, Flushing, NY 11354. Full line.

Edmont-Wilson Div., Becton Dickinson Co., Cohocton, OH 43812.

Macalaster Bicknell Co. of Conn. Inc., 181 Henry St., New Haven, CT 06500.

Mine Safety Appliance Co., 1100 Globe Ave., Mountainside, NJ 07092. Clothing, eyewear, respirators.

Willson Safety Products, 1985 Taince Ave., Melrose Park, IL 60160; 111 Sutter St., San Francisco, CA 94104. Respirators and face shields.

9
Metals

The beginning of technology may have been the discovery that fire could smelt metals out of ore-bearing rocks. Copper ore lies near the surface of the earth in many places. The concentration of heat necessary to bring liquid copper out of its ore seems to have been first achieved somewhere in the Near East around 3500 B.C. As copper is easily worked by hammering and grinding, workshops were soon set up to produce implements of many kinds.

The next discovery was that copper could be hardened so that it would hold a cutting edge if it was mixed, or *alloyed,* with tin. The working of bronze developed independently in many separate parts of the world, and came to others through information carried by traveling artisans and traders. Bronze weapons and tools were in use around the Aegean Sea as early as 2500 B.C. The Phoenicians traded tin throughout the Mediterranean world in the second millennium B.C., going as far West as England and Ireland. They carried with them wares from Egypt and Assyria, and disseminated knowledge of metallurgy.

Soon after the development of smelting and hammer-forging processes, ways were found to cast molten bronze in clay and earth molds. This made it possible to make shapes of a greater variety and complexity than was possible by beating and cutting pieces of metal. Forms could be made in the traditional shapes already in use for the sacred and ritual objects which had formerly been made of wood, clay, or stone. Thus the new material, metal, could be used as an "art" material. It was the versatility of casting which made this new role for metal possible. Tradition decreed that the first ritual objects made by Bronze Age artisans had to be near-copies of objects which were first made of clay, stone, or even animal skins. Gradually the full possibilities of bronze as a new medium of expression were developed.

The availability of metal tools greatly speeded up advances in farming, boatbuilding, construction of wheeled vehicles, and most of all in weaponry and armor. Manufacturing techniques became so complex that specialized artisans banded together in craft guilds, sharing their knowledge and cooperating on large projects. The discovery of iron further accelerated this process. For the first time a material was available which not only could cut all other materials but which also, when hardened, could easily cut

other pieces of itself. Iron, in the form of the tempered steel cutting edge, is the basis of all modern manufacturing equipment. So swift and intuitive was man's comprehension of the technical possibilities of the steel cutting edge that many of the first steel and iron hand tools, such as the ax and the plow, were so well designed that they have changed little to this day.

The development of metal sculpture contrasted with the development of metal implements and hardware is a good example of the way artistic tradition interacts with technological inventiveness. By the Middle Ages the working of steel and iron had reached an excellence of craftsmanship unsurpassed today. Sword blades of superb quality and accuracy were made in the steelworking centers of Toledo in Spain, Sheffield in England, and Damascus in Syria. Suits of armor were produced that demonstrate ex-

pertise with sheet metal and mechanical ingenuity equal to that needed for the best automobile body work of today.

Beautiful as it was, all the wrought ironwork of medieval and Renaissance Europe was hardware: weapons, armor, tools, and architectural elements like hinges, locks, railings, and grilles. Sculpture was produced by the same traditional methods—modeling, carving, and casting—that were perfected by the Greeks and Romans.

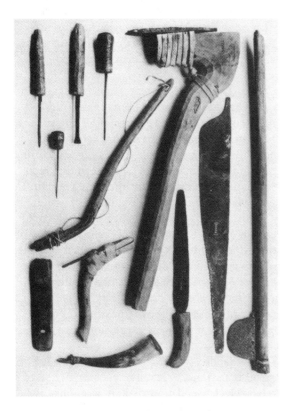

Plate 9.1. Tools of wood and bronze. Thebes, Upper Egypt, c. 1200 B.C. Courtesy of the British Museum, London. The first metal tools were derived from stone prototypes, as is evident in the adz and ax above. Where models did not exist, as with saws, designs were quickly developed which have changed little to this day.

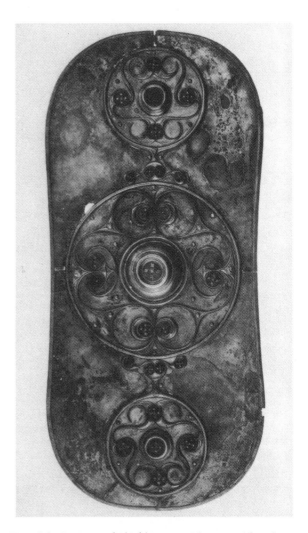

Plate 9.2. *Ceremonial Shield*, repoussé bronze with red glass inlays, 31½″ high, c. 1st century B.C. From Thames at Battersea, London, courtesy of the British Museum, London. Though removed from the Mediterranean centers of bronze working, the Celtic artisans of Britain did not lack the skills necessary to develop their own distinctive styles of ornament and weaponry.

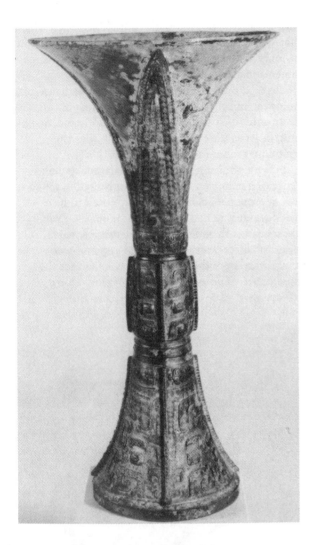

Plate 9.3. *Chinese Ceremonial Vessel of the Type Ku*, bronze, 11 3/16″ × 6 3/16″, Shang dynasty, middle-late An-yang, 12th–13th century B.C. Courtesy of the Smithsonian Institution, Freer Gallery of Art, Washingon, D.C. It is believed that the Chinese used clay piece molds for these early examples of bronze-casting expertise.

Plate 9.4. *Helmet: Corinthian Type*, bronze, 6th–5th century B.C. Courtesy of the National Museum, Athens, Greece (photo courtesy of Deutsches Archaeologisches Institute, Athens). The malleability of bronze and its ability to accept refined surface modulation and incised line are perfectly expressed in this piece of armor. It embodies the laws of Greek aesthetics as clearly as does the sculpture of this period.

Perhaps it is artificial to separate crafts from fine arts in this way. Many so-called crafts produced works of the highest artistic order. Nevertheless, it does seem that a distinction of this kind was developed during the fourteenth and fifteenth centuries in Europe. From the artisan's workshops, "artists" began to emerge who produced the sculpture and paintings that were now appreciated as individual entities, apart from the altars or buildings with which they were formerly associated. Sculpture stepped out from its niche on the wall and assumed a fully three-dimensional stance on its own base.

Easel painting, one form of high art, made use of a new technical invention: direct brushing of oil paint onto linen stretched over a wood frame. Sculpture, however, continued to be made with the techniques inherited from the past.

No one thought, or at any rate dared, to make a figure of a man by the same methods used to make a suit of armor. A sculpture was supposed to be a seamless unit, not an assemblage of pieces. Even in the seventeenth and eighteenth centuries, when wood sculptures were built up of separate pieces, the joints were smoothed or painted over so that the appearance of unity was not lost. Tremendous efforts were made to cast equestrian monuments in

Plate 9.5. *Votive Figure of Athena Armed*, Etruscan, bronze, 11¼″ high, 5th century B.C. Courtesy of Villa Giulia, Rome, Italy (photo courtesy of Leonard von Matt, Switzerland). The elegance of Etruscan sculpture was matched by the sophistication of Etruscan metallurgy. They produced consistent alloys though their foundry equipment was rudimentary.

Plate 9.6. *Band Saw*, J. A. Fay and Company, cast iron frame with wooden table, 60: × 37″ × 41″, 1868. Collections of Greenfield Village and the Henry Ford Museum, Dearborn, Michigan. Many early machines display a fresh and intuitive grasp of the design capabilities of cast metal.

Plate 9.7. *Gothic War-Harness For Man and Horse*, South German, forged and riveted iron, c. 1480. Courtesy of Trustees of the Wallace Collection, London. Fantasy and self-expression were not inhibited by the requirements of defense.

Plate 9.8. Parnelli Jones, *Viceroy Special*, aluminum, steel, rubber, 1970. Photo credit Firestone Tire and Rubber Co. The body of this Indianapolis racing car was fabricated by riveting together panels of hand-formed aluminum. The techniques are much the same as those employed in medieval Europe to make hand-wrought iron armor.

one continuous bronze pour, although it would have been much easier to make such a sculpture of smaller pieces.

It was not until the twentieth century that contemporary metalworking methods began to be used to make works of art. Today all the welding, shearing, bending, punching, and other metal-forming processes of modern industry are available to the metal sculptor. The distinction between "arts" and "crafts" seems increasingly artificial.

METAL PRODUCTION: MINE AND MILL

Most artists today use all the shortcuts they can to channel their creative energy in the directions in

Plate 9.9. J. Krans, *Tin Man*, a trade sign made for the West End Sheet Metal and Roofing Works in Brooklyn, sheet steel, 68″ high, c. 1894. Collection of Mr. and Mrs. Eugene Cooper (photo courtesy of Gerald Kornblau Gallery, New York). The simplicity of form native to the tinsmith's craft guided this artisan to snip out a tin man with all of the obsessive impact of a three-dimensional cartoon.

Plate 9.10. Julio González, *Téte Dite "Le Tunnel"*, iron, 18″ high, 1933–1935. Photo courtesy of Galerie de France, Paris. González made the first welded metal sculptures in Europe. He taught welding to his friend Pablo Picasso.

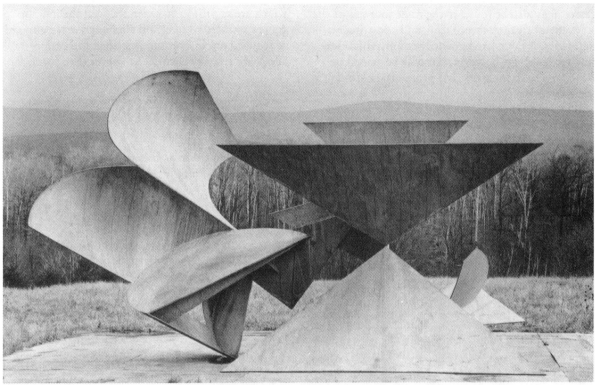

Plate 9.11. Isaac Witkin, *Kosazaan*, steel, 8'1" × 13'6" × 6'10", 1972. Courtesy of the Robert Elkon Gallery (photo courtesy of David Scribner). The construction of this piece entailed many contemporary metal fabrication processes such as shearing, bending, rolling, welding, and grinding. Note how the steel is handled in individual saillike sheets rather than as sides enclosing a volume.

which it will be most effective. No artists today mine raw materials or process them to produce supplies for their art. In metal fabricating, some sculptors, in fact, contract with metalworking shops to have the physical work of fabrication done for them by hired craftsmen. It is possible that the result may not be as personal in appearance as something made by the artist's own hands, but sometimes an impersonal quality of execution is what the artist is trying to achieve. Artists may be able to employ artisans who are more skillful at certain processes than they are, and the use of industrial shopwork opens up a broad range of processes that most artists would never have access to in their own studios. Artists must know enough about the processes they wish to contract out to be able to specify what they want done, and they must learn to speak the language of the industry they wish to employ.

The artist who works in metal usually orders sheets, bars, and tubes of metal from local metal supply companies, which maintain stockpiles of metal in standard dimensions. These sources of supply in turn order their stock from the major manufacturers, who maintain mines and rolling mills. A visit to a steel mill is a fascinating tour recommended for anyone interested in metal sculpture.

Intelligent buying of metal supplies requires a knowledge of the different forms and dimensions of metal stock. Specification catalogs can be obtained by writing to metal companies such as U.S. Steel, Anaconda Copper, Reynolds Aluminum, and the many other such companies that are listed in the yellow pages of the telephone books of large cities. These companies usually supply manuals describing forming and finishing operations for their products. Some information can also be found in these manuals on the colloquial and common terms used by workmen. These terms often have developed from long usage in the trade and may be quite different from strictly technical descriptions. Valuable sources

of information, especially about the newest processes, may also be found in the trade journals of the steel, metal-casting, sheet-metal, and construction industries. A complete knowledge of metal fabrication terminology, however, can only be gained by a familiarity with the work as it proceeds day-to-day in the shop.

The artist who does not have an exact specification to fill may find a valuable source of material in junkyards and scrapyards. The use of machinery and automobile parts in making sculpture is discussed in chapter fourteen. Aircraft and shipbuilding surplus yards may have sheets, bars, and tubes of metal which are as pristine as when they left the mill. In general, structural steel and aluminum may be found at reduced prices, and stainless steel and copper alloys are always expensive whatever their form.

METALS USED FOR SCULPTURE: IRON, STEEL, BRONZE, AND ALUMINUM

Cast Iron

The pure element iron does not occur in nature uncombined with other elements. Cast iron, as it is

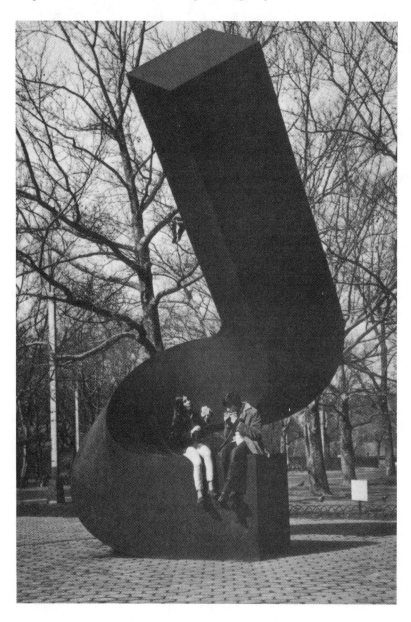

Plate 9.12. Clement Meadmore, *Upstart*, Cor-Ten steel, 20′6″ × 15′3″ × 13′6″, 1967. Collection of Bradley Family Foundation Inc. (photo courtesy of Lippincott, Inc., North Haven, Connecticut). This sculpture was made at the Lippincott factory in Connecticut. Today, sculptures of this scale almost inevitably require the assistance of a fabricator's shop equipped with more industrial tools than any one sculptor is likely to have in the studio.

Plate 9.13. Rolling standard steel shapes (credit American Iron and Steel Institute, Washington, D.C.). After their formation into bars, these steel sections are given their final shape by passing between rollers.

Plate 9.14. Terminal Island Scrap Yard (photo by the author). This scrap depot near the port of Long Beach, California, has piles of every size and kind of steel scrap.

Plate 9.15. Anthony Caro, *Mid-Day*, steel painted yellow, 7'10½" × 12' × 3'2", 1960. Collection of Timothy and Paul Caro, courtesy of the Solomon R. Guggenheim Museum, New York. Most of the joints of this sculpture are welded. The bolts that were parts of the steel girders used to make the sculpture have been left in place as natural details appropriate to the material.

Metals / 175

used in industry, contains 2 to 5 percent carbon, and up to 3.5 percent silicon. It is a grayish, brittle metal that is easily cast and can be forged, or pressed into shape when hot; but it is too brittle when cold to be malleable, or hammered and bent into shape. It is usually encountered by sculptors using some already manufactured article as part of a sculpture. Cast iron may be welded, using a cast-iron filler rod, or brazed with a bronze rod, as described in the next chapter. Cast iron is used for automobile engine blocks, stove burners, metal-forming blocks, machinery bases, and wheels for heavy equipment. Because of its resistance to corrosion, cast iron has been used in the past for plumbing fittings and drainage pipe, but it is rapidly being replaced by plastics. Eighty years ago cast iron was often used for furniture, stoves, sinks, bathtubs, and even architectural elements such as pillars and window frames. Today cast iron has been largely replaced for these uses by lighter forms of sheet metal and reinforced plastic.

Wrought Iron

If the *pig iron* obtained by smelting iron ore is stirred in a shallow open hearth, the carbon and most of the impurities can gradually be worked out of it, producing an almost pure iron that has excellent hot-working properties. This *wrought iron* was produced in small amounts, by hand, from the eighteenth century until 1975, for the use of blacksmiths. It is no longer manufactured commercially. Its structure is fine-grained and fibrous. When exposed to corrosive atmospheres, it forms a tight, protective oxide rather than the rust which afflicts steels.

Steel

The mixture of iron and carbon which is produced by smelting iron ore is transformed into steel by remelting the iron bars or *pigs* in a furnace. Here the impurities and some of the carbon are removed and the crystalline structure of the metal is changed, so that the resulting steel is much more *ductile* (capable of being drawn out into a wire or band) and *malleable* (capable of being hammered and bent).

Low-carbon (0.15 to 0.30 percent) or *mild* steel is the common steel that is used for rails, wire, automobile bodies, reinforcing bars for concrete, and hundreds of other everyday items. With a higher percentage of carbon (0.30 to 0.60 percent), and, usually, further purification, steel acquires the ability to be hardened by heat treatment. Steel in this

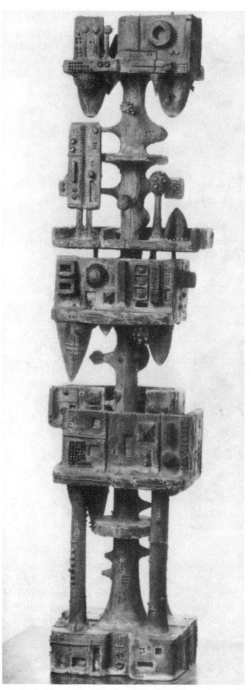

Plate 9.16. Julius Schmidt, *Iron Sculpture*, cast iron, 68″ high, 1958. Gift of Mr. and Mrs. Herman Sutherland, Mr. W. T. Kemper, and the 8th Mid-America Annual Exhibition. Collection of William Rockhill Nelson, Gallery of Art, Akins Museum of Fine Arts, Kansas City, Missouri. To cast this sculpture, iron was poured into a carved-out mold of baked sand, which imparted its granular roughness to the surface.

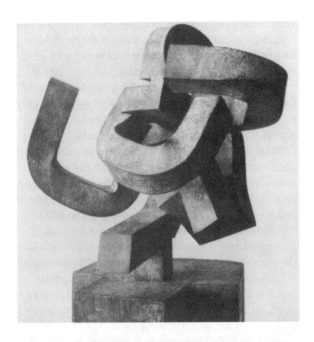

Plate 9.17. Eduardo Chillida, *Enclume de Rêve No. 10*, forged iron on wood block, 59″ high, 1962. Courtesy of Basel Art Museum, Switzerland. Solid bars of wrought iron have been curved and twisted when red hot. The base echoes the forms of the sculpture.

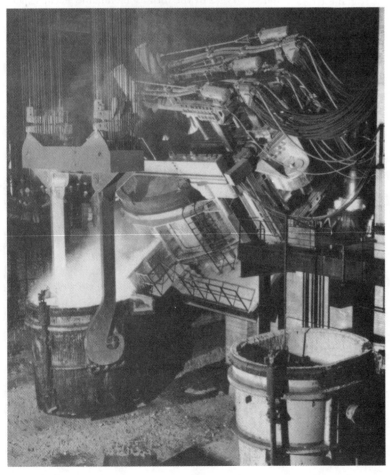

Plate 9.18. Tapping an electric furnace. Photo courtesy of the American Iron and Steel Institute, Washington, D.C. The refined steel pours from the furnace into a ladle, which will transfer the steel to ingot molds. What could an artist accomplish with one day's use of a steel mill?

medium-carbon range is used for tools which must have impact strength and wear resistance, such as hammers, punches, and railway rails.

High-carbon steel (0.60 to 1.50 percent) is used for tools that must maintain a cutting edge. When *tempered* or slightly reduced in hardness by reheating, high-carbon steel acquires a resilience that makes it useful for springs and many kinds of machinery parts where strength and toughness are required. Fully hardened steel is too brittle for these uses.

Most modern varieties of steel used for tools and machinery have been strengthened by the addition of small amounts of extra-tough metals such as vanadium, molybdenum, tungsten, and chromium. The resulting alloy steels are *high-speed* steels.

To manufacture the standard steel shapes like angles, channels, bars, and sheets, red-hot ingots of steel about 10 feet long, 4 feet high, and 3 feet wide are passed repeatedly between rollers that squeeze them into shape. Finally, after the steel is rolled into

successively thinner and longer shapes, the last set of rollers gives the red-hot steel its final shape. When this *hot rolled* steel cools off, it is covered with a skin, or scale, of black iron oxide.

Some of this hot rolled steel is cleaned in an acid bath, washed with water, then rolled between highly polished rollers that give it a bright finish and exact dimensions. The result is *cold rolled* steel.

Steel can be worked by the individual with standard metalworking tools and is one of the easiest metals to weld with the oxyacetylene torch. Because steel is not very heat-conductive, welding heat remains where it is directed rather than dissipating throughout the metal. Steel also retains enough strength when hot so that it can be welded without the elaborate supporting jigs that are often necessary with *hot-short* metals like aluminum. A hot-short metal is one that loses strength at elevated temperatures. Alloy steels, however, require special welding procedures, because the alloying elements change the characteristics of the molten metal, and because the

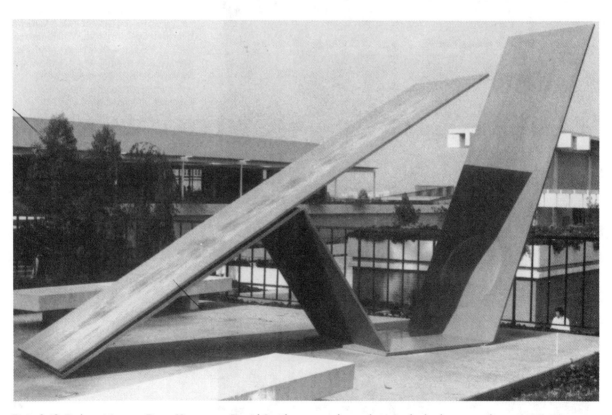

Plate 9.19. Robert Murray, *Dvet, Homage to David Smith*, steel, 10′ × 19′ × 5′, 1965. Courtesy of the California State University, Long Beach. These 1½″ thick slabs of steel were bent in the brake press of a steel mill. The two sandwiched slabs are bolted together. The surface is epoxy paint.

weld must be compatible with the material it is joining.

The one disadvantage that steel has for the sculptor is its susceptibility to corrosion. Rust on steel dusts and flakes off instead of forming a tight protective coating like the oxides of bronze and aluminum. Even when painted or plated, steel can rust under its protective coating if there is the smallest scratch where atmospheric moisture can enter.

Recently a new family of alloy steels has been developed. When exposed to the weather, these steels form a protective surface coating or *patina,* much as bronze does. The color begins as an orange-brown deepening to dark brown, and matures after several years to a purplish black. These nickel steels, which go under the trade names of Cor-Ten (U.S. Steel) and Mayari (Bethlehem Steel) are currently in use, exposed and unpainted, in many buildings and bridges. When painted, the surface of these steels forms a tight bond with the paint which cannot be undermined by corrosion. They can be welded and worked much like mild steel and are only slightly more expensive.

Stainless Steel

If chromium and nickel are alloyed with steel in amounts approximating 20 to 40 percent of the total, a *stainless* steel is produced which is relatively rust free and which is much stronger and tougher than common carbon steel. There are many types of stainless steel. They vary in color from gray to bright silver depending upon the amount of alloying elements they contain. One popular stainless steel is known as "18-8" because it contains 18 percent nickel and 8 percent chromium. It is used for tableware and restaurant and hospital equipment, and in other applications where appearance is important.

Another family of stainless steels is referred to as the *straight chromium* group, because these stainless steels contain from 11 to 30 percent chromium and no nickel. The corrosion resistance of stainless steels is dependent upon the amount of chromium they contain, so straight chromium steels, like nickel-chromium steels, are corrosion-resistant. Steels containing less than 11 percent chromium will rust when exposed to corrosive agents. The straight chromium steels are used for piping, pump shafts, turbine blades, and many other industrial applications where corrosion resistance and long wear are important.

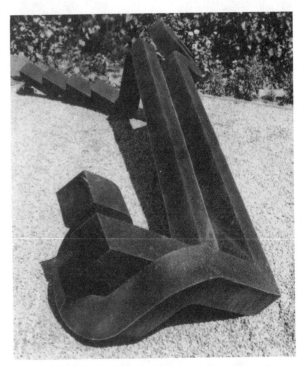

Plate 9.21. Miles A. Varner, *Untitled II*, Cor-Ten and stainless steel, 18' × 6' × 4', 1967. Santa Barbara, California, collection of the artist. This ground-oriented sculpture was fabricated from sheets of Cor-Ten steel with stainless steel facets applied to the steps at the end. It is hollow, not solid like the Chillida (pl. 9.17). Because of its nickel content, Cor-Ten steel builds up a tightly adhering crust that does not flake off as does ordinary rust.

When confronted with an unknown stainless steel, you can use the magnet test to make a rough estimate of the steel's corrosion resistance. If the material has enough chromium or nickel in it to be nonmagnetic, it is probably (but not certainly) corrosion-resistant.

It is possible to weld some stainless steels with the oxyacetylene torch and a special rod, but heliarc equipment gives much better results (see chapter eleven). Since stainless is much tougher than mild steel, it is harder to cut, grind, and polish. High-speed alloy blades must be used to cut it on the band saw. Small cutting tools, such as burrs, mills, and drills, should be made of tungsten carbide rather than steel.

One characteristic of stainless steel is that it shrinks after it has been heated or welded. This shrinkage must be taken into account when planning the fabrication procedure of a stainless steel sculpture.

Stainless steel can be ordered from the mill in a variety of surface finishes, from a coarse satin finish to a near mirror polish. Ordering the right surface may save much finishing work later. Remember, though, that you cannot duplicate a factory finish with hand tools. Unless you can keep the surface intact, it is best to purchase steel with a working finish one step coarser than the final one, and then to bring the whole work up to its final finish at the end of the job.

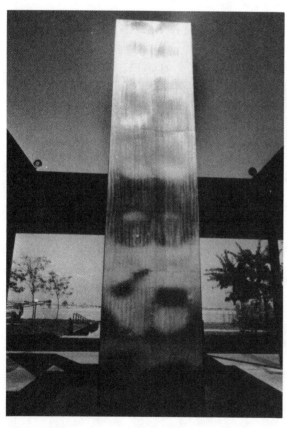

Plate 9.22. Oliver Andrews, *Water Blade*, stainless steel, 24′ × 6′ × 1′, 1971. Collection of the Los Angeles Times Mirror Company, Costa Mesa, California (photo by the author). From a trough at the top, water flows down the four sides of the sculpture at a rate of 100 gallons per minute, enveloping it in a glimmering wet sheath. Note the ripples in the surface of the stainless steel, caused by the deflection of the sheet steel in fabrication.

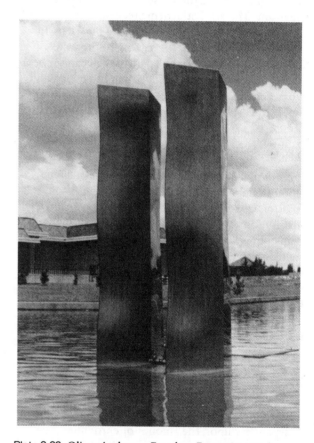

Plate 9.23. Oliver Andrews, *Freedom Fountain*, stainless steel, each 10′ × 4′ × 3′, 1976. From the collection of the Oasis Foundation, Odessa, Texas (photo by the author). The curved sides stiffen the sculpture by tightening up as the heat of welding shrinks the metal. This results in smooth curves rather than random bulging.

The heat of welding brings free iron to the surface of stainless steel in the area around the weld and causes initial rusting of this area. If the weld is cleaned regularly, the free iron will be removed and the corrosion resistance of the area restored.

Copper, Brass, and Bronze

As mentioned above, the alloys of copper were the earliest metals to be turned to human use. They are also enormously valuable to contemporary industrial society; they form the basis of electrical equipment and serve for plumbing and for architectural and marine hardware.

Since bronze casting is treated in chapter twelve, the following discusses the general properties of copper and its alloys and some common fabrication methods.

One of the most valuable properties of pure copper is its electrical and thermal conductivity. Electricity can be passed through copper with little loss and a minimal amount of heat buildup. Heat also travels very easily through copper. A copper frying pan heats up evenly all over instead of just in the middle. This property causes a difficulty in welding copper, because heat cannot be concentrated in one place but tends to radiate throughout the piece. This problem becomes more acute the larger the area of copper. Once molten, however, copper flows into the weld easily. For larger works some form of electric welding is necessary due to the intense and concentrated heat required.

Copper has another interesting property: it is said to "work-harden" because it becomes stiffer as a result of being bent or hammered. Once work-hardened, copper can be *annealed* or softened by heating it to red heat and allowing it to cool slowly. In its annealed state, copper is one of the most malleable of metals.

Copper is also one of the most attractive and versatile metals. Because it combines readily with a number of other elements, it has a range of surface colors, or patinas, which can be black, brown, red, orange, blue, and green, or a combination of these. (See chapter twelve for chemicals and processes for treating the surface of copper and bronze.) Since copper is the principal component of bronze, the colors produced by different chemical processes will be similar for both. Pure copper will react more rapidly to most chemicals than will its brass or bronze alloys.

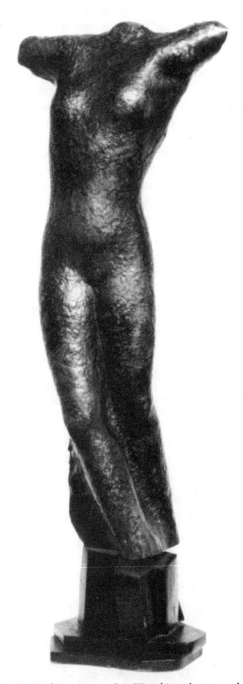

Plate 9.24. Saul Baizerman, *Sun Worshiper*, hammered copper, 37½″ high, 1940–1949. Courtesy of Zabriskie Gallery, New York (photo courtesy of John A. Ferrari). This figure began as a flat sheet of copper. As it was hammered into shape, mostly from the back side, the copper was repeatedly heated and allowed to cool to preserve its softness. This annealing process was necessary because copper "work-hardens."

Most everyone is confused by the terms *brass* and *bronze*. Sometimes "brass" is used to mean alloys of copper containing zinc, and "bronze" is used for those containing tin. Many copper alloys, however, contain both zinc and tin, and some bronzes contain no tin at all. Today the term *brass* is most commonly used to refer to low-copper alloys (50 to 80 percent copper) and *bronze* is used for high-copper alloys (80 to 96 percent).

Most brasses are yellowish in color, and most bronzes are golden or reddish because they contain more copper. The exceptions to these colors are Monel, which is a grayish nickel alloy of copper, and *nickel silver,* or *German silver,* which is actually a

nickel-chrome bronze. Nickel silver looks like chrome plating when polished, but is of course solid metal. It is used for dairy and hospital equipment.

The names for brass and bronze alloys derive from many years of usage in mills and foundries. An industry catalog will give you the specifications of dozens of them. Some of the most common are:

Gun metal or *Muntz metal.* A 60 percent copper, 40 percent zinc alloy used at one time for making cannon barrels. It is a tough yellow brass with good red-heat forming characteristics.

Cartridge brass. A 70 percent copper, 30 percent zinc yellow brass used for cartridge casings and other small objects formed by spinning and stamping. It has good cold-working properties.

Red brass. This should probably be called a bronze, but it is called red brass to indicate that beside 85 percent copper it contains mainly zinc as an alloying agent.

Architectural bronze. 85 percent copper, plus varying amounts of zinc and tin. A handsome bronze used for doors, railings, signs, letters, etc.

Statuary bronze. Sometimes called "Eighty-five five-five" because it contains 85 percent copper, 5 percent tin, 5 percent zinc, plus small amounts of other elements. Very similar to architectural bronze, it has been used for many years for the casting of sculpture. It is now being supplanted by the silicon bronzes, which are cleaner, more fluid, and easier to weld.

Silicon bronze. The addition of only 4 percent silicon to copper changes its nature considerably and makes a bronze which is strong, malleable, corrosion-resistant, and very weldable. Since silicon bronze contains no tin or zinc it melts cleanly without giving off fumes. The low heat conductivity of silicon bronze (relative to copper) makes possible a good concentration of welding heat. It can be welded by both oxyacetylene and heliarc. This recently developed bronze is supplanting many of the different varieties of bronze which were formerly required for sculpture, machinery parts, and marine hardware.

Aluminum bronze. The addition of 5 to 7 percent aluminum along with tin yields a tough springy bronze with a pale color.

Manganese bronze. Manganese in amounts of 2 to 5 percent imparts toughness to bronze destined for severe wear in bearings, gears, and boat propellers. Manganese also produces a greenish cast in

Plate 9.25. Roy Lichtenstein, *Modern Sculpture*, brass and mirror, 72″ × 31″ × 20½″, 1967. Courtesy of the collection of Mr. and Mrs. Frederick R. Weisman, Beverly Hills, California (photo courtesy of Rudolf Burckhardt, courtesy of Leo Castelli Gallery, New York). The highly polished brass tubing in this sculpture is reminiscent of the decor in theaters and ocean liners of the 1930s.

the usual bronze color, iridescent in the raw bright metal, slightly mossy in the patina.

Aluminum

Aluminum is the third most abundant element in the earth's crust, exceeded only by oxygen and silicon. Combined with oxygen as *alumina,* it is one of the principal ingredients of clay. It combines so readily with other elements that it never occurs in its pure metallic form in nature.

Aluminum was not isolated as a pure metal until 1825. It is used today in dozens of alloys with small amounts of other elements to give it a range of useful properties. These alloys range from very soft, when the aluminum is relatively pure, to alloys, usually containing silicon, that are strong, springy, and corrosion-resistant. The color ranges from gray through bluish-white to a bright silvery white.

Except for magnesium, which is difficult to work, aluminum is the lightest commonly used metal, and many sophisticated techniques for forming it have been developed for the aircraft and building industries. Aluminum can be cast, forged, and fabricated by welding and riveting. Aluminum is also produced as beams, tubes, bars, and thin lengths of complex cross-section by *extrusion,* or forcing the hot metal through a steel die.

Aluminum can be welded with oxyacetylene using a flux, or with heliarc equipment. Care must be taken to support the work since aluminum becomes weak or hot short as it approaches welding heat. As aluminum is quite conductive, the area affected can extend for some distance from the weld itself, especially in gas welding.

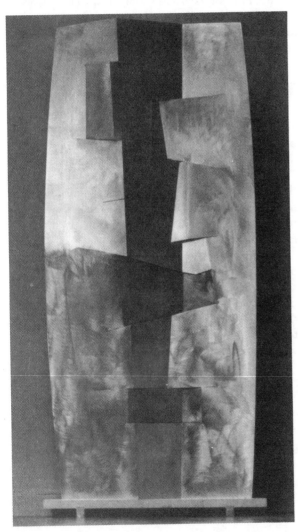

Plate 9.26. Isamu Noguchi, *Sesshu,* aluminum, 1959. Courtesy of Wadsworth Atheneum, Hartford, Connecticut (photo credit C. Irving Bhomstrann). A paradoxical combination of lightness and monumentality is achieved in this sculpture in the rigorous way light is controlled through slotting and bending the single sheet of aluminum.

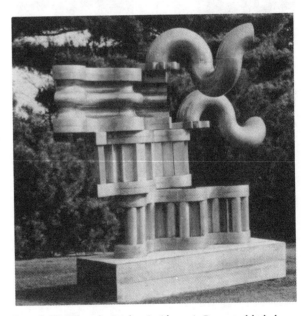

Plate 9.27. Eduardo Paolozzi, *Akapotic Rose,* welded aluminum, 109″ long. Collection of Nelson A. Rockefeller, New York (photo courtesy of Charles Uht). Cast sections of aluminum are welded together and buffed to a high luster.

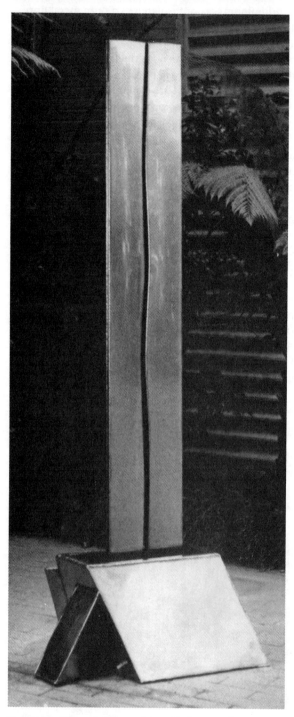

Although aluminum instantly forms a protective oxide film on its surface when exposed to air, it can be attacked by moisture, particularly when in contact with salty air near the ocean or in the contaminated atmosphere of cities. One way to combat this attack is to increase the thickness of the oxide coating by *anodizing,* subjecting the metal to electrolytic action to coat it with a protective film. During this process colored dyes can be incorporated in the surface. The most common colors are bright, transparent red, blue, green, purple, and gold, but more subtle colors in a range of straw to brown are available. The anodized surface is very hard, since aluminum oxide is so hard that it is used in granular form as an abrasive. Once the anodized coating is penetrated, however, corrosion can work under it, just as rust works under paint on steel.

Anodizing is an industrial process that requires a plant equipped with anodizing tanks. Recently, preparations have been developed which can be painted on aluminum to protect it. The degree of protection depends upon the periodic renewal of the coating. One such preparation is Coricone, manufactured by the Coricone Company of Chicago, Illinois. Aluminum, when properly primed, is an excellent surface for most types of paint. It is often painted with lacquer, baked enamel, and epoxy.

Most types of aluminums are softer than bronze or steel, so they are very easy to cut, grind, and shape. There are some heat-treated alloys of aluminum, however, which have a higher tensile strength than mild steel. These heat-treated alloys are difficult to shape by manual methods and often difficult to weld. Beginners are advised to stick to the nonheat-treated alloys.

Saws and grindstones tend to load up with particles of aluminum, but this can be alleviated by using one of the lubricants specially formulated for aluminum working, such as Alumacut. Flexible fiberglass grinding disks or coarse (24 and 36 grit) sanding disks work better than grindstones on aluminum.

Plate 9.28. Oliver Andrews, *River Blades*, titanium, 72″ × 24″ × 30″, 1978. From the collection of Mr. and Mrs. James H. Stone, Cincinnati, Ohio (photo by the artist). Titanium is light, strong and exceptionally corrosion proof. This piece was welded with TIG.

Plate 9.29. Richard Serra, *Casting*, lead, 4″ × 25′ × 15′, 1969. Now destroyed. Courtesy of the Leo Castelli Gallery, New York. Molten lead was hurled from a ladle into the corner between wall and floor. Each piece was pulled away when it hardened and a new section was cast in the same place as the previous one.

Plate 9.30. *Mask of Tutankhamon*, gold and lapis lazuli, eighteenth dynasty, c. 1300 B.C. Collection of the Cairo Museum, Egypt (photo courtesy of Hirmer Fotoarchiv., Munich). The splendor of pure gold radiates from this ancient portrait of the young king.

TABLE 9.1 Properties of Metals

	Typical composition	Color polished	Color weathered	Wt. lbs. cu./ft.	Melts deg.F.	Brinell hardness	Tensile strength: 1000 lbs. sq./in.
Iron, cast	92 Fe + 5 C + 3 Si	silver gray	dull gray	450	2742	200	20–30
Steel, mild	99.70 Fe + 0.3 C	silver	brown	475	2725	130	50–60
Steel, tool	99 Fe + 1 C	silver	brown	475		200–400	150–350
Steel, stainless	74 Fe + 18 Cr + 8 Nl	bright silver	silver or gray	490	2760	150–350	100–300
Copper	Cu	red	green	550	1982	60	30–60
Brass	70 Cu + 30 Zn	yellow	green to brown	525	1700	110	50–60
Bronze	90 Cu + 10 Sn	gold	green to brown	550	1625	120	60–75
Monel	7 In + 27 Cu + 2 Fe	silver	gray green	555	2460	150	75–100
Aluminum	A1	silver	gray	165	1212	30	30–40
Aluminum, alloy	88 A1 + 12 Si	silver	gray		1050	50	50–75
Zinc	Zn	blue silver	mottled gray	440	785	40	20–40
Lead	Pb	silver	dark gray	710	620	5	2–3
Silver	Ag	bright silver	black	655	1760	30	40–50
Titanium	Ti	silver	silver or gray-tan	282	3135	400	40–140

Properties of Metals

	Thermal conductivity	Weld ability	Cast ability	Hot work	Cold work	Corrosion resistance	Sparks
Iron, cast	low	OK	good	poor	no	good	orange
Steel, mild	low	good	OK	good	good	poor	yellow
Steel, tool	low	OK	OK	good	poor	poor	yellow + stars
Steel, stainless	low	good	OK	OK	good	super	yellow, thin
Copper	high	OK	OK	good	good	good	—
Brass	medium	good	good	OK	poor	good	—
Bronze	medium	good	good	good	good	good	—
Monel	medium	good	OK	good	good	good	—
Aluminum	high	good	good	poor	good	fair	—
Aluminum, alloy	high	poor	poor	poor	poor	fair	—
Zinc	low	poor	no	no	poor	fair	—
Lead	low	good	good	good	good	good	—
Silver	highest	good	good	good	good	fair	—
Titanium	low	good	no	no	OK	super	white

BIBLIOGRAPHY

Alexander, William, and Arthur Street. *Metals in the Service of Man*. Baltimore: Penguin, 1956.

American Iron and Steel Institute. *Steel Developments Digest*. New York: American Iron and Steel Institute. A periodic review of new alloys, products, and fabrication techniques.

American Society for Metals. *Metals Handbook*. 8th ed. Vol. I, Properties and Selection. Metals Park, Ohio: American Society for Metals, 1961, 9th printing, 1977.

Barratt, C. S. *Structure of Metals*. New York: McGraw-Hill, 1966.

Bullens, D. K. *Steel and Its Heat Treatment*. New York: John Wiley & Sons, 1948.

Darken, L. S., and R. W. Gurry. *Physical Chemistry of Metals*. New York: McGraw-Hill, 1953.

Fontana, Mars G., and Norbert D. Greene. *Corrosion Engineering*. 2d ed. New York: McGraw-Hill, 1978.

McGannon, Harold E., ed. *The Making, Shaping, and Treatment of Steel*. 9th ed. Pittsburgh: U. S. Steel Co., 1971.

Peckner, Donald, and I. M. Bernstein. *Handbook of Stainless Steels*. New York: McGraw-Hill, 1977.

Reynolds Metals Company. *The A. B. C.'s of Aluminum*. Richmond, Va.: Reynolds Metals Co., 1962.

Rollason, E. C. *Metallurgy for Engineers*. 3d ed. London: Edward Arnold, 1961.

Uhlig, Herbert H. *Corrosion and Corrosion Control*. 2d ed. New York: John Wiley & Sons, 1971.

SOURCES OF SUPPLY

A. Steel

Producers

Allegheny Ludlum Steel Corp., Oliver Bldg., Pittsburgh, PA 15222. Steel, stainless steel.

Bethlehem Steel, Bethlehem, PA 18016. Steel, stainless steel, Mayari weathering steel.

Kaiser Steel Corp., 612 S. Flower St., Los Angeles, CA 90017. Steel. The Kaiser plant is the largest steel mill on the West Coast.

Joseph T. Ryerson & Son, Inc., Box 3817, Los Angeles, CA 90051. Steel, stainless steel, steel fabricating.

United States Steel Corp., 5 Gateway Center, Pittsburgh, PA 15230; 71 Broadway, New York, NY 10006. Steel, stainless steel, Cor-Ten weathering steel.

Distributors

Advanced Alloys, Inc., 15-43 130th St., New York, NY 10037. Stainless and alloy steels.

Cary Steel Co., 2400 Dominguez St., Long Beach, CA 90810. Plates, bars, and structural shapes.

Crucible Steel Corp., 25 Greenbrook Rd., Fairfield, NJ 07006 and 22400 Lucerne Ave., Wilmington, CA 90744. Stainless and alloy steels.

Ducommun Metals & Supply Co., 4890 S. Alameda St., Los Angeles, CA 90058. All steels.

Fisher Bros. Steel Corp., 502 Nordhoff Pl., Englewood, NJ 07631. Sheets, bars, and structural shapes.

Lafayette Metals, Inc., 3025 E. Dominguez St., Long Beach, CA 90810. Sheet steel, galvanized, hot and cold rolled.

Starrow Steel, 14334 E. Firestone Blvd., La Mirada, CA 90638. Pipe, tubing, plate, angles, channels.

B. Aluminum

Producers

Alcoa (Aluminum Co. of America), 1145 Wilshire Blvd., Los Angeles, CA 90017.

Apex Smelting Co., 2211 E. Carson St., Long Beach, CA 90801.

Harvey Aluminum, 19200 S. Western Ave., Los Angeles, CA 90509 and 3158 N. Des Plaines Ave., Des Plaines, IL 60016.

Kaiser Aluminum and Chemical Sales, Inc., 6250 Bandini Blvd., Los Angeles, CA 90045.

Olin Aluminum, 5356 Jillson Ave., Los Angeles, CA 90022; 400 Park Ave., New York, NY 10022.

Reynolds Metals Co., 5670 Wilshire Blvd., Los Angeles, CA 90036; 19 E. 47th St., New York, NY 10036.

Distributors

Adam Metal Supply, 4-63 48th Ave., Long Island City, NY 11101.

Arts' Surplus, 6212 Sepulveda Blvd., Van Nuys, CA 91411.

Benjamin Metals Co., 1829 W. El Segundo Blvd., Compton, CA 90222.

Lewisohn Sales Co., Inc., 4001 Dell Ave., North Bergen, NJ 07047.

Pioneer Aluminum, Inc., 3800 E. 26th St., Los Angeles, CA 90023.

Strahs Aluminum Corp., 800 Snediker Ave., Brooklyn, NY 11207.

Turner Metals Supply Div., 6560 Bandini Blvd., Los Angeles, CA 90022.

C. Copper, Brass, and Bronze

Producers

Anaconda American Brass Co., 14900 Garfield, Paramount, CA 90723; 99 Park Ave., New York, NY 10013.

Chase Brass & Copper Co., Inc., 6500 E. Washington Blvd., Los Angeles, CA 90022; 1121 E. 260th St., Cleveland, OH 44100.

T. E. Conklin Brass & Copper Co., Inc., 270 Nevins St., Brooklyn, NY 11200.

Distributors

Ducommun Metals & Supply Co., 4890 S. Alameda St., Los Angeles, CA 90058.

Federated Metals Div. of American Smelting & Refining Co., 4010 E. 26th St., Los Angeles, CA 90023.

Major Alloys Co., Inc., 1950 Central Ave., Farmingdale, Long Island, NY 11735.

Monarch Brass & Copper Corp., 75 Beechwood Ave., New Rochelle, NY 10802.

Pacific Metals Div. of A. M. Castle & Co., 2187 S. Garfield, Los Angeles, CA 90022.

D. Cerro Alloys: Low-Melting Alloys

Cerro de Pasco Sales Corp., 300 Park Ave., New York, NY 10022.

Peck-Lewis Corp., 4436 Long Beach Ave., Los Angeles, CA 90058.

E. Titanium

Futura Titanium Sales Corp., 31166 Via Colinas, Westlake Village, CA 91360.

Universal Titanium Co., Inc., 1291 E. 6th St., Los Angeles, CA 90021; 333 Hurst St., Linden, NJ 07036.

F. Multiple Distributors

These firms stock steel, stainless steel, brass, bronze, aluminum, and other metals in a variety of shapes and sizes.

Alvin Metals, 5869 Rodeo Rd., Los Angeles, CA 90016.

Atlas Supply Co., Inc., 2960 Webster Ave., Bronx, NY 10451.

Bond Metal Surplus Co., 321 Canal St., New York, NY 10013.

C.B.C. Metal Supply Corp., 1523 63rd St., Brooklyn, NY 11201.

Central Surplus, 8786 Washington Blvd., Los Angeles, CA 90606.

Ducommun Metals & Supply Co., 4890 S. Alameda St., Los Angeles, CA 90058.

Ideal Metal & Salvage Co., 11510 W. Jefferson Blvd., Los Angeles, CA 90066.

Nimco Metal Sales, Inc., 1682 W. Washington Blvd., Los Angeles, CA 90007.

Pacific Metals Div. of A. M. Castle & Co., 2187 S. Garfield, Los Angeles, CA 90022.

10

Metal Forming

Metalworking tools range from the simplest hand
tools, virtually unchanged in design for centuries, to
the most advanced production machinery, guided by
computer. In contact with the metal to be formed
there is always an edge or face of hardened steel,
tungsten carbide, or an abrasive material. The rest of
the tool is a device to hold the cutting surface in
contact with the work.

HAND TOOLS

The Hacksaw

Metal can be cut swiftly with a sturdy hacksaw and a
sharp alloy-steel blade. Care must be taken to keep
the blade straight. If it is twisted while sawing it will
bind in the cut *(kerf)* and probably break. With a
rod-type blade coated with particles of carbide you
can saw ceramics and other hard materials, as well as
metals, and make curved as well as straight cuts. Use
a fine-tooth blade for cutting thin metals to avoid
chatter (rapid vibration of the tool). When replacing
the blade be sure that the teeth face forward (see pl.
10.3). Do not saw so fast that the blade becomes hot
or the teeth will lose their temper.

The Chisel and Hammer

The *cold chisel* is used for cutting sheet metal, shear-
ing off bolts, and cleaning up castings. The *punch* or
point is used for making holes in sheet metal, making
reference marks, and making indentations for drill
starting. The carbide-tipped chisel stays sharp for a
long time but chips easily if used on steel. It is just
right for bronze. There are different types of ham-
mers for driving chisels and for shaping metal by
pounding it directly.

Files

Filing is a fairly simple operation, but to do it well
requires skill and care. After selecting the right file
for the job, you should clean any oil off the work
and clamp it firmly so it will not vibrate. Then the file
must be pushed evenly over the work. It cuts only on
the forward stroke; the return stroke should be a
light one. Care should be taken not to run the file
over the jaws of the vise or the clamp, as this will
make a dull place on the file, making it slip and dull
further. A handle should always be used over the
tang of the file (see pl. 7.17).

It is worthwhile learning to file properly since
there are many jobs, especially those dealing with

intricate shapes, which a file can do better than a power tool. When the file becomes clogged with material it can be cleaned with a wire brush, or, if available, a rotary wire brush mounted on a stationary grinder. Be sure to wear goggles.

Shears

A *shear* is a device for slicing metal, with a sharp blade operated by a lever. The small bench shear requires successive shearing actions to make a long cut with its short blade. The floor shear makes a two- or three-foot cut with one action of its blade. Power shears work in the same way but can handle longer cuts and thicker metals.

The shear is an excellent tool for cutting metal up to around 3/16-inch thick because it is fast and leaves a clean edge.

Rod Cutters

These devices make a clean cut in rods up to one inch thick. Bolt clippers can also be used for cutting rod, wire, cable, and chain. Clippers are essentially large scissors. Specially tempered and ground blades are available for cutting hard materials such as stainless steel and tempered bolts.

Pipe Benders

A moderate curve can be formed in small sizes of pipe and tubing by hand bending. After a point, however, the inner wall of the pipe will start to collapse, forming a crimp. Sharper bends may be formed with a pipe bender because the bending shoe supports the walls of the pipe and allows them to stress without collapse. The larger-sized benders use a hydraulic cylinder similar to an automobile jack to create the necessary force.

The Press Brake

Making an even fold in a piece of sheet metal requires a *press brake*. The fold is accomplished by bringing a steel edge, or die, against the sheet, and then folding the metal with a rigid plate or wing

Plate 10.1. *Tool Making*, from Diderot's *Encyclopaedia of Trades and Industries*, Vol. IX, Pl. I, 1751–1765. Courtesy of the New York Public Library. Eighteenth-century toolmakers in France. In the foreground are large and small screw-cutting lathes. Farther back on the left an artisan at the bench vise strikes a punch, while on the rear center at the forge a smith pumps his bellows with an overhead lanyard.

assisted by counterweighted levers. Large machine shops have pneumatically powered brakes capable of bending ½-inch thick steel 14 feet wide. The largest hand brakes can handle sheets up to 8 feet wide and about 3/16-inch thick, depending upon the toughness of the material to be bent.

Handbrakes are relatively simple and inexpensive compared to power brakes. In the smaller sizes, the only advantage of the power brake is in rapid production of standard parts. Most brakes can be fitted with dies of different radii, so that curved bends, or ripples, can be produced. The *box and pan* brake has a die made up of detachable segments to allow the forming of the ends of box-shaped structures. This more versatile type of brake would be the one most sculptors would prefer.

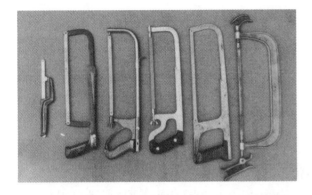

Plate 10.2. Hacksaws. A good hacksaw holds the blade firmly and is designed for easy blade replacement.

Plate 10.3. Power hacksaw. This tool saves time doing routine cutoff jobs.

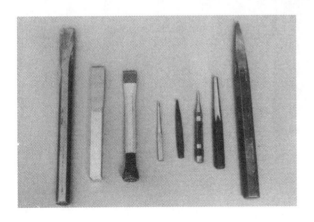

Plate 10.4. Chisels and punches for metal. The cold chisel cuts and trims metal and can be used for parting small bolts and nails. The center punch makes a pointed dent useful for marking and for guiding the point of a drill.

Plate 10.5. Three rubber hammers and one rawhide mallet, for pounding metal without damage (see also pl. 6.16*a* for metal hammers).

Plate 10.6. Lever action, bench shear. Courtesy of Roper-Whitney Inc., Rockford, Illinois. Bench mounted hand shear. Makes straight cuts or gradual curves in mild steel or bronze up to 1/8″ thick.

Plate 10.7. Foot squaring shear, floor model. Courtesy of Roper-Whitney Inc., Rockford, Illinois. The full weight of the operator may be brought to bear in cutting straight across sheets of metal up to 1/16″ thick. This tool is made in a range of sizes that will cut sheets from 2′ to 5′ wide.

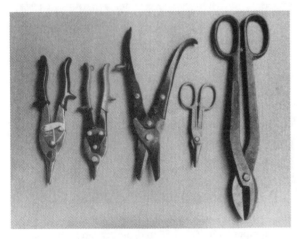

Plate 10.8. Metal shears for cutting sheet metal. The "aircraft shears" have compound cutting action to increase leverage. Jaws are designed to cut right, left, or straight. Alloy jaws are available for cutting stainless steel.

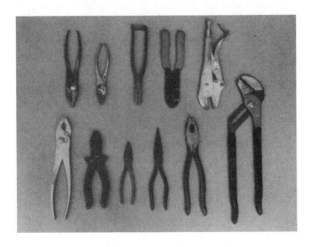

Plate 10.9. Pliers. Top, left to right: two flat-nose pliers for confined areas; wire-insulation stripping pliers; combination electrical pliers for stripping, cutting, crimping; visegrips for firm gripping. Bottom: oversized pliers; insulated pliers, pointed pliers, needle-nose pliers, heavy-duty pliers with wire-cutting jaws, plumber's pliers with wide opening.

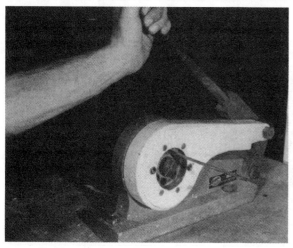

Plate 10.10. Small rod parter. This model cuts metal rods from 1/16″ to ⅝″ in diameter. Larger models cut up to 1″ rods and bars.

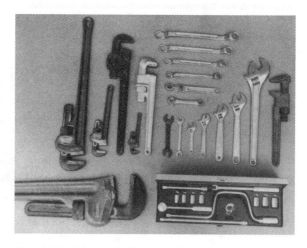

Plate 10.13. Wrenches. On the left: pipe wrenches. On the right: open-end wrenches and a Stilson wrench. On the top: box-end wrenches. On the bottom: a ½″ drive socket-wrench set.

Plate 10.11. Bolt clippers for cutting wire, cable, rods, bars, and bolts. The largest pair have 36″ handles and special alloy steel jaws for cutting hardened steel or stainless steel.

Plate 10.14. Hydraulic pipe benders. Steel, brass, and aluminum pipes from ½″ to 5″ in diameter can be bent in an even curve using the small or large bender with the proper bending shoe attached to the piston (the vertical cylinder).

Plate 10.12. Clipping pliers and end clippers for clipping wire and small rod. The clipping pliers left bottom have gripping jaws ahead of the cutting jaws.

Plate 10.15. Chicago Hand Bending Brake. Courtesy of Dreis and Krump Co., Chicago, Illinois. These brakes are made from 4″ to 12″ long and will bend material from ⅛″ to 3/16″ thick, depending on length of the bend and hardness of material.

Plate 10.16. Detail of box and pan brake showing fingers. The fingers are removable so that edges may be bent at right angles to each other. The 45° nosebars may be replaced with others, such as the radius nosebars shown. The capacity is ⅛″ to 3/16″, depending on length of bend and hardness of material.

Plate 10.17. Hydraulic-operated press brake. Courtesy of ACO Manufacturing and Engineering Co., Hawthorne, California (photograph by the author). This industrial tool can make fast, accurate bends in large sheets. Many bending edges are available, from sharp to rounded.

Taps and Dies

Taps are used for cutting internal threads such as those on the inside of a nut. Dies cut external threads on rods or pipes. Taps and dies are available to cut all types of threads, the main ones being coarse bolt threads, fine or "machine" threads, and pipe threads. Outside the United States, most countries use threads based on the metric system rather than on inches.

In making a sculpture of assembled parts it is often neater to thread and tap the parts themselves, instead of introducing bolts and nuts.

Vises and Clamps

One of the most important aspects of all shop procedures is the adequate holding and positioning of the work. Only by holding the work firmly in the right position can you make the most of the different processes that are available.

A great variety of devices are manufactured to do this job, some of which are illustrated on the accompanying pages. The experienced metalworker knows how to use a variety of clamps and develops a variety of inventive strategies for holding types of work which cannot be handled in the usual ways.

Plate 10.18. Cesar Baldaccini, *The Yellow Buick*, compressed automobile, 59½" × 30¾" × 24⅞", 1961. From the Collection of the Museum of Modern Art, New York, gift of Mr. and Mrs. John Rewald (photo courtesy of Rudolf Burckhardt). This sculpture was formed from the body of an automobile that was compressed by an industrial press ordinarily used to prepare scrap metal for transport to the steel mill.

Plate 10.19. Taps and dies. The screw plate is a selection of taps and dies; in this case, they are standard bolt sizes.

Plate 10.20. Pipe threading dies for pipe sizes ⅜″ through 1″. Cone-shaped tool is a pipe reamer for reaming inside diameter of pipe after cutting.

Plate 10.21. C-clamps. This type of clamp is more often used for metal than the bar clamps shown in pl. 7.28, which are commonly used for wood. Either type may be used for any job where the design is suitable.

When powerful rotary tools are in use, clamping becomes a matter of safety. A piece of work that suddenly gets free can hurtle toward the operator with dangerous force. Broken drills and saw blades are another consequence of poor clamping.

POWER TOOLS

The Band Saw

Band saws vary from delicate laboratory models to factory behemoths with four- or five-foot throats. A standard shop model would have a 15- or 20-inch throat and a 1½ to 2 horsepower variable-speed motor for sawing different materials. The throat measurement is the distance from the blade to the support post, the widest continuous cut that can be made. With a variety of speeds and blades you can cut many materials, such as wood, metal, plastics, cardboard, leather, and rubber.

The wider the blade, the steadier the cut. Teeth tend to last longer on a wide blade because the extra metal area helps to dissipate heat away from the teeth. If the teeth get too hot they lose their temper and fail; lubrication also helps to cool teeth. The thinner the blade, the tighter are the curves that can be cut. If a blade is used which is too wide for the curve to be cut, there is the danger that a crimp will be put into the blade which will cause it to wobble and weave in the cut. If a blade that is not bent weaves when cutting, it is usually because it has lost its sharpness, or the blade guides may be worn or out of adjustment.

Grinders

The band saw, the grinder, and the drill are the three basic tools around which the metal shop is organized. Many different heads can be used on the grinder: grinding stones of various shapes and grits,

Plate 10.22. Do-All Band Saw Model 3613-0. Courtesy of Do-All Co., Des Plaines, Illinois. Heavy duty deep-throat band saw. The three-wheel design allows a throat distance of 36″ when the center post is removed. Can also be operated as a two-wheel machine with shorter blades.

Plate 10.23. Adjustable speed band saw with 20″ throat. Courtesy of Powermatic, Houdaille, Inc., McMinnville, Tennessee. By running the correct blade at the correct speed, many different materials may be cut on this band saw. A blade-welder on the support post allows a blade to be cut, inserted in a hole, and rewelded for cutting shapes within the perimeter of a sheet.

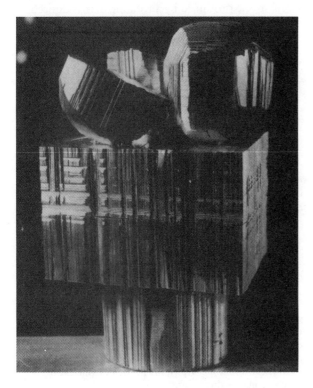

Plate 10.24. Tony Rosenthal, *Noon Offering*, bronze, 7⅝″ × 4⅝″ × 3¼″, 1962. Courtesy of Tony Rosenthal. The pieces were cut from solid blocks of bronze on a large powerful band saw. The saw marks are left in the metal to produce a striated surface that enhances the sculpture's rugged solidity.

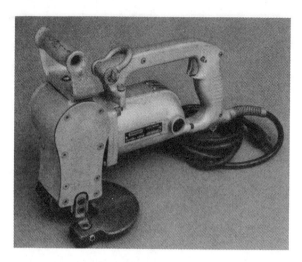

Plate 10.25. Stanley Unishear. This portable electric shear nibbles the cut with short alloy steel jaws capable of sustained cutting in stainless steel up to ⅛″ thick. The jaw design permits cutting of curves.

Plate 10.26. 10.23 Pedestal Grinder Milwaukee. Courtesy of Milwaukee Electric Tool Corp., Brookfield, Wisconsin. Eye shields, tool rests, and a water basin are incorporated into the design of this ¾ h.p. grinder. It is usual to drive a coarse stone on one end and a fine stone on the other. This type of grinder may also be mounted on a bench or table.

fiberglass-reinforced grinding disks, cloth buffing wheels, and rubber, metal, or plastic disks for mounting sandpaper. The portable grinder is used for large pieces of work and broad surfaces, whereas the stationary grinder is used for smaller objects that can be held against the grinding wheel. Stationary grinding wheels used for tool sharpening should not be used for other operations, since they must maintain perfectly flat, square surfaces if they are to provide accurate tool sharpening.

For driving very small stones for intricate work, smaller high-speed grinders, sometimes called die grinders, should be used. At this scale tungsten carbide mills are often more effective than grinding stones. They come in a great variety of shapes and sizes. Steel mills are also available, but they wear out rapidly at the high speeds necessary for this type of cutting.

A face shield or goggles should be worn for all grinding operations, and the grinder should be equipped with a safety guard of the proper type.

Sanders

A grinder can be made into a sander by fitting it with a rubber or metal sanding disk. There are many jobs, however, where a sanding action different from the circular one produced by a rotating disk is desired.

Plate 10.27. Grindstones and buffing wheels. At the top are grindstones, in the middle grindstone dressing tools. The thin bar to the right has a diamond point. The action of the dressing tool held against the face of the grindstone restores the face of the grinding wheel when it gets out-of-round. Cloth buffing wheels are at the bottom; more stitching makes them stiffer.

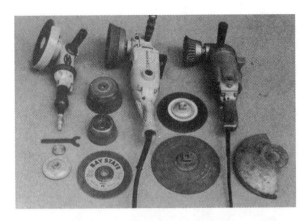

Plate 10.28*a*. Right angle grinders. The air grinder is fitted with a fiberglass grinding disk. One electric grinder runs a cup wheel, the other drives a cup brush. Note the guards on the disk and the cup wheel. A disk guard is shown separately on the right.

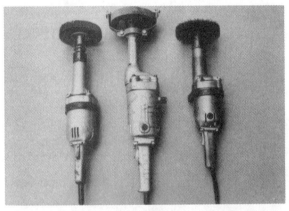

Plate 10.28*b*. Straight grinders. The three tools are mounted with (left to right) a wheel for sanding irregular contours, a grinding wheel with guard, and a circular brush. They are available in pneumatic versions, and with rpm's from 3,500 to 6,000.

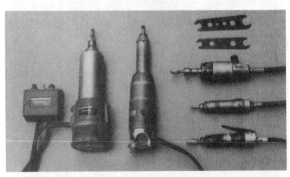

Plate 10.29*a*. High-speed grinders: two electric grinders (one with separate switchbox) and three pneumatic grinders. These turn at 45,000 rpm. Models are available at 20,000–80,000 rpm for large to small bits. Pneumatic grinders are more compact and do not heat up under load like electric grinders.

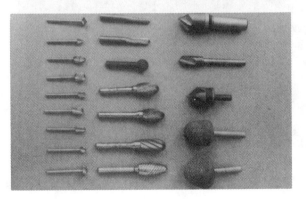

Plate 10.29*b*. High-speed mills and grinding stones for use in 20,000 to 45,000 rpm grinders. They will work, but not so efficiently in a ¼″ drill. Those in the center row are tungsten carbide, which lasts about ten times as long as steel. Steel mills are discarded when dull, and carbide mills are returned to the factory for resharpening.

Plate 10.30. Portable sanders—air and electric. Top row: pneumatic (air driven) disk sanders. Bottom row: the two square oscillating sanders are for flat finish work; compact disk sander; belt sander for heavy flat sanding; and heavy-duty disk sander for removing large amounts of material.

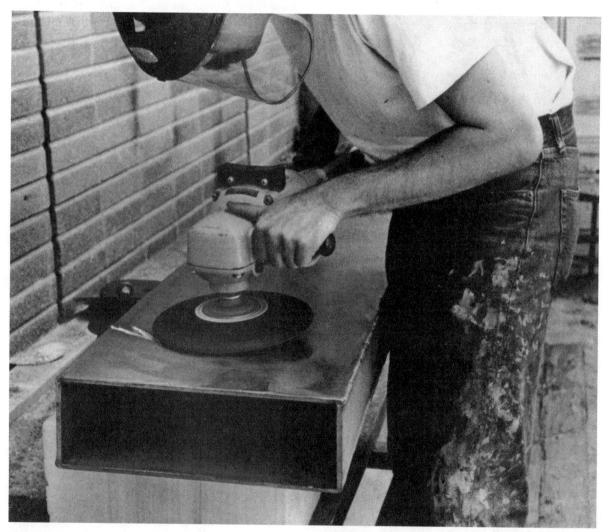

Plate 10.31. Sanding titanium with a disk sander. Each sanding device leaves its characteristic pattern. The disk sander produces a series of overlapping semicircular whorls, the orbital sander makes small circles, and the belt sander leaves straight parallel lines.

An orbital action is produced with a square-pad sander or with an eccentrically rotating disk sander. This gives a nondirectional pattern to surfaces finished with the finer grades of sandpaper. It also utilizes more of the edges of the abrasive particles on the sandpaper and has a self-cleaning action.

Square-pad sanders are also made with a straight-line action which is useful for finish sanding of wood where one wishes to keep the sanding action in line with the wood grain. Belt sanders produce a straight-line pattern, too, but the belt rotates continuously in one direction instead of back and forth like a pad sander. Belt sanders are usually larger and more powerful than pad sanders, so they may be used for coarse sanding of large areas.

Stationary disk sanders and belt sanders are very useful for finishing objects that are small enough to pick up, yet big enough to hold with the hands. Pedestal-mounted disk sanders are especially good for squaring up corners and edges. A succession of sanders and abrasives usually provides the ideal rough-to-finish sanding operation (see the section on abrasives later in this chapter).

Drills and Drilling

The well-equipped shop should have a stationary drill press, several portable drills of different sizes, and a complete set of fractional drill bits in an indexed box or rack. Each size of hole in a particular material has its correct drilling speed and lubricant. Cutting oil should be used for steel and iron, kerosene for brass, and soluble oil for aluminum.

The work must be clamped securely for good drilling results. A small indentation at the center of the proposed hole should be made with a punch so the point of the drill will start in the right place without skidding around. Holes larger than ¼ inch should be started with a pilot hole smaller than the final hole. Large holes will require several preliminary holes of successively larger diameters. Holes from ½ inch to 4 inches can be cut in thin materials with a hole saw.

Drills must be kept sharp. After some practice it is possible to sharpen drills by hand-holding them against a grindstone. This is a crude method at best, however, and can never approach the accuracy obtained with a drill-sharpening tool. Good results can be obtained from an attachment which positions the drill against the wheel of a bench grinder. More accurate drill sharpeners have a self-contained motor

Plate 10.32. Drill press. This floor model has an adjustable table for the work and variable speeds. The vise that holds the work to be drilled can be clamped to the drill press table.

Plate 10.33. Portable drills. The three in the upper left are ¼″ drills with speeds from 1,500 to 5,000 rpm. The smallest are air driven. The drill on the lower left is ⅜″ capacity with a trigger-operated speed control. The rest of the drills are ½″, the most powerful being the Milwaukee Hole-Hawg, middle right, which has two speeds and a reversing switch.

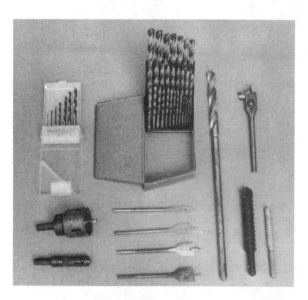

Plate 10.34. Drill bits. Top: drill bits in index boxes. Bottom left to right: hole saws, spade-type wood bits, extra-long bit, adjustable bit for large holes, carbide-tipped bits for masonry.

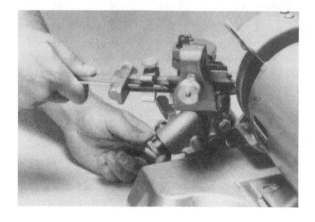

Plate 10.35. Drill-bit sharpener. Courtesy of Lisle Corp., Clarinda, Iowa. The holding device accurately positions the drill and allows the tip to be moved across the face of the sharpening stone.

and grinding wheel. Compact drill sharpeners have recently become available. The operator simply inserts a drill in the right size hole, much like using an electric pencil sharpener.

Power Sources

In the shop or studio 110-volt power is commonly available to drive power tools. If large stationary saws and grinders are to be used, it is worthwhile to obtain 220-volt 3-phase service, as motors using 220-volt 3-phase power are more durable and efficient, especially in sizes over ½ horsepower.

In the long run, pneumatic power is more efficient for hand tools than is electric power. Though their initial expense is higher, air tools last much longer between repairs and can be used continuously on long jobs because they do not heat up. They are also safer because they cannot short out and shock the operator. Finally, pneumatic tools are not as likely to be stolen as electric tools because most people do not have air compressors in their homes. See chapter fifteen for illustrations of air stations.

For work with power tools in remote areas where power is not available, there are several options. For small jobs there are 12-volt tools available which will run off automobile batteries. For larger jobs you can use a portable gasoline-driven generator that can be carried in the back of a pickup truck. You can then use all of your regular 110-volt tools at the end of an adequate extension cord. For heavy work with pneumatic tools, portable gasoline-driven compressors are available. They usually have their own wheels and are towed behind a car or truck.

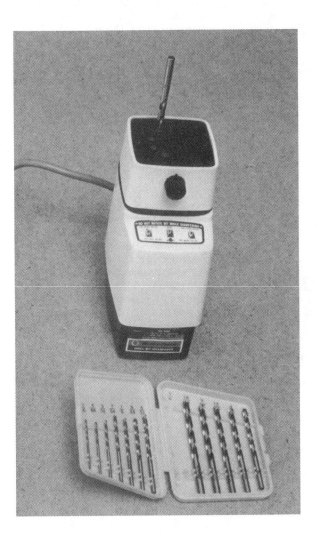

Plate 10.36. Compact drill-bit sharpener. This tool will sharpen drill bits from ⅛″ to ⅜″ in diameter. Each bit must be inserted twice to sharpen each of the two cutting edges.

FORGING

The ancient craft of the blacksmith still has many attractions for the sculptor who wishes to form objects out of metal. It involves the satisfying process of actually beating shapes out of the red-hot metal. All that is required is some kind of forge for heating the metal, an anvil, tongs for holding the work, and a hammer for beating it with. In addition it is useful to have an iron shape-block with indentations and holes in it to aid in forming some of the more commonly used shapes. Though the tools are simple, the technique is not. The artist wishing to practice blacksmithing should read widely on the subject and then get some personal instruction.

In these days of universally available gas fuel it is easier to use a gas-fired forge than to pump a primitive bellows forge, unless you are well supplied with indefatigable apprentices.

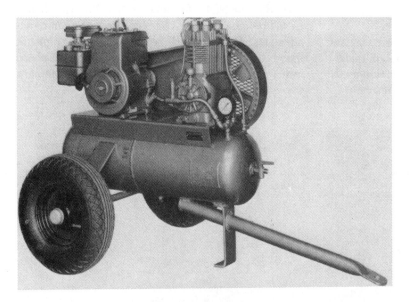

Plate 10.37. Portable air compressor. Courtesy of Essick Manufacturing Co., Essick Portable Compressor Model GT-10. This compressor may be towed behind a car to remote areas. The 6 h.p. gasoline engine drives the compressor, filling the 12 gal. tank with air at 150 psi (pounds per square inch). This will supply 7 cfm. (cubic feet per minute) at 80 psi, or enough to drive one medium-size pneumatic tool like a sander or grinder.

Plate 10.38. Milwaukee Heavy Duty Alternator. The alternator offers better performance than the conventional electric generator, with less weight and less maintenance. This one delivers 5,000 watts at 3,600 rpm from a 13 h.p. gasoline engine. There are two 15-amp 125-volt circuits, one 30-amp 125-volt circuit, and one 20-amp 250-volt circuit.

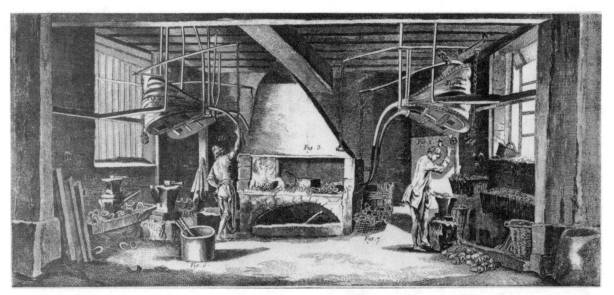

Plate 10.39. *Blacksmith's Forge*, from *Diderot's Encyclopaedia of Trades and Industries*, Volume VII, Pl. II, 1751–1765. Two farriers making horseshoes. One pumps the bellows to blow air into the forge. His partner beats the red-hot iron into shape on an anvil. These tools have changed little in two hundred years.

Plate 10.40. Gas-fired forge showing anvil, hammer and forging tongs. The centrifugal blower on the left sends air to the forge, or it can be switched to feed a furnace off the picture to the left. Gas enters the air stream through the round platter-shaped gas regulators.

FASTENERS

If the final sculpture is not entirely welded together, some other means of fastening pieces together must be used. Adhesives such as epoxies have some use, especially in fastening small pieces of materials like glass, wood, or plastic to metal. Otherwise, mechanical fastening methods must be used. Bolts and nuts are the most common mechanical means of fastening. They may be used in a very frank and obvious way, or they may be recessed into the forms in such a way as to be hardly noticeable.

There are also many kinds of rivets available. They range from crude "country style" rivets, where one side is beaten down with a hammer, to the most sophisticated pneumatic aircraft rivets. It is obvious from airplane construction that riveting is an excellent way to fasten together thin sheets of metal.

By examining aircraft, automobile, and boat construction as well as architectural hardware, you can

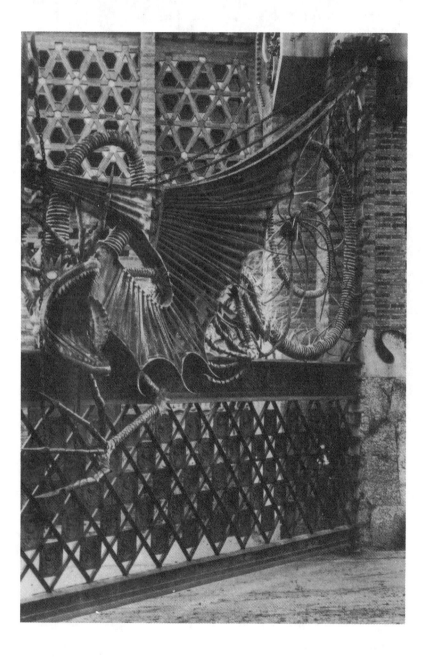

Plate 10.41. Antonio Gaudí, *"El-Drac" Gate*, combination laminated, cast, and wrought iron, wire mesh used for the dragon's wings, 1885. Güell Pavilions, Barcelona, Spain (photo credit Ampliaciones y Reproducciones "MAS," Barcelona). A superb example of the level of achievement that can result when a master of form like Gaudí is able to extend the possibilities of a highly developed local craft such as that of the early twentieth-century Barcelona blacksmith. The early iron sculptures of Pablo Picasso and Julio González are related to this tradition.

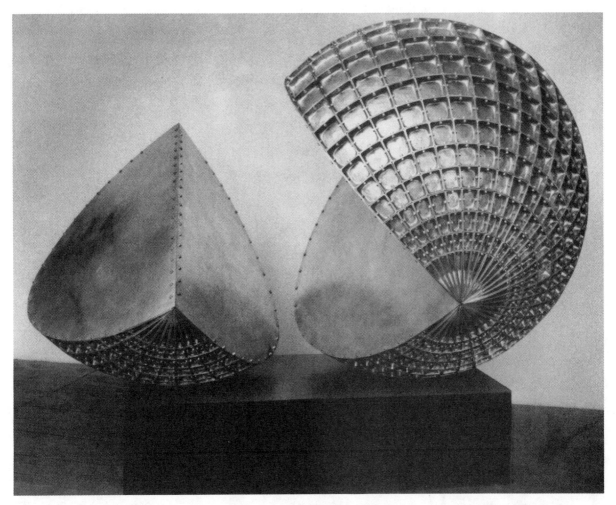

Plate 10.42. Robert Bart, *Untitled*, cast aluminum, bolted, 12¾″ × 17¾″ × 17½″, 1965. Courtesy of Leo Castelli Gallery, New York (photo credit John A. Ferrari). A sculpture that raises nuts and bolts to a new level of aesthetic appreciation.

Plate 10.43. Hand-operated rivet tool and self-expanding rivets. The rivet is inserted in a hole and the shank is withdrawn by the rivet tool, expanding the inner end of the rivet to make a tight fit. The excess shank is then cut off flush with the rivet head.

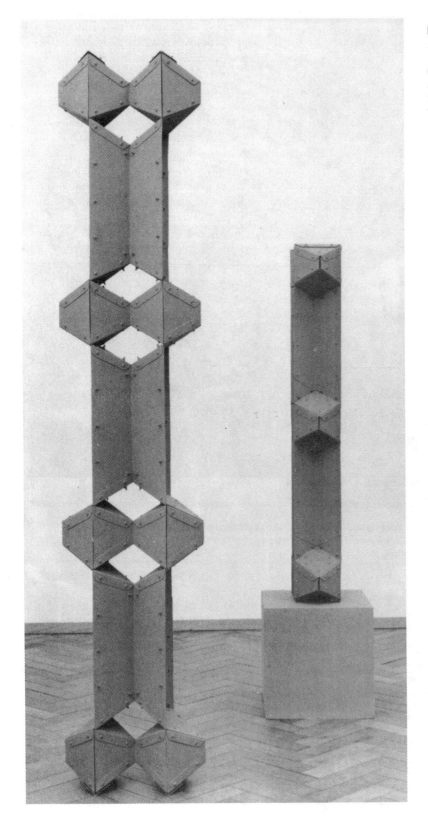

Plate 10.44. Edgar Negret, *Stanchion 2*, aluminum, 66″ × 17″ × 9″, 1968–1970. Collection of the artist (photo courtesy of Stedelijk Museum, Amsterdam). Rivets and bolts contribute to the structural presence of these works.

discover many types of latches, locks, clasps, and other kinds of fastening devices that might have application to your own work.

ABRASIVES

An entire book could be written on abrasives and their uses for the sculptor. Here we will mention a few of the main kinds and their most common applications. While this section refers specifically to metals, these same abrasives are also used with stone, wood, plastics, and other materials.

After granular or powdered abrasive is graded by the manufacturer, it must be put into a form that is convenient to use. Glued to cloth or paper, it is sold in standard 9-by-12-inch sheets to be cut up and used by hand or on sanding tools. Abrasive cloth and sandpaper are also sold as belts, as disks, and in the form of cylinders and flap wheels for sanding curved and irregular surfaces. *Closed cost* sandpaper is covered with particles of abrasive packed closely together. *Open cost* paper has more space between particles so the paper will not become clogged when sanding soft materials.

Sandpaper for wet sanding is prepared with a waterproof paper and binder so water can flush the sanding residue out of the abrasive surface and lubricate the cutting action. Glue-bonded sandpaper is more flexible than resin-bonded sandpaper but not as durable, especially in high-speed operations.

Grindstones are made of abrasive particles mixed with a binder, formed in molds, and baked until hard. Thin grinding wheels are usually reinforced with fiberglass. Grindstones and wheels usually contain the coarser abrasives, from 12 to about 60 grit.

Sandpapers start at number 12 also; standard coarse grades are 40, 50, 60, and 80 grit. These grades are used principally for removing material and taking out deep scratches. Finishing grades of sandpaper are 120, 220, and 320 grit, followed by fine grades of 420 and 600 grit. Silicon carbide abrasives are black or white and are preferred for working hard metals. Abrasive surfaces colored dark brown are usually aluminum oxide, whereas tan is usually garnet (mostly for woodworking). Aluminum oxide is used for both metal and wood. It is not quite as hard as silicon carbide and therefore produces a slightly softer abrasive effect.

The decreasing order of hardness among abrasives is: diamond, silicon carbide (carborundum), aluminum oxide, emery, garnet, and flint. Diamond can be either natural or synthetic. Silicon carbide and aluminum oxide are synthetic materials; emery, garnet, and flint are natural materials. Emery is natural aluminum oxide containing about 40 percent iron oxide and is black in color. It is better for polishing than for cutting. Garnet is a silicate of iron and aluminum. Flint is a form of quartz, and was one of the earliest abrasives. Since it is fairly soft it is used mostly for wood and for paint removal.

Final smoothing and polishing operations are usually carried out with a cloth buffing wheel coated with abrasive that is applied to the moving wheel from a tube or stick. Coarser abrasive from 80 to

Plate 10.45. Sandpaper shapes and wire wheels. The flap wheels at the top sand with the outer edge, whereas the disks in the next row are used flat. At the far end is a disk with a peel-off adhesive backing. At the bottom are some of the many types of wire wheels, some steel, some stainless steel.

120 grit is supplied mixed with an air-drying adhesive and applied to a firm spiral-sewn wheel. Finer abrasives are mixed with a hard wax base and are applied to the looser, softer wheels, which are better for fine polishing. Three of the many common polishing compounds are tripoli, white silica powder, and rouge (red iron oxide). It is best to use a separate buff for each type of polishing compound.

The purpose of abrasive finishing is to change a rough, uneven surface with irregular scratches to a surface with very fine, uniform, parallel cuts or grooves. After fine polishing, these grooves cannot be seen with the naked eye, but they are still there. Scratches that are not uniform will show. This is why it takes a lot of work to go from one sanding pattern to another, as when shifting from the disk sander to the orbital. It also explains why you must completely finish the job with one grit of abrasive before proceeding to the next. The harder the material being finished, the closer together must be the series of grits used.

The softer the material being finished, the more the abrasive will become clogged. Plastics and wood present an additional problem; if the sanding action is too fast, they will burn. Very soft materials like plaster are best sanded with a material that has openings, like a sanding screen.

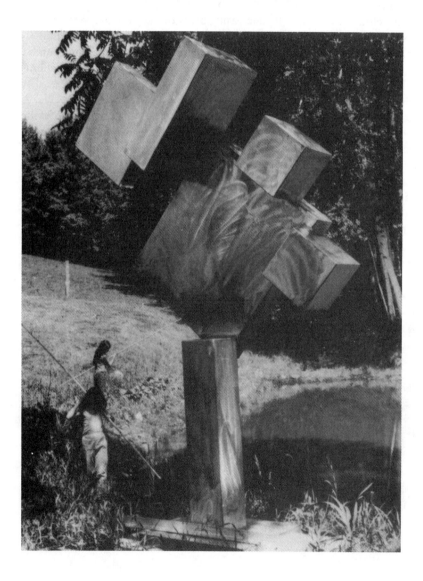

Plate 10.46. David Smith, *CUBI VII*, stainless steel, 111⅝″, 1963. Collection of the Art Institute of Chicago, Grant J. Pick Purchase Fund (photo courtesy of David Smith Papers, Archives of American Art, Smithsonian Institution). This sculpture is welded of stainless steel sheets thick enough so that the faces of the boxlike sections do not distort when stressed by the heat of welding. The disk-sanded surface reflects the varying colors of the sky throughout the day.

FINISHES

Bare Metal

Some metals are so resistant to the atmosphere that they may be left unprotected by any type of coating over the bare metal. Inconel and titanium, for instance, may be given a surface by grinding or polishing which will remain virtually unchanged under severe atmospheric conditions. Most stainless steels are also very durable, but some of them will begin to rust under conditions of atmospheric pollution, unless they are regularly cleaned. Some rare heavy metals, like gold and platinum, are virtually tarnish-proof, but they are so expensive that they are commonly used only for jewelry or for plating small parts. In the past many beautiful sculptures were made of beaten gold.

In addition to grinding and polishing, metals may also be finished by sandblasting or powder blasting.

These processes may also form the basis for a later process such as plating or oxidizing. Blasting has the advantage of reaching into the crevices of intricate parts where sanding might be difficult.

Oxidization and Patinas

Contact with the atmosphere forms on some metals a protective coating that can be left as the finished surface. Aluminum, for instance, forms a tough, transparent oxide immediately upon exposure to air. This coating can be thickened and colored with dyes by anodizing. Anodizing produces a very hard surface, but it is susceptible to pitting by sea water and industrial atmospheres. Once pitting works its way under the surface, deterioration of the metal begins. See chapter nine for more information on aluminum. Similarly, the section on steel describes Cor-Ten and Mayari, which form natural protective coatings, and the section on bronze and copper describes the

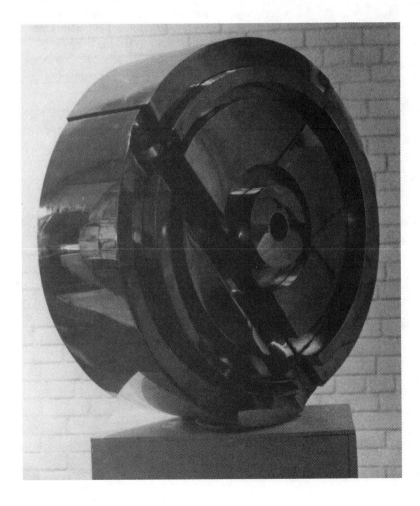

Plate 10.47. Tony Rosenthal, *Ergal*, bronze, 36″ diameter, 14″ deep, 1967. Collection of the Whitney Museum of American Art, New York, gift of Mrs. Susan Morse Hilles. The closely fitting parts of this sculpture were cut on a band saw and then highly polished.

naturally-formed coatings for these metals. Just as anodizing is the synthetic reinforcement of a common everyday process, *patination* is the chemical reinforcement and control of the inevitable growth of a colored coating on bronze and brass by atmospheric action.

A well-known industrial finishing process for steel is the black oxide process used for firearms and instruments. It is not durable enough for exterior protection unless accompanied by regular waxing or oiling.

Plating and Metal Spraying

One way to protect a metal is to coat it with a layer of durable metal like chromium, nickel, cadmium, tin, or even gold. Usually this is accomplished by the electroplating process, where the work to be plated forms the cathode of the plating metal in a bath of salts. A bar of the plating metal forms the *anode* or positive pole of this system. When an electric current is passed through the solution, the plating metal is deposited in an even layer on the *cathode* (negative

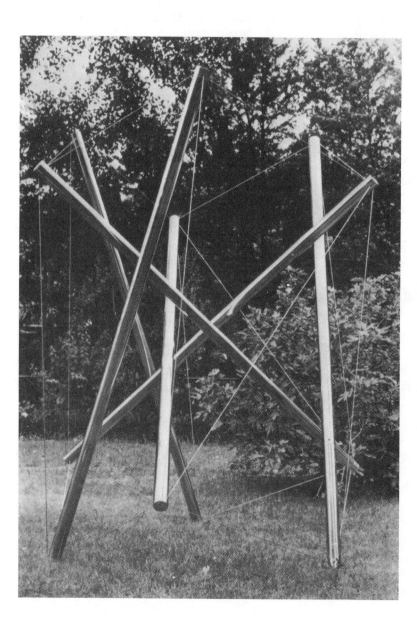

Plate 10.48. Kenneth Snelson, *Untitled*, stainless steel, 12′ high × 10′ wide at base, 1968. Collection of Mrs. Brooke Blake, Dallas (photo credit John Weber Gallery, New York). Stainless steel, because of its hardness, requires more work to polish than do brass or aluminum. Once polished, however, it holds its luster without dulling.

pole) object. Since the deposited metal follows exactly the surface it is applied to, it will reproduce the texture of that surface. In other words, if you want a brilliant chromium-plated surface, you must first polish the surface to be plated, or have the plating company do it for you. In most chrome plating operations, the polishing is the larger proportion of the expense, so you can save money by doing your own polishing if you have the equipment.

For a first-class chrome plating job, a layer of copper and nickel is deposited first to give a good base for the chromium. Even the best chrome job does not last forever out-of-doors, as the fate of automobile bumpers testifies. Polishing and waxing help.

A copper- or brass-plated sculpture can be patinated just as though it were solid.

Zinc is applied over another metal, usually steel, by hot-dipping rather than electroplating. This *galvanizing* process is used for sheet metal as well as for hardware such as hinges, brackets, bolts, and screws.

In metal spraying, a stream of molten droplets of metal is sprayed by a special gun onto a surface, forming a coating about 1/32 to ⅛ inch thick. Metal can be sprayed onto many different surfaces, including other metals, ceramics, glass, fiberglass, wood, and even cardboard. Since the droplets stick together rather than actually melting together into an impervious coating, the metal-sprayed surface does not provide much protection from moisture, nor is it very strong. The surface, as deposited, is rough and granular in appearance, though it may be smoothed by sanding. Many metals can be applied by spraying, including steel, iron, copper, brass, bronze, tin, zinc, and lead.

Paint and Other Organic Coatings

Each of the finishing processes mentioned so far may be used as a preliminary step to a final coat of paint, plastic, or wax. In general, the more secure the surface, the more durable will be the final coat of protective material. The purpose may be purely protective, as when a polished surface is coated with wax or a clear plastic, or it may be an integral part of the expressive function of the sculpture, as when the surface is painted with color.

A word about transparent coatings: none that are presently available will protect a polished surface exposed to the weather for more than a year or two.

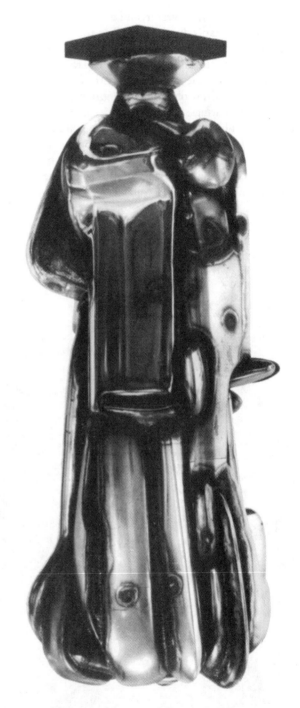

Plate 10.49. Jason Seley, *Canticle*, welded steel, 57″ × 23″, 1964. Collection of Hirshhorn Museum and Sculpture Garden, Washington, D.C. (photo by Charles Uht). Jason Seley's work is fabricated from the bumpers of automobiles. The weld areas are bluish black. The bright chrome plating remains intact on the unheated areas. Sculptures may also be plated after welding.

Acrylic, epoxy, polyester, and urethane plastics, though remarkably durable, all begin to break down after a while and turn yellow, or allow atmospheric penetration to the underlying surface. Transparent coatings also have less resistance to the damaging effects of the ultraviolet component of sunlight than do opaque coatings. Clear finishes are now manufactured with ultraviolet filter additives which increase their outdoor durability by a small amount. Perhaps the most durable coating of this type is clear baked enamel. To renew a deteriorated surface all the old coating must be removed, which can be difficult.

Steel is a difficult metal to protect because of its tendency to continue to rust under a coating once a penetration has been made. Steel, as well as other metals, requires a primer coat to bond the final coat firmly to the underlying metal. Paint manufacturers should be consulted for the correct primer material to go between the base metal and the finish coats. The cleanliness of the underlying metal is also an important factor in paint adhesion, making sanding, sandblasting, or chemical etching advisable where durability is an issue.

Once a metal surface has been prepared and primed it may be painted in a great variety of ways derived from artistic or industrial practice. It may be treated as a field for painterly activity much like the surface of a canvas, or it may be finished with techniques derived from motorcycle and car craft, such as layers of transparent lacquer, metal flaking, pinstriping and the like. The object can be considered an elegant instrument like a telescope, and

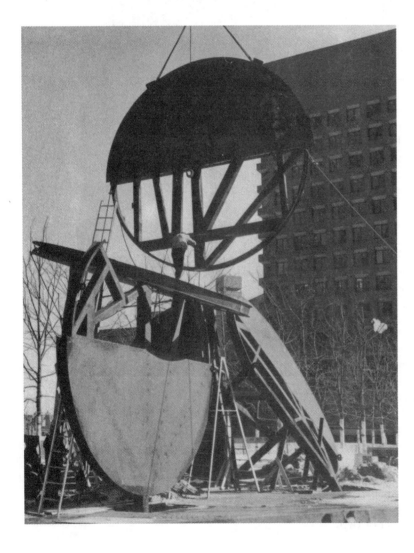

Plate 10.50. Tony Rosenthal, *5 in 1* under construction, weathering steel, 42′ × 32′ × 28′, 1974. Construction industry methods are needed to assemble the parts of this monumental sculpture. Details of the design must be carefully worked out beforehand.

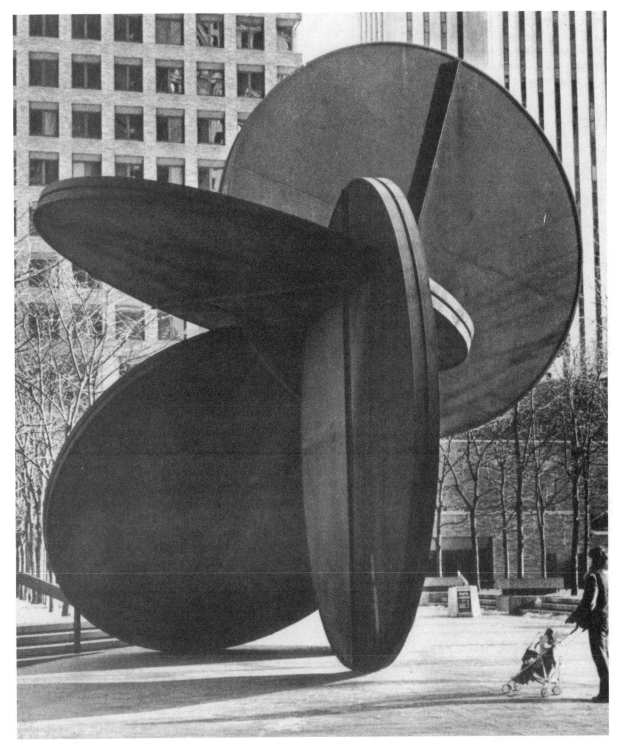

Plate 10.51. Tony Rosenthal, *5 in 1*, in Police Plaza, New York, weathering steel, 42′ × 32′ × 28′, 1974. Note the excellent fit of all the parts.

painted with crackle lacquer or baked enamel. Or again, the surface might be built up and modeled with plastic materials like fiberglass paste; until an entirely new terrain is created with the metal as the underlying base.

SAFETY

As the tools used for working metal are, as a rule, sharp and powerful, special attention should be paid to safety procedures. All tools purchased new will be equipped with safety devices such as guards, screens, tool rests, and emergency switches. Older tools may have never been equipped with modern safety devices, or these may have been removed. Therefore, all older tools should be inspected to make sure they comply with contemporary safety standards. In the shop or studio everyone using tools must be impressed with the necessity of maintaining safety devices in operating order. There is a tendency for inexperienced operators to remove safety devices for the sake of "convenience."

There is a limit to how safe a tool can be made if it is to remain effective for cutting metals. The operator must make use of protective devices; availability alone is not enough.

For all grinding and heavy metal-handling jobs, gloves should be worn which are heavy enough to protect the hands but light enough to retain the feeling and mobility of the fingers. Gloves of soft, pliable leather are recommended.

Sandals or open-toed shoes should never be worn in a metal shop. Long hair and loose clothing should be securely bound out of the way before the operation of any power equipment. When using equipment such as metal grinders with a high noise level, ear protectors are advisable, especially for long work periods.

Special attention must be given to protecting the eyes in all metalworking operations. Shatter-proof goggles or face shields must be worn for all grinding, drilling, sawing, punching, sanding, chipping, and any operation in which power is used. This holds true even though the tool itself may have a safety shield over it, as particles of metal or abrasive can bounce out from under the shield and into the face of the operator. Common eyeglasses are not a substitute for goggles, even if they are made of tempered glass, because they do not entirely cover the eyes. Face shields are preferred over goggles because they protect the whole face and offer better visibility with less chance of fogging.

Nine safety rules for power tools:

1. You, the operator, are the ultimate safety factor.
2. On entering a shop to work, be sure you know the whereabouts of (a) emergency telephone numbers, (b) first aid kit, (c) fire extinguishers.
3. Before operating a tool, be sure it is in good working order.
4. Be sure the work is firmly clamped in position.
5. Be sure your personal safety equipment is in place and that you have no loose hair or clothing in the way.
6. Be sure that there is no trash or excess material around to hinder your use of the tool or to trip you.
7. When turning on the tool, focus all your attention on the work and the immediate job to be done.
8. Turn off the tool as soon as you have finished the operation and are going to rest or perform a different operation.
9. Disconnect a portable tool from its power source if you are going to leave the work area, even if you will be away only a few minutes.

BIBLIOGRAPHY

American Society for Metals. *Metals Handbook*. 8th ed. Vol. 2, Heat Treating, Cleaning and Finishing (1965); vol. 3, Machining (1967); vol. 4, Forming (1968); vol. 5, Forging and Casting (1970). Metals Park, Ohio: American Society for Metals, 1961, 9th printing 1977.

Burns, R. M., and W. W. Bradley. *Protective Coatings for Metals*. 3d ed. New York: Reinhold, 1967.

Granstrom, K. E. *Creating with Metal*. New York: Reinhold, 1968.

Haedeke, Hans-Ulrich. *Metalwork*. Translated by Vivienne Menkes. New York: Universe Books, 1970.

Horton, Holbrook L., Franklin D. Jones, and Eric Oberk. *Machinery's Handbook*. 20th ed. New York: Industrial Press, 1976.

Ludwig, Oswald. *Metalwork, Technology and Practice*. Bloomington, Ill.: McKnight and McKnight, 1947.

Lynch, John. *Metal Sculpture*. New York: Studio Publications, 1957.

McDonnell, Leo P. *The Use of Portable Power Tools*. New York: Von Nostrand Reinhold, 1977.

Meilach, Dona Z. *Decorative and Sculptural Ironwork*. New York: Crown, 1977.

Meilach, Dona, and Don Seiden. *Direct Metal Sculpture*. New York: Crown, 1966.

Morris, John D. *Creative Metal Sculpture*. New York: Bruce, 1971.

Thomas, Richard. *Metalsmithing for the Artist Craftsman*. Philadelphia: Chilton, 1960.

Untracht, Oppi. *Enameling on Metal*. Philadelphia: Chilton, 1957.

——. *Metal Techniques for Craftsmen*. Garden City, N.Y.: Doubleday, 1968.

SOURCES OF SUPPLY

A. Hand Operated Tools

Adjustable Clamp Co., 417 N. Ashland Ave., Chicago, IL 60622. Clamps.

Beverly Shear Mfg. Co., 3004 W. 111th St., Chicago, IL 60655. Hand and electric shears.

Blackhawk Industrial Products Co., Butler, WI 53007. Hand and hydraulic pipe benders.

Brookstone Co., Brookstone Bldg., Peterborough, NH 03458. Unusual and hard-to-find tools.

The Desmond-Stephan Mfg. Co., Urbana, OH 43078. Vises.

DiAcro Div. of Houdaille Industries, Lake City, MN 55041. Pipe benders, shears, rodparters, hand and power press brakes.

Dreis & Krump, 7400 S. Loomis Blvd., Chicago, IL 60636. Hand and power press brakes.

Greenfield Tap & Die Corp., Greenfield, MA 01301. Taps and dies.

Heinrich Tools, Inc., 2707 Industrial Dr., Racine, WI 53403. Vises and clamps.

Pepto Div., Roper Whitney, Inc., 2833 Huffman Blvd., Rockford, IL 61101. Pexto hammers, wrenches, shears, benders, brakes, etc.

Percival Steel & Supply Co., 4600 Santa Fe Ave., Los Angeles, CA 90058. Anvils.

H. K. Porter, Inc., Somerville, MA 02143. Rod cutters and other metal-cutting tools, Disston saws and files.

Proto Tool Co., 2209 Santa Fe Ave., Los Angeles, CA 90054. Hammers, chisels, wrenches, pliers, and many other types of hand tools.

Ridge Tool Co., Elyria, OH 44035. Ridgid pipe tools.

Stanley Tools, New Britain, CT 06050. Many types of hand tools, including saws, files, chisels, etc.

J. H. Williams Co., 400 Vulcan St., Buffalo, NY 14217. All types of hand tools.

Wilton Tool Mfg. Co., Schiller Park, IL 60176. Vises and clamps.

B. Portable Electric Tools

The Black & Decker Mfg. Co., Towson, MD 21204. Complete line of moderately priced tools.

Foredom Electric Co., Inc., Bethel, CT 06801. Flexible shaft grinders.

Ingersoll-Rand, Inc., 11 Broadway, New York, NY 10004. Complete line.

Milwaukee Electric Tool Corp., 13135 W. Lisbon Rd., Brookfield, WI 53005. Complete line of heavy-duty tools.

Porter Cable Machine Co., 700 Marcellus St., Syracuse, NY 13200. Complete line.

The Precise Corp., 3715 Blue River Ave., Racine, WI 53401. High-speed grinders and carbide mills.

Rockwell Mfg. Co., 400 N. Lexington Ave., Pittsburgh, PA 15208. Complete line.

Skil Corporation, 5033 Elston Ave., Chicago, IL 60630. Complete line.

Thor Power Tool Co., 6200 E. Slauson Ave., Los Angeles, CA 90022 and 1834 S. Laramie Ave., Chicago, IL 60650. Complete line.

C. Portable Pneumatic Tools

Air Tool Specialty Co., 3517 W. Washington Blvd., Los Angeles, CA 90018. New and rebuilt tools, repairing.

Albertson & Co., 2801 Floyd Blvd., Sioux City, IA 51102. Sioux tools.

The ARO Corp., One Aro Center, Bryan, OH 43506. Complete line.

Astro Pneumatic Tool Co., 4455 E. Shiela St., Los Angeles, CA 90023. Astro tools.

The DeVilbiss Co., Toledo, OH 43611. Compressors.

Essick Mfg. Co., 1950 Santa Fe Ave., Los Angeles, CA 90021; 850 Woodruff Ln., Elizabeth, NJ 07200. Compressors.

General Pneumatic Prods. Corp., 9422 Trenton Ave., St. Louis, MO 63132. Blue Dart tools.

Ingersoll Rand, Inc., 77 Broadway, New York, NY 10004. Complete line.

Millers Falls Co., 57 Wells St., Greenfield, MA 01301. Drills and hammers.

National-Detroit, Inc., 2810 Auburn St., Rockford, IL 61105. Sanders.

Remington Arms Co., Inc., Park Forest, IL 60466. Complete line.

D. Stationary Equipment

Armstrong-Blum Mfg. Co., 5700 W. Bloomingdale Ave., Chicago, IL 60639. Heavy-duty band saws.

Buffalo Forge Co., 465 Broadway, Buffalo, NY 14203. Forges and forging equipment.

Clausing Div. Atlas Press Co., Kalamazoo, MI 49001. Heavy-duty drill presses.

DeWalt, Inc., Div. of Black & Decker Mfg. Co., Lancaster, PA 17600. Radial-arm saws.

The Do-All Co., Des Plaines, IL 60016. Band saws.

Fisher & Norris, Inc., 301 Monmouth St., Trenton, NJ 08609. Eagle anvils and vises.

Lisle Corp., 807 Main Street, Clarinda, IA 51632. Drill sharpening equipment.

Milwaukee Electric Tool Corp., 13135 W. Lisbon Rd., Brookfield, WI 53005. Bench grinders.

Pexto Div. Roper Whitney, Inc., 2833 Huffman Blvd., Rockford, IL 61101. Hydraulic press brakes, shears.

Powermatic Machine Co., McMinville, TN 37110. Drill presses, band saws, bench grinders, disk and belt sanders.

Rockwell Mfg. Co., 400 N. Lexington Ave., Pittsburgh, PA 15208. Drill presses, band saws, bench grinders, etc.

E. Abrasives

Abrasive Engineering Tool & Equipment Co., 15401 S. San Pedro St., Gardena, CA 90248. Sanding disks, wheels, and tools.

Bay State Abrasive Prods., Westboro, MA 01581. Complete line.

The Carborundum Co., Niagara Falls, NY 14300. Manufacturers of complete line.

Divine Bros. Co., Utica, NY 13500. Dico buffing wheels and compounds.

Eastern Abrasives, Inc., 740 Jefferson Ave., Kenilworth, NJ 07033. Wheels and compounds.

Kysor Industrial Corp., 11515 Alameda Dr., Strongsville, OH 44136. Cut-off wheels.

Lea Mfg. Co., Waterbury, CT 06702. Grinding and buffing compounds.

Chas. F. L'Hommedieu & Sons Co., 4521 Ogden Ave., Chicago, IL 60623; 6052 Ferguson Dr., Los Angeles, CA 90022. Buffing and polishing wheels and compounds.

Merit Abrasive Products, Inc., 201 W. Manville, Compton, CA 90224. Sanding disks and flap wheels.

Minnesota Mining & Mfg. Co., 700 Grand Ave., Ridgefield, NJ 07657. Wide range of abrasive products.

Norton Co., Abrasive Materials Div., 6 Executive Mall Bldg., Wayne, PA 19087. Manufacturers of complete line.

Nu-Matic Grinders, Inc., 875 E. 104th St., Cleveland, OH 44110. Inflated sanding wheels.

Schaffner Mfg. Co., Inc., Schaffner Center, Ensworth, Pittsburgh, PA 15202. Sanding and buffing wheels.

Thermacote Co., 108 S. DeLacey Ave., Pasadena, CA 91100. Grinding wheels.

F. Carbide Bits and Burrs

Fullerton Tool Co., 5451 McFadden Ave., Huntington Beach, CA 92649.

The Precise Corp., 3715 Blue River Ave., Racine, WI 53401.

Severance Tool Industries, 3790 Orange St., Box 1866, Saginaw, MI 48609.

G. Metal Cleaning and Polishing Preparations

Bradford Dernstit Corp., Box 151, Clifton Park, NY 12065. Dernstit SS.3.

The Coulter Co., Box 482, Temple City, CA 91780. Manganesed-Phospholene No. 7 rust remover and preventive.

E-Z-Est Products Co., Inc., Oakland, CA 94607. Metal polishes.

W. J. Hagerty & Sons, Inc., South Bend, IN 46624. Metal polishes.

The Kleen-Strip Co., Inc., Box 6083, Memphis, TN 38106. Rust and paint removers.

Neilson Chemical Co., 3425 Union Pacific Ave., Los Angeles, CA 90028. Metalprep rust remover.

Revere Copper & Brass, Inc., Rome, NY 13440. Polishes and cleaners for copper, brass, bronze, and aluminum.

Rinshed-Mason Div. of Inmont Corp., Detroit, MI 48210; Anaheim, CA 92803. Rust removers and metal conditioners.

W. D. L. Inc., Box 25160, Los Angeles, CA 90025. Metal cleaners and conditioners.

H. Fabricators of Metal Sculpture

Environmental Arts/Milgo Art Systems, 520 Morgan Ave., Brooklyn, NY 11222. Sculpture fabricating.

Lippincott, Inc., 400 Sackett Point Rd., North Haven, CT 06473.

Omega Point Constructions, 1 Dailey Dr., Croton-on-Hudson, NY 10520.

I. Blacksmithing

The Brotman Forge, Box 157-A, Lynne, NH 03768. Courses in blacksmithing.

Daryl Meier, 700 W. Walnut, Carbondale, IL 62901. Books on blacksmithing and ironworking.

Philadelphia Blacksmith's Supply Co., 208 Race St., Philadelphia, PA 19109. Anvils, forges, blacksmithing supplies.

J. Safety

For safety equipment see distributors listed after chapter eight and chapter twelve.

11

Welding

All methods of welding are essentially ways of forming a concentrated zone of heat which can be directed at a particular point on a piece of metal. When the metal reaches melting temperature, it flows, and the maneuverability of the welding instrument allows a skilled operator to guide the flowing metal so that it will make a joint. The ability to control the source of heat precisely and to move it about over the surface of the metal provides the welder with much more than just a method for joining metals. He can also cut metal with his torch, heat it so that it can be bent or hammered into shape, and build up surfaces by the addition of molten metal. Although, strictly speaking, *welding* means joining by flowing together, the capabilities of welding equipment enable the operator to build and to cut apart, as well as to join.

Welding also complements casting and forging, allowing the joining of sections so that large and complex forms can be made which would be difficult or impossible to make in one piece. In fact, both casting and forging were practiced for thousands of years before welding was perfected in the late nineteenth century. Welding was the key technique which transformed these two ancient crafts into a technology capable of producing complex machines.

In the thirties, a few artists—Picasso and González in France, David Smith in America—began experimenting with this heretofore industrial technique. This was a period when artists were beginning to create assemblages and collages—works which were composed by joining together separate objects and materials, in direct opposition to the academic idea that a sculpture must be a homogeneous object of stone, bronze, or wood, or that a painting is a surface covered uniformly with paint. Welding was well adapted to this construction-oriented point of view. By World War II there were a number of artists in Europe and America who worked exclusively with welding.

After World War II welding became extremely popular among younger artists. Perhaps this had something to do with the usefulness of welding in salvaging the broken debris of an industrial society and forming it into shapes with new meanings. In any case, by the mid-fifties every art school with a sculpture studio had to have a welding torch, and junkyards and dumps were yielding their rusted treasures to be resurrected as art.

Today welding is an important sculpture technique. It is an indication of the versatility of welding

that it is as adaptable to producing clean and sharply defined forms as it is to making ones that are ragged and textured, or assembled from assorted junk.

OXYACETYLENE WELDING

The Flame

The hottest known flame (6300°F) is produced by the combustion of acetylene (C_2H_2) with an equal amount of oxygen. When acetylene gas is burned in air it is unable to get enough oxygen from the air to achieve complete combustion. The result is a residue of black carbon smoke. As oxygen is added to the acetylene flame, it becomes more and more luminous and more concentrated. When a neutral flame is achieved (neither an excess of oxygen nor of carbon) there is no smoke, and the flame has become an intense white cone about the size of a pencil point. It

Plate 11.1. Wilfrid Zogbaum, *III*, welded steel, cast iron, stone, 57″ × 22¼″ × 27¾″, 1963. From the collection of the Whitney Museum of American Art, New York, gift under the Ford Foundation Purchase Program (photo by Geoffrey Clements, New York). Zogbaum made a series of sculptures on which he mounted "Zog-stones" collected from the beach. This piece is welded from square and round bar stock plus machine parts, such as the axle spline at the top.

Plate 11.2. Pablo Picasso, *Head of a Woman*, painted iron, 39⅜″ high, 1931 (photo credit John Hedgecoe, Ltd., United Kingdom). Picasso was one of the first artists to weld together pieces of metal and found objects. This figure combines a kitchen colander and a rake with angle bars and other standard metal shapes.

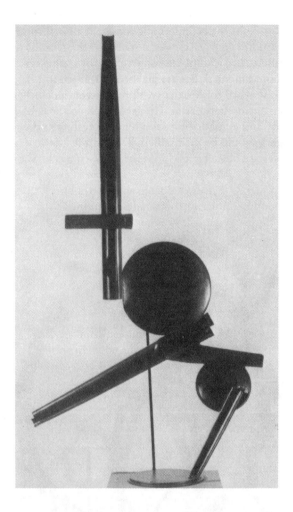

Plate 11.3. David Smith, *Tanktotem V*, varnished steel, 96¾″ high, 1955–1956. From the collection of Howard and Jean Lipman (photo by Geoffrey Clements, New York). Courtesy of the Whitney Museum of American Art, New York. David Smith began making welded steel sculpture in 1933. In 1953 he began a series of "Tanktotem" works based on the ends of tanks, or boiler heads, which are available as stock items in steel catalogs.

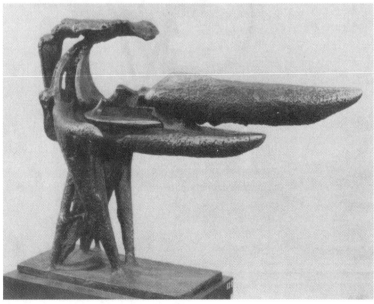

Plate 11.4. Theodore Roszak, *Whaler of Nantucket*, steel, 34½″ × 45½″, 1952–1953. From the collection of the Art Institute of Chicago, Edward E. Ayer Fund (photo courtesy of the Art Institute of Chicago). The forms of this sculpture are built up by depositing many layers of welded metal and then grinding back into the pitted surface. One senses that this sculpture is as dense and heavy as an anvil.

is with this point that the welder controls the continuous welding *bead* or rippled ridge that forms a welded joint.

Equipment

The equipment used to produce this flame consists of a pair of cylinders equipped with gas regulators, a double hose, the torch body, and a set of tips to provide a choice in flame size. Accessories include a cart to hold the cylinders and move the unit around the studio, goggles, gloves, a spark lighter, a set of tip cleaners, and a combination wrench for setting up the equipment. A leather jacket and leather apron may be worn for heavier work to protect the clothes from accidental spatter. Gloves should not be too heavy and cumbersome, as a sense of feeling in the fingers should be maintained. Thin soft leather gloves are best. Tie up loose hair or wear a cap. Wear

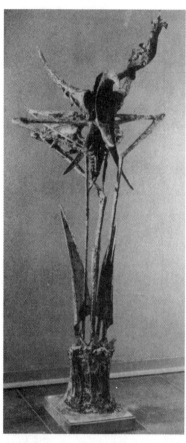

Plate 11.5. Theodore Roszak, *Sea Sentinel*, steel brazed with bronze, 105″ high, 1956. From the collection of the Whitney Museum of American Art, New York (photo credit Geoffrey Clements, New York). This sculpture is made by building up forms with welded bronze, grinding back and re-welding in places to achieve the desired contour. Entire surface has rippled and pitted texture characteristic of multiple-pass welding.

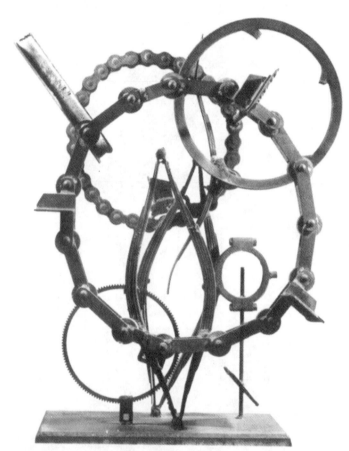

Plate 11.6. Richard Stankiewicz, *Untitled*, welded found objects, 49″ high, 1964. From the collection of Mr. and Mrs. Arthur Mones, New York (photo credit O. E. Nelson, New York). All of the elements of this piece are salvaged machinery parts such as springs, chains, and gears.

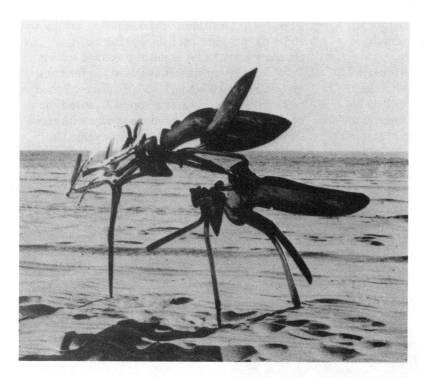

Plate 11.7. Richard Hunt, *The Chase*, welded steel, 44⅝″ × 66½″ × 52½″, 1965. From the collection of the artist (photo credit the Museum of Modern Art, New York). Richard Hunt works with found elements including auto bumper parts, combined with stock tubes and rods. The found shapes are usually altered by bending and hammering.

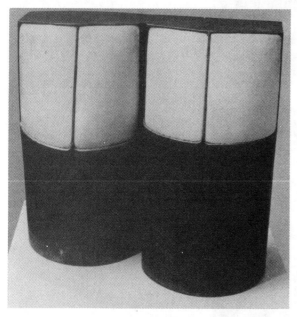

Plate 11.8. Edward Higgins, *Double Portrait-Torsos*, steel and epoxy, 16¼″ × 17″ × 7¾″, 1960. From the collection of the Museum of Modern Art, New York, Larry Aldrich Foundation Fund (photo courtesy of the Museum of Modern Art). Like oversized jewels, the bars of white epoxy are mounted in a finely crafted enclosure of welded steel.

Figure 11.1. Flame chart. 1) The neutral flame. 2) The oxidizing flame. 3) The reducing flame.

shoes! If the material being welded is dirty, or has paint or zinc coating on it, a respirator should be worn to protect the lungs from fumes.

A large, flat metal table is very useful for laying out work to be welded. It should be of steel or aluminum thick enough to withstand the heat of welding without warping. A covering of firebricks will protect thinner tables from the direct heat of the welding flame. The usefulness of this table will be increased if it has tubes or racks holding welding rod and if there is sufficient overhang for the use of clamps. Firebricks are useful as props and spacers.

Welding on the floor is awkward but sometimes necessary when working with large pieces. A welding flame directed at a concrete floor will cause a chunk of concrete to fracture from the surface with explosive force. Welding areas on the floor should be shielded with pieces of metal, asbestos, or transite.

Plate 11.9. Welding booth. In the booth is all the equipment one person needs to perform oxyacetylene welding. The flame-resistant curtains protect nearby workers from welding flash and sparks.

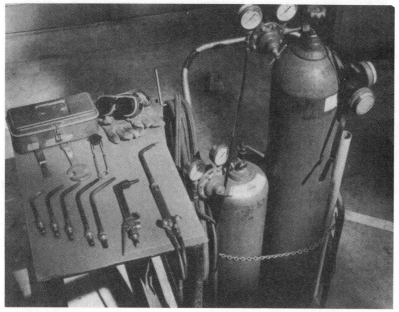

Plate 11.10. Oxyacetylene welding unit. An equipment box is helpful for storing extra tips, tip cleaners, spark lighter, and wrench.

Plate 11.11. Welding table. The perforated cast iron table makes a good tool holder and welding surface. Note sections of metal grill for use as props and spacers, and the large cutting torch in foreground.

TABLE 11.1 Welding Methods for Common Metals

	Metal melts at degrees F	Oxyacetylene welding	Arc welding	Braze welding and brazing	Silver brazing	Soft solder
Ferrous	Mild steel 2729	good	all good	good	OK	OK
	Galvanized steel zinc melts 785	poor	no	good	no	good
	Stainless steel 2760	poor	TIG & MIG	good	good	OK
	Cast iron 2742	OK	poor	good	OK	OK
Nonferrous	Copper 1982	OK	TIG	good	good	good
	Bronze 1629	good	TIG & MIG	good	good	OK
	Yellow Brass 1700	good	poor	OK	good	OK
	Aluminum 1212	OK	TIG & MIG	OK	no	no
	Silver 1760	OK	no	OK	good	no
	Lead 620	good	no	no	no	OK
	Titanium 3135	no	TIG & MIG	special	no	no

Safety

To prepare to weld with oxyacetylene equipment, or any other type of welding equipment, check these five conditions before beginning:

1. Your own person must be adequately protected with the proper goggles, gloves, shoes, and clothing.
2. Cylinders must be securely fastened so they cannot fall over.
3. There must be adequate ventilation. In a closed room an exhaust fan may be necessary.
4. The area must be clear of flammable (burnable) materials. When the operator is wearing dark goggles and concentrating on the bright point of the welding flame, *a fire can break out nearby without the welder being aware of it.* Before welding in unfamiliar surroundings, check the location of the nearest source of water and the nearest fire extinguisher.
5. Make sure the material to be worked on is safe. Zinc-coated steel gives off toxic fumes that may be intercepted by a respirator with the proper filters. Cadmium plating gives off fumes that are more toxic than those from zinc. Cadmium should never be heated to welding temperature unless you are wearing a respirator connected to an independent air supply. Drums and other closed containers are always potentially dangerous. Do not weld or heat any container that has contained gasoline or alcohol, even if it appears to be empty. A violent explosion may be the result.

Setting Up

Before the regulators are mounted on the cylinder valves, the valves are cracked open for an instant to blow away any debris that may have become lodged in the valve orifice. Next, connection threads should be checked to ensure that they are not bent or stripped. Minor imperfections may be corrected with a small half-round file. The threads should turn together without obstruction. Oil is never used on gas welding equipment because it ignites spontaneously in the presence of oxygen. The connectors should finally be turned up snugly with a broad-jawed wrench. As the fittings are brass, overtightening can distort or strip the threads. All the acetylene fittings have left-hand threads (counterclockwise for tightening, clockwise for loosening). A notched nut always means left-hand threads.

When setting up new equipment or reassembling old equipment, turn up all the connections snugly

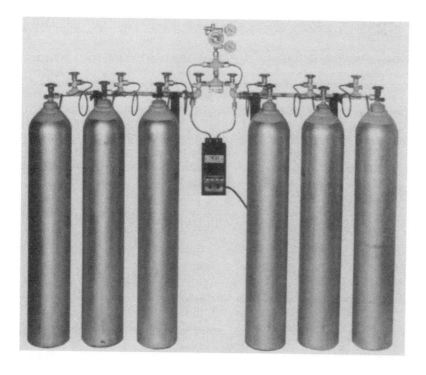

Plate 11.12. Oxyacetylene manifold. Oxygen and acetylene are piped from the gang manifold to welding stations in the studio, keeping the work area clear of cylinders and carts. A portable unit or two is always desirable to reach locations inaccessible from a station.

Plate 11.13. John Chamberlain, *Ditto-Lilith New Moon*, galvanized steel, 82″ × 80″ × 48″, 1967. Courtesy of Leo Castelli Gallery, New York (photo credit Rudolph Burckhardt, New York). The artist takes crumpled air-conditioning ducting and transforms it into a contemporary statement that has the elegance of classical windblown drapery. In welding or brazing galvanized metal, care must be taken not to breathe the white fumes given off by the zinc coating.

Plate 11.14. Two-stage heavy-duty oxygen regulator. Courtesy of Victor Equipment Company, San Francisco, California. More expensive and more impressive looking than single-stage regulators, two-stage regulators can handle big cutting and heating jobs that require maximum gas flow without diminishing working pressure as the cylinder pressure drops. Single-stage regulators are less expensive than two-stage regulators and will give satisfactory service for small and medium-size jobs.

but not forcefully, turn on the cylinder valves, and check for leaks by brushing a soap solution onto the connections. Leaks will cause bubbles. If gentle tightening does not stop the leaks, there must be something wrong with the threads. Cylinders that leak should be immediately returned to the supplier.

Oxygen is odorless and noncombustible. It does not burn itself; it accelerates the burning of combustible materials. Acetylene is the fuel in the oxyacetylene process; it is highly inflammable; it has a very pronounced "stinky" odor. When you are welding or in the studio and you smell the odor of acetylene, determine the source of the leak immediately.

When the equipment is properly set up, turn the cylinder valve handles gently to avoid blasting the full cylinder pressure against the diaphragm of the regulator. The oxygen valve is turned several turns until it seats at its upward limit of travel. The acetylene is turned only a half turn. The primary gauges on the regulators (the gauges nearest the cylinder valves) will now register the contents of the cylinders. When full, the oxygen cylinder will register 2,200 pounds per square inch and the acetylene about 320 pounds per square inch. Next, turn in the regulator adjusting screws until the pointers on the

line pressure gauges register the desired working pressure. This will be from 3 to 5 pounds for acetylene and from 10 to 20 pounds for oxygen, depending on the size of the tip being used.

To light the torch, goggles are pulled down, the torch's acetylene valve is opened slightly, and a spark is struck with the lighter so that it ignites the acetylene, which should be quickly trimmed so that it is burning briskly but not so fully that it jumps away from the tip. Now oxygen is gradually added until the inner and outer cones in the flame coincide, resulting in a neutral flame (see fig. 11.1). The neutral flame is used for welding steel, the reducing or carbonizing flame for cast iron, and the oxidizing flame for bronze and brass.

When welding is over for the day, the cylinder valves should be closed and the torch valves opened one at a time to bleed gas from the lines until the supply gauges read zero. Then the diaphragm screws can be unscrewed until the pressure is relieved. The screws are left in the gauges in the unscrewed position. To close the valves on the torch handle it is necessary only to turn the handles until the needle valves close gently in their seats. Excess pressure will cause rapid wear of the valve seats.

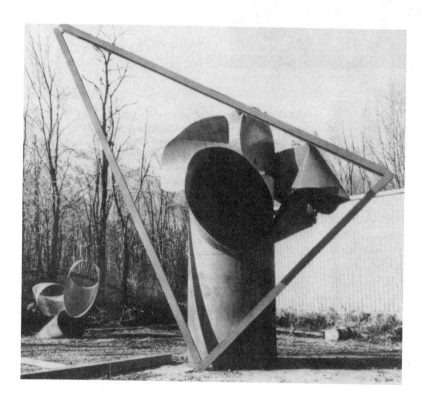

Plate 11.15. Alexander Liberman, *Adam*, painted steel, 28'6" × 29'6", 1970. Courtesy of Andre Emmerich Gallery, New York. A work of monumental scale made of cylindrical tank sections and steel channels.

Basic Technique

To begin a weld, a puddle of molten metal is formed by directing the point of the welding flame at the metal at about a forty-five-degree angle. The heavier the metal to be welded, the larger the puddle, and the larger the tip that must be used. When the puddle is formed it can be moved ahead across the surface of the metal by advancing the torch while rhythmically weaving it from side to side in a crescent motion. This motion distributes the heat evenly from one side of the puddle to the other. While learning to weld it is a good idea to practice moving the puddle evenly and smoothly before proceeding to the next step—adding the filler rod.

The rod is usually of the same composition as the *base* or *parent* metal (the metal to be welded). The rod is held in the opposite hand from the torch and also directed downward at a forty-five-degree angle. The rod weaves ahead of the flame in a series of linked crescents which harmonizes with the motion of the flame. Ideally, the tip of the rod skims the surface of the welding puddle, flowing evenly into it without dripping or getting stuck to the sides of the puddle. More or less rod will build a thicker or flatter bead. Some practice is necessary to make an even bead under various conditions. The primary concern is that the edges to be joined melt fully so that they flow into and become part of the weld.

The torch will occasionally pop or backfire during welding. This is usually caused by insufficient gas flow out of the tip, which allows the flame to burn back inside the tip. Increase the pressure. In a restricted area, as in the corner of a box, the heat of welding can be reflected onto the tip, causing it to get so hot that it pops. The tip must be allowed to

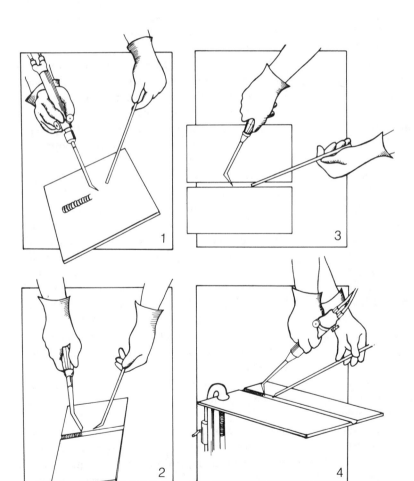

Figure 11.2. Torch and rod positions for oxyacetylene welding, typical welding positions.

cool. If you have several tips of the same size you can exchange tips.

Brazing and Braze Welding

To produce a sound weld, the joint must be fully fused (melted together). In brazing and soldering the molten filler metal is flowed onto the base metal at a temperature just hot enough to melt the filler metal, but not hot enough to melt the base metal. The filler metals commonly used for this process—brass, silver alloy, and lead—have the property of forming a tight bond with a clean metallic surface that is near the melting temperature of the filler metal.

Brazing, according to the American Welding Society, is "a group of welding processes wherein coalescence is produced by heating to suitable temperatures above 800°F, and by using a nonferrous filler metal having a melting point below that of the base metals. The filler metal is distributed between the closely fitted surfaces of the joint by capillary attraction."

Braze welding is defined by the American Welding Society as "a method of welding whereby a groove, fillet, plug, or slot weld is made using a nonferrous filler metal having a melting point below that of the base metals, but above 800°F. The filler metal is *not* distributed in the joint by capillary attraction."

Brazing or braze welding can be used to join copper, certain bronzes, aluminum, steel, stainless steel, and cast iron. It can also be used to join one of these materials to another.

To braze weld steel, cast iron, or bronze, the base metal is cleaned by brushing or grinding until it is bright and clean. Then it is heated to around 600°F and further prepared by coating it with a flux to protect it from contamination by the atmosphere. The metal is heated before the flux is applied so the flux will stick to it. Otherwise, the welding flame would blow away the flux. When fluxed, the base metal is heated to a cherry red color, about 1500°F. The brazing rod is then heated and dipped into a container of flux so that several inches of the end of the rod are coated with flux. The rod is then flowed onto the heated base metal and a bead is built up much as in conventional welding. A slightly oxidizing flame is usually used as it makes the weld metal more fluid. When a stickier consistency is desired the flame may be slightly reducing.

Mild steel is the only metal which can be welded (but not braze welded) without a flux; all other metals require a coating of flux because, at welding temperatures, contact with the atmosphere forms a scum which prevents the molten surfaces of the metals from flowing together. Flux is purchased in powder or paste form to be applied to the area to be welded or brazed, where it melts to form a liquid glassy coating. There are different fluxes for different metals. Borox is the base for most fluxes for use with brass filler rods. The filler rod is dipped into flux during welding to keep the coating intact as the weld progresses. Brass rods are available precoated with flux; most other rods must be dipped into the flux.

Braze welding is often used to join galvanized (zinc-dipped) sheet metal and galvanized pipe because the zinc coating is compatible with the zinc-bearing brass in the brazing rod. The lower heat required (lower than welding heat) minimizes zinc fumes and spalling-off of the zinc coating. Low heat is also a reason for using braze welding to join thin sheets of mild steel and stainless steel. These materials are almost impossible to weld with oxyacetylene without burning holes and producing considerable heat distortion.

While cast iron can be welded using cast iron rod and the proper flux, it is easier to braze weld it, and the lower heat minimizes the danger of the brittle cast iron cracking as it cools.

The standard brazing rod contains about 40 percent zinc and tin and about 60 percent copper, making it similar in composition and melting point to yellow brass. In fact, it makes a good welding rod for yellow brass. The joint formed is a welded joint when the bead is melted into the base metal. Copper alloys like silicon bronze and red brass with more than 70 percent copper have higher melting points than standard brazing rod. They are welded with rods approximating their own composition, but they may still be braze welded with brazing rod, in which case the base metal is not melted. Such a procedure is especially useful in the case of leaded brasses where melting would release toxic lead fumes.

Braze welding is also a method for coating a sheet of steel or stainless, or even copper or Monel metal, with a layer of bronze, brass, or nickel silver. The surface may then be polished or chemically treated. Unless it is ground down, the outer surface will have the characteristic ripple pattern of the welding bead.

The terms *silver-solder, hard-solder* or, correctly, *silver-brazing alloy,* cover a family of copper-nickel-silver alloys that melt at temperatures ranging from 1000°F to 1700°F. They are used with fluxes and are usually applied by heating the base metal, not the

rod itself, and by allowing the silver alloy to flow onto the base metal by attraction for true brazing. The right amount of heat is important. Too little heat causes the alloy to ball up and run away from the joint. Too much heat causes splattering, fuming, and contamination of the joint area. When the heat is just right the silver alloy becomes very fluid, and flows into joints and between surfaces that would not be penetrated by bronze. Thus silver brazing is suited for making neat, compact joints between thin sheets or small parts, as in the electronics industry. Silver brazing also makes a closer color match to

stainless steel than a bronze or brass joint would, but the high cost of silver tends to limit its use to fairly small-scale work. Silver-brazing alloys are available for use with bronze, brass, copper, stainless steel, and even aluminum.

Soldering

Solders are alloys containing lead, some tin, and sometimes small amounts of antimony and bismuth. They melt between 400°F and 600°F. As in silver brazing, heat is applied to the surface to be soldered

Plate 11.16. Seymour Lipton working on *Sorcerer*, 1957. Courtesy of Marlborough Gallery, New York (photo credit Oliver Baker, New York). The artist fabricates the basic forms of the sculpture by snipping and bending thin sheets of Monel (a bronze alloy of nickel and copper), tacking the pieces together with brazing rod. When the entire work has been composed in this way, the sheet metal will be covered with welded nickel silver.

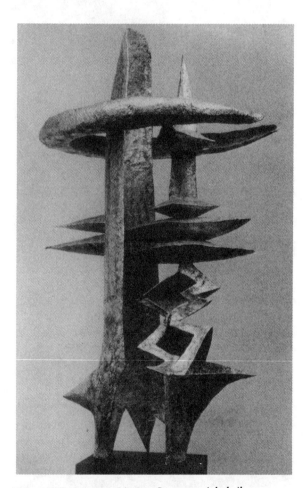

Plate 11.17. Seymour Lipton, *Sorcerer*, nickel silver or Monel metal, 60″ high, 1957. Collection of the Whitney Museum of American Art, New York (photo credit Oliver Baker, New York). The finished sculpture is totally covered with welded nickel silver, a high-nickel bronze alloy. Nickel silver contains more nickel than Monel, and is therefore brighter and harder.

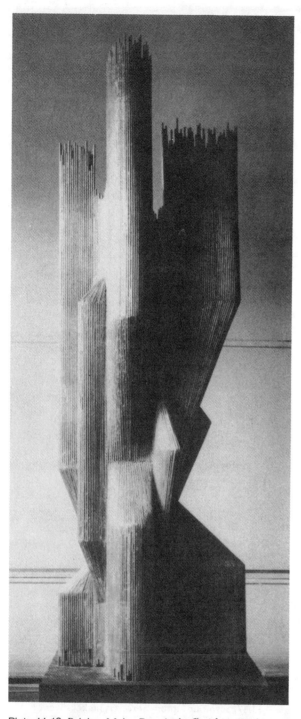

rather than directly to the solder. Since the temperature is so low, the heat source is usually a self-contained propane torch or an electric soldering iron. Rather than being fluxed, the surface to be soldered is cleaned with mild hydrochloric acid. The solder itself may have a core containing acid or rosin to facilitate the cleaning action, or a soldering paste such as Nokorode may be used. Soldering is suitable for making small objects of copper, galvanized wire, or light sheet metal. It is widely used for connections in electrical circuitry. It is inexpensive and convenient, but is not structurally strong.

The art of *body-leading* (the repair and modification of automobile sheet metal by adding contoured patches of lead) is a subject too lengthy and specialized to treat here. Plastic fillers are rapidly supplanting lead for this use.

Oxyacetylene Cutting

One of the unique advantages of the oxyacetylene welding system is the ease with which the equipment may be adapted to cutting ferrous metals. This is done by heating the work to red heat, then directing a jet of pure oxygen upon it. The oxygen actually burns the iron and blasts the residue or *slag* from the cut in a shower of sparks. Steel and iron up to two inches thick may be cut with the largest cutting tips available for standard size welding torches. Industrial torches are made which will cut through steel several feet thick.

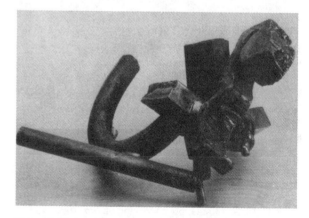

Plate 11.18. Brigitte Meier-Denninghoff, *Africa IV*, brass, 118⅛″ high, 1962. Courtesy of Malborough Gallery, New York (photo credit Martin Matschinsky, New York). The low melting point and smooth flow of lead solder enables the artist to join these rods without distortion or bulging seams.

Plate 11.19. Joseph Goto, *No. 12*, welded steel, 13¼″ high, 1963. Courtesy of Zabriskie Gallery, New York (photo credit John A. Ferrari, New York). The roughness of freehand flame cutting goes well with the calligraphic energy of this small piece.

Oxyacetylene cutting works only on ferrous metals. See the Arcair torch in this chapter's discussion of arc cutting for another method of cutting which works on all metals.

Special precautions should be taken when torch cutting because of the sparks and slag showering from the cut. A bucket or tray of sand under the cut helps to contain the sparks. Adequate footgear is a must to keep red-hot slag nuggets from achieving their fiendish desire to get inside shoes.

ARC WELDING

Stick Welding

In arc welding the source of heat and the source of filler metal are the same: a consumable electrode or *stick*, that forms an electrically charged gap between its tip and the metal to be welded. Across this gap flows a plasma of vaporized metal at 7232°F to deposit itself on the molten surface of the work.

Arc welding produces a more intense and concentrated heat than the oxyacetylene flame, and therefore is useful for welding heavy sections of

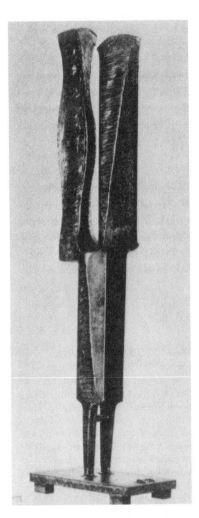

Plate 11.20. Rudolf Hoflehner, *Figur II*, steel, 72″ high, 1961. Courtesy of Städtische Kunsthalle, Mannheim, Germany. After carving the pillars from solid bars with a large cutting torch, the artist allowed the flame pattern to remain as a surface feature.

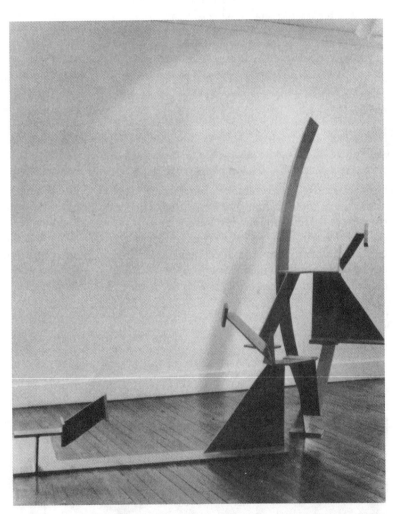

Plate 11.21. Isaac Witkin, *Navaho*, mild steel, 74″ × 47″ × 110″, 1969. Collection of Mr. and Mrs. William A. M. Burden, New York, courtesy of Robert Elkon Gallery, New York (photo credit Eeva-Inkeri, New York). Cut from I-beam stock, the parts of this sculpture are composed in a work of severely ordered tension.

metal that would consume a great deal of time and gas by the oxyacetylene method. Steel plate, for instance, over one-quarter inch thick, is easier to weld with arc than with gas. For lighter work, gas is more versatile, delicate, and calligraphic than arc welding. Shielded arc welding, discussed in the next section, combines some of the best characteristics of both methods.

While arc welding does not require the finesse of gas welding to make a sound weld, it would be a mistake to think that learning to weld could be made easier by starting with arc first. The student experiences the feeling of metal flowing together so much more clearly with gas welding that if this process is mastered first, all other methods will be simply a matter of acquiring information. If the student learns arc welding first, however, there will be some habits to unlearn before oxyacetylene welding can be mastered.

Equipment

The source of electricity for the arc welding transformer is either a 220/440-volt single-phase electrical outlet or direct-current generator driven by a gasoline or diesel engine. The transformer produces the type of current required for welding and provides controls for adjusting the intensity and mode of the current. Both alternate- and direct-current welders are available but the combination AC/DC welder is much more useful to the sculptor who needs the ability to cope with different types of materials.

Welding units of 150 and 200 amperes can deal with about the same range of material sizes as a medium-size gas welding torch. If the biggest advantage of arc welding is to be realized—ease in dealing with heavy materials—a unit of 300 to 500 amperes is needed. If shielded arc welding capability is desired, a welder with this equipment built in is the best choice.

From the welder extend two heavy rubber-sheathed cables, one with a ground clamp at its end, the other with an electrode holder. The operator should wear heavy gloves, a leather or asbestos jacket, and a welding helmet fitted with a No.9 or No.10 lens. The glare from arc welding is much more intense than that from gas welding. It can damage the unprotected eyes of onlookers, even by reflection off walls. Therefore, if arc welding is taking place in an area where other persons are working, the welding area should be shielded with curtains or portable screens.

Basic Technique

The ground clamp is attached to the work or to a fixture in contact with the work, such as a clamp or metal table. The electrode in its holder is positioned just above the work, and the helmet lens is brought into position over the eyes. This moment is unlike the equivalent situation in gas welding, because you cannot see.

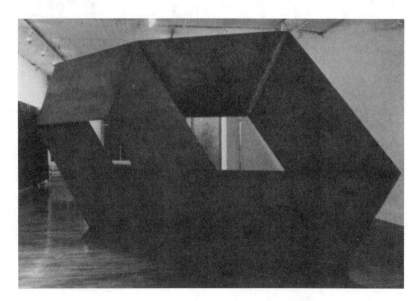

Plate 11.22. Charles Ginnever, *Fayette: For Charles and Medgar Evers*, welded Cor-Ten steel, 100″ × 198″ × 18″, 1971. From the collection of Storm King Art Center, New York (photo credit Geoffrey Clements, New York). The massive plates of steel articulate an inward-outward movement of space rather than enclosing a static volume. Steel of this size is best welded by arc welding rather than by gas.

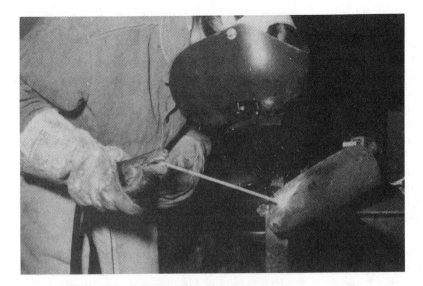

Plate 11.23. Striking an arc with the stick electrode. Courtesy of Hobart Bros., Troy, Ohio. A properly equipped welder strikes an arc to begin welding. A cap would protect his hair from "bumblebees" (hot flying particles).

Plate 11.24. Airco MSM Busybee AC/DC Welder. Courtesy of Airco Welding Products Company, Union, New Jersey. This medium-range stick welder will do AC arc welding in two current ranges (20–115 and 60–180 amps) and DC welding in one range (40–150 amps). It runs from a 230-volt single-phase electrical supply.

Plate 11.25. Airco Wasp III-E gasoline-driven 250 h.p. AC welder with AC power supply. Courtesy of Airco Welding Products Company, Union, New Jersey. This gasoline-driven DC stick welder is a self-contained unit that does not require an external electrical source. Units like this are often mounted on a truck or trailer for working in remote areas. Five AC welding ranges are provided between 50 and 200 amps. Small electrical tools may be run from the 115-volt, 3.5 KVA, AC power supply.

By feel you scratch the electrode tip against the work and immediately withdraw it to a position just far enough above the work to maintain the proper arc gap. Too far away and the arc is broken, too near and the electrode sticks to the work and must be broken away.

Only a little practice is required to master striking the arc. When the arc is struck there is enough light to see the work and you can proceed to move the electrode along the line of the weld. The welding machine may need adjusting to find a setting which will give good penetration without burning through. The electrode tip should maintain a gap approximately the distance of the width of the electrode. When everything is going just right there is a characteristic crackling sound like frying bacon. For small welds the electrode can be advanced in a straight line; for larger welds some weaving may give better coverage. For even larger welds several "passes" or layers of welding bead may be required. The glassy slag must be chipped off with a chipping hammer between passes and when the weld is completed.

All arc welding rods are precoated with flux, which leaves a glassy coating over the weld. Since the arc weld takes place in an atmosphere 1000°F hotter than the oxyacetylene weld, even mild steel requires a flux to protect it from atmospheric contamination. There are many types of arc welding rods, identified by index numbers that are listed in the manufacturers' catalogs. For steel alone there are dozens of rod compositions as well as different flux compositions.

Some rods are for AC current, some for DC straight polarity, and some for DC reverse polarity. General purpose rods will work for all three modes.

Although different maunfacturers have different numbers for their rods, all these numbers are coordinated by one set of numbers called the AWS-ASTM specifications (American Welding Society-American Society for Testing Materials). All the companies list the AWS-ASTM numbers for their rods in handbooks or pocket guides. For sculpture in mild steel, AWS-ASTM 6013 and 7014 are general purpose, easy-to-use rods suitable for all positions. AWS-ASTM 6011 has a little greater penetration for greater strength.

Steel may be welded AC, DC straight polarity, or the reverse, with different results. Straight polarity is good for general welding, with good penetration and moderate buildup. Alternating current produces deeper penetration, while reverse polarity makes a stickier weld with more buildup, suitable for vertical or overhead welds or for depositing a quantity of metal.

Arc Cutting

The Arcair torch, manufactured by the Arcair Company of Lancaster, Ohio, uses a carbon electrode in a holder much like a standard stick electrode holder, except that there is an air passage which directs a blast of air onto the point of the electrode, blasting away the molten metal at that point. Since the metal to be removed is blown out of the cut, rather than

Plate 11.26. The Arcair torch will cut both ferrous and nonferrous metals. It makes a wide cut of ⅜″ to ½″, but the sides of the cut can be accurately contoured.

burned as with the oxyacetylene cutting torch, Arc-air works equally well with ferrous and nonferrous metals. It is particularly useful in cutting the gates off bronze castings.

Spot Welding

The spot welder is a floor-mounted machine from which project two fingerlike electrodes that clamp together to produce a small round area of fused metal. It is used to fabricate cabinets and boxes of sheet metal.

SHIELDED ARC WELDING: TIG AND MIG

Stick welding is not very delicate, leaves a coating of slag which must be removed, and does not achieve high quality welds in aluminum, bronze, or stainless steel. During World War II a method of welding was developed which overcomes all of these difficulties. Shielded arc or *heliarc* welding has been widely used ever since, especially in the aircraft and space industries where ultra-high quality welds are required in aluminum, titanium, and super-stainless alloys like Inconel. Heliarc equipment is manufactured to weld metal that ranges in thickness from paper thin to several inches.

TIG Welding

Tungsten-inert gas (TIG) welding uses a nonconsumable tungsten electrode barely protruding from a ceramic cup from which an inert gas, usually argon,

Plate 11.27. Miller MPS air-operated pedestal model spot welder with built-in heat control. Courtesy of Miller Electric Manufacturing Company, Appleton, Wisconsin. This welder is useful for joining articles of sheet metal that do not require a continuous welding bead.

Plate 11.28. Airco 160 amp AC/DC MIG and TIG welder. Courtesy of Airco Welding Products Company, Union, New Jersey. In MIG (metal-inert gas) or "dip" welding the filler wire is fed automatically into the weld through the center of the "gun," or torch handle. This welder is mounted on a cart carrying the argon or CO_2 cylinder and a wire-feeding spool. The unit may also be used for TIG welding and for stick welding with a flux-coated electrode, no cover gas.

flows over the weld area, shielding it from the atmosphere. Argon is commonly used today instead of helium because it is heavier and thus forms a better cover over the weld area. The result is an unusually clean and fluid weld. The filler rod is introduced to the weld area by the left hand in a manner similar to oxyacetylene welding. When the weld is finished there is no slag to be removed.

Shielded arc welding produces an intense glare as does arc welding and an even greater amount of ultraviolet radiation, which is harmful to the skin and eyes. Operators doing continuous shielded arc welding should wear light flash goggles with side guards under the welding helmet to shield against reflections inside the helmet. Sunburned wrists result from gaps between cuffs and gloves.

MIG Welding

Metal-inert gas (MIG) welding is similar to TIG in that the weld takes place within a shielding envelope of inert gas. In the MIG process, however, the electrode is a consumable metal wire which automatically feeds into the weld, providing filler material. The MIG wire control, cooling passages, and current

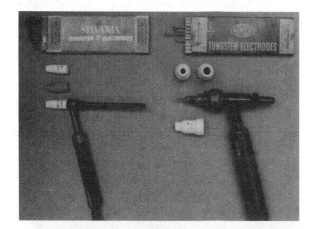

Plate 11.29. TIG torches. The smaller torch will work with current up to 120 amps; the larger, heavy-duty torch will handle up to 500 amps. They are both water cooled and use a variety of electrode sizes and ceramic cup styles.

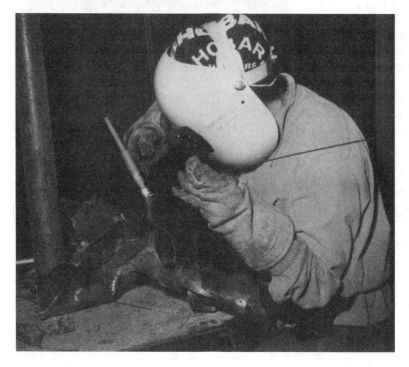

Plate 11.30. Welding with TIG (tungsten-inert gas). Courtesy of Hobart Bros., Troy, Ohio. The action of TIG welding is quite similar to oxyacetylene welding. TIG can make many different types of welds in a broad range of metals.

control are combined in a compact welding gun. Once adjusted for the job at hand, the MIG outfit is relatively easy to operate. The large coil of filler wire permits long, uninterrupted welds.

A further refinement of the MIG system called *short-arc* uses an adjustable shorting-out process to produce heat at the electrode. This allows great versatility in welding different thicknesses of metal, from the thinnest to the thickest, and maximum linear speed of welding.

At the time of this writing the MIG short-arc welder costs about $7,000 for a complete outfit.

MIG and TIG welders cost from $2,000 to $7,000 depending on their power and accessories. Convenient as the MIG welder is for making continuous welds in one material, the TIG welder is much easier to change from one material to another and makes a smoother and more controllable weld. If a studio is to have one arc welder for many purposes it should be a 300–450 ampere AC/DC TIG welder with jacks for stick welding and Arcair cutting. Some existing stick welding outfits can be modified to do TIG welding.

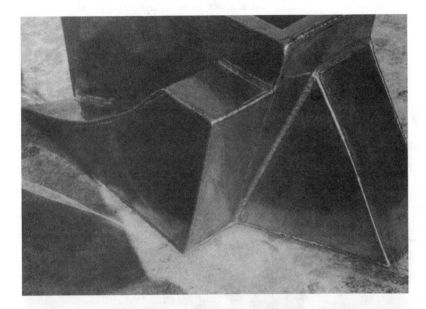

Plate 11.31. Heliarc (TIG) welds in titanium. The TIG weld is very controllable. It resembles an oxyacetylene weld in appearance but is usually smoother and more even.

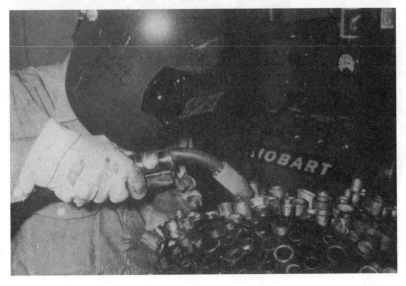

Plate 11.32. Welding with MIG (metal-inert gas). Courtesy of Hobart Bros., Troy, Ohio. The filler wire is automatically fed into the weld through the center of the gas nozzle, freeing one hand that the operator may use to brace the "gun," as shown, or to hold something else.

WELDING STAINLESS STEEL, BRONZE, AND ALUMINUM

The techniques described above apply in general to welding mild steel. Each metal has special characteristics which affect its welding behavior.

Stainless Steel

It is possible to weld stainless steel with oxyacetylene equipment and good technique, the right flux, and the correct rod for the type of stainless. MIG and TIG welding give better results, however, and are almost always employed for thicknesses over 16-gauge. Straight polarity is standard. Braze welding provides a way to join stainless steel to other metals.

Most stainless steels distort radically when heated, so shapes must be clamped and jigged carefully if accurate results are to be achieved. Most stainless steels shrink upon cooling rather than retain their expansion as do mild steels. Careful planning of the order in which welds are made can usually minimize shrinkage distortions in the finished work. Skip-welds are recommended for all long seams. The welds should be made with as little excess heat as possible.

Some discoloration will always be present around the weld area. This can be removed by brushing, sanding, sandblasting, or scrubbing with oxalic acid. Light rust is liable to form around the weld even after initial cleaning because of the free iron that

Plate 11.33. MIG weld in stainless steel. The continuous wire-feed weld gives good penetration and speed, so it is recommended for long seams. Note the flat, liquid appearance. MIG produces more spatter than TIG.

Plate 11.34. MIG tack welding. The edges of these ⅛″ stainless steel sheets were tack welded with a MIG welder before running a continuous bead. In this way the sculpture can be assembled and held in place before it undergoes the heat stress of welding. The MIG gun is good for tacking because it can be operated with one hand.

dissociates from the alloying elements during the heat of welding. This rust may be removed as above, and should not reappear after a few cleanings unless the area has been badly burned by welding heat. Note that only stainless steel brushes should be used on stainless, and only clean abrasives that have never been in contact with other steels or iron. Free iron ground into the surface of stainless steel by contaminating abrasives is very difficult to remove and will cause rust.

Bronze and Brass

All copper alloys, and copper itself, may be welded and braze welded by gas, TIG, and MIG. Alloys containing considerable proportions of zinc, such as yellow brass, gun metal, and cartridge brass, are best gas welded because of the zinc fumes produced by electric welding. A flux is always used for gas welding copper alloys. The flame should be slightly oxidizing. Silicon bronze is the easiest of the bronzes to weld and can be handled either with gas or shielded arc on straight polarity. Care should be taken to support sections of brass or bronze being welded. Since these alloys conduct heat very readily, large areas around the weld can soften and sag.

Copper can be welded and brazed by gas or shielded arc. Because of its high conductivity, large sections require a great amount of heat, making flame welding impractical for anything with a surface area of more than about a square foot. Silicon bronze makes an excellent brazing rod for copper and is not far off in color. Phos-Copper rod also works well, melts at about 1300°F, and has nearly the same electrical conductivity as copper. Copper has been fabricated for centuries by soldering.

Aluminum

Aluminum, like copper, is very conductive, but its welding temperature is so low that it is easy to weld once its behavior is learned. One of aluminum's characteristics is that it does not change color and glow red when it approaches welding heat. It is also weakened greatly as it approaches welding temperature. This, combined with the rapid spread of heat due to its conductivity, means that large areas

Plate 11.35. MIG welded bronze sculpture by Oliver Andrews. This sculpture has 64 welding passes on each of its 20-foot sides.

around the weld will collapse without warning if not adequately supported.

The work must be bright and clean before welding begins, as aluminum oxide forms a barrier to fusion and can also find its way into the weld as brittle inclusions which weaken the weld. To further combat oxidation when welding with gas, both the work and the rod should be generously coated with flux. A slightly reducing flame is used and careful attention is directed to judging the temperature of the weld area to avoid overheating.

It is easier to attain good-looking welds in aluminum with TIG or MIG than with gas. An alternating current setting is used in combination with a high-frequency oscillator which helps to break up the oxide coating on the surface of the work.

As there are many alloys of aluminum, care should be taken to select a rod which is compatible with the work. When in doubt general purpose type 4043 will blend with most alloys and produce a satisfactory weld if ultimate strength and color matching is not too important.

It is possible to braze weld aluminum with the correct flux and filler rod. This provides a method for joining aluminum to copper and its alloys. Aluminum and steel are not usually joined by braze welding because the melting temperatures of these two materials are so far apart.

Many other metals can be welded. The advanced welder can find information in the references at the end of this chapter on commonly welded metals, as well as on more exotic metals, like titanium, Inconel, Monel, nickel silver, silver, gold, zinc, and many others.

BIBLIOGRAPHY

Althouse, Andrew D., Carl H. Turnquist, and William A. Bowditch. *Modern Welding*. South Holland, Ill.: Goodheart-Willcox, 1976.

American Society for Metals. *Metals Handbook*. Vol. 6, Welding and Brazing. Metals Park, Ohio: American Society for Metals, 1971.

American Welding Society. *Safety in Welding and Cutting*. Publication Z49-1. New York: American Welding Society, 1973.

Anaconda American Brass Company. *Copper Metal Welding Rod*. Publication B-13. Waterbury, Conn.: Anaconda American Brass Co., 1962.

Baldwin, John. *Contemporary Sculpture Techniques, Welded Metal and Fiberglass*. New York: Reinhold, 1967.

Benton, Suzanne. *The Art of Welded Sculpture*. New York: Van Nostrand Reinhold, 1975.

Griffin, Ivan H., Edward M. Roden, and Charles W. Briggs. *Basic Welding Techniques*. New York: Van Nostrand Reinhold, 1977.

Hale, Nathan Cabot. *Welded Sculpture*. New York: Watson-Guptill, 1968, 4th printing 1975.

Hobart School of Welding Technology. *Modern Arc Welding*. Troy, Ohio: Hobart Bros. Co., 1951.

Plate 11.36. Anthony Caro, *Source*, steel and aluminum, painted green, 6'1" × 10" × 11'9", 1967 (photo credit Guy Marfin, London). This sculpture makes use of the ground plane as a space that is activated by the positioning of the flat element in relation to the perforated screen. Tension is heightened by the nonstructural bar between the two. The steel bars are connected to the aluminum screen by bolting, not welding, since steel cannot be welded to aluminum.

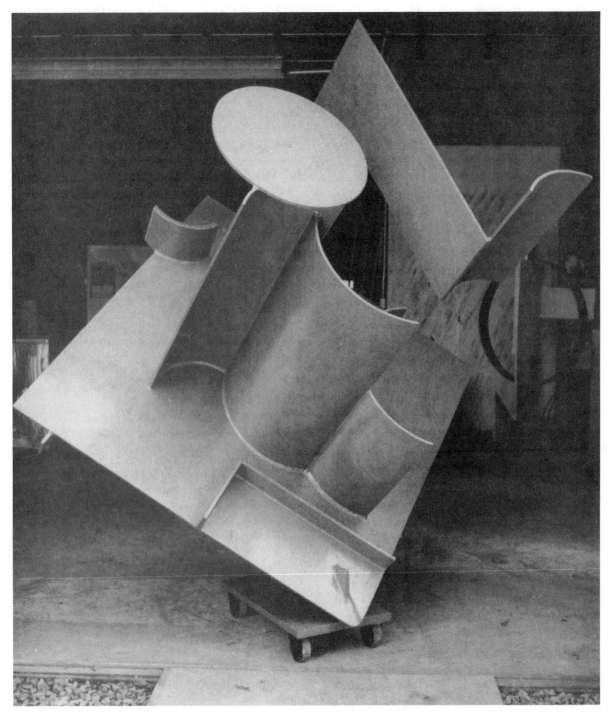

Plate 11.37. David Smith, *Zig IV*, steel, painted yellow-gold, 93⅜″ × 84¼″ × 76″, 1961. Collection of Lincoln Center for the Performing Arts, New York; courtesy of David Smith Papers, Archives of American Art, Smithsonian Institution, Washington, D.C. This sculpture was fabricated from ½″ thick plates of mild steel. Then many coats of paint were *brushed* onto the surface. The wheeled dolly at the base is part of the sculpture.

———. *Vest Pocket Guide.* 12th ed. Troy, Ohio: Hobart Bros. Co., 1964.

Irving, Donald I. *Sculpture, Material and Process.* New York: Reinhold, 1970.

Jefferson, T. B., ed. *The Welding Encyclopaedia.* 17th ed. Morton Grove, Ill.: Jefferson Publications, 1974.

Lynch, John. *Metal Sculpture.* New York: Studio Publications, 1957.

Meilach, Dona, and Don Seiden. *Direct Metal Sculpture.* New York: Crown, 1966.

Morris, John D. *Creative Metal Sculpture.* New York: Bruce, 1971.

Phillips, Arthur L., ed. *Welding Handbook*, Sections I through V. 6th ed. New York: American Welding Society, 1974.

Rood, John. *Sculpture with a Torch.* Minneapolis: University of Minnesota Press, 1963.

Udin, Harry, Edward Funk, and John Wulff. *Welding for Engineers.* New York: John Wiley & Sons, 1954.

Union Carbide Corporation. *The Oxy-Acetylene Handbook.* 2d ed. New York: The Union Carbide Corp., Linde Division, 1966.

United States Steel Corporation. *Fabrication of Stainless Steel.* 3d ed. Pittsburgh, Pa.: United States Steel Corp., 1960.

Welding Design and Fabrication. Monthly periodical. Cleveland: Industrial Publishing Co.

Welding Journal. Monthly periodical published since 1922. New York: American Welding Society.

MANUFACTURERS OF WELDING EQUIPMENT AND SUPPLIES

Airco, 150 E. 42nd St., New York, NY 10017, 100 California St., San Francisco, CA 94111. Gas and arc welding equipment and supplies.

All-State Welding Alloy Co., Inc., White Plains, NY 10600; South Gate, CA 90280. Brazing fluxes and alloys.

Arcair Co., Box 406, Lancaster, OH 43130; 5201 First St., Bremerton, WA 98310. Arc cutting torches and electrodes.

Bernard Welding Equipment Co., 10232 Ave. N., Chicago, IL 60617. Water-cooling equipment for arc welding.

MW Dunton Co., Providence, RI 02900. Nokorode soldering paste and other soldering materials.

Frommelt Industries, Inc., 465 Huff St., Dubuque, IA 52001. Safety clothing, curtains, and screens.

Handy and Harmon Co., 850 Third Ave., New York, NY 10022. Brazing fluxes and alloys.

Hobart Bros., Box EW-330, Troy, OH 45373. Arc welders and electrodes, Hobart School of Welding Technology.

Jackson Products, 5523 Nine Mile Road, Warren, MI 48090. Welding helmets and goggles, electrode holders.

Kedman Co., 233 S. 5th W., Salt Lake City, UT 84110. Welding helmets and goggles.

McKay Co., 1005 Liberty Ave., Pittsburgh, PA 15333. Electrodes and wire-feeders.

Miller Electric Mfg. Co., Appleton, WI 54911. Arc welders.

National Cylinder Gas Co., 840 N. Michigan Ave., Chicago, IL 60611. Gas welding equipment and supplies.

Smith Welding Equipment Co., 2633 S.E. Fourth St., Minneapolis, MN 55414. Gas welding equipment.

Tweeco Products, Inc., P.O. Box 666, Wichita, KS 67201. Electrode holders and connectors.

Union Carbide Corp., Linde Div., 270 Park Ave., New York, NY 10017. Gas and arc welding equipment and supplies.

Victor Equipment Co., 3821 Santa Fe Ave., Los Angeles, CA 90058. Gas welding equipment.

Walter Kidde Co., Inc., Belleville, NJ 07109. Fire extinguishers.

Wheeler Protective Apparel, Inc., 224 W. Huron St., Chicago, IL 60610. Protective clothing for welding and casting.

Willson Safety Products, 111 Sutter St., San Francisco, CA 94104; 1985 Janice Ave., Melrose Park, IL 60160. Respirators for welding fumes.

12

Bronze Casting By the Lost-Wax Method

BRIEF HISTORY OF BRONZE CASTING

The lost-wax, or *cire-perdu,* method of bronze casting is an ancient art. No one knows where it was first invented. It was practiced in Mesopotamia during the second millennium B.C., and it was highly developed by Chinese artisans during the Shang Dynasty about 1500 B.C. Shang ceremonial vessels, cast in clay molds or *investments,* were masterfully executed and accompanied a great period in Chinese history. The Chinese continued to produce exceptional bronzes for over two thousand years.

The technique of bronze casting from a wax pattern was rediscovered many times in history, notably by the Egyptians and the Etruscans. Bronze casting was practiced in Europe during the Renaissance and was once thought to have been carried to the Gold Coast of Africa by Portuguese traders in the fifteenth century. Actually, the Benin and Ife peoples of this region had gained their knowledge of the craft two hundred years earlier from older peoples in the interior of Africa. These people may have discovered bronze casting independently, or they may have brought the knowledge from Egypt to central Africa in ancient times. Other cultures that developed the art of bronze casting to a high state flourished in Greece, Rome, Iran, India, and Japan. The use of flexible, versatile wax patterns for bronze casting allowed its discoverers a new fluency and eloquence in their art, and usually accompanied an expansion of ideas in their culture.

During the nineteenth and the first half of the twentieth century it was assumed that artistic bronze casting was a skill of baffling complexity and delicacy, which could be practiced only by craftsmen trained for generations at their inherited trade. The casting of bronze, iron, and aluminum was, of course, practiced regularly in industry, but these manufacturing processes were thought to be too cumbersome and technically awesome for an artist to carry out in the studio.

Sometime in the late 1950s a number of forward-thinking sculptors realized that this situation was ready for change. Sculptors were interested in the permanence and freedom of expression possible with lost-wax casting. During World War II, welding methods had been developed which made the welding of bronze much easier than before. Most important perhaps was that there were now many younger artists who could not afford the high costs

of having their work cast in a commercial bronze foundry. So the stage was set for sculptors to begin to cast their work in their own studios. The Old World craftsmen, however, understandably were not too eager to enlighten their customers about the secrets of their craft, and there was still little contact between industrial foundrymen and artists. Sculptors had to begin with what they could find out and a large measure of trial-and-error experimentation.

As these artists looked around for information, it became apparent that there was a great deal of similarity in the casting methods of village foundries throughout the world. Artisans and small manufacturers in American midwestern towns, in Mexico, in Japan, in India, in Scandinavia, and in Italy, used methods readily adaptable to the sculptor's backyard foundry.

As early as 1951 Julius Schmidt, working at Cranbrook Academy in Michigan, showed that a sculptor can do his own foundry work, even for iron, which melts at 2700°F, 1000 degrees hotter than the melting point of bronze. Julius Schmidt introduced his methods to the Kansas City Art Institute in 1959, and later worked at the Rhode Island School of Design.

In the meantime Peter Voulkos was casting bronze at the University of California at Berkeley. Following his lead, foundries were assembled in garages, rented sheds, and the courtyards of university art departments. Many other sculptors

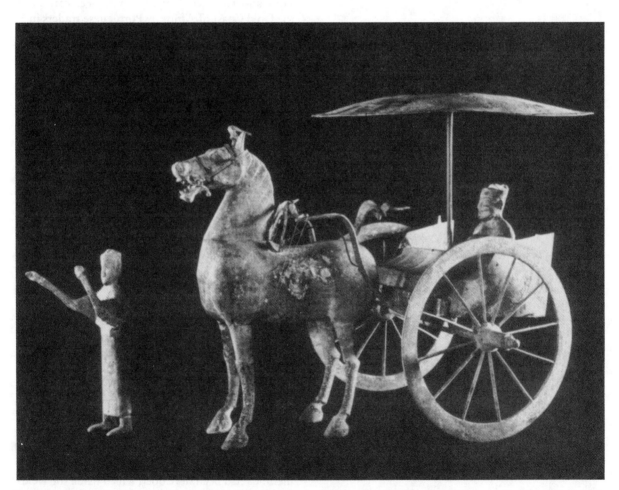

Plate 12.1. *Bronze Figures, Chariot, and Horse from Eastern Han Dynasty Tomb in Wuwei Kansu Province, China,* bronze, height of horse 15¾", height of chariot 17", 2d century A.D. Collection of the People's Republic of China (photo credit Robert Harding Associates, London). The delicacy and elegance of Han bronzes constitute a summit of bronze-casting excellence.

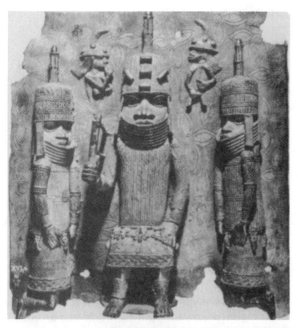

Plate 12.2. *Benin King (Oba) and Attendants*, Nigeria, bronze, 16¾″ × 15¼″, 17th century, British Museum, London. This relief was cast by the lost-wax method. Notice the skillfully incised decorative surfaces and the powerful simplification of forms.

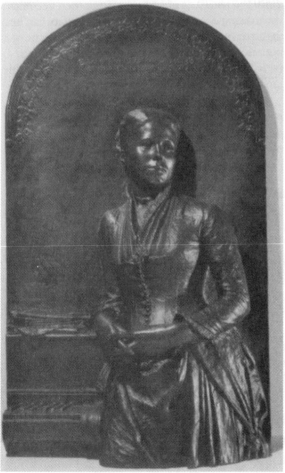

Plate 12.3. Augustus Saint-Gaudens, *Louise Miller Howland*, bronze plaque, 39⅛″ × 23½″, 1884. Collection of Mr. and Mrs. John Howland Drake, New York (photo courtesy of the National Portrait Gallery, Smithsonian Institution, Washington, D.C.). The virtuoso rendering of fabrics and facial details is comparable to painted portraits of the period. This master is able to control surface activity so that it enhances psychological expressiveness.

participated in this movement in the late fifties and early sixties, rapidly refining existing techniques and developing new ones that would have seemed impossible to the traditional foundrymen. Today virtually every art school has its furnace, even if it is only a trash can lined with refractory concrete and fed by a converted vacuum cleaner blower. In some university art departments students operate induction furnaces, hydraulic hoists, and heliarc welders, in casting facilities that many small industries would envy.

Every two years beginning in 1960 the University of Kansas has organized a National Sculpture Conference. Under the directorship of Professor Elden Tefft, several hundred sculptors from every part of the United States have gathered to hear lectures by sculptors, craftsmen, and manufacturers' representatives, and to watch movies and demonstrations of the latest sculpture techniques. The first four conferences (through 1966) were devoted entirely to metal casting. Since then, the conferences have included lectures and demonstrations on plastics, glass, and stone, and on subjects of general interest to all sculptors, such as environmental sculpture and the handling of commissions. Since 1966, delegates from Japan, India, Africa, South America, and several European countries have made the conference a truly international gathering. In 1976 the conference was held in New Orleans and in 1978 it took place in Toronto, Canada, drawing more than 1,200 participants.

PREPARING THE WAX

Much of the fluency and richness of description possible in lost-wax casting is due to the nature of wax as a sculpting medium. It is easy to bend and stretch, yet when cool supports itself with remarkable stiffness and cohesion. When soft the wax can be squeezed and twisted, and then a slight drop in temperature will render it hard enough to be carved to a sharp and accurate edge.

The crucial discovery that wax and metal behave very similarly when heated and worked must have been made by craftsmen who were familiar with both materials, since it is not obvious when you look at wax and metal in their everyday room-temperature states. A sheet of warm wax bends much like a sheet of heated metal, and its edges can be welded in the same manner. When the wax liquefies at around 200°F its freely-flowing consistency is much like that of its high-temperature equivalent, molten bronze, at 2000°F. The basis of bronze casting then becomes the making of a mold out of which the wax can be made to run, and into which the bronze may be poured to take its place. The result is a process in which an original may be created in a very workable medium, then cast in a very durable medium.

Since wax and metal have this resemblance it is not difficult to imagine how the wax sculpture will look when cast in metal, and structural problems solved in one material will usually work out in the

Plate 12.4. Peter Voulkos, *Remington*, bronze, 4′ × 6′, 1961. Courtesy of David Stuart Gallery, Los Angeles. The character of wax in bent sheets and fractured blocks is carried over into this bronze, which is cast directly from the original wax without intermediate molds.

other. You can appreciate this idea if you look at some bronzes that were made from clay or stone originals. They often look "translated," like frozen clay or hollow stone. You can, of course, make patterns for bronze casting in materials other than wax. Plaster with mesh, for instance, is sometimes used as a pattern and can produce a sculpture that looks right in metal if the sculptor has metal in mind while working.

This chapter will describe how to make a bronze casting from a wax original. If the original is in a material other than wax, a mold must be made from which a wax replica is produced (this process is described in chapter three). Once the wax replica is ready, you proceed as with a wax original.

Wax is usually purchased in blocks or cakes. These are melted down and recast into shapes which are convenient for making the various parts of the sculpture, including the tubes or bars which are attached to it in preparation for casting. In the past sculptors have usually made up their own wax, combining a number of ingredients to produce certain desirable qualities: paraffin for stiffness, beeswax for plasticity, some petroleum jelly or lanolin for slickness and "feel," lampblack and iron oxide for color, and so on. The basis of most formulas is an equal amount of beeswax and paraffin to which are added the other ingredients in small quantities, their sum not to exceed one-third of the total. Most waxes, though naturally yellowish, are prepared with brown or black coloring so that detail will be easier to see and so that there will be a resemblance to the surface of darkened bronze. This resemblance can be enhanced by rubbing the finished wax with bronzing powder.

There are several commercial waxes specially formulated for investment casting. They are supplied in sheets of various thicknesses and in tubes, rods, and bars. They can be had in various degrees of hardness and in a range of melting points. While they are very convenient, these ready-made shapes are more expensive than making your own by melting and cutting the standard blocks. Ready-made waxes are useful to jewelers and precision model makers, who work small and have critical stiffness requirements.

Waxes known as "microcrystalline" because of their fine microscopic structure are now readily available through petroleum companies. They are by-products of the oil refining process and are very economical when purchased in bulk amounts. A

Plate 12.5. Eduardo Paolozzi, *Japanese War God*, bronze, 64½″ high, 1958. Courtesy of Albright-Knox Art Gallery, Buffalo, New York, gift of Seymour H. Knox. Wax sheets are cast over collections of small objects embedded in clay. The sheets are then cut up and bent into the cylinders, drums, and boxes from which the complete sculpture is constructed. The whole is then cast in bronze by the lost-wax method.

number of these waxes are dark in color and pliable at room temperature. A sculptor who is not inclined to spend the time and money necessary to be a wax alchemist can accommodate to straight microcrystalline wax, once its behavior is understood. A good type to start with is Victory B-44 brown wax, manufactured by the Bareco Wax Company of Tulsa, Oklahoma. Write them for your nearest bulk distributor. Many art stores now carry this or a similar microcrystalline, if you need only a slab or two.

To cut a two-inch-thick slab of wax by hand, use a three- or four-inch-wide mason's chisel and a hand sledge or hammer. Cut a groove across both sides of the slab, then slam the edge of the slab down against a concrete floor or other solid surface. (Not your dining room table; you'll probably demolish it!) After you do this the first time you will have a good idea of how tough wax really is.

Wax slabs can be cut with an electric reciprocating saw using the coarsest tooth roughing-in blades. Either clamp down the wax as though it were a board to be sawed, or clamp the saw to something solid, blade up, and push the wax through the blade. The hotter the blade gets the better it cuts. Don't try to cut wax on a band saw, as it will gum up the band saw wheels and guides.

You can melt wax in a saucepan on your stove or on a hot plate, but the most convenient way is to use a vessel with a self-contained electric heating element, such as a fryer or portable oven. The larger oven illustrated costs only about fifteen dollars and is

Plate 12.6. Alberto Giacometti, *Chariot*, bronze, 57″ × 26″ × 26⅛″, 1950. From the collection of the Museum of Modern Art, New York. Purchase. The original is created by applying a sheath of plaster to a metal armature and then carving some of it away. For bronze casting, an intermediate version in wax must be cast. The final bronze gives needed strength to the fragile proportions and adds to the quality of archaic mystery inherent in the subject matter.

large enough to take a standard ten-pound twelve-by-nine-inch slab of wax with only a two-inch bar cut off the end. You usually need some bars and strips of wax anyway, so there is no lost motion here. If you use a smaller melter you will have to cut the wax up into suitable pieces. The simplest, cheapest method is to use a galvanized washtub over a two- or three-unit gas burner.

The only trouble with the portable oven wax melter is that it is awkward to pour from. An industrial heater often used for wax melting is the *bucket warmer*, a cylindrical heater into which a bucket or pot of wax may be lowered, then lifted out for pouring. If you or your institution can afford it, you will probably eventually want a vessel specially made for wax melting, like the ten-gallon Sta-Warm melter illustrated. It costs about $400 and will take whole slabs of wax and large pieces of discarded sculptures. It has a valve in the bottom so wax can be drawn off without tilting the melting pot. The best method is to draw the wax off into a pitcher or a saucepan with a handle, which is then used to distribute the wax evenly over the pouring slab.

The pouring slab is a dampened plaster bat used to form the wax into a sheet. It can be carved to impart a texture to the wax. Wax can also be poured

Plate 12.7. Types of wax. At the top are blocks of beeswax, microcrystalline wax, and paraffin. In the middle is sheet wax, smooth and textured, and at the bottom ready-made bars for gating material. Often manufacturers color-code their wax so material of different hardness and melting temperature can be identified.

Plate 12.8. Wax melters and slabs. The ten-gallon Sta-Warm melter has a tap for drawing off the liquid wax into a pouring pitcher. The smaller deep-fryer is lifted and poured directly onto the slab, or the wax may be ladled out to pour smaller amounts. The plaster slabs are moistened so the wax will not stick.

onto greased marble or damp wood, but plaster seems to be the best. Before you pour the wax, be sure the plaster is well saturated, but with no water actually remaining on the surface. Be sure the bat is level. If it is a portable bat on casters, you may have to shim it level before pouring. The trick in pouring wax is to pour at the lowest possible temperature, just before the wax begins to solidify. This produces a uniform sheet without bubbles. If you can transfer the wax from the melter to a pitcher, you can allow the wax to cool off in the pitcher before pouring it. Distribute the wax evenly over the surface of the bat so the wax will spread over the damp plaster rather than dehydrating a patch on the surface and then sinking in. When the wax has solidified, slice the edges with a knife and lift off the new sheet. The first few sheets will not be as clean and uniform as the later ones.

FORMING WAX

Once you have a supply of wax sheets you are ready to make the wax version of the sculpture you wish to cast. The most straightforward method is to construct a hollow form of sheet wax, later filling the inside with plaster investment material to make a core. This investment material is a mixture of plaster and *refractory* (heat resisting) materials such as grog, vermiculite, or silica flour. Some sculptors who like the feeling of working in plastery materials make the core first, of layers of built-up investment. When the core has almost reached the shape desired, it is covered with a layer of wax and the final details of the surface are executed in the wax. In either case the thickness of the wax represents the thickness of the metal which will finally replace it.

Bronze prices being what they are, there is no point in making the metal walls thicker than necessary. If they are too thin, however, the bronze may not be able to flow through them to all parts of the sculpture. Somewhere between one-fourth and one-eighth of an inch will be found about right for most applications. Aluminum, which is lighter and less expensive, is often cast thicker. Usually only very small objects are cast solid. Where the object being cast is composed of simple sheets or rods rather than volumes, the core problem does not exist.

Wax can easily be cut with a sharp stiff-bladed knife; a six-inch butcher's knife is ideal. For welding pieces together use a soldering pencil or soldering iron. These are available with a variety of tips and in

wattages from 25 to 60, for delicate to heavy work. Where a large area must be heated evenly, use a self-contained propane torch. These can be found in most hardware stores and are commonly used for soldering and paint burning. To make sharp bends, score the wax along the inside of the bend with a soldering tip and bend it quickly, while the score line is still soft.

A wax such as Victory B-44, which is pliable at room temperature, is used for most work. To soften it more you can put it out in the sun, immerse it in hot water, or use infrared heat lamps. To stiffen the wax, you can place it momentarily in a refrigerator or cold room.

Part of the sculpture may be constructed of materials other than wax, as long as the materials are combustible and will not leave behind a residue. Materials that have actually been used in sculptures include cloth, rope, string, cardboard, plastics, and wood, as well as plants, flowers, stuffed animals, and dried fish. Some of these last items produce an unforgettable odor during the burnout cycle and are not recommended for backyard burnout kilns in residential areas. The delicate textures of cloth and skin are quite accurately translated into bronze, and they can be modified by additions of wax where desired. Styrofoam is an excellent material to use in conjunction with wax where large areas must be spanned without sagging. The wax sheets themselves may be stiffened for use in large sculptures by embedding burlap or copper screen in the wax when pouring it out into sheets. The screen is not burned out but is absorbed by the bronze as it enters the mold.

GATES AND VENTS

Once the object to be cast is completed in wax, the next step is the formation and attachment of the channels through which the bronze will be distributed, and out of which the hot gases formed within the mold will escape. The former are called *gates* and the latter *vents*. Together with the pouring cup that receives the molten metal from the crucible, this structure is referred to as the gating system. If your sculpture is fairly small and simple, you can gate the whole thing as a unit. To find out how much bronze you will need, multiply the weight of the wax by a factor of ten. If the amount of material in the sculpture is too much for one pour, or if the mold made around it would be too big to get in your

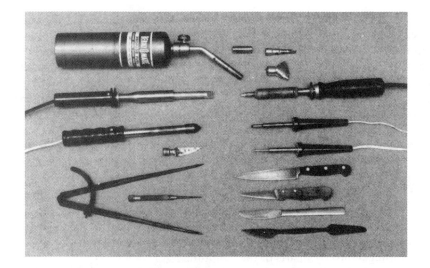

Plate 12.9. Wax tools. A propane torch is at top with alternate tips. At right center, shaped like a small knife, is a handmade copper cutting tip which may be attached to the end of a soldering iron for hot slicing.

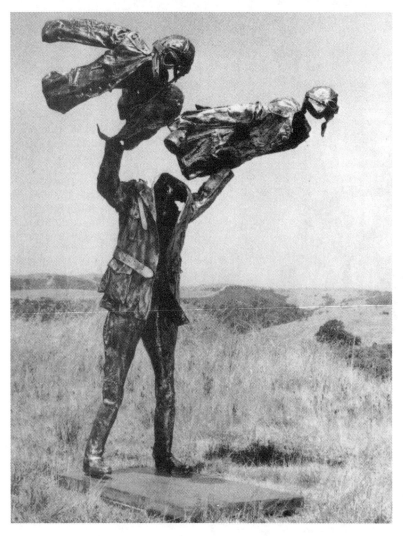

Plate 12.10. John Battenberg, *Johnny's First Trip*, cast aluminum, 8' high, 1966. From the collection of the Krannert Art Museum, University of Illinois, Champaign (photo by William La Rue). This artist uses real uniforms of World War I aviators. They are cast in plaster investments and burned out to make molds for pouring bronze or aluminum.

burnout oven, you must divide the sculpture up into separate units that will later be welded together. The parts of an extensive or rangy sculpture can often be assembled in compact groupings that can be economically gated and invested.

Modern welding and finishing equipment makes it possible to cast a large sculpture in small, easily-handled units. Many risks and hazards are thereby avoided. There is still an undeniable fascination in the daring, all-or-nothing pours of the past, when five furnaces would be tapped simultaneously to fill a full-size equestrian monument buried in the floor of the foundry.

The Cup

As well as receiving the metal and channeling it into the gates, the cup serves the important purpose of forming a reservoir of molten metal which will continue to feed the gates as the metal in the mold shrinks while cooling. Ideally, solidification should begin in the parts farthest from the cup and proceed in an orderly wave toward the cup, which solidifies last. Solidification visualized in cross section starts at the interface between the mold and the bronze, and proceeds inward to the center of the section. As you can see, if any part solidifies too soon, or if there is insufficient molten metal in reserve in the cup, there will be voids in the center of some parts that are supposed to be solid. The practical measures to meet these conditions call for an adequate pouring cup attached to an ample gating system that gradually becomes lighter as it branches out to the various parts of the sculpture.

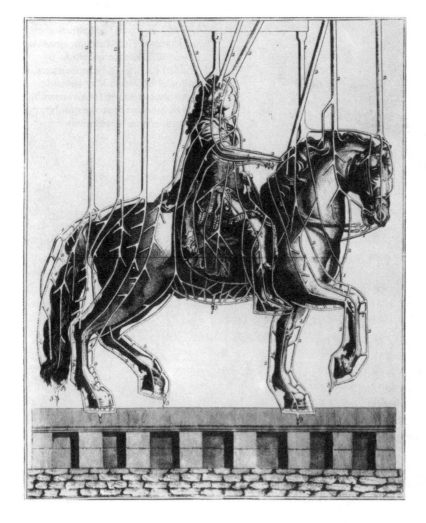

Plate 12.11a. *Casting a Large Equestrian Statue I*, from Diderot's *Encyclopaedia of Trades and Industries*, Vol. VIII, Sculpture, Fonte des Statues Equestres, Pl. IV. Courtesy of the New York Public Library. These engravings depict the steps in casting a mounted figure of Louis XIV which was erected in Paris in 1699. Here we see the wax pattern ready to be encased in an investment mold of plaster and clay. Notice the many small branching gates designed to distribute the bronze evenly and keep the wall thickness to a minimum.

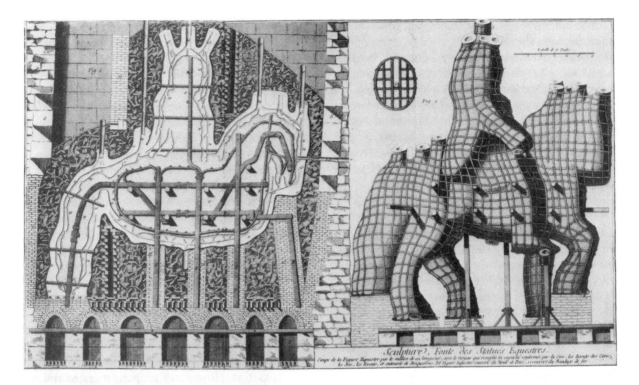

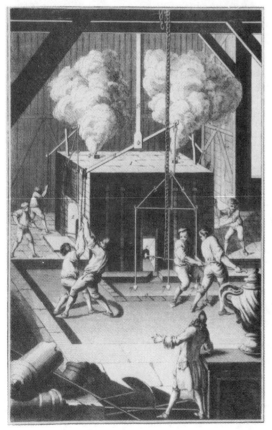

Plate 12.11b. *Casting a Large Equestrian Statue II*, Diderot's *Encyclopaedia of Trades and Industries*, Vol. VIII, Sculpture, Fonte des Statues Equestres, Pl. V. Courtesy of the New York Public Library. On the left is a cutaway diagram of the wax pattern encased in its plaster and clay mold filled with core sand. The core is anchored by the interior metal framework to keep it from shifting when the wax is burned out by firing the fuel packed around the mold. The arches at the bottom are the inlet flues of the burnout oven that has been erected around the mold. On the right is the external view of the burned-out mold ready to be lowered into the casting pit. The exterior of the mold has been reinforced with iron bands.

Plate 12.11c. *Casting A Large Equestrian Statue III*, Diderot's *Encyclopaedia of Trades and Industries*, Vol. VIII, Sculpture, Fonte des Statues Equestres, Pl. I. Courtesy of the New York Public Library. The bronze pour is about to take place. When the taphole is opened, the molten bronze will flow out of the furnace into the pouring basin. Then the riser openings will be unplugged by the overhead lever, and the bronze will flow down through the gating system to fill the mold, which is packed in sand in the pit beneath the foundry floor.

You can make a pouring cup of wax which tapers smoothly into the *sprue,* as the initial downspout in the gating system is called. Many people believe this adds beauty but doubtful efficiency to the gating system (it is a sad fact that many a gating system turns out to be more beautiful than the sculpture it feeds) so they use a paper cup or a Styrofoam cup, both of which give excellent results. A paper or Styrofoam cup can be removed from the investment before burnout, allowing more rapid egress of wax from the mold.

Gates

The gates should carry the metal evenly to all parts of the sculpture. Their simplicity or complexity will depend on the form of the sculpture and the thinness of its walls. The practice usually followed is called *bottom-gating,* and means that the sprue conducts the bronze to the bottom of the sculpture, which it fills by rising. The sprue takes the brunt of the force of the entering bronze and distributes it evenly. Gates higher on the sprue allow the bronze to flow directly to the higher parts of the sculpture when the lower levels have filled. In *top-gating,* the forms of the sculpture itself must act as channels to allow the bronze to reach the bottom of the mold. Good gating practice indicates that you should not allow any large area to be too far from the source of metal. Remember that after the sculpture is cast you will

have to cut off every gate you put on, so don't use more gates than you need, and keep them out of inaccessible places.

European gating tends to be thin and finely divided, whereas contemporary gating in the United States is heavier and simpler. This may be partly due to the fact that gate cutting in European foundries is usually still done by hand and the demand there is for thin wall castings, which require multiple gates.

The gates themselves may be made of strips or rods of wax cut from sheets. When making sheets it is a good idea to make a few thick ones from which gating strips can be cut. Round bars can be made from square strips by hammering them on an anvil or other solid surface. There are proponents of both square and round gates. Round gate supporters hold that roundness makes for smoother pouring, while the proponents of the square shape say the corners cut down *vortexing,* a swirling of the metal which draws oxygen into the mold. It is demonstrably true that sharp corners on any of the forms in the mold are promoters of fine cracks which later become fins on the casting. However, a properly invested and burned-out mold should not have cracks even if it is full of corners.

One of the biggest problems in burning the wax out of the mold is that in the initial stages, when the mold is beginning to get hot, the wax expands just before it melts. If the wax cannot escape from the

Figure 12.1. Gating sytems.

mold freely, this action will crack the mold. The problem is alleviated by using hollow gates and vents. These can be made from sheet wax, or by dipping tubes of paper or cardboard in molten wax. Another way to deal with this problem is to use Styrofoam bars for the heavier sprues, especially the main sprue from the pouring cup. The Styrofoam is dissolved with acetone before placing the investment in the burnout kiln.

An additional gating measure sometimes employed is to run the sprue straight through the mold to the other side. This prevents suction from holding wax in the gating system and allows the heated gas of the kiln to circulate directly through the mold. The hold in the bottom of the mold is sealed with a firebrick plug before pouring.

Vents

The gates and vents used in bronze casting can be compared to the intake and exhaust manifolds of an automobile engine, with the pouring cup as the equivalent of the carburetor. The exhaust system in both cases carries off expanding hot gases and vents them to the atmosphere. If the vents in a mold are inadequate, the pressure of the entering molten bronze can crack open the mold. If the vents are not in the right places, the bronze will not be able to fill the mold completely. In general, the vents should come from the tops and ends of the forms in the mold. Visualize the bronze rising in the mold and vent any air pockets that would be formed as the bronze progresses. Just as there is no exact scientific formula for pruning a tree, there is none for gating an irregular sculpture. If you have a feeling for form, you will get the idea after a little practice.

When the gating system is complete it can be reinforced by driving bronze pins made of $1/32$- to $1/8$- inch welding rod through the important intersections, leaving the ends of the rods sticking out a couple of inches to anchor in the investment plaster. These rods can also be used to pass through any hollows in the sculpture body to anchor the cores that will be formed there when the mold is made. Without core pins the cores would rattle around when the wax walls are melted out. The larger the sculpture and the thicker the walls, the heavier should be the core pins, so that they will not melt out during the pour. On a large piece with thick core, such as a full-size torso, stainless steel pins should be used. Core pins can also be used to

stabilize other parts of the piece which may be in danger of distortion or separation. Since the pins also reinforce the mold itself, they are highly recommended, although the holes they leave in the bronze must be welded up later.

Before you begin the next step, making the investment, you should check over your gated sculpture and reattach joints that have separated. A small crack can produce a fin of plaster which will check the flow of bronze into the mold.

THE PLASTER INVESTMENT

The investment is the plaster mold into which the bronze is poured after the wax is burned out. It can be applied to the surface of the wax until a thick shell is built up, or it can be cast as a solid block around the wax. The built-up mold is stronger and lighter than the cast mold but more laborious to make. One easy method is to mix up a drum of investment and carefully lower the gated wax sculpture into it. The whole process takes only a few minutes and there is no cleanup. This "easy" method, however, can turn into a disaster if your timing is off and the investment sets up before the wax is all the way in. Practice on a few small things until your timing is right.

To invest your sculpture by the easy method you need a container large enough to accommodate the gated wax form with two or three inches to spare on the sides and top. You should have the drum available to take measurements from while you are working on the gating system. Fiber drums can be used, but steel barrels or garbage cans are better because they contribute extra protection to the mold while it is being handled. For reinforcement of the investment itself you need a piece of wire mesh or expanded metal lath cut to fit around the sculpture, between it and the inner wall of the drum. Smaller pieces should be kept handy to slip into any extra spaces around the sculpture.

Be sure you have everything ready before you start mixing. In addition to the barrel and the wire you will need the investment materials, Hydrocal plaster and vermiculite (expanded mica), and an electric mixer. For small investments of one to five gallons a $1/4$- or $3/8$-inch drill with a slotted disk at the end of a rod will be sufficient. For larger investments you should use a $1/2$-inch portable drill equipped with a $1/2$-inch steel rod, ending in a disk of steel 6 inches in

Plate 12.12. Completed wax ready for investment. The wax pattern with sprues, risers, and core pins in place is held here over the trough in the burnout kiln, showing the position it will occupy in the kiln after it has been surrounded by the investment mold and placed in position so that the risers and sprues will drain into the trough.

Plate 12.13. Gated pattern with core pins. The stainless steel core pins are left protruding about three inches around the sculpture to reinforce the investment and anchor the core firmly.

diameter and 1/16-inch thick, slotted and bent to form a propeller as shown in the drawing. For really big investments it is best to mount the drill or industrial mixer on a forklift or counterweighted stand (see pl. 3.5a., b., and c.).

First fill the drum with clean water to half the height of the final investment. Since you want to leave at least a two-inch rim at the top of the can to keep the investment from slopping out in the final stages of mixing, this waterline mark will be about an inch below the midline of the drum. Dump in the plaster. Never mind sifting, just dump it in until the level of the water rises to three-quarters of the height of the completed investment. Start mixing immediately, moving the mixer around to break all the lumps. When you think the plaster is thoroughly mixed, mix for five more seconds, then plunge your arm in as far as you can reach and see if you can feel any lumps. If there are none, wash off your arm, dry it, and add a two-inch layer of vermiculite to the mix. Mix this in and keep adding vermiculite slowly until the level of the investment has risen to the correct height. Next take the wire mesh and lower it into the investment, pressing it out toward the sides of the drum so there is room for the sculpture. Then carefully pick up the sculpture and lower it slowly into the investment without striking the wire. Jiggle it gently as you lower it so that the investment will fill all the holes and crevices. Be careful not to bend

the sculpture or detach the gates. If your sculpture has a complicated core that will not fill when immersing the wax in this way, the core must be filled with investment material before beginning the main mix. When the sculpture is all the way in, hold it for a few minutes until the investment sets enough to keep it in place.

After the investment is set, an oxyacetylene cutting torch is used to cut the bottom out of the drum to provide breathing area for the mold. Alternatively, on small investments, the bottom may be punched full of holes. The mold may then be placed in the burnout kiln, and the burnout started as soon as is convenient, even though the mold is still damp. A damp mold actually burns out more cleanly than a dry one because the water helps to conduct the heat inward to the wax, and also resists absorption of the wax into the mold.

For fine rendition of surface detail, a facing coat of equal parts plaster and silica flour is often applied to the surface of the sculpture before investing it in the coarser investment material. Spraying the surface of the wax with a silicone lubricant also helps to produce a good surface and reduce bubbles.

The procedure described above is only one of many different methods using various ingredients and proportions. In addition to the formulas of individual sculptors, there are also ready-mixed commercial investment materials that, despite their

Plate 12.14. Mixing investment. Vermiculite is poured into the vortex of the mix. When enough has been added the consistency should be like cake batter. At this point the mixture will harden in five minutes.

expense, are excellent for sculpture work. In fact, the occasional use of a commercial investment is a good way of checking the quality of your own homemade formula. There are three principal ingredients in any investment:

1. *The binder.* This may be ordinary casting plaster, super-strength plaster like Hydrocal or Ultracal, or a special high-temperature plaster manufactured by a refractories company.
2. *The refractory.* Plaster by itself cannot withstand the temperature changes encountered in the burnout and casting processes. Mixed with 40 to 60 percent granular refractory, however, the mixture can survive considerable temperature shock. Commonly used refractories are silica flour, clay, grog, brick dust, vermiculite, ground pumice, and

luto, which is simply pounded-up recycled investment.

The reinforcement. Even the best investment material is quite brittle and needs to be supported in a cage of wire just beneath the surface. All the advantages of two-phase materials, as discussed in chapters three and five on plaster and concrete, also apply to investments. This cage is usually made of wire mesh, but can be handmade by wrapping a coil of wire around and around the investment over vertical iron rods. The rods keep the wire from biting too deeply into the plaster and provide lengthwise support. The cage thus formed is plastered over with a final layer of investment; it is definitely a superior reinforcement, but time-consuming to make.

Plate 12.15. Lowering sculpture into investment mix. Care must be taken to fill all cavities and to avoid pushing the sculpture out of shape. The Styrofoam pouring cup can be removed as soon as the plaster sets.

As an additional reinforcement you can add chopped organic fiber to the investment mix. Some of the best commercial investments contain fibers. Avoid any that list asbestos fibers as an ingredient, as asbestos fibers are extremely dangerous to inhale. Be careful of glass fibers also. Some investment formulas, particularly old-fashioned ones, specify various kinds of organic materials which, when burned out, make the investment porous. Short pieces of bent wire called *crimp wire* are also used to reinforce investments.

Ever since the earliest casters achieved beautiful results with investments of mud and lime, craftsmen have been experimenting with investment formulas. Here is a famous one from Benvenuto Cellini:

Tripoli powder (gesso of Tripoli)	4 parts
Burnt ox-horn cores	2 parts
Iron filings	1 part

The ingredients are finely ground together and mixed with liquid manure, which has first been washed and sieved.

There can be no perfect formula because the conditions under which casting is done are so variable, and because the investment itself is a compromise between many conflicting requirements. The investment must be tough enough to remain intact until after it is poured, and then it should be soft enough to remove easily. It should be porous enough to withstand heat shock and allow for gas escape, but dense enough to resist wax penetration during burnout.

BURNOUT

A clean burnout is the prerequisite for a good pour. If there is any organic material or carbon left in the mold when the bronze enters, it will burn, producing gas bubbles that will make the cast porous and spongy.

There are two phases to the burnout—a low-temperature and a high-temperature phase. The first phase takes place between 200°F and 450°F, when the moisture and wax leave the mold and either run out the kiln or are volatilized and escape up the flue. It is important to get as much wax as possible out of the kiln at this point, because when it burns it creates a reducing atmosphere in the kiln, driving carbon particles into the investment material. This absorbed carbon takes many hours to burn out of

the investment at the 1000°F to 1200°F temperatures that the investment can withstand.

The trough illustrated is one way of conducting the wax out of the kiln as soon as it comes from the molds. A smaller kiln may have a collection pan that empties directly through the bottom of the kiln. If you collect the wax in a wax melter it can be converted immediately back into sheets.

The heat of the kiln should be kept below 450°F until all the wax is melted out; then it can be raised at the rate of 100°F per hour to a termperature of about 1100°F and held there for twelve to thirty-six hours, depending on mold thickness. Above 1200°F plaster begins to break down and silica goes through an expansion phase, so it is wise to stay below this temperature. A temperature control is a great advantage in burnout firing because the kiln must be held at a given temperature for a long period of time. At this second stage of the burnout cycle, the wax that has been absorbed into the investment material is changed to carbon and finally burned and carried away up the flue. The inside of the mold must remain between 800°F and 1000°F for at least twelve hours for this process to be completed. The thicker the mold, the longer it will take for the heat to penetrate to the interior.

When the burnout is complete, the kiln may be shut down and the dampers closed to promote gradual cooling. With thick molds the temperature is sometimes brought down even more gradually by leaving the burners at a reduced setting for up to twelve hours.

As soon as the molds are cool enough to handle they may be placed in the sand pit for pouring. If handling equipment is available they may be poured very hot, eliminating some of the heat differential between the bronze and the walls of the mold. This begins to be a distinct advantage when the shapes to be filled are thin and complicated. The mold may also be poured cold, but on no account should the mold be left sitting around long enough to absorb moisture, or it may explode when poured. A damp mold is a bomb. It should be returned to the kiln and dried out before pouring.

The fact that investments are heavy, fragile, and awkward to handle, even with overhead hoists, is critical in the design of burnout kilns and furnaces. The most difficult thing to do with a large investment is to get it in and out of the door of a conventional front-loading ceramic kiln. In all other respects a

ceramic kiln works well as a burnout kiln, if provision is made for wax removal. A good solution is a shuttle kiln with a cart which rolls out under a crane bridge, as shown in plate 12.16.

In a commercial bronze foundry the burnout furnace will be designed for burnout alone. Plate 12.17 is a top-opening furnace at a modern foundry specializing in sculpture casting. In European foundries a very ancient method is still in frequent use, in which the furnace is simply stacked up brick by brick around the investment and a burner is introduced through a hole near the bottom. The furnace is dismantled when the burnout is completed. A more advanced version of this process uses a permanent platform equipped with burners. A sort of brick igloo is then built on top of this base. At the University of Kansas an updated version of this type of furnace uses large lightweight bricks with keyed edges which permit the making of round furnaces of varying diameters.

POURING BRONZE

The investment is placed in position for pouring in a bed of sand. Additional sand is packed around it to brace it for the shock of the molten metal and to absorb any metal that might escape through a crack in the mold. The sand pit may be dug or cast in the floor of the foundry; it may be a wood or steel box resting on the floor; or it may be just a pile of sand. A smaller individual box or drum may be placed around the mold so the sand can be rammed tighter for more support. The ultimate form of this procedure is the use of steel shot instead of sand. The shot is dropped around the mold from a shot silo and recovered magnetically after the pour.

The bronze is melted in a silicon carbide crucible placed in a furnace fired by gas or oil. A centrifugal blower sends a blast of gas-laden air into the furnace along one side so that the flame swirls around the crucible before it leaves the furnace through a hole

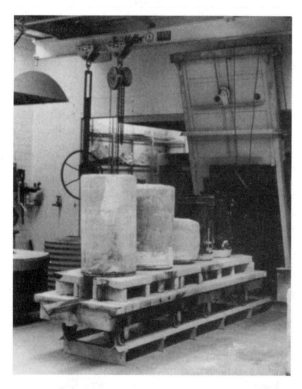

Plate 12.16. Molds on kiln cart ready to be pushed into burnout kiln. The first three investment molds have been poured in cardboard drums, which were then stripped off, leaving the bare plaster. The two investments on the rear of the cart were poured in steel drums.

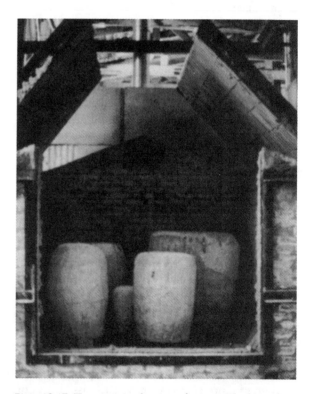

Plate 12.17. Top-opening burnout furnace. The hinged doors forming the roof of this furnace allow investments to be lowered directly into the furnace from the monorail running overhead.

in the furnace lid. A crucible furnace is a fairly simple device which can be made by a person with a little mechanical ingenuity. Excellent castable refractory concretes are now available to make the liner, or high-temperature firebricks may be used which are available in many different configurations.

Tongs for lifting the crucible out of the furnace and the shank for pouring from it can be made by standard welding and cutting methods. It is best to use as a model some furnace tools that are known to work. A blacksmith can make these tools, or they may be ordered from a foundry supply company.

While the crucible can be removed from the furnace and poured by hand, an overhead hoist makes the operation much safer and simpler. An ordinary chain hoist works well for lifting this equipment, if you are careful to keep the end of the chain out of the crucible. The pouring device in plate

Plate 12.18a. Ramming up investment in flasks. Investments that are fragile can be reinforced by placing around them a steel drum or "flask." The space between the flask and the investment is then filled with sand packed tightly by ramming with a blunt metal bar.

Plate 12.18b. Investment ready to pour. This investment was not initially cast in a steel drum; therefore, it is strengthened by ramming it up in a flask. The top of the wire mesh reinforcement may be seen around the edge, as well as the openings of eight risers, with the pouring cup in the center.

12.20 is operated by a wheel and track. It is convenient and steady. An electric or pneumatic hoist is nice if you can afford it.

Now you are ready to melt and pour the bronze. Two people can handle the operations if they are experienced; three make the best team, one person on each side of the tongs or shank, the third handling the hoist. Do not try to pour bronze by yourself.

Charge the crucible with clean ingots of bronze and add any scraps you have ready. Don't wedge the ingots into the crucible or you may crack it.

Light the furnace, turn on the blower, and allow the furnace to warm up for a while with the air valve partially open. This warm-up is especially important if the furnace or the crucible is new or has not been used for some time so that it may have absorbed some moisture. The next ingots to go into the crucible should set near the furnace so they can be warming up. When you believe the furnace is well warmed and any moisture has been driven off, turn the air valve fully open. It should take between thirty minutes and an hour for the bronze to begin to melt. Every action from this point on should proceed with

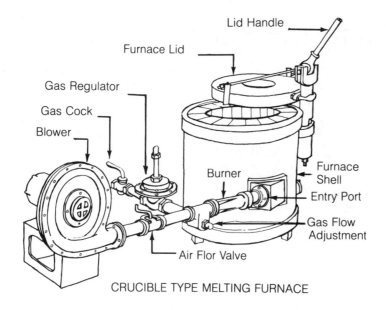

CRUCIBLE TYPE MELTING FURNACE

Figure 12.2. Crucible furnace. Crucible furnaces come in many sizes and styles. Illustrated is a stationary (non-tilting) furnace mounted on the floor. A blower directly coupled to a 1½ h.p. electric motor drives a mixture of gas and air through the venturi-shaped burner. A No. 50 furnace like this will melt 150 lbs. of bronze or 50 lbs. of aluminum in about 45 minutes.

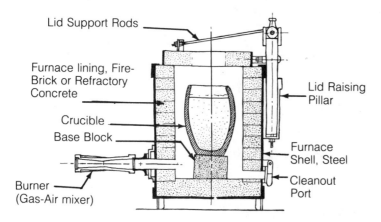

SECTION OF TYPICAL FURNACE

great precision. You have a short time now before the next move to make sure everything is ready.

The way the metal behaves when melting will depend on what type of bronze alloy it is. The most popular bronze in the past was what is now called by foundrymen "red brass," and by sculptors "statuary bronze." It contains 85 percent copper, 5 percent tin, 5 percent zinc, and 5 percent other metals. In general, high-copper alloys with some tin in them are called bronzes, and low-copper alloys with 25 percent or 35 percent zinc are called brasses, but the terms "brass" and "bronze" have no exact meaning today. Specification booklets are available from bronze companies such as Anaconda, Chase, and Asarco, listing the compositions, properties, and trade names of the dozen or so alloys in common use today.

Yellow brass is less expensive than red brass, but it is just as durable and tougher. It is yellower because it contains only 65 percent to 75 percent copper compared to 85 percent for red brass. The large proportion of zinc causes it to smoke during melting, and it forms a thick crust that must be skimmed off before pouring. The addition of a flux to the melt helps to cut down the zinc loss and protects the surface from oxidation. Flux will also help in melting red brass, though the zinc problem is not as critical. While pounded-up glass bottles make a pretty good flux, your local foundry supply can

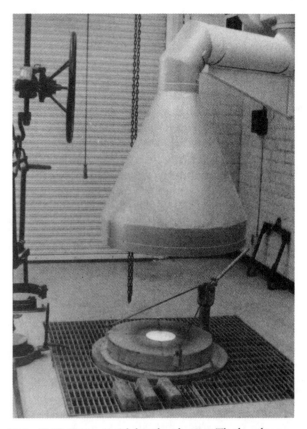

Plate 12.20. Furnace with hood and tongs. The hood can be pushed aside when no longer needed. A wheel-operated pouring device holds the tongs over the shank.

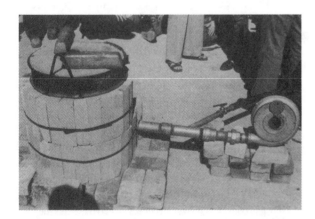

Plate 12.19. Temporary furnace. Photographed by the author at St. Francis Xavier University, New Orleans, during the Ninth International Sculpture Conference, April 1976. William Ludwig and John Scott of Xavier University demonstrate their one-day casting setup. The foundry was constructed, bronze poured, and the foundry dismantled, all in one day. Note steel straps binding furnace bricks.

Plate 12.21. Furnace with lid open. The furnace must be opened once or twice during the melt in order to charge the crucible with additional ingots. Sand is spread on the crucible block to prevent the hot crucible from sticking to it.

provide the correct flux to cover whatever alloy you are pouring.

Aluminum bronze and manganese bronze are yellow brasses to which 10 percent aluminum, or 5 percent aluminum and 3 percent manganese, have been added. They are no more difficult to cast than yellow brass; they are between it and red brass in cost, and they have beautiful color. They are very tough, which means they are tough to grind and saw as well as being strong.

Silicon bronze, sold under the trade names Everdur and Herculoy, is the ideal casting bronze. It was developed in the 1930s and has displaced many of the older casting alloys because of its combination of excellent properties. It is 95 percent copper, 4 percent silicon, and 1 percent small amounts of tin and manganese. It pours cleanly and fluidly without fumes; it can be welded with both oxyacetylene and inert gas methods. It is strong and malleable, and colors richly with age. Another advantage is that its composition changes little when being melted and poured, so scraps can be reused without loss of properties. Silicon bronze is more expensive than red brass, but it is worth it. See chapter nine for additional information on brasses and bronzes.

It is not a good idea to melt down a mixed batch of water faucets, bolts, door handles, and other assorted hardware to make casting bronze. You are likely to produce an alloy that, on cooling, will go through an intermediate stage between solid and liquid. This will cause voids and cracks in the casting and result in an inferior metal that is brittle and hard to weld. Another disadvantage of melting down miscellaneous objects is that some of them may contain a percentage of lead, which is added to bronze to increase machinability. Lead fumes are toxic. Unless you have a supply of a single type of item of known composition, you would do well to rely on the centuries of experience that have gone into the formulation of the modern casting ingot.

When the first ingots have melted, the furnace should be shut off and additional ingots added with long tongs, taking care to lower each ingot gently into the melt without splashing. The bronze should be heated for ten minutes or more after it has completely melted. This "superheating" gets the bronze hot enough to stay fluid until it reaches its final destination within the mold. Avoid *over*heating the bronze, however, as this will cause alteration in its composition and the production of "gas" within

the metal. "Gas" comes from the breakdown of water vapor into hydrogen and oxygen at elevated temperatures, and oxidation of components within the alloy. Every bronze has its optimum temperature limit. In the case of Everdur, this temperature is 2200°F. There are many degassing additives on the foundry supply market, but the best precaution is to avoid "cooking" the bronze.

During the final minutes of melting, the bronze pouring crew dresses in their heat-resistant clothing. Ideally they should wear aluminized asbestos coveralls or suits, asbestos gloves, heavy leather shoes, and fiberglass arc welder's helmets with lightly tinted four-by-five-inch faceplates. Leather welder's jackets and aprons are sometimes substituted for the asbestos clothing but they do not provide as good protection. No one should participate in a pouring unless all parts of his or her body are protected. No one should be allowed in the pouring area with bare feet or sandals. If molten bronze is spilled on the floor, it travels very rapidly across the floor in all directions.

The bronze pouring operation now proceeds in three distinct phases:

1. *Extracting the crucible.* The furnace is shut off, opened, and the tongs lowered into the furnace. One person operates the hoist while two others guide the tongs and make sure they are locked in place. The hoist operator then raises the tongs and crucible while the other two guide them out of the furnace. Together they guide the crucible to a spot just above a base block positioned on the floor in the center of the pouring shank. The hoist operator lowers the crucible onto the base block, which has been coated with a layer of fine sand to keep the hot crucible from sticking to it. The person operating the tong latch then disengages the tongs from the crucible, and they are lifted and put aside.

2. *Preparing the bronze.* The crucible is now resting unsupported on the floor between the furnace and the pouring pit. During this moment of rest, the top is skimmed and the temperature is taken with a pyrometer. Most bronzes pour best in the range between 1950°F and 2200°F. The object is to pour at the lowest temperature that will allow the bronze to fill the mold, thus minimizing stress and shrinkage. Everdur bronze should come out of the furnace around 2100°F and cool to around 2000°F before pouring. This cooling period allows some of

the gases trapped in the melt to escape. High zinc bronzes tend to have more gassing problems than silicon bronzes. After spending some time around the foundry you will find that you have a fairly good idea of the bronze's temperature without measuring it.

3. *Pouring into the mold*. Skimmed and tempered, the crucible of bronze is now ready for its final trajectory out over the pouring pit. The shank-yoke is hooked to the hoist and the shank is then raised by the hoist operator while the persons guiding the shank fit the ring of the shank into position around the crucible. One of the persons guiding the shank sets the post and tab to hold the crucible secure in

the ring. The two shank guides then take opposite ends of the shank and guide it over the investment.

The crucible is now out over the pit and poised above the mold. The person who is to pour tilts the crucible with the handlebars on the end of the shank, while the partner steadies the shank. The lip of the crucible should be as close to the pouring cup as possible, to minimize oxidation of the metal and splashing within the mold. The bronze should be poured in a steady stream as quickly as the capacity of the pouring cup will allow. If all the foregoing steps have been faithfully executed, the brilliant molten metal should soon be seen rising evenly through the vents to the surface of the mold, indicating that

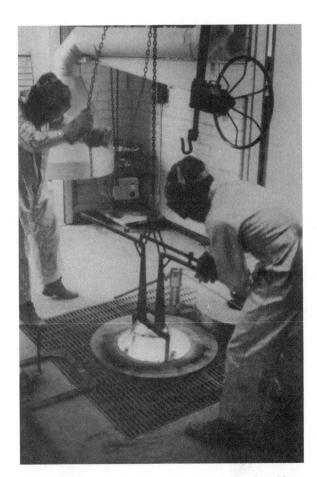

Plate 12.22. Extracting the crucible. The furnace hood has been swung out of the way so the tongs can be lowered into the furnace. A chair hoist is usually preferred over a wheel hoist (background) for this operation, because it allows the operator to stand back from the heat of the open furnace.

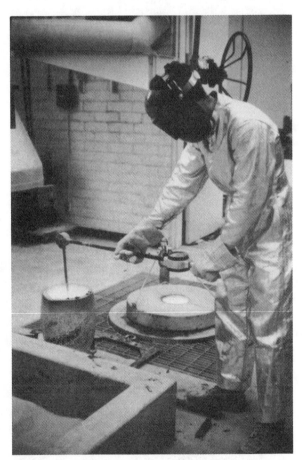

Plate 12.23. Taking the temperature. The tip of the pyrometer is gradually immersed in the molten bronze. The metal should be poured at the lowest temperature that will allow the mold to fill. This is somewhere around 1900°F, depending on the alloy and the complexity of the mold.

Plate 12.24. Lifting the crucible in the shank. Dressed in asbestos overalls and fiberglass helmets, the pouring team is ready to lift the crucible and move it into position over the molds. The molds are packed in sand in the pit on the left.

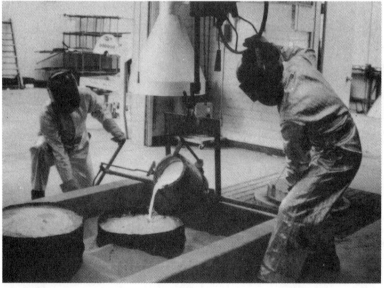

Plate 12.25. Pouring bronze. One person tilts the crucible and guides the stream of metal into the pouring cup. The partner lowers and raises the wheel hoist and steadies the other end of the pouring shank. These two students are wearing fiberglass helmets and aluminized asbestos overalls.

it has flowed smoothly through all the passages within. Needless to say, the sight of the metal rising successfully in the vents is a welcome one to the sculptor, who has spent many hours preparing for this moment.

If there are more molds in the pit to be poured, the person directing the casting must quickly decide whether there is enough metal left in the crucible and whether it is hot enough to fill the next mold. If so, this is done immediately, and then the crucible is returned to its base block. If there is another pour to be made that day, the crucible is recharged with metal and lowered into the furnace.

DEVESTING AND FINISHING

When the molds are cool enough to handle they are removed from the sand pit, with the hoist if neces-

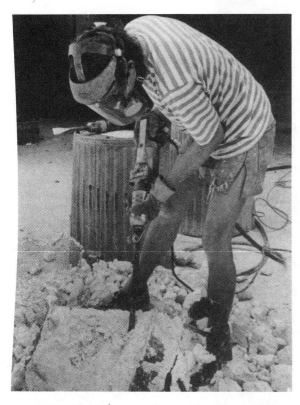

Plate 12.26. Chipping off investment. The artist carefully chips off the investment with an electric hammer, avoiding damage to the surface of the bronze. Pneumatic hammers are also good for this work. Note the respirator and visor worn as protection from plaster dust.

sary, and placed on a floor where a pile of debris can be made and easily removed. Some foundries have a *devesting* area where the investment debris falls through a grating into a collection pit.

The mold is broken open and the investment chipped away with a chisel, or with an air or electric hammer. The remainder of the investment may be removed by sandblasting, wire brushing, or soaking in mild sulphuric acid. The gating system is cut away using a reciprocating saw or a carborundum cut-off wheel. If a DC arc-welding machine with an amperage of at least 350 is available, the Arcair cutting torch is a very effective tool for cutting gates and heavy *flashing* (bronze that has flowed into cracks in the mold). The operation of the Arcair torch is described in chapter eleven.

Once the parts of the sculpture are freed from the investment and the gating system, the core pins are removed and the holes welded over with a filler rod matching the composition of the bronze. Any holes or depressions in the casting are filled at the same time. Then the surface of the casting may be patinated, polished, or finished in other ways, as described in the previous two chapters. Fine flashing and other imperfections of the surfaces are often dressed with a sharp cold chisel with a steel or tungsten carbide edge. The final cleaning up of castings with a chisel, including the reinforcement of details, is called *chasing*.

Plate 12.27. Casting freed of investment. This casting of a hand in aluminum has been devested and cleaned in preparation for cutting off the gates, grinding, and chasing. Though there is some "flashing" (fins of excess metal) around the gates, the sculpture itself is clean and sharply detailed.

PATINATION

When the desired surface texture and detailing of the casting have been attained, it is possible to give the sculpture a *patina,* or colored oxide coating produced by treatment with various chemicals. The surface must first be made uniform, if this has not already been accomplished, so that all areas of the sculpture will be affected evenly by the chemicals to be applied. In addition to grinding, sanding, and polishing, the surface may be cleaned and unified by sandblasting and by etching with acid. When the casting is first removed from the investment it is covered with a dark layer of fire scale. All of this scale must be removed by one of the aforementioned methods, so that clean, bare metal is available for the development of the patina.

In general, the chemical preparations used to color the bronze will work more rapidly if the bronze is heated. Care must be taken, however, to

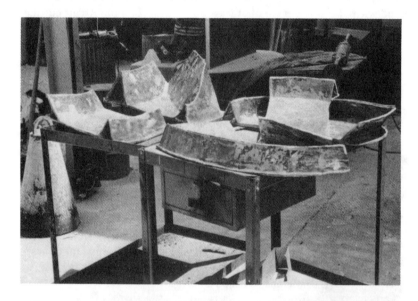

Plate 12.28. Sections of sculpture ready for assembly. These parts of a larger sculpture have been cast in silicon bronze. The gates have been removed and the surfaces rough ground in preparation for welding.

Plate 12.29. Cast sections assembled by welding. The parts in the previous illustration have been assembled and welded to make this spiral ramp about four feet high and six feet in diameter. The ramp will support a unit of stainless steel to form the completed sculpture.

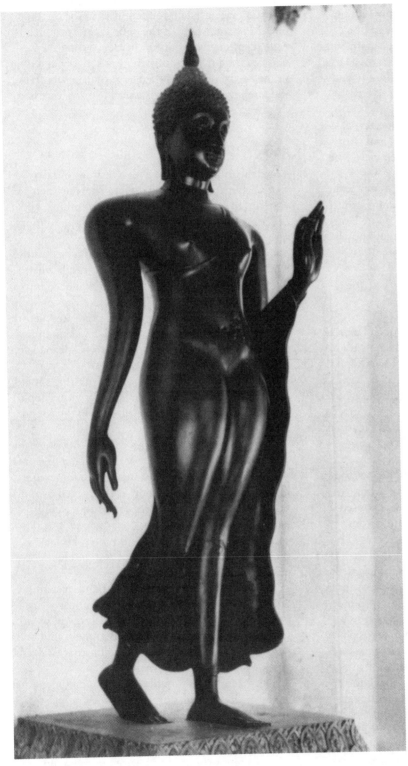

Plate 12.30. *Walking Buddha*, Siamese, Sukhodaya style, bronze, 88" high, 14th century A.D., Monastery of the Fifth King, Bangkok, Thailand. Perfection of surface and detail is unified by sweeping contours. The clay and sand core often remains within the sculpture in Thai castings of this period.

heat the surface evenly, or a splotchy effect will result. Smaller pieces can be heated in the kiln or suspended over a furnace. Larger pieces can be heated in sections with an oxyacetylene torch. Some experience is necessary to do an even job on a large piece using this method. The heat required for most patination is in the neighborhood of 180°F to 200°F.

A way to produce a very even patina is to enclose the sculpture in an airtight box or tent, and then place inside bowls of concentrated chemicals. The effect will be gradual and uniform.

Patinas may also be applied at room temperature by brush or sponge. The effect will be quite controllable and gradual. The patina process can be largely experimental coming from a fundamental knowledge of the chemicals and their applications.

1. Liver of sulfur makes black
2. Copper nitrite makes red
3. Ferric nitrite makes green

A light application of liver of sulfur may be used as a base coat. Each chemical should have its own brush. The brush strokes are used in conjunction with a heating flame, one after the other, creating the right metal temperature to give a maximum reaction of color. Patination may take from several hours to several weeks, with possible additional applications of chemicals, before the desired result is attained. The patina of a bronze sculpture goes on changing indefinitely unless a coating of wax or lacquer is put over it to preserve it, and even then the patina develops slowly from within. Sculptures exposed to industrial fumes or sea air will change quite drastically as time goes by unless they are protected by constant waxing.

"Bronze disease" is the pitting of a bronze surface due to the corrosive action of the atmosphere, usually aided by porosity in the bronze itself (produced by minute gas bubbles in the bronze when it was poured). A continuous corrosive action takes place in these pits, especially in the presence of moisture. The compounds produced by this corrosion are not hard and protective like the normal patina compounds; instead, they are soft and tend to slough away, exposing fresh metallic bronze to further corrosive action. The treatments for bronze disease are beyond the scope of this book, but are well known to the curatorial staffs of museums throughout the United States and Europe.

It is amazing how well preserved are some of the bronzes that have lain for centuries in the earth or under the sea. Many of the patinas thus produced are exceptionally beautiful. In fact, during the Renaissance many patination methods involving burial in the earth were developed as a result of observing the interesting colors on classical bronzes that had just been excavated.

SAFETY

The danger of exposure to high heat in foundry work is fairly obvious and direct. There are many varieties of protective gloves, boots, clothing, and headgear which make working around the foundry more comfortable as well as safer.

Novices and students should be informed of the explosions and metal splattering that result when cold, dirty, or moist materials are introduced into a crucible of molten metal. Ingots and pieces of scrap should be thoroughly cleaned and preheated before they are placed in the melt. Stirring and skimming tools and pyrometer tips should also be cleaned and preheated before use.

Spectators in the foundry during pouring should be kept well back from the area of activity. People with bare feet should not be allowed in the foundry area at any time.

Zinc-bearing copper alloys will give off zinc fumes during melting and welding. Melting scrap brass may give off lead or beryllium fumes. These fumes are highly toxic and are not completely filtered by most small respirators. Zinc fumes can produce chills, nausea, and fever, but do not produce serious poisoning as do lead and beryllium fumes. Home therapy for zinc fever is a day of rest and lots of milk.

While respirators for zinc fumes and dust are effective if worn correctly and continuously, breathing problems will be greatly alleviated by installation of forced air ventilation in the foundry and by use of fan-ducted hoods over all furnaces, ovens, and kilns.

Dust respirators should be worn at all times when preparing investments or working around plaster, luto, dry clay, grog, powdered pumice, and mica aggregates, as when emptying bags into bins. Glass fibers should be treated with extreme care. Loose asbestos fibers should not be used in the sculpture studio.

BIBLIOGRAPHY

American Society for Metals. *Metals Handbook.* 8th ed. Vol. 5, Forging and Casting (1970); vol. 8, Metallography, Structures, and Phase Diagrams. Metals Park, Ohio: American Society for Metals, 1961, 9th printing, 1977.

Crucible Manufacturers' Association. *Crucible Melting Handbook.* New York: Crucible Manufacturers' Association, 1956.

Federated Metals Division, American Smelting and Refining Company. *Copper Base Casting Alloys.* New York: American Smelting and Refining Co., 1965

Flinn, Richard A. *Modern Cast Metals Practice.* Ann Arbor: The University of Michigan, 1955.

Foseco Inc. *Foseco Foundryman's Handbook.* London and Elmsford, N.Y.: Pergamon Press, 1975.

Harbison-Walker Refractories Company. *Modern Refractories Practice.* Pittsburgh: Harbison-Walker Refractories Co., 1961.

Irving, Donald J. *Sculpture Material and Process.* New York: Van Nostrand Reinhold, 1970.

Jackson, Harry. *Lost Wax Bronze Casting.* Flagstaff, Ariz.: Northland Press, 1972.

Krishnan, M. V. *Cire Perdu Casting in India.* New Delhi: Kanak Publications, 1976.

Meilach, Dona Z., and Dennis Kowal. *Sculpture Casting.* New York: Crown, 1972.

Mills, John W. *The Technique of Casting for Sculpture.* New York: Reinhold, 1967.

Modern Casting. Des Plaines, Ill.: American Foundrymen's Society, Inc. See especially vol. 58, no. 1 (July 1970), "Metal Art Casting in America Today." Each year the November issue is a "Buyer's Directory."

Roast, Harold I. *Cast Bronze.* Cleveland: The American Society for Metals, 1953.

Savage, George A. *A Concise History of Bronzes.* New York: Praeger, 1969.

Shearman, William M. *Metal Alloys and Patinas for Casting.* Kent, Ohio: Kent State University Press, 1976.

Shimoji, Mitsuo. *Liquid Metals.* London: Academic Press, 1977.

Tefft, Elden C. *Sculpture Casting in Mexico.* 2d ed. Lawrence: The University of Kansas, 1968.

———. *Lost Wax Sculpture Foundry Equipment: Recommendations and Sources.* Lawrence: The University of Kansas, 1977.

United States Gypsum Company. *Metal Casting Plasters.* Chicago, Ill.: United States Gypsum Co., 1970.

University of Kansas. *Proceedings of the National Sculpture Casting Conference, 1960, 1962, 1964, 1966; Proceedings of the National/International Sculpture Conference, 1974, 1976.* Lawrence, Kans.: The University of Kansas, 1960, 1976.

EQUIPMENT AND MATERIALS

A. Equipment

Alnor Instrument Co., 420 N. LaSalle St., Chicago, IL 60600. Pyrometers.

A. D. Alpine, Inc., 3051 Fujita St., Torrance, CA 90910. Kilns, ovens, furnaces.

The Campbell-Hausfeld Co., Harrison, OH 45030. Furnaces.

The Joseph Dixon Crucible Co., Wayne St., Jersey City, NJ 07303. Crucibles, base blocks, refractories.

Dick Ells Co., 908 Venice Blvd., Los Angeles CA 90015. Foundry equipment and supplies.

Inductotherm Corp., 10 Indel Ave., Rancocas, NJ 08073. Induction furnaces.

Johnson Mfg. Co., 2829 E. Hennepin Ave., Minneapolis, MN 55413. Furnaces, tongs, shanks.

Lindberg-Fisher Div., Lindberg Engineering Co., 2443 West Hubbard St., Chicago, IL 60612. Furnaces.

Modern Equipment Co., Box 266, Port Washington, WI 53074. Crucible shanks, ladles, pouring devices.

Pyrometer Instrument Co., Inc., Bergenfield, NJ 07621. Pyro pyrometers.

Ross-Tacony Crucible Co., Tacony, PA 19135. Crucibles and base blocks.

Sta-Warm Electric Co., Ravenna, OH 44266. Electric wax and lead melters.

Waage Electric Inc., 720 Colfax Ave., Kenilworth, NJ 07033. Electric wax tools and melters.

West Instrument Corp., Subsidiary of Gulton Industries, Inc., 3860 N. River Rd., Schiller Park, IL 60176. Pyrometers and thermocouples.

B. Protective Clothing and Safety Equipment

E. D. Bullard Co., 5586 E. Imperial Hwy, South Gate, CA 90280. Distributor of many lines of safety equipment.

Fromwelt Industries, Inc., 465 Huff St., Dubuque, IA 52001. Protective clothing and fire curtains.

Industrial Products Co., 21 Cabot Ave., Langhorne, PA 19047. Clothing, face shields, etc.

Jackson Products, 5523 Nine Mile Road, Warren, MI 48090. Helmets, goggles, face shields.

Walter Kiddle and Co., Inc., Belleville, NJ 07109. Fire extinguishers.

Mine Safety Appliance Co., 1100 Glove Ave., Mountainside, NJ 07092. Respirators and breathing apparatus.

Wheeler Protective Apparel, Inc., 2-4 W. Huron St., Chicago, IL 60610. Asbestos coats, suits, gloves, etc.

Willson Safety Products, 111 Sutter St., San Francisco, CA 94104; 1985 Taince Ave., Melrose Park, IL 60160. Respirators and face shields.

See also distributors listed after chapter eight.

C. Materials

Sources for bronze, aluminum, and iron will be found in the materials listed for chapters nine and thirteen.

A. P. Green Products, 655 Amboy Ave., Woodbridge, NJ 07095. Refractories and firebrick.

Babcock & Wilcox, 161 E. 42nd St., New York, NY 10017. Kaowool refractory fiber.

Bareco Wax Co., 917 Enterprise Bldg., Tulsa, OK 74103. Wax.

Brumley-Donaldson Co., 3050 E. Slauson Blvd., Huntington Park, CA 90255. Foundry equipment and supplies.

Farmer Mfg. Co., Brookside Park, Cleveland OH 44135. Fluxes and deoxidizers.

Georgia Pacific Corp., 14750 Nelson Ave., City of Industry, CA 91744. Denscal plasters.

Harbison-Walker Refractories Co., Pittsburgh, PA 15222; 6444 Fleet St., Los Angeles, CA 90022. Refractory cements and bricks.

Independent Foundry Supply Co., 6463 Canning St., Los Angeles, CA 90040. Foundry equipment and supplies.

International Foundry Supply Inc., 400 Orrton Ave., Reading, PA 19603. Foundry equipment and supplies.

J. F. McCaughin Co., 2628 River Ave., Rosemead, CA 91770. Wax and crimp-wire.

Ransom and Randolf Co., 2337 S. Yates Ave., Los Angeles, CA 90022; P.O. Box 905, Toledo, OH 42691. Investments and refractories.

Alexander Saunders and Co., Box 275, Cold Springs, NY 10516. Foundry equipment and supplies.

U.S. Gypsum, 300 W. Adams Blvd., Chicago, IL 60606. Metal casting plasters.

Yates Mfg. Co., 1615 W. 15th St., Chicago, IL 60608. Preformed wax bars, rods, and tubes.

BRONZE FOUNDRIES

Alden Foundry Corp., 186 N. Narragansett Ave., Riverside, RI 02915.

The Art Foundry, 611 South Palm, La Habra, CA 90631.

Belmont Metals Inc., 330 Belmont Ave., Brooklyn, NY 11207.

Bossiso Bronze Corp., Box 91456, W. Vancouver, B.C., Canada V7V3P1.

Classic Bronze Div., J.H. Matthews Co., 2230 N. Chico St., S. El Monte, CA 91733.

Colson Sculpture Casting Service, 1666 Hillview, Sarasota, FL 33579.

Dell Western Ltd., 1310 Silet Rd., Santa Fe, NM 87501.

Detroit Sculpture Foundry, 6460 Theodore St., Detroit, MI 48211.

Fondaria Bruin, Via Cessati Spiriti 32, Rome, Italy.

Fondaria Cavallari, Via degli Orti d'Alibert, Rome, Italy.

Fundidores Artisticos, S.A., Mexico, c/o Yanez Anargyros Sculpture Services, 2503 Clay St., San Francisco, CA 94119.

La Haye Bronze, 1460 Gannet St., Santa Fe Springs, CA 90670; 8707 San Leandro St., Oakland, CA 94621.

Modern Art Foundry, Inc., 18–70 41st St., Long Island City, NY 11105.

Prescott Metal Casters, 1201 N. Highway 89, Prescott, AZ 86301.

Promethean Metals, Ltd., 13009 Los Nietos Rd., Santa Fe Springs, CA 90670.

Shidoni Foundry, Inc., Box 172, Tesque, NM 87574.

The Morris Singer Foundry, Ltd., Bond Close, Basingstoke, Hants RG24 OPT, United Kingdom.

Stampinato Art Foundry, 2200 W. 6th St., Broadview, IL 60153.

Studio Foundry, 1001 Old River Rd., Cleveland, OH 44113.

Sun Foundry, 2730 E. Tenth St., Long Beach, CA 90804.

West Coast Sculptors Foundry, 1941 Pontius Ave., Los Angeles, CA 90025.

13

Sand Casting and Shell Casting

LIMITATIONS OF LOST-WAX INVESTMENT CASTING

The casting of large metal shapes that are intricate and delicate has been handled by the lost-wax investment method for many years. There are, however, several drawbacks to this method. The investment is heavy and cumbersome, and the burnout time (to rid the mold of wax which has penetrated it) is from twenty-four to over forty-eight hours. Moreover, since the investment is thick and dense, an elaborate gating system is necessary to carry off the hot gases formed when the metal is poured.

These problems are tolerable in an art foundry, where it is expected that a lot of time will be spent on each casting, but they are severe in a commercial foundry where the profit margin on each casting is narrow. Several alternative casting methods have been initiated by the casting industry, and they have been further developed by artists for the casting of sculpture.

Sand molds offer a rapid and economical casting method for simple forms, and some of the more advanced methods employing wax and Styrofoam rival the versatility of investment casting. Some sand casting methods are especially adaptable to casting with iron or aluminum.

Ceramic shell molds, originally developed by the aircraft industry for the casting of small precision parts, allow the freedom of using wax originals, but offer much shorter burnout times and greater ease of handling than do plaster investments. Ceramic shell is most advantageous where a considerable number of castings are to be made over a period of time.

GREEN SAND MOLDS

For centuries simple shapes such as bells, wheels, cauldrons, and cannon barrels have been cast by pouring metal into a hollow cavity formed in sand by packing the sand around a wood replica, or *pattern,* of the shape to be cast. In order to remove the pattern before casting, the mold is separated into an upper and a lower half, the *cope* and the *drag.*

To begin making a sand mold the pattern is embedded in a flat plane of sand and dusted with a parting agent (talc or graphite). A box or *flask* is set over it to receive the sand, which is *riddled* (sifted) over the pattern and then rammed solid with a wood or metal bar. To adapt this operation to serial production, half of the pattern is glued to a flat board or

match plate, eliminating the necessity of preparing a sand bed each time. When the sand is thoroughly rammed it becomes hard and coherent, so that the mold may be lifted and turned over without the sand falling out. The sand used is basically fine silica sand mixed with 10 to 20 percent clay. When the moisture content of this *green sand* is just right for molding, it can be squeezed in the hand to a lump that will retain its form and the details of the skin when the hand is opened. When the test lump is broken between the fingers it should separate in the middle with a clean fracture.

When the bottom half of the mold has been rammed it is *struck,* or skimmed off level, with a flat blade of metal. Then the mold is turned over and dusted with parting agent, and the flask for the top half of the mold is set in place, rammed, and struck in the same way as the bottom half. The two halves of the mold may now be separated and the sprue and riser cut with a mold knife. Since green sand is porous enough to allow gases to escape through it, the gating system can be very simple. Usually a sprue at one end and a riser at the other is sufficient. The mold is now reassembled, the upper and lower flasks clamped together, and it is set for pouring on the foundry floor, in the sand pit, or on a conveyor belt. After pouring comes the *shake-out,* the freeing of the casting from the mold. The sand can be used again after it has been reconditioned. Sometimes the used sand, called "black" or "floor" sand, is used for *backup* (filling in around the fresh sand used for facing sand next to the pattern). The facing sand may also be finer than the backup sand if a smooth surface is required on the casting.

The green sand method is employed today in the casting of iron and bronze gears, iron pipe and fittings, brass valve bodies, iron street gratings, and other essentially bisymmetrical shapes. Sculptural shapes may also be cast by the green sand method, if they are simple and bisymmetrical. If there are undercuts or projecting forms, the mold must be divided into smaller parts so that the mold can be separated to remove the pattern. The green sand mold gets cumbersome if more than a few parts are needed.

To cast a hollow shape a sand core must be made to occupy the space inside the mold, leaving a space around it equal to thickness of the metal. In industry the core is rammed up in a mold called a *core box.* For one-off molds a core may be cast in the main mold and then shaved down to provide clearance for the metal. Though it is possible to make the core of regular green sand, it is usually made of silica sand with a linseed oil binder, then baked in an oven to harden and dry it. This produces a core that is drier, tougher, and more porous than a green sand core.

Plate 13.1. Steven Urry, *Psychedilly Rose,* cast and welded aluminum, 10′6″ × 8′2″ × 14′2″, 1967. Courtesy of the Royal Marks Gallery, New York. Here we see casting used in an unusual way, to create linear rather than volumetric forms. The artist capitalizes on the ability of casting to make shapes that are flowing and organic.

The core is then positioned in the mold by small metal spacers or *chaplets*. Sometimes wood flour is incorporated into the core mix, so that the core will break down more easily for removal after firing.

As oil-bonded core sand is easier to handle and to join than green sand, some sculptors, notably Julius Schmidt, have used it to make piece molds for large and complex works. Discussed below are several other ways of using sands and bonding agents which offer the sculptor more freedom than the traditional green sand method. To make the most of these methods it is necessary to have a working knowledge of the nature of sands and binders.

SANDS

Sands are roughly defined as mineral granules ranging from one-thousandth to one-fourth of an inch.

Plate 13.2. Sand cast ship's propeller, nickel steel, 10′ diameter. Photo by the author at Mark di Suvero Sculpture Yard.

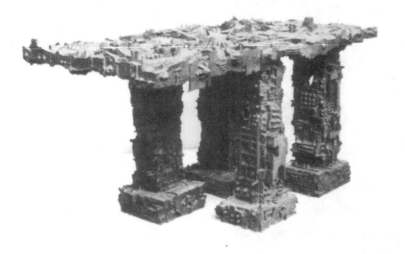

Plate 13.3. Julius Schmidt, *Untitled*, cast iron, 18½″ × 38½″, 1961. Collection of Don Boyd, Brookings, South Dakota. Small sections of prebaked core sand are individually carved and glued together with foundry cement to build the mold for this cast iron sculpture. The mold is broken away when the iron has solidified.

Plate 13.4. Julius Schmidt, *Laminated Wood Maquettes* (for the 1971 bronze), Julius Schmidt Studio, Iowa City, 1971. Laminated wood patterns for 1971 bronze Iowa cylinder series. Each was cut from a single block of laminated pine, using a large band saw. Fine sand with a no-bake binder was used to make piece molds with sand cores.

Plate 13.5. Julius Schmidt, *Iowa Cylinder Series*, cast bronze, 20⅛″ diameter × 15½″ long, 1971. Collection of the artist, Iowa City. The finished sculpture. The precision of the wood patterns shown in the preceding illustration allows a close, sliding fit between the parts.

Above this size there is gravel, and below it, powder. Most sands are composed of mixtures of silicates; the most common is quartz or silica (SiO_2). Silica sand, the sand most commonly used in foundries, is composed of grains of relatively pure silica, free of impurities and organic materials. Silica can be colored, especially by iron oxides, which make it brown. Clean, uncolored silica sand seen in a mass is white and sparkling.

Two other sands used in the foundry are zircon sand and olivine sand. Zircon is zirconium silicate. Olivine is composed of a series of mixed crystals of magnesium silicate and iron silicate. Both of these sands are highly refractory and resistant to thermal shock. They are mixed with silica sands to make molding sands for high-temperature casting (as for stainless steel), and they are used in high-temperature firebrick for furnaces.

Sands can be either natural or synthetic. Natural sands have certain useful properties just as they are found in dunes, river banks, or on the shores of lakes. They may be 99 percent silica, like Ottawa sand from Illinois, or they may be mixed with clay, as is Albany sand from New York. Synthetic sands are prepared by washing and grading natural sands, or by crushing rock. Pulverized ceramic materials

like grog and brick dust are used as mold ingredients, as are glass spheres and granules.

The particle size of sand is determined by sifting it through a series of wire sieves graduated according to the number of meshes per inch. The American Foundrymen's Society has set standards that determine what proportion of a sand should be retained on each sieve in order to classify it as a sand of a certain grit number. The building trades also have their standards. Natural sands will vary in their distribution of grits. Sand from the dunes of Oceano, California, for instance, is a closely graded sand, whereas sand from Pittsburg, California, has a wide distribution of particle sizes.

Number 30 silica sand is a common building grade used in brick mortar and wall plaster. It is used in the foundry for sand pits and coarse molding. Number 100 is like average beach sand in texture. Most foundry work is done with sand of 100 to 200 grit.

Another characteristic of sand is its angularity. Freshly formed sand has sharp angular corners, whereas sand that has been tumbled and moved a great deal, like beach sand, has rounded edges. Angular sand is stronger when rammed, but smooth sand flows more easily around projections and into

Plate 13.6a. California brown river sand (magnification 10X) is a mixed sand containing a range of particle sizes. Note how some of the grains are more worn and rounded than others.

Plate 13.6b. #30 white silica sand (magnification 10X) has a uniformity of particle size, structure, and color.

details. Ideally a good foundry should have a balance of these types of sand.

BINDERS AND THEIR USES

Clay. Either kaolin or bentonite clay (see chapter two) is used as the binder for green sand molds. The amount of clay that can be used is limited to 10 to 20 percent because of shrinkage and the need to keep the mold porous.

A type of clay-bonded sand used for detailed castings is "French" sand. Originally found at Fon- tenay des Roses near Paris, this sand is duplicated by several companies in the United States and Europe. It is an angular sand with a gradation of grit sizes with excellent fit, or interlocking of particles with one another, producing a strong but fine sand. It is used commercially for casting lettering and memorial plaques.

Cement. High-early-strength Portland cement (see chapter five) can be used as a mold binder mixed 1 to 10 with #40 or #60 silica sand and not more than 5 percent water (barely damp). The batch should be very thoroughly mixed and firmly rammed.

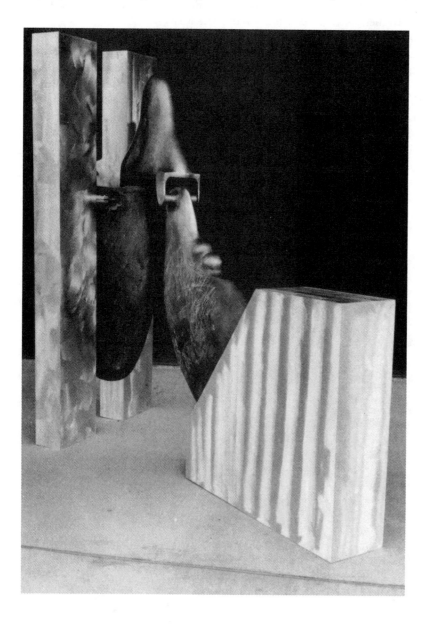

Plate 13.7. Stephen Daly, *Arch Piece*, cast manganese bronze and fabricated aluminum, 7′ × 9′ × 4′6″, 1973. Courtesy of Stephen Daly, collection of the artist. The rectangular elements are fabricated from aluminum sheet and slabs. The center section is cast in manganese bronze from a piece mold of sand compounded with Ashland Lino-Cure self-set binder.

Because of its strength it is good for large molds. It is advisable to add 5 to 10 percent wood flour to increase porosity and collapsibility.

Linseed oil. As mentioned above, linseed oil is used as the binder in making cores for green sand molds. When the core is baked at 300°F for one to six hours, the linseed oil turns to varnish. Care must be taken not to overheat, as linseed oil starts to break down at 400°F. This temperature range means that an unfaced linseed oil-bonded sand would not be suitable for a wax pattern mold, as the wax would seep into the sand during meltout, and require more than 300°F to burn it out. A baked linseed oil mold could, however, be used with a Styrofoam pattern.

Another method of working with core sand is to carve individual blocks after they have been baked, cementing the blocks together with core cement (lacquer and silica flour) to form the mold for pouring. The mold is encased in a flask or box and sand is rammed up around the mold as reinforcement. In this method there is no pattern at all, as all shaping is done by carving the mold directly.

In 1966 a catalyst for hardening linseed oil became available from the Baker Products Company of Chicago. In the Quick-Cure system #60 silica sand, 2 percent by weight of Jordan or other plastic clay, and 2 percent red iron oxide (for hot strength) are mixed together with the required amount of linseed oil binder. A muller, bread mixer, or cement mixer with modified blades may be used. When the basic ingredients have been thoroughly mixed for several minutes, the catalyst is added and mixed. The pattern is then rammed up in a wood or metal flask; working time is about twenty minutes.

A Quick-Cure mold can be used like an investment over a wax pattern if the pattern is first faced with Ceramol, a zircon-alcohol facing manufactured by Foseco Incorporated. The Ceramol prevents the wax from penetrating the mold and imparts a smooth surface to the casting.

After the mold has cured overnight it can be poured, or, if it contains a wax pattern, melted out like an investment, except that the procedure will be a melt-out (300°F for six to twelve hours) rather than a burnout (900°F–1100°F for twenty-four to forty-eight hours). These molds can be used for iron as well as for bronze and aluminum.

Resins. Furfuryl alcohol resins and combination furfuryl alcohol-urea formaldehyde resins are widely used as binders for sands. They are catalyzed by acetic or phosphoric acid. These binders are commercially called *furan* binders. There are also commercial binders based on urea and phenolic resins and their combinations. See chapter eight for a discussion of resins and how they set by polymerization. These resin binders are all mixed and handled much as has been described for the Quick-Cure process. In all binder-catalyst preparations the catalyst must *never* be mixed directly with the binder or a violent reaction may occur. Always mix the binder with the sand first, then add the catalyst. Precautions should be taken to avoid skin contact with acid catalysts as they are quite caustic.

Resin-bonded sands make tough molds that can withstand the stress of iron casting. When casting with bronze and aluminum, less resin is used to make the mold easier to remove. Ceramol facing coat can be used on resin-bound molds.

Petroleum. Foundry sand can be prepared with oil so that it behaves much like a moisturized green sand. It can be rammed up in a flask, and it can be reused by riddling between casts. After a number of cycles it can be refreshed by adding more oil and other additives. The advantage is that there is no moisture in the sand to expand when the hot metal enters the mold.

Sand for oil-base molds is typically prepared by mulling #130 silica sand with 2 percent by weight of red iron oxide and 2 percent bentonite clay. Then the oil is added with a small amount of alcohol catalyst in the proportions recommended by the manufacturer.

The Baroid Chemical Company has developed an oil binder preparation named Petro Bond which is used with fine pure sand (no clay) to give an exceptionally sharp, smooth casting with very exact tolerances. A typical Petro Bond mix is:

100 lbs. #180 pure silica sand
5 lbs. Petro Bond
2 lbs. Citgo Oil NR. 90101
1 oz. P-1 catalyst

This mixture is said to be reusable for many cycles, and is then capable of being restored with one pound of Petro Bond and one-half ounce of the catalyst.

The oil in these sands smokes somewhat when they are poured and they are usually used with bronze and aluminum. They are not suitable for use with wax patterns but can be used with Styrofoam.

The CO_2 process. This method produces a tough mold very quickly and economically. The mold will withstand temperatures up to 600°F so it can be used mostly with Styrofoam and wood patterns, but it can be used for lost wax with a low-temperature dewaxing. The CO_2 process is also useful for making cores.

The binder is sodium silicate, or water glass. It is mixed with dry (no clay) silica sand #60 to #120 grit, in a proportion of 3 to 4 percent by weight. The sodium silicate preparations sold by foundry supply houses are the correct consistency and contain a small amount of sugar to aid in sand collapsibility after casting. The ingredients are mixed in a muller

and rammed into the flask in the usual way, then the unique operation of this system, gassing, takes place. A bottle of compressed CO_2 gas is connected by a flexible hose to a rubber cup, which is pressed against the surface of the mold to force the CO_2 gas through the sand, hardening it in ten to thirty seconds. For deep molds a hollow needle may be used to inject the CO_2 into the sand. One ingenious method for large molds is to embed perforated steel pipes in the sand to distribute the CO_2 gas. The pipes reinforce the mold and also act as vents for escaping gases during the pouring operation.

The CO_2 method is used mostly for aluminum and bronze but it can also be used for iron. By

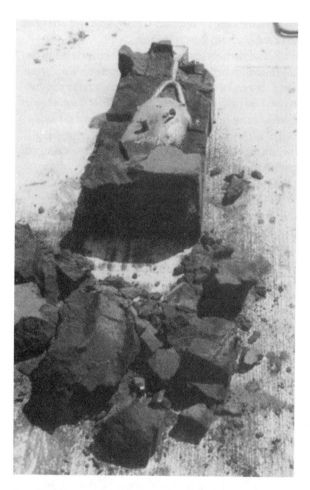

Plate 13.8. Iron casting in Lino-Cure-bonded sand mold. Courtesy of Ken Ryden, Greenville College, Illinois. Photo by the author at the Tenth International Sculpture Conference, Toronto, Canada, 1978. The mold separates in large chunks after the iron solidifies.

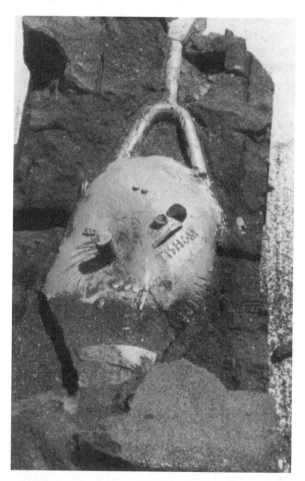

Plate 13.9. Iron casting in Lino-Cure-bonded sand mold, detail. Courtesy of Ken Ryden, Greenville College, Illinois. Photo by the author at the Tenth International Sculpture Conference, Toronto, Canada, 1978. Note the accurate detailing and absence of casting flaws.

mixing silica flour with the sand, very smooth castings and fine textures can be obtained with the CO_2 method.

Additives. In addition to the binders described above, several other ingredients are often added to sands to improve their casting qualities. Wood flour has already been mentioned as an additive that gives porosity to the mold and aids in breaking down the sand after the metal has been poured. Wood flour also creates a slight reducing action as it burns, guarding the surface of the metal from oxidation. Bituminous sea coal produces the same effects when mixed with molding sand as do corn flour or starch. Cereal flours also contribute green (prebaked) strength to the mold.

Red iron oxide is added in small amounts of 2 to 5 percent to foundry sand, to give it hot strength and resistance to metal penetration.

CERAMIC SHELL CASTING.

The need for precise, high-temperature molds in the aircraft and space industries has brought about the development of binders and silica granules that are so strong and refractory that the thickness of an investment for lost wax can be reduced to a shell one-quarter to one-half inch thick. These shell molds can be inserted cold into a furnace preheated to 1000°F and burned out in twenty minutes at temperatures up to 2000°F. They may be recovered from the furnace while still red hot and poured immediately with any castable metal from aluminum to stainless steel.

The silica of which the shell is composed is fused by the high burnout heat and becomes a hard, brittle, strong ceramic. It is slightly porous, permitting gas escape while pouring and eliminating the need for a complex gating system. After casting, the mold can be shattered with a few blows of a hammer, and the residue eliminated by sandblasting or glass bead blasting.

Ceramic shell is a great improvement over plaster investment in terms of time from wax to metal. The differences in cost between the two processes depend on many variables, since both ceramic shell and plaster investment casting can be made more economical by substituting common materials for expensive ones. Ceramic shell materials take up less space than investment materials, and cleanup of casting refuse is greatly simplified.

The weakness of the shell when it is green, however, limits the size of shell casts to pieces about three feet high. Furthermore, shell casting is much better suited to continuous production than it is to single works separated by intervals longer than a few days. This is because the silica slurry binder must be constantly stirred, or it settles to a hard mass.

The one ingredient for which there is no cheap substitute in shell casting is the binder. There are

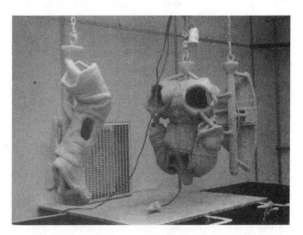

Plate 13.10. Two large shell molds drying. Photo courtesy of Johnson Atelier, Princeton, New Jersey. Each mold is suspended from a hoist, which allows a minimum amount of handling during stuccoing and rotating in front of the drying fan.

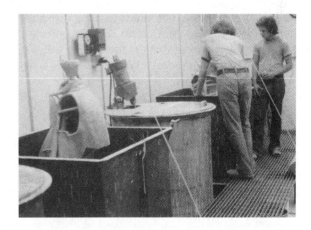

Plate 13.11. Shell casting equipment. Photo courtesy of Johnson Atelier, Princeton, New Jersey. A well-organized facility for applying shell investment to wax patterns. In the foreground a shell mold is suspended over a fluidizing bed for applying stucco grains. At center a mixer controlled by a timer mixes the slurry vat.

two general types, a water solution of colloidal silica and a hydrolyzed ethyl silicate. The Nalco Chemical Company is the principal producer of the first and the Avnet Shaw Company of the second. Alternate shell casting materials are offered by several firms listed at the end of this chapter. A complete process using Avnet Shaw materials exclusively is licensed as "The Shaw Process."

The Nalco process is typical of the others, and capable of modification to suit individual needs. It will be described here as it applies to artists, not as it is practiced in industry.

The slurry is composed of Nalcoag 1030 colloidal silica mixed with Nalcast P-1 W fused silica flour in the proportion thirty parts binder to seventy parts silica flour. This fused silica has been melted, re-solidified, ground up, and screened to a very exact proportion of particle sizes. When used in shell casting, the granular type of silica is called *stucco*. Unlike natural silica sand, it has a very low coefficient of thermal expansion. The slurry of binder and silica flour is mixed with water in a stainless steel bucket or tank. A galvanized tank must not be used, as it will affect the properties of the slurry; nor should a flexible plastic container be used, as it will cause lumps of solidified slurry to drop off the sides into the mix. A mild-steel tank can be used if it is thoroughly coated with epoxy or urethane.

For every hundred pounds of slurry, one teaspoonful of Ultrawet 60-L or Fulsol wetting agent should be added. While mixing slowly with a portable mixer, water should be added to bring the slurry to the consistency of thick cream. The slurry must be constantly stirred so that the fused silica will remain suspended in the mix. General practice is to use an electric timer so that the mixer runs for two minutes out of every fifteen. See figures 3.1, 3.2, and 3.3 for mixing devices.

To measure viscosity accurately, a Zahn cup is used, a standardized cup with a hole in the bottom, through which the flow of slurry is timed. Manufacturers usually include Zahn cup measurements in the directions for use of their shell casting preparations.

The following formulas for slurry are used by the Johnson Atelier Technical Institute of Sculpture in Princeton, New Jersey.

For primary coat:
 85 lbs. Ludox SM (binder)
 100 lbs. 325 mesh zircon flour
 100 lbs. 325 mesh silica flour
 2 gals. distilled water
 0.5% Victawet (wetting agent)
 Viscosity: 30–35 sec. on #4 Zahn cup, using a 90 gal. cylindrical primary slurry tank, 30″ wide and 30″ high; this formula makes approximately 30 gals. of slurry.
Backup coats:
 80 lbs. Ludox SM (binder)
 200 lbs. 120 mesh silica flour
 30 lbs. distilled water
 Viscosity: 10–15 sec. on #4 Zahn cup.

The wax pattern for shell casting is usually top-gated, rather than bottom-gated as for investment casting. The gating can be much simpler because of the porosity of the shell walls. As rapid wax evacuation is desirable, however, risers should be ample. Thick bars on the sculpture or in the gating system should be made of hollow wax tubes, so that wax expansion will not crack the shell. A Styrofoam cup is often used to form the pouring cup. In industrial foundries a very strong, hard wax is used for shell casting to provide strength while the shell is green.

Many sculptors make cores for shell molds by cutting holes in the hollow wax to allow the slurry to pour into the inside of the mold. The access holes should be large enough to allow drying and the application of stucco coats to the inside surfaces. Hatch covers the size of the holes can be cast along with the sculpture, to be welded over the holes later.

Some sculptors prefer to pour a solid core into the wax before building up the shell. One solid core mix among many, this is also from the Johnson Atelier:

20 parts Refractomix
 2 parts Ransome & Randolf #903 investment, or plaster
 1 part Silica Sol binder
 3 parts water
Mix Silica Sol binder with water, add Refractomix, then R & R #903 or plaster. At this point there are four minutes until gel time. Pour in core and gently shake to remove air bubbles. Undercuts should be vented to allow air escape. When core is set, apply shell.

Before the slurry coat is applied, the wax must be dipped in alcohol to degrease it, or sprayed with

Johnson's Glo-Coat wax. This is essential to ensure even coating with the slurry.

The slurry may be applied by dipping, brushing, pouring, or spraying. Small pieces are easily dipped, but larger pieces may flex when handled and crack the shell. If a spray gun is used, it must be capable of handling the creamy consistency of the slurry. If the slurry does not coat the pattern evenly and completely, it is not of the right consistency, or else the pattern is not clean.

Immediately after the pattern has been coated with the slurry, it is sprayed or sprinkled with a coating of granular fused silica. The Nalco product, Nalcast S-1, contains graduated particle sizes from #50 to #200, and has an AFS particle size classification of #80. Nalcast S-2 contains particles from #20

to #70 and is classified #40. Most sculptors use the coarser Nalcast S-2 for the first two coats and coarse ceramic grog of #20 mesh for the following coats. If grog is used it is important that it be an air-polished grog from which the dust and finer particles have been removed. If a spray gun is used to apply the stucco coats, the S-2 fused silica can be used for all the coats.

In industrial foundries and at the Johnson Atelier, the stucco coats are applied to small molds by immersing the molds in a box filled with air-suspended grains of silica. This *fluidizing bed* assures an even coating on all surfaces of the mold.

A granulated glass stucco material called Glascast is manufactured by the Corning Glass Works. It is supplied in several grain sizes and is used in the same manner as the fused silica stucco.

As each coat dries, another coat of slurry and stucco is applied over it until the desired thickness is attained. Four or five coats will make a shell about one-quarter-inch thick, suitable for small shapes to be cast in aluminum. Larger forms and hotter metals require thicker walls, up to about one-half inch. As the shell thickens it grows heavier, and care must be taken not to crack it when handling it. Large pieces with projecting forms should be reinforced by wrapping with fiberglass cloth or stainless steel wire.

To dry the slurry between coats the mold can be placed on a turntable rotating in front of an electric fan. It is important that the temperature in the studio

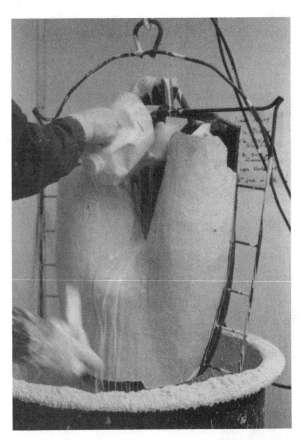

Plate 13.12. Pouring slurry over wax pattern. Photo courtesy of Johnson Atelier, Princeton, New Jersey. Perforated plastic jug distributes slurry with brush follow-up. Steel rod frame protects the pattern and provides lifting yoke. From the slurry vat, the shell mold moves to fluidizing bed for coat of stucco grains.

Plate 13.13. Shell mold with steel bars. Courtesy of West Coast Sculptor's Foundry, West Los Angeles, California. Concrete rebar forms a protective grid around this mold. Joints are wire-wrapped.

does not rise while the molds are waiting to be burned out, as this could cause the wax to expand and crack the molds.

Before the mold is burned out it is sometimes dewaxed by directing an oxyacetylene torch up inside the sprue so that the wax melts from the inside out. This allows the wax to collapse inward, avoiding expansion and mold cracking. If the wax is kept thin, and tubes rather than bars are used, the mold can be placed directly in the burnout furnace without preliminary dewaxing, other than clearing the pouring cup. When the wax is to be melted out in the furnace, small holes are sometimes drilled at the ends of the sculpture to provide escape vents for the wax. The same results can be more easily obtained by inserting small nails or toothpicks in the wax, removing them when the shell is complete. After burnout the holes are patched with slurry and dried with a torch.

The burnout furnace for ceramic shell molds should have a straight, open draft so that the atmosphere will be oxidizing. There should be a hole in the bottom so the wax may run out freely into a waiting pan of water. The idea here is not to save the wax but to get it out of the furnace as quickly as possible so it will not form a carbonizing atmosphere that will contaminate the mold with carbon. It takes a long time to burn the carbon out of a shell mold once it is allowed to penetrate. An autoclave, or steam oven, works well for shell mold dewaxing since the wax is not burned.

There must be a convenient way to put the mold into the furnace and take it out again while the furnace is hot. This can be accomplished by dropping the floor of the furnace, raising the furnace above the floor, or using a shuttle kiln arrangement. A good burnout furnace for shell casting can be made from a steel oil drum and castable refractory cement.

For the "shock" burnout used in shell casting, the furnace is preheated to around 900°F. The idea behind this is that the heat penetrates the mold so suddenly that the wax begins to melt at the mold interface before the wax has time to expand and crack the mold. There is, however, some strain on the mold as the heat strikes the wax. Preliminary dewaxing is insurance against this strain cracking the mold. When the furnace is at the proper heat, it is opened and the mold is inserted with tongs. The furnace is immediately closed, wax spurts out into the water pan, and a small amount of smoke goes out the flue. After five minutes the temperature is raised to between 1400°F and 2000°F, where it is held for about twenty minutes; then the furnace is shut off.

In the meantime the metal should be melting in the crucible and a sand bed readied. The mold may be taken directly from the furnace to the sand bed

Plate 13.14. Fan drying small shell molds. Courtesy of West Coast Sculptor's Foundry, West Los Angeles, California. Small ceramics-type turn tables would allow the molds to be rotated for even drying.

and poured immediately. It is a good idea to set the mold in a flask and pack sand or shot around it to reinforce the mold and contain any run-out that may accidentally occur.

FOAM VAPORIZATION CASTING

The fact that expanded polystyrene foam (see chapter eight for more about this material) vaporizes instantly at the temperature of molten metal makes it possible to overcome one of the main problems in sand casting: the necessity of removing the pattern before the metal is poured. The Styrofoam pattern

can be left in the mold and the metal poured right on top of it. Thus sand molds can be used to cast complicated shapes that formerly could only be cast by the lost-wax-plaster investment method.

All methods of sand casting—green sand, oil and resin bonded sand, and the CO_2 process—may be used for foam vaporization casting. Information and ingredients for foam casting are available from Full Mold Process Incorporated, which has licensed several complete systems for this method.

Styrofoam can be used as the pattern, or as part of the pattern, in shell casting and in conventional plaster investments. Since these molds must be baked

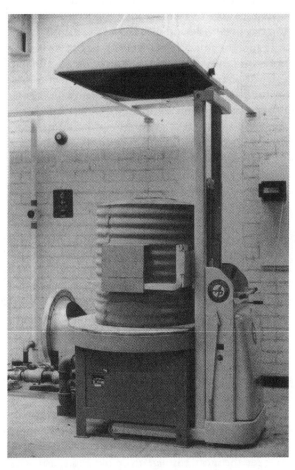

Plate 13.15a. Burnout furnace for shell casting, raised position for loading and unloading. A gas-fired black-smith's forge is converted to a shell casting furnace by placing over it a cylindrical furnace body made of a section of steel culvert lined with six inches of castable refractory. A battery-powered forklift does the lifting.

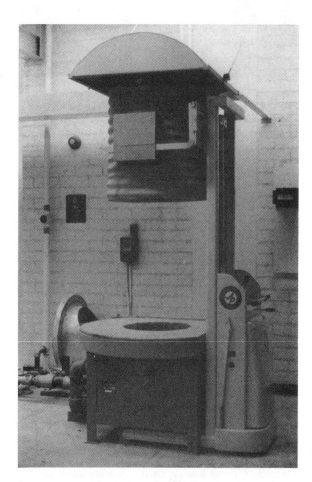

Plate 13.15b. Burnout furnace for shell casting, lowered position for firing. A hood connected to an exhaust fan is necessary to pull off the dense smoke created by the sudden combustion of the wax within the ceramic shell investment. About half the wax spurts through a hole in the floor of the forge into a receiving pan containing one-half inch of water. Burnout takes twenty minutes.

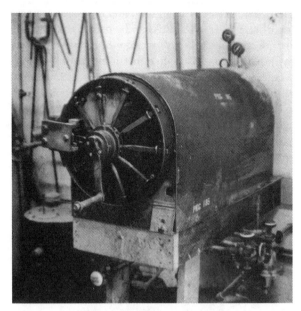

Plate 13.16. Autoclave. Courtesy of West Coast Sculptor's Foundry, West Los Angeles, California. This steam oven allows steam dewaxing without burning the wax. It is limited by oven size to small molds.

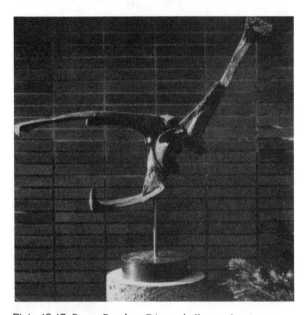

Plate 13.17. Bruce Beasley, *Dione*, shell cast aluminum from Styrofoam core, 39″ × 39″ × 22″, 1964. Courtesy of the University of California, Los Angeles, Franklin D. Murphy Sculpture Garden, gift of Anna Bing Arnold (photo credit John Swope, Los Angeles). This sculpture is a shell casting made with a Styrofoam pattern. The texture of the Styrofoam is carried over into the surface of the aluminum.

before they are cast, the foam is consumed during burnout rather than as a result of the casting itself.

One of the most intriguing developments in foam vaporization casting is the burying of foam patterns in dry sand directly in the casting pit without flasks or ramming. Large aluminum castings have been made by this method with amazing speed and economy. It appears to be particularly adaptable to large flat shapes with a minimum of coring. In England Geoffrey Clarke has executed several architectural commissions for aluminum doors and panels with dry sand and Styrofoam. Other sculptors have experimented with the inclusion of large chunks of glass in aluminum frames and lattices.

Styrofoam for a foam vaporization pattern should be in the range of 1½ to 2 pounds per cubic foot. It can be cut with a handsaw, a band saw, a heated wire tool, or an electric carving knife. Shaping is done with rasps, files, and sandpaper. Special effects can be obtained with a propane torch or by brushing acetone on the surface to partially dissolve it. Letters or shapes painted on Styrofoam with black poster paint will be heat-etched into the surface if the foam is held in front of an electric heater.

Pieces of foam may be cemented with white glue, rubber cement, or special Styrofoam glues like Theim Styro-Bond. Do not use acetone-base cements. Foam pieces may also be taped with Scotch or Mylar tape and reinforced with toothpicks. The texture of the Styrofoam may be smoothed over with a thin coat of wax, with Theim Styro-Kote, or with Mylar tape. Metal flow speed is of the essence in foam vaporization casting, however, so the less junk inside the mold the better.

Large pieces of Styrofoam may be hollowed out and packed with bonded core sand. Be sure the binder does not react with the Styrofoam. Cores must be supported by pins or chaplets. Wall thicknesses should not be too thin, as an unimpeded flow of metal is essential.

Adequate vents must be attached to the pattern to allow the escape of hot gases generated by the vaporization of the Styrofoam. Otherwise these gases will precede the metal through the mold and cause premature vaporization and sand collapse. In large molds, blind vents should be provided of a thickness capable of feeding molten metal back to the casting as it shrinks. The mold should be fed from the bottom to minimize sand erosion as the metal enters the mold. It is a good idea to use a main feeder and

pouring cup made of iron or other refractory, and to minimize washing sand into the mold. Placement of this feeder and cup should take place at the time the mold is laid out on the sand bed.

If the mold is large and flat it should be tilted slightly toward the bottom end, to aid the flow of the metal from the cup to the farthest part to be filled. Once placed, the mold is covered by simply shoveling sand over it. Difficult spots may be hand-tucked but no ramming or tamping is necessary.

Plate 13.18. Geoffrey Clarke, *Plasma Stabile*, sand cast aluminum, 10′ high, 1964. United Kingdom Atomic Energy Authority, Culham Laboratory, Abingdon, United Kingdom. A good example of the foam vaporization process for large-scale aluminum casting in sand. The three sections were cast separately, then joined. Mounted on a 16-ton Portland stone base.

Pure, dry #30 to #60 silica is used, with no binders or additives.

The aluminum pour should be smooth and continuous, slightly slower than for a conventional sand mold. Metal handling should be well rehearsed beforehand to make sure there will be no interruptions in pouring.

Due to the weight and higher pouring temperature of bronze it cannot be used in a dry sand mold composed of ordinary silica sand. Experiments are being conducted with special heavyweight zircon sands.

ALUMINUM CASTING

Aluminum is widely used as a casting metal because of its combination of lightness and strength and its good fabrication qualities. See chapters nine, ten, and eleven for methods of welding, forming, and finishing aluminum. Since aluminum is cheaper than bronze and has a lower melting temperature, it offers advantages for use in schools and for the individual sculptor working alone. Aluminum pours well in traditional investment molds, as well as in the sand and shell molds described in this chapter.

Aluminum melts between 1100°F and 1200°F depending on its alloying elements, and is poured about 200°F hotter than its melting point, with variance according to the type of mold and the thickness of the elements to be cast. As aluminum oxidizes rapidly on contact with the air, it should be melted with a cover flux, and often deoxidizing preparations are added to it just before casting. Aluminum can also be deoxidized by bubbling dry nitrogen through it with a lance. Aluminum is melted in a refractory-lined metal furnace of the same type as used for bronze. To melt large quantities of aluminum in industry a tilt-type furnace is often used. The metal is poured out of the tilt furnace into smaller ladles for distribution to the molds.

There are many alloys of aluminum, as well as several formulations of nearly pure aluminum. Not all of these aluminums are suitable for casting, as some of them have poor fluidity or tend to crack when solidifying. Others produce brittle castings and are difficult to weld. In general, if an aluminum of unknown composition is easy to weld, it will probably be suitable for casting also.

Some aluminums that are good for casting are types 43, 355, and 356, relatively pure aluminums

containing 4 to 6 percent silicon, and types 108, 113, and 319, which contain 3 to 6 percent silicon and 4 to 6 percent copper. Aluminums like 360 and 384, with 10 to 12 percent silicon, are very fluid. They are intended for die casting but some sculptors use them for dry sand casting with foam vaporization. Most high-silicon aluminums are only fair for casting and turn gray with weathering. They are good for dark anodizing but not for bright colors.

IRON CASTING

Cast iron is used today for rugged castings like street gratings, manhole covers, and frames for machinery. Its use for many items like bathtubs and plumbing fittings is declining, as steel stampings and plastic "pipe" are lighter and cheaper. Today the most advanced iron casting techniques are employed in the casting of automobile engine blocks. Around the turn of the century, those casting iron reached a high point of virtuosity. Many elegant architectural elements such as doors, columns, staircases, and even entire store fronts were cast in iron, as were many household furnishings such as stoves, fireplaces, and beds.

The availability of sand binders and the use of Styrofoam have made it possible for the artist to cast complex shapes in iron. Economical and plentiful as

iron is, a good deal of labor and cooperative help is required to work with it on any scale.

Pure iron, or *ferrite,* melts at 2700°F. However, the common gray iron used for most casting contains 2 to 5 percent carbon and 5 to 6 percent other impurities such as silicon, manganese, sulfur, and phosphorus, which act as a flux to lower the melting point to around 2000°F. Thus gray iron could be melted in an ordinary silicon carbide crucible the same way bronze is melted. This is not common practice, however, as iron is so rough and corrosive when molten that it will deteriorate a crucible in a few pours. Crucible melting in a fireclay crucible is occasionally used for special malleable irons like pearlite and nodular or spheritic irons. In these irons the carbon forms graphite flakes (pearlite) or spherical nodules which give the iron extra strength and flexibility. To maintain these characteristics the iron is melted in a vacuum or a controlled atmosphere in an electric induction furnace. The expense of this process is out of the reach of most sculptors. See chapters nine, ten, and eleven for further information on working with iron.

Iron for casting is commonly melted in a *cupola furnace,* a cylindrical metal tower lined with firebrick and refractory cement. It is loaded with coke (fuel), limestone (flux), and chunks of gray iron. These ingredients are stacked in several layers (see log for

Plate 13.19. Tio Giambruni, *Road,* cast aluminum and bronze, 27′ long × 14′ wide × 17′ high, 1967. Collection of Helen Giambruni (photo credit Joanne Leonard). An assembly of individually sand cast sections. Note the casting irregularities on the flanges.

proportions) on top of a bed of coke. It is important that the chunks of the iron and coke not be too large for the size of the cupola; otherwise insufficient heat and melting will take place. The bed is heated with a jet of gas and air through the cupola spout until it is white-hot. Once the combustion of the coke is underway, air is blown into the cupola through pipes called *tuyeres,* raising the temperature and melting the iron, which drips down into the well at the bottom of the cupola, from which it is drawn off into ladles for pouring. Once in operation, the cupola is charged continuously. Iron melting in a cupola requires experience in timing and judging temperatures since it is a self-sustaining operation.

The iron can solidify in the well, necessitating removal with a cutting torch. A log should be kept of the entire melt from starting the bed of coke to final shutdown.

After the molten iron is tapped off, the cupola may be recharged and the operation continued as long as there are molds to be poured. With each charge, additives such as molybdenum, copper, and silicon are included to improve the fluidity of the iron and also, sometimes, its metallurgical characteristics. Fluidity can be one of the problems with iron. Even at its optimum maximum pouring temperature of around 2400°F it is still quite syrupy (though with care iron can be poured as high as 2900°F). Gating of the molds should take this into account.

When the molds have been poured and the cupola shut down, it is time to "drop the bed." The bottom plate is removed so that all the remaining coke and slag will fall out of the furnace. Since the wear on the inside of the cupola is severe, it is frequently necessary to patch the inside with refractory cement. Some cupolas can be tilted to facilitate inspection and repair.

Cupolas are manufactured for use by industrial iron foundries, so even the smallest, of about a thousand pounds well capacity, may be too large for the average sculpture studio. Small cupolas down to

Plate 13.20. George H. Wyman, architect, the Bradbury Building, cast iron, glass, brick, and Belgian marble, 1893. 304 S. Broadway, Los Angeles, California. When this building was finished, it was the realization of a futuristic fantasy.

Plate 13.21. Louis Sullivan, decorative panel from the Gage Building, Chicago, cast iron, 4′3″ × 5′9″, 1899. Collection of the University of California, Los Angeles, Franklin D. Murphy Sculpture Garden, gift of Vicci Sperry (photo by the author). This 19th-century sand casting shows great finesse in the rendering of graceful linear details.

ninety pounds in size can be welded up out of steel drums and lined with firebrick and refractory cement. Silica brick is usually used, giving what is called an acid lining. In industry some furnaces are given a basic lining of dolomite bricks made of calcium and magnesium carbonate. A basic lining aids in reducing the sulfur and phosphorus content of the iron, where high quality iron is desired with minimum embrittlement.

Cupolas are measured by their working diameter at the melt zone. A given diameter will deliver a given melt rate with the proper balance of air, coke, and iron (approximately 440 cubic feet per minute per square foot of working diameter, with a ratio of seven pounds of iron for each pound of coke).

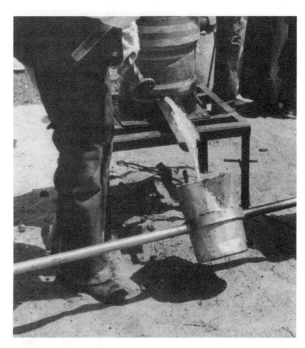

Plate 13.23. Tapping. Courtesy of Ken Ryden, Greenville College, Illinois. Photo by the author from the 1977 National Sculpture Conference, Arkansas State University, Jonesboro, Arkansas. Iron flows from the pouring spout when the "bott" or refractory plug is removed. Steel ladle is also lined with refractory.

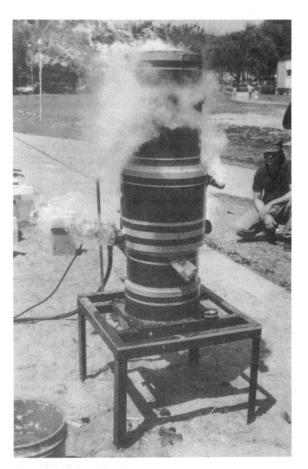

Plate 13.22. Cupola. Courtesy of Ken Ryden, Greenville College, Illinois. Photo by the author from the 1977 National Sculpture Conference, Arkansas State University, Jonesboro, Arkansas. This 8″ iron cupola was handmade from 14-gauge sheet steel and castable refractory.

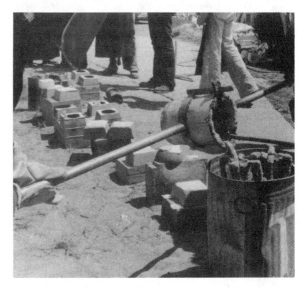

Plate 13.24. Pouring iron. In the center, pouring a shell mold in garbage can flask; at rear on ground are sand molds with resin binder.

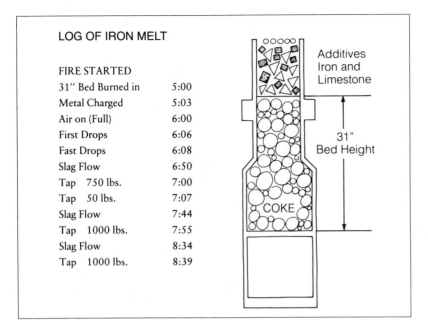

LOG OF IRON MELT

FIRE STARTED

31″ Bed Burned in	5:00
Metal Charged	5:03
Air on (Full)	6:00
First Drops	6:06
Fast Drops	6:08
Slag Flow	6:50
Tap 750 lbs.	7:00
Tap 50 lbs.	7:07
Slag Flow	7:44
Tap 1000 lbs.	7:55
Slag Flow	8:34
Tap 1000 lbs.	8:39

Figure 13.1. Log of iron melt.

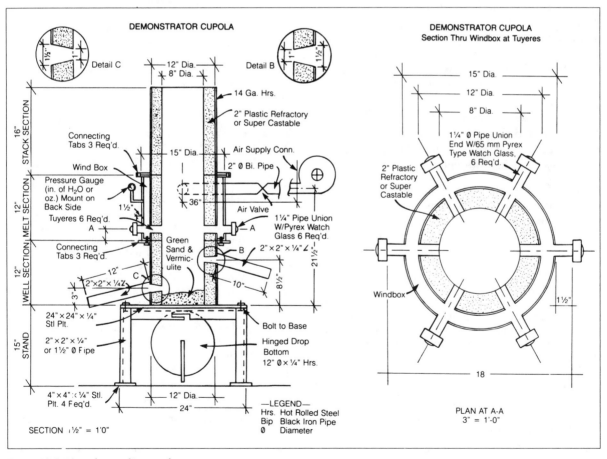

Figure 13.2 Plans for studio cupola.

Scrap iron can be used to load the cupola if it is broken up into chunks. Although there is a variation of consistency in irons from different types of objects, it is not enough to seriously affect the quality of the iron for most art casting purposes. An Arcair torch (see chapter eleven) is a good tool for cutting up large sections of iron. A sledge hammer will break up smaller castings. Iron ingots, of course, can be obtained from a supply house or steel mill.

SAFETY

The general precautions to be taken when working in the foundry are discussed in the previous chapter on investment casting. In all types of casting activity you must take measures to protect yourself from heat and fumes. When finishing castings by chasing, grinding, and polishing, proper protection for the eyes, face, and hands must be used as described in chapter ten.

The greatest hidden danger in the foundry is silicosis. Most common sands, unless they have been specially graded or washed, contain quantities of fine silica dust. This dust remains floating in the air for long periods after shaking out molds or shoveling sand. When the silica dust particles enter the respiratory tract, they are not screened out like most dust particles, but enter the finest recesses of the lungs where scar tissue is formed around them. This scar tissue keeps growing even when the affected person is no longer exposed to silica dust. There is no cure for silicosis. The best precautions are:

1. Knowledge of the effects of silicosis.
2. Adequate ventilation systems.
3. Available respirators.
4. Design of studio so silica dust is confined to certain areas.

BIBLIOGRAPHY

Books on casting procedures in general will be found at the end of chapter seven. Listed here are books, manuals, and articles with specific information on sand casting and shell casting.

A. Books and Manuals

American Foundrymen's Society. *Principles of Production Metallurgy for Ferrous Castings*. In *Basic Metallurgy, vol.1*. Reading, Mass.: Addison-Wesley, 1970.

American Foundrymen's Society Training and Research Institute. *Volume I: Basic Principles of Gating; Volume II: Basic Principles of Risering*. Reading, Mass.: Addison-Wesley, 1967 and 1968.

Clarke, Geoffrey, and Stroud Cornock. *A Sculptor's Manual*. New York: Reinhold, 1968. Contains a section on foam-vaporization casting.

Corning Glass Company. *Glasscast: Precision Shell Molds Made by the Lost Wax Process*. Bul. GC-3. Corning, N.Y.: Corning Glass Works, 1957.

Harbison-Walker Refractories Company. *Modern Refractory Practice*. 4th ed. Pittsburgh: Harbison-Walker Refractories Co., 1961.

Jenni, Clyde B. *Principles of Physical Metallurgy for Ferrous Castings*. In *Basic Metallurgy, vol. 1*. Reading, Mass.: Addison-Wesley, 1968.

Johnson Atelier Technical Institute of Sculpture, 743 Alexander Road, Princeton, NJ 08540. Information bulletins and slide series on shell casting and other sculpture techniques.

Nalco Chemical Company. *Investment Castings with Nalcoag Colloidal Silica, and Nalcast Fused Silica*. Chicago: Nalco Chemical Co., 1969.

Pekay Machine and Engine Company. *Sand Conditioning System Brochure*. Chicago: Pekay Machine and Engine Co., 1970.

Reynolds Metals Company. *Casting Aluminum*. Richmond, Va.: Reynolds Metals Co., 1965.

B. Articles in the Proceedings of the National and International Sculpture Conferences at the University of Kansas

Eight of these conferences were held at the University of Kansas from 1960 through 1974. The ninth took place in New Orleans in 1976, and the tenth in Toronto, Canada, in 1978. A great deal of information on casting is contained in the published *Proceedings,* particularly those from 1960 to 1968. The conferences in 1968 and 1970 dealt with plastics and other materials as well as with casting. The 1972 conference focused mainly on glass, but concerned itself also with environmental questions. The theme of the 1976 conference was monumental sculpture. Ten articles dealing with sand and shell casting are listed here. The Proceedings of the conferences are referred to below as K-60 through K-76. The Proceedings may be obtained through the International Sculpture Center, University of Kansas, Lawrence, Kansas 66045.

Schmidt, Julius, Jules Struppek, Paul Suttman, and Bernard Frazier. "Experimental Casting Panel" (CO_2 and core sand), K-60, 49.

Spangler, Robert N. "The Petro Bond Story," K-62, 28.

Gadbury, Howard M. "Unconventional and Experimental Casting" (foam vaporization), K-64, 63.

Schnier, Jacques. "Ceramic Shell Moulding for Sculpture Casting," K-64, 1.

Sigerfoos, Charles. "Consultation Session" (CO_2 and oil bonds), K-64, 43.

Clarke, Geoffrey. "The Foam-Vaporization Process," K-66, 97.

Haskin, Don. "Ceramic Shell for Sculpture Casting Demonstration," K-66, 43.

Colson, Frank A., and Thomas Walsh. "Problems in Ceramic Shell," K-68, 78.

Daly, Stephen. "The Melt-Out Process" (Quick-Cure and Ceramol), K-68, 68.

Van Tongeren, Herr. "Ceramic Shell Techniques," K-76, 233.

EQUIPMENT AND MATERIALS

General equipment and supplies are listed at the end of chapter twelve. Items listed here are specifically for sand and shell casting.

A. Equipment

Adams Co., Box 268, Dubuque, IA 52001. Wood and aluminum flasks.

Admar Specialty Machines, Ltd., Box 550, Maple, Ontario, Canada. Sand mullers and mixing equipment.

Alnor Instruments Co., 420 N. LaSalle St., Chicago, IL 60610. Pyrometers.

American Air Filter Co., 215 Central Ave., Louisville, KY 40208. Dust collectors.

American Standard, Industrial Products Dept., 8111 Tireman Rd., Detroit, MI 48232. Dust collectors.

Beardsley and Piper, Div. Pettibone Corp., 5501 W. Grand Ave., Chicago, IL 60639. Sand mullers.

Bell, M. A. Co., 217 Lombard St., St. Louis, MO 63102. Cupolas, foundry equipment.

Biggs-United Co., 1007 Bank St., Akron, OH 44305. Autoclaves for steam dewaxing.

Clearfield Machine Co., Third and Everett Sts., Clearfield, PA 16830. Sand mullers.

Fernholtz Machinery Co., 8468 Melrose Pl., Los Angeles, CA 90069. Sand mullers and mixing equipment.

Foundry Systems and Supply, Inc., 3400 Peachtree Rd., N.E., Atlanta, GA 30326. Foundry equipment and planning supplies.

Independent Foundry Supply Co., 6463 Canning St., Los Angeles, CA 90040. Foundry equipment and supplies.

International Foundry Supply, Inc., 400 Orrton Ave., Reading, PA 19603. Foundry equipment and supplies.

Minarik Electric Co., 224 E. Third St., Los Angeles, CA 90013. Timing devices for mixers and electric motors.

Mixing Equipment Co., 216 Mt. Read Blvd., Rochester, NY 14603. Lightnin portable mixers for slurries, investments, etc.

Saunders, Alexander, and Co., Box 265, Cold Springs, NY 10516. Induction furnaces, fluidizing beds, foundry equipment of all kinds.

Whiting Corp. 157th and Lathrop, Harvey, IL 60426. Cupolas.

B. Materials

Aluminum Casting

The following manufacturers of aluminum casting ingots have representatives in most major cities in the United States. They can supply brochures listing the properties of different types of aluminum.

Aluminum Co. of America (ALCOA), 1501 Alcoa Bldg., Pittsburgh, PA 15219.

American Smelting and Refining Co. (ASARCO), 120 Broadway, New York, NY 10005.

Apex Smelting Co., Div. American Metal Climax, Inc., 2537 W. Taylor St., Chicago, IL 60612; 2211 E. Carson St., Long Beach, CA 90801.

Harvey Aluminum, 19200 S. Western Ave., Torrance, CA 90509.

Olin Metals, Division Olin Mathieson Chemical Corp., 400 Park Ave., New York, NY 10022.

Reynolds Metals Co., Box 2346, Richmond, VA 23218.

Iron Casting

Associated Metals and Minerals Co., 733 Third Ave., New York, NY 10017. Ferro-additives.

Bell, M. A., Co., 217 Lombard St., St. Louis, MO 63102. Fluxes and ferro-additives.

Miller and Co., 332 S. Michigan Ave., Chicago, IL 60604; 282 Covina Ave., Long Beach, CA 90803. Pig iron, coke, iron foundry supplies.

Woodward Iron Co., 2151 Highland Ave., Birmingham, AL 35205. Pig iron, coke, iron foundry supplies.

Foam-Vaporization Casting

See chapter eight for distributors of Styrofoam board, foaming agents, cements, and cutting tools.

Full Mold Process, Inc., 27224 Southfield Rd., Lathrop Village, MI 48075. A patented foam-vaporization process.

Mystic Tape, Division Borden Inc., 1700 Winnetka Ave., Northfield, IL 60093. Mylar tape.

Ottawa Silica Co., Boyce Memorial Dr., Ottawa, IL 61350; Crystal Silica Co., Box 1280, Oceanside, CA 92054. Pure silica sand.

Thiem Products, Inc., 9800 W. Rogers St., Milwaukee, WI 53227. Styro-Bond, Styro-Fill, and Styro-Kote for Styrofoam casting patterns.

Wilson Paper Co., 4200 S. Alameda St., Los Angeles, CA 90054. Mylar tape.

Sand Casting

Acme Resin Co., 1401 S. Circle Ave., Forest Park, IL 60130. Furan and CO_2 binders.

Aristo International, 6000 E. Davidson Rd., Detroit, MI 48212. Binders, oils, catalysts.

Ashland Chemical Co., Foundry Products Div., 2191 W. 110th St., Cleveland OH 44102. Alkyd resins, sea coal, bentonite, core paste, oil binders, etc.

Baker Products Co., Core Oils Div., 10236 S. Forest St., Chicago, IL 60628. Quick-Cure binder.

Baroid Chemicals, Inc., 1512 South Coast Bldg., Houston, TX 77033. Petro Bond.

Brumley Donaldson Co., 3050 E. Slauson Ave., Huntington Park, CA 90255. Foundry supplies.

Carpenter Bros., Inc., 606 W. Wisconsin Ave., Milwaukee, WI 53203. Sand and CO_2 binders.

Foseco Inc., Box 8728, Cleveland, OH 44135. Fluxes and coatings, Ceramol mold facing, CO_2 binders.

Foundry Systems and Supply Co., 3400 Peachtree Rd., N.E., Atlanta, GA 30326. Resin, oil, and CO_2 binders, sand, bentonite, and other supplies.

Independent Foundry Supply Co., 6463 Canning St., Los Angeles, CA 90040. Foundry supplies.

International Foundry Supply, Inc., 400 Orrton Ave., Reading, PA 19603. Resin, oil, and CO_2 binders, sand, bentonite, and other supplies.

J.F. McCaughin Co., 2628 N. River Ave., Rosemead, CA 91770. Wax, crimp wire, foundry supplies.

New York Sand and Facing Co., 106 Brand Ave., Brooklyn, NY 11205. Silica and zircon sands.

Northwest International Co., 5515 Fourth Ave., South Seattle, WA 98108. Olivine sand.

Ottawa Silica Co., Box 577, Ottawa, IL 61350 and Crystal Silica Co., Box 1280, Oceanside, CA 92054. Silica sand.

Saunders, Alexander and Co., Box 265, Cold Springs, NY 10516. Very complete and extensive line of sands, binders, additives, and other supplies.

Theim Products, Inc., 9800 W. Rogers St., Milwaukee, WI 53227. Chem Set furan binder.

Whitehead Bros., Inc., 324 W. 23rd St., New York, NY 10011. French sand.

Wolverine Foundry Supply Co., 14329 Wyoming Ave., Detroit, MI 48238. Binders, oils, supplies.

Shell Casting

Avnet-Shaw Co., 91 Commercial St., Plainview, Long Island, NY 11803. The Shaw Process, a licensed shell casting system based on an ethyl silicate binder.

Casting House Supply Co., 62 W. 47th St., New York, NY 10036. Du Pont and Ludox colloidal silica binder and zircon stucco grains.

Corning Glass Works, Corning, NY 14830. Glascast powder and stucco grains.

DuPont de Nemours, E. I., and Co., Minerals Sales Div., 1007 Market St., Wilmington, DE 19898. Colloidal silica binder.

Interpace Corp., 2901 Los Feliz Blvd., Los Angeles, CA 90039. Ione grog. Air-polished ceramic grog for stucco coating.

Nalco Chemical Co., 9165 S. Harbor Ave., Chicago, IL 60617; 4244 Santa Ana St., South Gate, CA 90280. Nalcoag colloidal silica and Nalcast fused silica powder and stucco grains.

Oil Products and Chemical Co., 9165 S. Harbor Ave., Chicago, IL 60617. Ultrawet 60-L wetting agent.

Ransom and Randolf Co., 324 Chestnut St., Toledo, OH 43601 and 2337 Yates Ave., Los Angeles, CA 90022. Ranco-Sil fused silica powder and stucco grains.

Saunders, Alexander, and Co., Box 265, Cold Spring, NY 10516. Shell casting supplies and equipment.

Yates Mfg. Co., 1615 W. 15th St., Chicago, IL 60608. Hollow wax bars and tubes.

14

New Forms

THE FOUND OBJECT

In 1912, Pablo Picasso glued a small piece of rope onto the canvas he was painting. He must have liked the juxtaposition of an object from the real world with the forms he had painted, for during the next few years, he attached many different kinds of small objects and pieces of newspaper and wallpaper to his canvases. One of the expressed aims of cubism was to break the illusion that the picture plane is a window into an imaginary scene. The fragments of the real world attached to Picasso's paintings made instant reference to the materiality of paint and canvas.

The "collage" (from the French *coller*—to glue) was quickly adopted by Picasso's friends Georges Braque and Juan Gris, who, with Picasso, developed the early stages of cubism. In Germany, the dadaist Kurt Schwitters began using pieces of newspaper and magazine illustrations in his collages as early as 1919.

When Picasso turned to sculpture, he continued to juxtapose found objects, leaving parts of the objects showing through. Sometimes he would paint over the whole with oil paint, making marks and descriptive lines, just as he would paint on canvas. After about 1925 Picasso stopped fastening things to his canvases, but all his life he continued to make sculptures in which objects reinforced the ambiguity and tension between what he found and what he created. Often Picasso transformed the "real-world" object he selected, so that its change suggested some other object that it resembled, sometimes with a surprising switch of scale.

The dadaists in the twenties and the surrealists in the thirties continued to explore ways of combining objects to reveal their hidden symbolism and psycho-logical overtones. Not only did this tend to sanction the use of all kinds of objects by artists as material for art, but it also tended to make people aware of the symbolic aspects of the things they were in contact with every day. In the sixties, the life that surrealism had breathed into everyday objects had a new flowering as pop art. In the thirty years between surrealism and pop, the aura of objects changed from slightly creepy and menacing to brash and exuberant.

Throughout the cubist and surrealist eras and right up to the present another influence has been at work on our appreciation of objects, the influence of Marcel Duchamp. In 1913, Duchamp inserted the

front wheel of a bicycle into a common kitchen stool and exhibited it as a work of art. In 1914, he exhibited a bottle-drying rack; in 1917, a urinal and a typewriter cover; and subsequently other objects such as a snow shovel and a casement window. The surrealists' objects were mostly exotic, such as paraphernalia from the 1890s or illustrations from scientific and medical texts, and they were used in surprising and novel contexts to suppress their everyday associations in favor of their Freudian overtones. Duchamp's objects were presented with utter simplicity and straightforwardness. His timing was perfect. The effect of Duchamp's presentation of everyday objects in the context of art was to make manifest an idea that had been trembling on the verge of the world's consciousness: that ultimately it is the artist's sensibility alone which makes a work of art, not his skill in manipulating materials. The artist may use any means at his disposal to give us an understanding we have not had before. The means that he uses to do this are irrelevant; thus *anything* may be the subject matter for art. The second point that Duchamp made was that objects are mysterious and disturbing even when they are presented as simply and straightforwardly as possible.

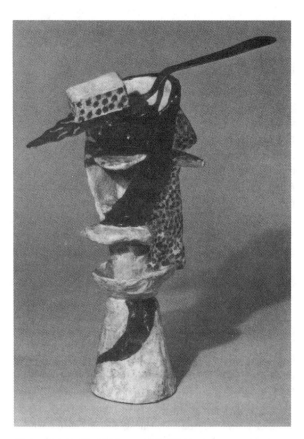

Plate 14.1. Pablo Picasso, *Glass of Absinth*, painted bronze with silver spoon, 8½″ × 6½″, 1914. Collection of the Museum of Modern Art, New York, gift of Mrs. Bertram Smith, New York. This small bronze sculpture sums up many of the questions which were to interest sculptors for years after its execution (compare Jasper Johns' ale cans, pl. 14.4). It is a cubistically rendered sculpture of a glass, surmounted by a real spoon. The glass is freely painted over in such a way that the painted contours contrast with the contours of the solid form.

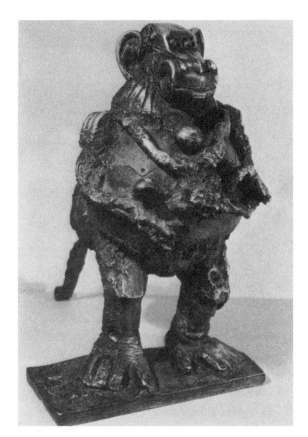

Plate 14.2. Pablo Picasso, *Baboon and Young*, bronze, 21″ high, base is 13¼″ × 6⅞″, 1951. From the collection of the Museum of Modern Art, New York, Mrs. Simon Guggenheim Fund. A beachball, an urn, and two toy automobiles are surprisingly juxtaposed in a blend of sardonic humor and artistic power which are typically Picasso's.

These two effects of Marcel Duchamp's work had a profound influence on the development of art in the twentieth century. We can see Duchamp's concepts manifest today in the use of objects by artists like Jasper Johns, Robert Rauschenberg, Robert Morris, Carl André, Arman, and many others, and in movements like pop art and conceptual art. Duchamp's ideas have also affected music (John Cage), dance (Merce Cunningham), literature (Alain Robbe-Grillet), the theater, and film.

The use of objects in sculpture has had a great deal of appeal for artists over the last fifty years.

Plate 14.4. Jasper Johns, *Painted Bronze*, painted bronze, 5½″ × 8″ × 4½″, 1964. Courtesy of Leo Castelli Gallery, New York. One can is open, the other is not. The labels are painted by hand.

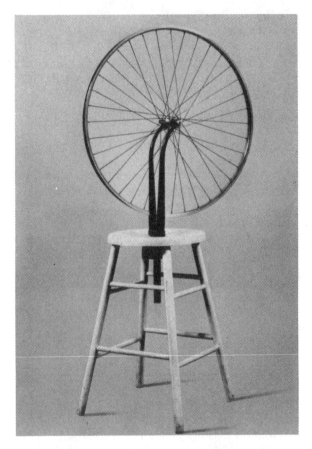

Plate 14.3. Marcel Duchamp, *Bicycle Wheel*, assemblage: metal wheel 25½″ diameter, mounted on painted wood stool, 23¾″ high; 50½″ high overall, 1951 (third version, after lost original of 1913). From the Sydney and Harriet Janis Collection, gift to the Museum of Modern Art, New York. What is there about a bicycle wheel that makes it the perfect mate for a kitchen stool?

Plate 14.5. Arman, *Béton Musical*, accordion in cement, 56″ × 40½″, 1974. Arman's wizardry is both irreverent and elegant. He exuberantly offers us images of our suppressed fantasies—in this case, a desire to smash something valuable and complex. The concrete ground gives archaeological weight to this evidence of folly.

Plate 14.7. Arthur Dove, *Goin' Fishin'*, collage: paint, bamboo, cloth, wood, etc., 19½″ × 24″, c. 1920–1925. Courtesy of the Phillips Collection, Washington, D.C. (photo credit Schwartz). Although executed fifty years ago, this Dove collage has a freshness and immediacy that speaks to us directly today.

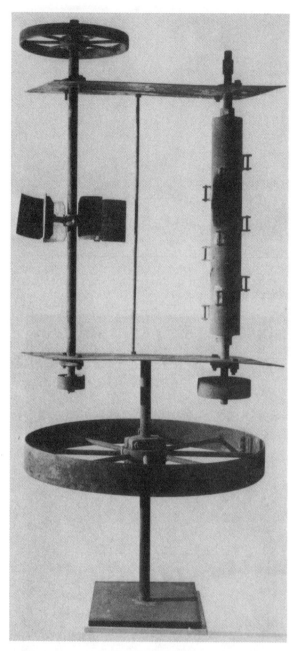

Plate 14.6. Ettore Colla, *Officina Solare*, iron, 88″ × 44″, 1964. Courtesy of Marlborough Gallery, Rome, from the collection of Mrs. Maria Colla (photo credit Pucci, Rome). The strong, simple shapes of farm implements are presented in a composition of classical restraint and formality.

After two wars in which the hardware of the world's greatest industrial nations has been blown to bits and proud cities have been reduced to rubble, it somehow seems appropriate that it should be the artist's task to resurrect some of this debris and make it into art. Even when there is not a war on, there is a constant accumulation of old cars, discarded furniture, and broken refrigerators on the outskirts of the cities of the world. It is only natural that artists should turn to what is available, just as a primitive artist might use shells and bones. As object sculpture reached its heyday in the fifties and early sixties, artists used material from everywhere, from the mountains and the seashore, as well as from the attic, the dump, and the secondhand store.

From the beginnings of modern art around 1912 until about 1960, by which time most of the issues raised in the early part of the century had been resolved, many advanced artists felt their work was unappreciated by society at large. There seemed to be a kind of justice and defiance in using objects cast off by society or relegated to the attic and the cellar.

Pop art in the sixties was a celebration of the reconciliation of the artist with a consumer society. Bright colors and fresh materials were seen again. Of

course, this brash and exuberant art was not without an underlying element of cynicism.

In the sixties, as artists gained recognition and affluence, they not only used new materials purchased directly from industry, but enlisted the aid of scientists and engineers to solve the technical problems of their work. To come full circle, we now have sculpture factories where sculptures are manufactured according to specifications, just like ships or bridges.

PAINTED IMAGES, REFLECTION, TRANSPARENCY

Sculptures have been painted for ages. Polychromed sculpture is in fact usual for most cultural periods. In the last twenty years, however, a new attitude has developed toward sculptural surface which goes beyond merely coloring or decorating the surface. This is the idea that one can paint or otherwise treat the surface in such a way that it projects a new image independent of the form of the sculpture itself. The new image may refer in some way to the shape of the sculpture or it may merely use the form as a support for a separate statement.

This is the opposite of a collage, where one inserts an object into the illusionary space of a painting; here one creates an illusionary image on the surface of an object. Picasso was one of the earliest practitioners of this art, as he was of the collage. On the surface of some of his early sculptures we see his painterly brushwork moving in a descriptive way as though he were painting a passage on a canvas.

Later, we see David Smith painting his sculptures of the fifties with obvious brush strokes, creating an atmospheric effect almost like an impressionist sky. Smith continued this direction in his stainless steel sculptures by polishing the surface so that it became reflective, changing with the time of day when the sculptures are seen outside under the sky as he intended (see pl. 10.46).

Many contemporary transparent and reflective sculptures have the capacity to project images or atmospheric light qualities. Techniques available today for working with glass and plastics offer a wide range of possibilities as do the opportunities for artistic use of holograms and lasers.

Light is the carrier of reflected and projected images. Light is also the source of the photographic images that some sculptors are presenting on the

Plate 14.8. Robert Rauschenberg, *Bed*, combine painting, 74″ × 31″, 1955. Courtesy of Leo Castelli Gallery, New York, private collection (photo credit Rudolph Burckhardt, New York). As you can see from the dripping paint, Rauschenberg painted his bed fastened vertically to the wall like a painting.

surfaces of their works. New developments in emulsions and photographic linens make it possible to print photographs on large irregular surfaces.

Words too are images. The first use of words as subject matter in contemporary art was probably in early cubist paintings, where words such as "Le Journal" and "Tabac" functioned more as surface-flatteners than as carriers of a message. Today, letters and words are used in painting and sculpture as forms interesting in themselves, and also in a poetic way, where the actual meaning of the word is its reason for being there. In some of the work of Robert Indiana there is a double ambiguity in that, rather than the word being *on* the sculpture, the word *is* the sculpture.

Plate 14.9. Larry Bell, *Garst's Mind No. 2*, 1971. Courtesy of the Pace Gallery, New York (photo credit Eric Sutherland, Walker Art Center, Minneapolis). These 6′ × 8′ panels of plate glass were treated in a vacuum chamber with a thin metallic vapor that leaves a reflective and slightly transparent coating.

COMBINATIONS

During "classical" periods, societies seem to prefer that sculptures be made from continuous, homogeneous materials. Thus we have the granite monoliths of the great kingdoms of Egypt, the marble heroes of classical Greece, and the bronze horsemen of the Renaissance. This attitude is best exemplified by Michelangelo, whose marble figures became, as his art progressed, more and more like the very blocks of stone from which he carved them (see pl. 6.23).

After Michelangelo, there was no one who could follow in the tradition he invented and completed.

Plate 14.10. Piotr Kowalski, *Identity + No. 2*, mirrors (concave, convex, and flat), red neon, steel, 1973. Photo credit Ingeborg Lommatzsch, West Berlin. Kowalski plays on the apparent contradictions between real images and reflected images. Because of the contours of the mirrors, the reflected images are all of equal size.

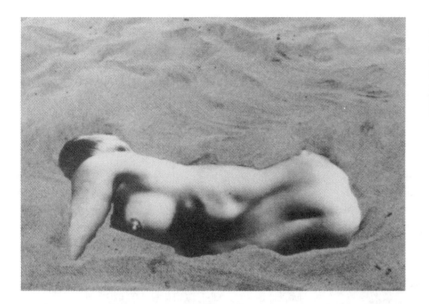

Plate 14.11. Ellen Brooks, *Beach Piece*, photograph on sensitized cloth, arranged in sand, over-life size. The over-life-size image is printed on photolinen, which is then mounted on a plywood backing and stuffed with latex foam.

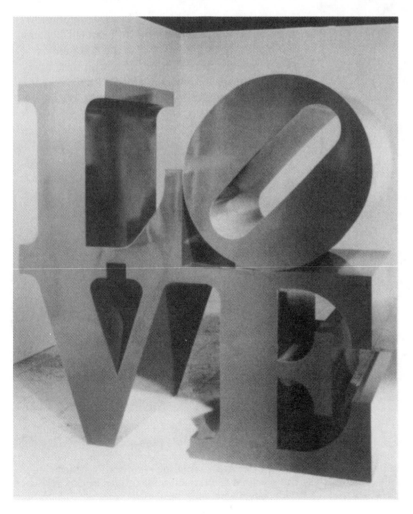

Plate 14.12. Robert Indiana, *Love*, polychrome aluminum, 72″ × 72″ × 36″, 1969. Courtesy of Galerie Denise René, New York. The sculpture and its title are one, but the formality of execution and coldness of material spell contradiction.

Sculptors instead reproduced the textures of skin, cloth, and foliage in marble. It was only a step to using many materials—stone, metal, glass, ceramics, and cloth—in a single sculpture. The sculptures of Bernini are the best examples of the magnificent and opulent works that were constructed for palaces and churches during this period in the seventeenth and eighteenth century.

In other spiritually excited and well-supplied cultures, there has been a similar proliferation of art combining many materials—the ceremonial sculptures and masks of Africa, the inlaid jaguar thrones of the Maya, the gilded bronze and wood altars of Fujiwara Japan.

In our own time, the practice of combining materials had a humbler origin in the freeing of everyday materials for use in art. This was in itself an attack on the nineteenth century's academic notions about proper art materials. The greatest sculptor of the nineteenth century, Rodin, radical as were his forms, worked entirely in the classical materials: clay, bronze, and white marble. Once artists felt free to use all kinds of materials, the fact that the new works were shocking to the general public was an incentive to be even bolder.

Today the shock value is no longer there. A vast array of materials is available. Artists are finding new affinities between materials and new contrasts, of lightness with mass, of transparency with density, that were never possible in the past.

MOBILE AND KINETIC SCULPTURE

In searching for the origins of kinetic sculpture, we must again return to the work of Marcel Duchamp, for his *Bicycle Wheel* of 1913 is the first modern sculpture capable of motion. This sculpture, however, is not specifically concerned with motion as a primary effect. For this we must turn to Naum

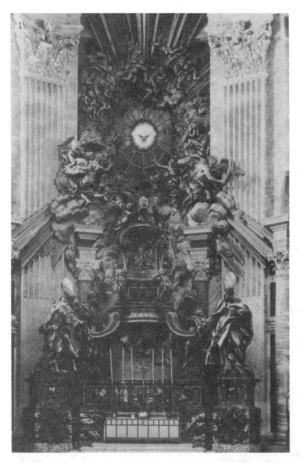

Plate 14.13. Lorenzo Bernini, *Cathedra Petri*, marble, gilt bronze, stucco, 1657–1666. Apse, St. Peter's Cathedral, Rome (photo credit Alinart-Art Reference Bureau). Total unity of the material and spiritual world was the aspiration of Bernini. He brought together bronze, marble, and paint in this monumental baroque altar in St. Peter's.

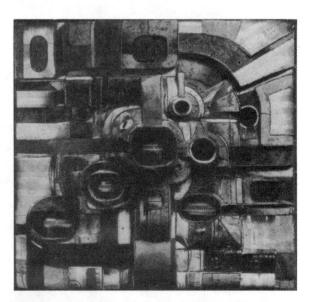

Plate 14.14. Lee Bontecou, *Untitled*, welded steel and canvas, 6′ × 6′8″ × 1′6″, 1964. Collection of the Honolulu Academy of Arts, Hawaii (photo credit Honolulu Academy of Arts). Menacing yet mysteriously feminine, this relief has a steel framework covered by canvas sewn with copper wire.

Gabo's *Kinetic Construction* of 1920. This work gave its name to the entire field of sculpture that moves.

The first mobiles were made by Alexander Calder in Paris in 1931. Returning to the United States, Calder continued to develop his very personal type of motion sculptures, which combine Yankee ingenuity with shapes derived from European abstract painting of the 1930s. Calder's title, "mobile," has been freely applied to almost every type of suspended nonpowered motion sculpture.

Since the thirties, kinetic sculpture has developed along the two lines represented by mechanical, power-driven works, and more loosely jointed air- or hand-operated works. Many of Calder's larger works, though they have broad blades and swivels, do not move unless deliberately pushed by hand.

George Rickey's kinetic sculptures are often exquisitely delicate, so that they move with the slightest current of air. Rickey's earlier pieces are composed with multiple joints and swivels so that they have a complex lilting and swaying motion like shrubs or small trees, rather than the simple rotary motion used by Calder. Rickey's more recent work stresses simpler, more monumental forms and less intricate movement.

In contrast to the polished precision of much kinetic sculpture is the whimsical and scrappy junk sculpture of Jean Tinguely. Provisionally wired together, these works clank and creak through their inanely repetitive gyrations, frequently breaking down during exhibitions. Now that we know that engineering is not going to save the world, it is comforting to be able to sympathize with these pathetic and absurd marvels of sloppy workmanship.

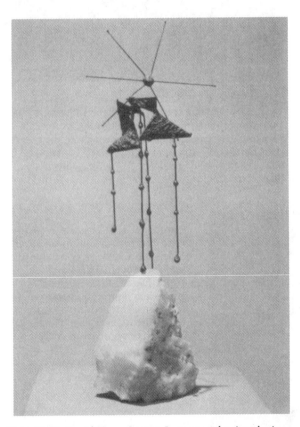

Plate 14.15. David Hare, *Sunset, I*, stone and painted wire, 19¼″ high, 1953. Collection of the Museum of Modern Art, New York, fund given in memory of Philip L. Goodwin. Stone and steel are combined here to convey an image seldom attempted in these materials: the sun shining through rain clouds.

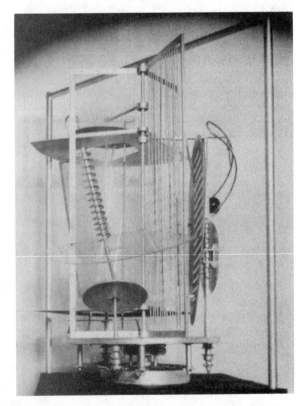

Plate 14.16. Lazlo Maholy-Nagy, *Light Space Modulator*, mobile construction: steel, plastics, wood, 51″ high, 1921–1930. Courtesy of the Busch-Reisinger Museum, Harvard University, Cambridge, Massachusetts. A complex machine sculpture displaying a programmed series of movements which result in a play of light and reflections.

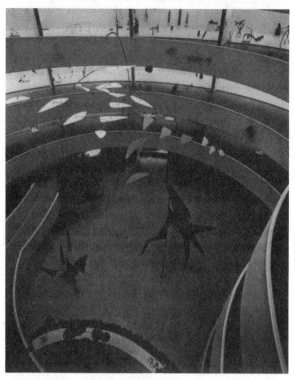

Plate 14.17. Installation photo of the Alexander Calder Retrospective Exhibition, 1964. Courtesy of the Solomon R. Guggenheim Museum, New York. The elements of the mobile suspended from the ceiling drift slowly as they are moved by air currents.

Plate 14.18. George Rickey, *Two Lines Oblique Down, Variation III*, stainless steel, 21′ high × 15′ wide, 1970. Collection of the University of California, Los Angeles, Franklin D. Murphy Sculpture Garden, gift of the UCLA Art Council, 1971 (photo by the author). The two free-swinging arms at the tip of the "Y" move gently in the faintest breeze.

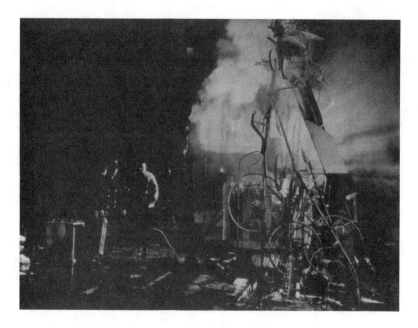

Plate 14.19. Jean Tinguely, *Homage to New York: A Self-Constructing and Self-Destroying Work of Art*, the Museum of Modern Art, New York, 1960. The self-destruction of Tinguely's sculpture in the garden of the Museum of Modern Art was attended by hundreds of museum officials, gallery directors, critics, art collectors, and artists.

ELECTRIC ART AND LIGHT SCULPTURE

Many electrically driven kinetic sculptures combined movement with other effects such as sound and light. As new as light art seems, it has been around for over sixty years. In 1905, in his native Denmark, Thomas Wilfred constructed the first kinetic light sculpture. In the 1920s, Wilfred toured the United States giving recitals on his Clavilux, a keyboard instrument that displayed colored forms moving on a glass screen. These forms were rear-projected from within the instrument by a series of moving filters, mirrors, and polished strips of metal. In 1930, Wilfred founded the Art Institute of Light, and in 1934 he opened a Lumia theater in New York where demonstrations and performances of his works were regularly held. After World War II, Wilfred continued to create Lumia works at his studio in New York until his death in 1968.

While most of Wilfred's works that can be seen today are self-contained units, Wilfred also designed several scenic projections for the theater which were similar in general concept to the light shows that are performed today with multiple projectors, film loops, and color wheels.

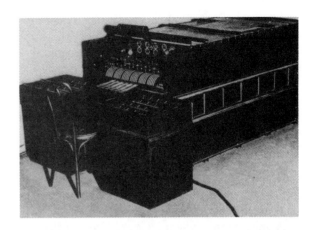

Plate 14.21. Thomas Wilfred, *Clavilux, Model B*, 1921. Photo courtesy of Donna Stein, New York. The front of the projection box had four openings in the center, each equipped with five double glass color filters controlled by steel wires attached to rotating keys on the keyboard. Rheostats on either side of the "lumianist," or player, regulated light.

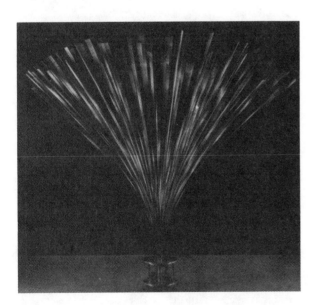

Plate 14.20. Len Lye, *Fountain II*, stainless steel, 80″ × 86″, 1963. Collection of the Tel Aviv Museum, Israel (photo credit Geoffrey Clements, New York). An electric motor moves the metal vanes to create a fan-shaped play of light.

Plate 14.22. Chryssa, *Fragment for the Gates to Times Square II*, neon tubing and Plexiglas, 43″ × 34 1/16″ × 27 1/16″, 1966. Courtesy of the Pace Gallery, New York. The transformers and rheostats are housed in the bottom section of the acrylic box and are operated on a programmed sequence.

Light art in its present variety started in the early sixties. In 1962, Chryssa began working with neon and many other artists began using neon and incandescent light sources. Chryssa was not originally a New York artist raised near the glow of Broadway, but a native of Greece who had lived only two years in New York when she first began using neon. Neon artists have been making use of the last remaining neon craftsmen, a disappearing guild. Today signs made of acrylic sheets illuminated with fluorescent tubes are spelling the end of the neon sign industry, just as neon in the thirties took over from the earlier signs made of twinkling light bulbs.

A unique form of light art is practiced by Dan Flavin, who uses only standard fluorescent lighting fixtures. Flavin's work involves many of the ambiguities associated with "ready-mades" which first became evident in the work of Marcel Duchamp. It also succeeds in operating on several different levels: as spatial composition, as the demarcation of an environmental area, as mood-creating ambience, and as sheer seductive luminescence.

Some artists combine sound and light in their work, or make use of other properties of electricity. Takis suspends parts of his sculptures with an invisible tension created by electromagnetism. Some artists use feedback circuits that cause the sculpture to respond to sound or heat radiation from persons nearby. Other artists are experimenting with the thin, glittering beams of laser projectors.

SOFT SCULPTURE AND INFLATABLES

With the relaxed and comic spirit that became a common artistic attitude in the mid-sixties, artists began making shapes that lay flaccidly upon the floor or hung limply from ceiling or wall. Claes Oldenburg made giant hamburgers and other food items of painted canvas stuffed with shredded latex. Later Oldenburg created preliminary sketches or "ghost models" of household appliances, using white muslin with stitched seams. These were followed by final versions in slick, bright vinyl.

Plate 14.23. Takis, *Telé-Magnétique*, steel with electromagnet, 20″ × 15″ × 24″, 1960. From the collection of Mr. Arturo Schwarz, Italy (photo credit Enrico Cattaneo, Italy). The tethered darts are held in trembling suspension by a humming electromagnet at the center.

Plate 14.24. Alberto Collie, *Spatial Absolute #1*, aluminum, 6″ × 16″ × 16″, 1963. Collection of Johnson Wax Company, Racine, Wisconsin (photo credit Geoffrey Clements, New York). Magnetic repulsion keeps the polished brass disk suspended in midair over its base.

Plate 14.25. Morio Shinoda, *Biolomatic Incubator*, aluminum, acrylic plastic, and electric circuitry, 3' × 5' × 2', 1969. Collection of the artist (photo credit Tom Dargis, Texas). Sound impulses fed into the microphone cause responsive circuits to activate the light table and the randomly tuned radio. Shinoda also creates touch-response sculptures.

Plate 14.26. Claes Oldenburg, *Soft Wash Stand*, vinyl filled with kapok on metal rack, 55" × 36" × 28" deep, 1966. Courtesy of the artist, collection of Dr. Hubert Peeters, Bruges, Belgium. The glossy black and white vinyl was sewn on a sewing machine according to a "ghost-version" pattern worked out in white muslin. Many of Oldenburg's "ghost-versions" constitute sculptures in themselves.

Soft sculptures are made of natural materials such as cloth, leather, and rubber, as well as synthetics like vinyl, Neoprene, Mylar, and polyethylene. Since many of these plastics can be made into airtight bags by heat sealing or taping the seams, some artists have inflated their sculptures with air, or used helium to make them airborne. Very large air-inflated works can be entered by the spectator who then experiences the sculpture from the inside.

Plate 14.28. Paul Harris, *Norissa Rushing*, stuffed cloth on wood frame, 8' × 5' × 5', 1972. Courtesy of Poindexter Gallery, New York (photo credit Roger Gass). There is humor and style to Paul Harris's sewn and upholstered ladies.

Plate 14.27. Hannah Wilke, *Venus Basin*, latex, snaps, 6' × 3'8", 1972. Ronald Feldman Fine Arts Inc., New York (photo credit Eeva-Inkeri, New York). The fleshy stretchiness and limpness of rubber compounds offer the artist a wide range of sensibilities.

Plate 14.29. John Henninger, *Old Couple*, life-sized figures with wheel chair, sewn and stuffed cloth, 1973. Collection of the artist (photo by the author). Henninger stitches lines as a draftsman would use a pen, sometimes reinforcing naturalistic contours, at other times for psychological emphasis.

AIRBORNE SCULPTURE

Around 1960, artists began to look for places other than galleries and museums to show their work. There was a feeling that art should seek a wider audience and that it should deal with questions of social and ecological importance, from which it was isolated by the increasingly artificial limitations of galleries, and their audiences. It must be said that many art dealers and museum directors were equally aware of these limitations and began to arrange exhibitions of art in city streets, parks, and warehouses. In addition, artists were commissioned to execute works in the deserts, in the mountains, and at the seashore. Sculpture symposia were organized to create monumental works for highways and freeways.

One expression of this liberation has been the many forms of flying sculpture sent aloft from parks and rooftops all over the world. These works have usually taken the form of balloons or kites or combinations thereof ("kitoons"). Rocket pieces and works propelled by model airplane motors have also been seen. More atmospheric presentations make use of smoke, fire, or water. Perhaps more difficult to define, these latter works often make use of the sky as their arena of display.

Inflated airborne sculptures make use of many of the same techniques used for terrestrial works of the soft variety. Plastic films such as vinyl, Mylar, and

Plate 14.30. Judy Chicago, *Fullerton Atmosphere #3*, fireworks, 1970. Photo credit John F. Waggaman. Lyrical romanticism carried off with a flourish of pyrotechnic brilliance.

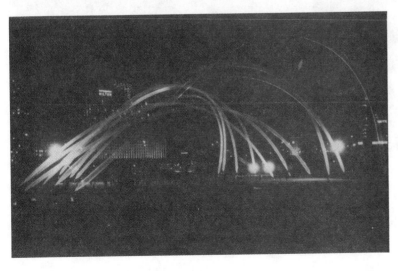

Plate 14.31. Otto Piene, *Citything Sky Ballet: Manned Helium Sculpture*, polyethylene film and helium, Pittsburgh, Pennsylvania, April 18, 1970. Photo credit Walt Seng, Versailles, Pennsylvania. The grand spectacle of these helium-filled polyethylene tubes mounted for one night in the city of Pittsburgh required months of planning and the cooperation of many city agencies and officials.

polyethylene are widely used. Heat sealing and taping with vinyl or Mylar tapes are the most common joining methods. Many types of filler tubes and valves are available from toy and plastic wading-pool companies.

The process of manufacturing polyethylene results in an initial product that is a tube two to eight feet in diameter. If the tubes are procured before they are slit into sheets, they may be closed at the ends to make flexible sausagelike forms of unlimited length.

Plastic materials are also widely used in rigid airborne sculptures, which frequently have frames of fiberglass tubing, though bamboo, reeds, and clear pipe are also used. The traditional coverings of paper or lacquered silk have been augmented by superlight films of Mylar and polyethylene and by dacron fabrics. Aluminum and magnesium frames, while promising from an aerodynamic point of view, present hazards if a sculpture encounters electric wires during its flight.

While kites have been flown for centuries in the Orient, their imaginative development in the West did not begin until the end of the nineteenth century, when interest mounted in aerial vehicles that could be ridden and controlled. The Wright brothers' biplane was essentially a powered box kite. Before interest in airplanes eclipsed the development of kites, Alexander Graham Bell designed and flew some of the largest and most extraordinary kites ever invented. He developed many of the construction principles used in today's flying sculptures.

A word of caution to builders of flying sculptures: many urban areas have strict laws about the types of objects that may be flown in the skies, in order to

Plate 14.32. Oliver Andrews, *Cortes Skyfountain*, aluminized Mylar and helium balloons, 100′ × 5′, Cold Mountain Institute, Cortes Island, British Columbia, Canada, August 10, 1971 (photo by the author). The Mylar is suspended from helium balloons (see also pl. 13.10).

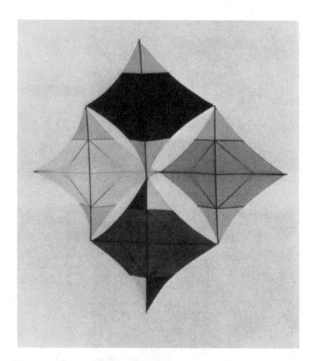

Plate 14.33. Loren Madsen and Jeffrey Lindsay, *Tetrahedron Kite*, aluminum tubing and nylon, 24′ × 24′, 1968 (photo by the author). This 24-foot kite is constructed of four 12 × 12 foot tetrahedron modules. The tubular aluminum frame is assembled at the flying site with glass filament tape. Sails are rip-stop nylon. The kite will lift off and fly in a four mph wind.

protect electrical installations and low-flying aircraft, and to avoid public hysteria over unidentified flying objects. It is irresponsible and dangerous to allow an airborne object to enter the atmosphere unless it is controlled by a line or a radio device, or followed by a tracking aircraft.

EARTH SCULPTURE

As artists began to present their works outside of galleries and museums, they searched for ways in which the character of the work itself might change to become more pertinent to the problems and opportunities of contemporary life. A large metal sculpture displayed in the street or in a park is still the same designed and fabricated object of commerce that it was in the art gallery. But if the pavement of the street itself is the material of the sculpture, or if the earth is carved and molded, a unity of site and subject matter will be established, and the portability of the work as an object of commerce will be negated. In the late sixties, artists began carving trenches in the earth, trampling paths through fields of snow and grain, and transporting large boulders to new sites.

There are, of course, precedents for this type of work to be found in many parts of the world where primitive peoples have formed rock and earth sculptures that are still visible today. Some of these works, such as Stonehenge on Salisbury Plain in England, are still effective in the grandeur of their conception and the way in which they occupy crucial positions in vast landscapes. Contemporary artists, in fact, have often chosen magnificent and remote stretches of coastline or desert for the execution of their works, dramatizing by contrast the congestion and frenzy of cities.

Earthwork sculptors, however, have not been simply readapting ancient methods in order to produce similar earth sculptures of their own. Many of the current earthworks are intentional illustrations of a geological, botanical, or meteorological process, and almost all are concerned with the gradual changes which the work will undergo as it is transformed by the forces of nature. Thus earthworks function as reminders of the interrelatedness of ecological processes, and call our attention to the fact that even the most desolate wilderness is not inaccessible to the encroachments of man. Perhaps this last point is not one that all earthworks artists intend. It must be clear to everyone, however, that the relative permanence of many of the ancient earthworks demonstrates how long we will have to live with other disruptions of the earth's surface,

Plate 14.34. Christo, *Wrapped Coast*, Little Bay, Australia, one million square feet of vinyl sheet, 1969. Coordinator John Kaldor (photo credit Shunk-Kender). Christo wrapped a mile of Australian coastline in plastic sheeting. In 1969 this was one of the largest works of art attempted in recent times. It raised many questions, such as the environmental impact of monumental artworks in natural settings. Christo had to deal with this question again when he erected his twenty-mile *Running Fence* in California in 1976.

such as underground atomic explosions and arctic pipelines. An evocative work of art often serves as a means of mobilizing incoherent and dimly-felt needs in society, even though these needs may not have been uppermost in the artist's mind when he conceived the work.

It is ironic that, in an attempt to make art more relevant, artists have created works that are inaccessible to most people except through photographs. This has had a predictable effect, in that the principal medium for the dissemination of photographs of earth art has been art magazines, which exist largely to serve the world of the art dealers and collectors that the artists were attempting to bypass in the first place.

Thus it has happened that once the movement back to nature gained popularity, the many backyard and city park experimenters were forgotten. Virtually all of the recent earth sculptures that have been widely publicized have been sponsored by a handful of art galleries and wealthy collectors. These projects have involved leasing large tracts of land and the rental of helicoptors, trucks, and earth movers on a scale far beyond what the average artist can afford.

As in many art movements, there has been a reverse version of the original movement. In the case of earth sculpture this resulted in galleries holding exhibitions of earth, rocks, and grass, removed from their original sites and displayed in various configurations within the gallery.

Some artists have turned to the ocean as a site for their art. So far, few of these efforts have produced art forms which make use of the ocean's enormous potential, or express the nature of its processes with any of the ingenuity we have seen in some of the better earthworks.

Any attempts to use the ocean as a site for art works should take into consideration the navigation of boats in the area and possible effects on the marine environment. It should also be borne in mind that in inhabited parts of the world the navy and coast guard maintain close surveillance over offshore waters. Any spectacular effects are likely to bring their representatives quickly to the scene unless they have been contacted in advance.

ENVIRONMENTS, HAPPENINGS, PERFORMANCES

Earth sculptures and flying sculptures can be considered environmental sculptures in the sense that they take place in "the environment," out-of-doors, and often out of the city. This much-overused word, "environmental," has been applied to several other types of works, all of which are large enough in scale so that a person can be surrounded by the work, or at least enter the work in the imagination, if it is not possible physically.

Plate 14.35. Walter de Maria, *1600 Cubic Feet of Level Dirt*, 1600 cubic feet of earth, September–October 1968. Installation at Gallery Heiner Friedrich, Munich, West Germany (photo credit Heiner Friedrich). It was a startling experience to visit an art gallery and find it filled wall-to-wall with earth.

There are many historical precedents for environmental art. In fact, most of the art of the past has been environmental, in the sense that it was made to be seen as part of a surrounding setting, not as an isolated artifact separated from its background. Our modern museums and galleries, which present historical art outside its original context, have their origins in the museums and private collections that were established in the sixteenth century for the display and study of classical antiquities. As sculptors and painters began to have patrons outside the church, contemporary art began to be collected along with classical art. During the earlier medieval period, the greatest works of sculpture and painting were truly environmental in nature, since they were an integral part of the total experience offered by the medieval cathedral. Here painting and sculpture merged with architecture, and were augmented by stained glass, incense, music, and costumes in a sensually saturated continuum.

Earlier, in the classical Greece which the Renaissance so admired, an exceptional unity of art and environment was achieved. Paintings were executed directly on walls, sculptures were parts of buildings. In the so-called mystery religions, which were widespread throughout the Near East for centuries, communal audiences participated in orgiastic and mystical initiations that involved drugs, light projections, smoke and vapor displays, and other peculiarly modern effects.

In the seventeenth and eighteenth centuries, the spiritual crisis of the Reformation brought about a striving for unity which produced the last great synthesis of religious art in Western culture, as exemplified by baroque architecture, in which sculptures, paintings, walls, and windows merge in a flowing, undulating unity. It was for these interiors that Bach wrote his mighty choral and organ works.

Today, the traditional boundaries between architecture, sculpture, and painting have been broken through in many places. Some architecture has such a feeling of plastic vitality that we could just as well call it environmental sculpture. We are becoming aware that this quality is not a prerogative of modern architecture, nor of the great buildings of the past. It has been a characteristic of human building almost everywhere that people have invented and built their own buildings, where the people who conceived the buildings were the people who actually lived in them.

In art, painting and sculpture began growing in scale throughout the 1950s. The canvases of Jackson Pollock, for instance, were so wide that a person standing in front of one in an ordinary gallery could not take in the work with a single look. The patterns on the canvas were the result of sweeping body gestures rather than carefully controlled brushstrokes. Sculpture, too, began to grow in scale, so that the spectator could walk through it or under it, or even be contained by it.

It was only a step to the completely environmental works that were actually called "Environments" by the artists who created them. Some of these works were set up in galleries, but many were executed in the street, or in lofts or warehouses where there was more room. 1960 was the year Environments burst exuberantly into being in New York City and were written about extensively in newspapers and magazines. In this year, Alan Kaprow, Jim Dine, Claes Oldenburg, and Robert Whitman all constructed Environments. In the next few years,

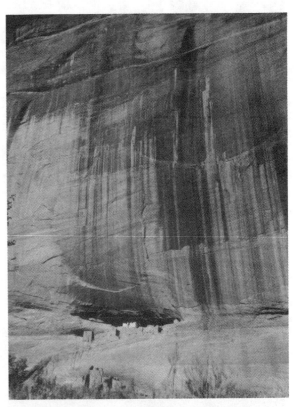

Plate 14.36. Canyon de Chelly, White House and lower ruins, Anasazi Culture, Arizona, A.D. 1050–1250. Photo credit United States Department of the Interior, National Park Service. These dwellings fit their site with an unpretentious rightness.

Environments were presented in many major cities in the United States and Europe. Kaprow and Oldenburg organized several in Los Angeles, which were followed by the works of Judy Chicago, Lloyd Hamrol, Eric Orr, James Byars, and many others. The perceptual experiences that take place between space and spectator continue to be investigated today by such different and highly sensitive artists as Robert Irwin, Michael Asher, and James Turrell.

In another branch of environmental sculpture, the artist presents a figure or figures with a portion of the figure's own environment included as part of the sculpture. The added portion may be as simple as a piece of furniture or an implement of some kind, or as complicated as an entire room. In some of these works, such as George Segal's, the environment serves as a background for the figure, and can be appreciated visually but not entered. In other works, such as Ed Kienholtz's tableaus, we are invited to actually enter the environment and share it with sculptures of people which the artist has created.

There has been a great deal of interest over the last twenty years, as there still is today, in the appearance of the work of art as the sum of the gestures and actions which go into making it. It was only natural that Environments should become settings for the performance of dramatic actions which were considered part of the total work, just as the

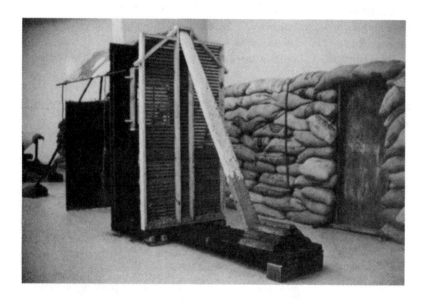

Plate 14.37. George Trakas, *Shack*, mixed media, 8′ × 4′ × 24′, 1971. Installation at Guggenheim Museum, New York. This life-size structure of copper, glass, and wood is propped up in front of a sandbagged barricade.

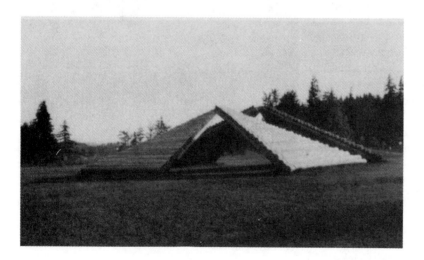

Plate 14.38. Lloyd Hamrol, *Log Ramps*, cedar logs, galvanized wire, concrete, 9′ × 36′ × 36′, 1974. Collection of the University of West Washington, Bellingham, Washington. This structure has a powerful sculptural presence and also offers itself as a ceremonial shelter. The four cantilevered ramps of logs are anchored in the ground by concrete caissons.

acts required to bring an Environment into being (and dismantle it) were to be considered essential elements in the work. Scripts were written for performance. Sometimes audiences were invited to participate. Many of the directions were designed to be open-ended, so that the work became a series of unfolding spontaneous events that "happened" rather than being completely controlled by instructions. A quality which "Happenings" had was that of seeming to emerge out of the stream of daily events without a definite beginning, and merging back again into the day and the surroundings without a definite end.

In time, Environments and Happenings began separating into their components, as their boisterous beginnings developed refinements in the directions of dance, theatre, and pure sculpture. The street works of the early 1960s had a pervasive influence on the

Plate 14.39. Michael Asher, *Untitled*, standard grade drywall construction, approximately 70′ long × 28′ wide, 1970. Installation at Pomona College Art Gallery, California (photo credit Frank J. Thomas, Los Angeles). This space was constructed to receive and enhance the changing light of the day as it flows through the vertical opening at the far end.

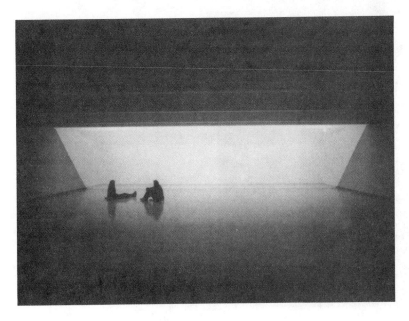

Plate 14.40. Robert Irwin, *Untitled Environment* at the new Walker Art Center, Minneapolis, Minnesota, May 18–July 25, 1971. Photo credit Walker Art Center, Eric Sutherland. A panel of clear light in an unobstructed space offers the possibility of contemplating the nature of perception itself.

dance works of Merce Cunningham, Alwyn Nikolai, Twyla Tharp, and other advanced dancers throughout the country. It must be recognized that this influence was reciprocal. The gestural art of the fifties and sixties owes a great deal to the revolutionary dance performances of Martha Graham in the thirties and to John Cage's ideas about music in the forties and fifties.

During the 1970s many artists in different parts of the world created and participated in performances. If there is any consistent theme which has begun to emerge from this activity, it is probably the development of a social consciousness among artists. There seems to be growing awareness that art can dramatize people's needs and carry messages to parts of society that have been out of reach for artists before.

Many alternative spaces have been found for displaying art and mounting performances. The people who turn old buildings, schools, barns, and parks into art centers constitute a new group of art organizers, many of them artists themselves. They often have visions different from those of the museum, gallery, and established magazine people who used to control the showing of art.

Museums and galleries have not lost their importance, but now they find themselves acting in a world in which they are not virtually the only places where people go to experience art. This situation has had a strong influence on these institutions as they have attempted to keep up with the uncollectable nature of much of today's art. Some museums have simply given up and decided to concentrate on preserving

Plate 14.41. Lucas Samaras, *Bedroom*, installation at Green Gallery, New York, 1964. Courtesy of Pace Gallery, New York. In an art gallery, the artist has recreated his own room at home, cluttered, rumpled, and completely authentic.

the past. Other museums have adopted more flexible tactics, showing new work almost as soon as it is produced, sponsoring performances, and reaching out into the city to support some of the same kinds of projects that the alternative spaces are involved with. The overall effect of these efforts has been that the most significant changes in art during the seventies were not in terms of art movements or styles, as in the sixties, but in the forms by which artists relate to their audience.

There is no doubt that interest in making art more sensitive to public needs will change the way art looks and acts. In any case, it would seem that we can look forward for some time to arts which focus public attention on matters directly affecting the survival of human beings.

BIBLIOGRAPHY

A. Books

Alloway, Lawrence. *American Pop Art.* New York: Collier, 1974.

Ashton, Dore. *Modern American Sculpture.* New York: Abrams, 1968.

Battcock, Gregory, ed. *Idea Art, A Critical Anthology.* New York: E. P. Dutton, 1973.

Brett, Guy. *Kinetic Art, The Language of Movement.* New York: Reinhold, 1968.

Brockman, John, and Edward Rosenfeld. *Real Time 2.* New York: Anchor Books, 1973.

Burnham, Jack. *Beyond Modern Sculpture.* New York: Braziller, 1968.

————. *The Structure of Art.* New York: Braziller, 1971.

Plate 14.42. Allan Kaprow, *Fluids,* Happening, October 1967, detail of one of fifteen sites constructed during three days, Beverly Hills, California, 50-pound blocks of ice, 90′ × 12′ × 10′. Photo credit Julian Wasser. Crews of volunteers met each ice truck at its appointed site and constructed the walled enclosures according to the artist's plan. The ice took about twenty-four hours to melt.

Plate 14.43. Paul Thek, *Ark, Pyramid,* installation, Dokumenta, Kassel, West Germany, mixed media, 150′ × 50′, 1972. Photo credit Balthasar Burkhard, Berne, Switzerland. A newspaper pyramid establishes the center of a multimedia work that evokes many levels of imagery concerned with transience and the passage of time.

Burnham, Jack, Louis Kalm, Herbert Marcuse, Annette Michelson, James Seawright, B. F. Skinner, and Arnold Toynbee. *On the Future of Art*. New York: Viking, 1970.

Goldwater, Robert. *What Is Modern Sculpture*. New York: Museum of Modern Art, 1969.

Kaprow, Allan. *Assemblage, Environments and Happenings*. New York: Abrams, 1966.

Kepes, Gygory, ed. *The Man-Made Object*. New York: Braziller, 1966.

Kulterman, Udo. *Art and Life*. New York: Praeger, 1970.

———. *The New Sculpture*. New York: Praeger, 1968.

Lasers and Light: Readings from Scientific American. San Francisco: W. H. Freeman, 1969.

Lippard, Lucy, ed. *Six Years: The Dematerialization of the Art Object from 1966 to 1972*. New York: Praeger, 1973.

Meilach, Dona Z. *Soft Sculpture and Other Soft Art Forms*. New York: Crown, 1974.

Muller, Gregoire. *The New Avant Garde, Issues for the Art of the Seventies*. New York: Praeger, 1972.

Pincus-Witten, Robert. *Postminimalism*. New York: Out of London Press, 1978.

Popper, Frank. *Origins and Development of Kinetic Art*. New York: New York Graphic Society, 1968.

Read, Herbert. *A Concise History of Modern Sculpture*. New York: Praeger, 1964.

Richter, Hans. *Dada, Art and Anti-Art*. New York: McGraw-Hill, 1965.

Rickey, George. *Constructivism*. New York: Braziller, 1967.

Soundheim, Alan, ed. *Individuals: Post Movement Art in America*. New York: E. P. Dutton, 1976.

Tomkins, Calvin. *The Bride and the Bachelors, Five Masters of the Avant-Garde*. New York: Viking, 1968.

B. Periodicals

Art Forum, P.O. Box 980, Farmingdale, N.Y. 11737.

The Art Gallery and *Exhibition Guide*, Hollycraft Press, Ivoryton, Conn. 06442.

Art in America, Art in America, Inc., 150 E. 58th St., New York, N.Y. 10022.

Art International, Via Maraini 17-A, Lugano, Switzerland.

Art News, P.O. Box 969, Farmingdale, N.Y. 11737.

Arts Canada, 3 Church St., Toronto, Ontario M5E 1M2.

Arts Magazine, 23 E. 26th St., New York, N.Y. 10010.

Art Week, 1305 Franklin St., Oakland, Calif. 94612.

Craft Horizons, American Crafts Council, 44 W. 53rd St., New York, N.Y. 10019.

Leonardo, Pergamon Press, Maxwell House, Fairview Park, Elmsford, N.Y. 10523.

Studio International, 155 W. 15th St., New York, N.Y. 10011.

15

Planning a Studio

Imaginative planning in setting up a sculpture studio can result in significant savings in time and energy over the years the studio is used. Planning can also affect the quality of the working experience. Studio activities can be well organized and effective or they can be awkward, frustrating, and even dangerous.

A good way to start planning a studio is to lay out all the processes—welding, sawing, painting, and so forth—that will take place in the studio and then consider how these processes relate to one another. Which tools should be near each other? Which should be separated? What kind of space does each tool need around it? What utilities, such as air, gas, electricity, and water, should be available at each tool area and work station? What are the ventilation and lighting requirements?

The most valuable concept to have in mind when composing a studio is the idea of the "work station," the arrangement of all the facilities in a work area so that they serve the human needs of a person working there. Arm-reach distances, step lengths, toe spaces, eye levels, visibility; the consideration of these factors, not the convenience of the equipment, should determine the placement of equipment. Why shouldn't an artist's work space be as carefully designed as an astronaut's or a tea master's?

TYPES OF STUDIOS

Individual sculptors have different needs and so their studios are organized around different groupings of tools and working spaces. An artist who works in fiberglass and resin will have a different setup than an artist who does welding and casting. The studios of these two sculptors would be organized differently from the studio of the sculptor who carves stone and wood. All of these artists, however, use saws, sanders, and grinders, and they would probably all have a welding torch somewhere in the studio. Yet an artist who works entirely with electronic circuitry, or one who makes forms of sewn cloth, would have an entirely different studio from the first three artists.

It is possible, with exceptions, to talk about a Basic studio that could serve the needs of artists working in many different media. Artists today do, in fact, often change from one medium to another without having to radically reorganize their studios. The Basic studio is also a concept which applies to colleges and art schools, where attempts are made to provide students with a range of possibilities in both traditional and contemporary media.

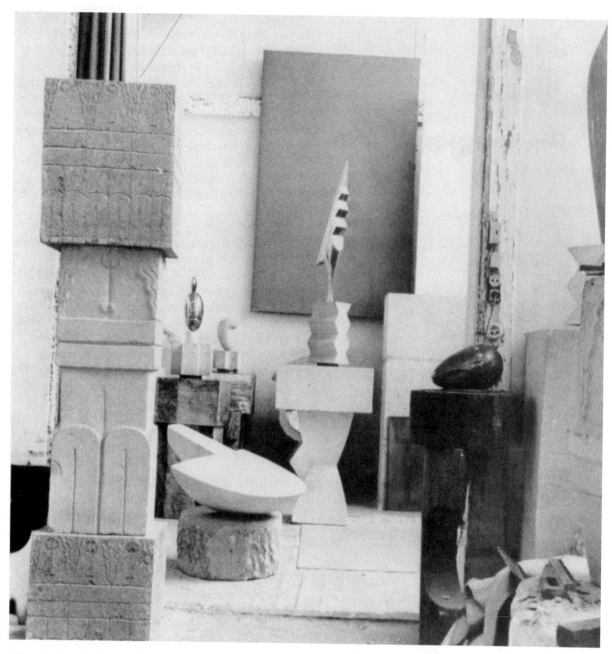

Plate 15.1. View of sculpture in Brancusi's studio (photo credit Magnum, New York). Left to right:

1. *Boundary Marker*, stone, 72¾″ × 16″ × 12″, 1945, Musée National d'Art Moderne, Paris.

2. *Blond Negress*, polished bronze, 15⅞″ high, 1933, Museum of Modern Art, New York.

3. *Eileen*, white stone, 11¼″ high, c. 1923, Musée National d'Art Moderne, Paris.

4. *Flying Turtle*, marble, 12½″ × 36⅝″ × 27⅛″, the

Solomon R. Guggenheim Museum, New York.

5. *The Cock*, polished bronze, 40¾″ high, 1935, Musée National d'Art Moderne, Paris.

6. *Sleeping Muse*, bronze, 10⅝″ long, 1910, Musée National d'Art Moderne, Paris.

7. *Bird* (top right), blue-gray marble, 35½″ high, c. 1923–1952. Collection Alain de Gunzburg, Paris.

8. *The Kiss* (right front), yellow stone, 28¼″, early 1940s, Musée National d'Art Moderne, Paris.

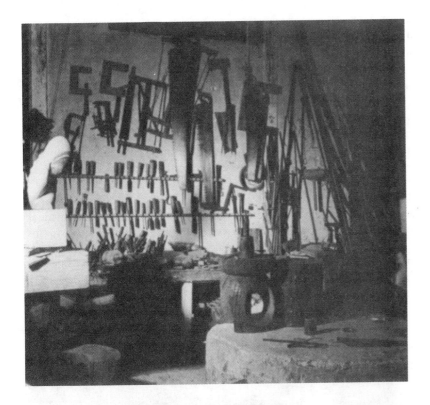

Plate 15.2. View of tools in Brancusi's studio (photo credit Magnum, New York). Head on left: *Mademoiselle Pogany*, marble, 17½″ × 7½″ × 11¼″, 1931, Walter Arensberg Collection, Philadelphia Museum of Art. Wood chisels, saws, and clamps on wall of studio.

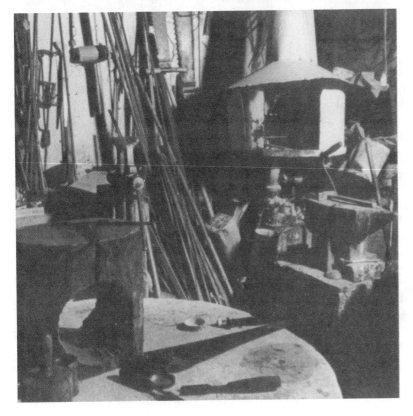

Plate 15.3. View of tools and furnace in Brancusi's studio (photo credit Magnum, New York). Clockwise from lower left: wood mallet, vise, double-ended wood saws, forge, iron hammer, anvil.

The Basic studio provides one of each of the large stationary items of equipment required in the sculpture media in use today, and at least one of each kind of standard portable power tool. The space is organized around the stationary tools, and the portable tools are kept out of the way in a tool crib or tool room which permits their ready availability. Hand tools, attachments, and accessories are kept in drawers or racks that are clearly labeled. The organization of these three classes of tools—stationary tools, portable tools, and accessories—in a way which is humanly convenient, is the difference between a studio and a room full of tools.

Where there is no shortage of space and funds, the Basic studio can be expanded into the Ideal studio, where there is very little overlapping of function between areas. There is some duplication of tools within the Ideal studio, since the shop for each medium is fully equipped and self-contained. A metalworking area and a woodworking area each has its own band saw and drill press, while certain related types of equipment, such as the kiln and the furnaces, share the same area.

The Ideal studio is well suited for one person to work in as well as for many people to work in at the same time. It is as large a unit as a studio can become without turning into a factory. If a larger facility is desired, other units, perhaps more specialized ones, can be established at a distance from the central studio.

In a school where there is emphasis on individual work by advanced students, small individual studios surround the main studio complex, with electric and air lines to each studio for use of portable tools there. Students come to the main studio to use the stationary facilities.

What follows is a plan for an Ideal studio, fully equipped for work in all media. This plan is not offered as the one and only layout for a complete

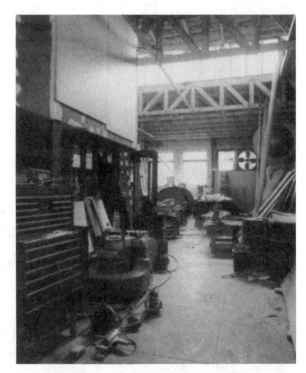

Plate 15.4. Richard O'Hanlon's studio. Courtesy of Richard O'Hanlon, Mill Valley, California. Overhead rail and high clerestory windows provide spacious working area.

Plate 15.5. DeWain Valentine's studio. Courtesy of De-Wain Valentine, Venice, California. This is a resin-casting and fiberglassing studio. From left to right: tool cabinet, forklift, vacuum cleaner, fiberglass disk sculpture, ventilating fan, stacked materials, resin drums.

sculpture studio. No doubt every sculptor has his own idea of an Ideal studio, his own preferences for the arrangement of equipment and space. The objective here is to present a plan that is practical both as a professional studio and as an instructional facility. By examining it in some detail we will be able to cover the main points that must be considered in designing any sculpture studio.

THE IDEAL STUDIO

This suggested plan for a large studio combines four workshops around a central courtyard, with a separate "clean" building for drawing and viewing. Each shop has an adjacent work court. The central communal court is for relaxation and discussion. The areas and their facilities are:

A. Ceramics and Metal Casting Shop
1. Kilns, one large ceramic, and burnout, one small.
2. Pug mill.
3. Forge.
4. Furnace.
5. Shell burnout furnace if desired.
6. Sandpit for metal casting.
7. Heliarc welder and arc cutter.
8. Potter's wheels and wedging tables.
9. Wax melter and wax tables.
10. Clay and plaster mixers.
11. Portable tools: pneumatic or electric grinders, chisels, sanders, drills.
12. Hand tools: tongs, hammers, chisels, etc.
13. Bridge crane and overhead rails.
14. Forklift.

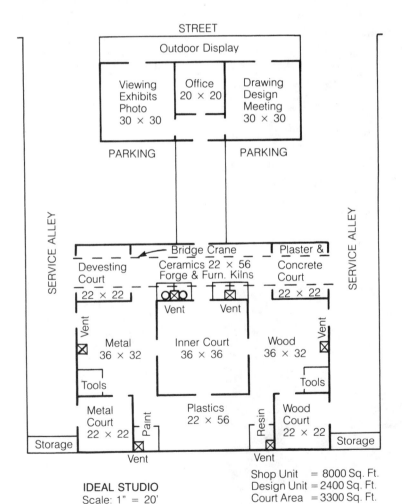

Figure 15.1. Ideal studio. Shop unit is 8,000 sq. ft.; design unit is 2,400 sq. ft.; court area is 3,300 sq. ft. Total area is 13,700 sq. ft.

IDEAL STUDIO
Scale: 1" = 20'

Shop Unit = 8000 Sq. Ft.
Design Unit = 2400 Sq. Ft.
Court Area = 3300 Sq. Ft.

15. Forced ventilation system for kilns, forge, furnace.
16. Mixing tank for shell casting if practiced.
17. Fluidizing bed if shell casting.
18. Clay and plaster storage bins.

The overhead rails continue through a large roll-up door to the outside work court. During casting operations the door can be raised to provide added ventilation. The bridge crane permits plaster investments or large ceramic sculptures to be lifted into the kiln. Investments are taken out of the kiln (preferably a shuttle kiln) with the bridge crane hoist, and placed in the pouring pit. After pouring, the investments are lifted out of the pouring pit and moved outside to the work court where they can be devested by hand or with a power hammer. Along the wall are clay and plaster storage bins.

There should be truck access to the work court so debris can be removed. Additional kilns can be placed outside if desired, with other outdoor equipment such as a brick saw. Additional information on the equipment discussed here is given in the chapters on ceramics and metal casting. Ovens and tools for working with glass could be in this shop, or outside under a partial roof.

Plate 15.6. Bridge crane with A-frame and hydraulic engine hoist. This bridge crane can pass through the roll-up door and connect with other rails serving the interior of the studio. The A-frame and engine hoist serve areas beyond the overhead rails.

Plate 15.7. Crossover tab for bridge crane rail. Two of these on each side of the door opening make it possible to connect the inside rails to the outside rails, so that the bridge crane may be rolled through the door.

B. Plaster and Concrete Court

On the other side of the ceramic and metal casting studio is a courtyard devoted to plaster and concrete. This area is roofed over in temperate climates, or capable of being totally enclosed where there are cold winters, with a roof made of transparent panels, or, where there is snow, steeply pitched with clerestory windows to admit daylight. Daylight should be available to all the rooms on the north side of this studio complex, for drawing and for working with concrete, plaster, wood, and stone. The metal and plastics shops are adequately illuminated by fluorescent light, though of course it would be nice to have daylight everywhere. People often weld and work with plastics at night, whereas carvers seem to prefer the day.

The plaster and concrete area is equipped with faucets and hoses, and deep sinks with floor pedals and heavy-duty traps (see pl. 3.8). Except for cement and plaster mixers, there is little other equipment here. Fifty or one hundred gallon settling barrels are provided for washing plaster equipment. The walls and floor are smooth sealed concrete. The area is periodically scraped and hosed out into the large floor drains.

C. Woodshop
1. Table saw.
2. Radial arm saw.
3. Band saw.
4. Jigsaw.
5. Planer and joiner.
6. Stationary belt and disk sanders.
7. Drill press.
8. Other special woodworking tools.
9. Portable tools: drills, routers, sanders, jigsaws, skillsaws.
10. Hand tools: saws, chisels, mallets, files, planes, etc.
11. Tables, vises, clamps.
12. Dust collection equipment.
13. Storage for wood.

See chapter eight for additional information on woodworking.

D. Wood and Stone Yard
1. Portable tools: grinders, sanders, drills, etc.
2. Hand tools: saws, chisels, mallets, hammers, axes, adzes, picks, rasps, etc.
3. Dollies and pallets, chains.
4. Forklift.

This courtyard should be roofed over like the plaster and concrete court, open on the sides most of the year if weather permits. A single overhead track allows heavy work to be transported from the court into the shop and back. A truck can back under the rail for unloading heavy logs or blocks of stone. Outlets are provided for electric and pneumatic tools.

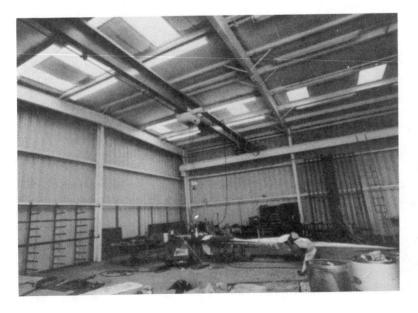

Plate 15.8. Bruce Beasley's bridge crane. Courtesy of Bruce Beasley, Oakland, California. This forty-foot bridge crane is operated electrically. Its range covers the entire area of the corrugated steel building. Note skylights, pipe and bar racks on left wall, panel saw rack to right.

E. Plastics Shop
 1. Resin-casting booth.
 2. Spray booth.
 3. Drum dollies.
 4. Large tables.
 5. Vacuum press.
 6. Band saw.
 7. Planer.
 8. Dust collection system.
 9. Portable tools: sander, buffers, jigsaw, etc.
 10. Hand tools: saws, files, clamps, etc.
 11. Fume evacuation system.
 12. Fireproof storage for resins and solvents.
 13. Rollers on wall for holding glass cloth, plastic sheeting.

The resin-casting booth is similar in construction to a spray booth. It is used to isolate freshly cast resin from the rest of the studio. It is an advantage to be able to control the temperature and humidity in this booth. See chapter eight for further information on equipment for working with plastics.

F. Metal Shop and Court
 1. Heliarc and stick welder.
 2. Gas welding torches.
 3. Metal or brick tables.
 4. Metal cutting band saw.
 5. Power cut-off saw.
 6. Drill press.
 7. Small sandblasting booth.
 8. Bending brake.
 9. Shear.
 10. Pipe bender.
 11. Rod cutter.
 12. Floor- and table-mounted vises.
 13. Metalworking benches with stake plate and stakes.
 14. Portable tools: pneumatic and electric grinders, sanders, drills, shears, etc.
 15. Hand tools: files, snips, punches, hammers, pliers, wrenches, taps, dies, etc.
 16. Dollies, clamps, jigs, respirators, gloves, eye shields.
 17. Fume evacuation system.
 18. Storage for metal.
 19. Storage for bolts and hardware.

Like the stone and wood yard, the metalworking yard is served by an overhead rail and equipped with air and electric outlets. Air tools are more durable than electric tools, can be run continuously without heating up, and are less likely to be stolen. They do tend to make more noise than electric tools. Large-scale welding, cutting, and burning are done in the metalworking yard. This area can be covered or not, depending on the climate. Curtains should be provided to isolate flash from arc welders. See chapters nine, ten, and eleven for more information.

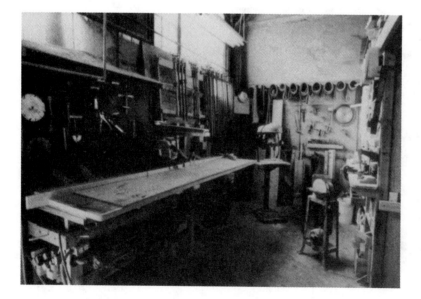

Plate 15.9. Tool area for woodshop. Sanding belts on pegs on the far wall, clamps on rack beneath window. Peg boards are convenient for holding saw blades and hand tools. The long table with radial arm saw is for cutting boards and panels.

G. Central Court

This area is used for relaxation, eating, drinking, and discussion. It serves as a general meeting area for the persons working at the studio. No work in progress is allowed to clutter up this court but it may be used for display of finished sculpture. It can contain benches, tables, trees, shrubs, and perhaps even a fountain. Alternatively, this area can be used as an indoor or outdoor classroom, for lectures, films, seminars, and so forth.

Plate 15.10. Saw blades in woodshop. Circular blades stored by size, band saw blades coiled and labeled.

H. Drawing and Designing Room

The ideal studio has a well-lit area for drawing and designing, set apart from the noise, dust, and fumes of the workshops. Here there are drafting tables and cabinets for storing tracings, drawings, and blueprints. Small models and maquettes of cardboard, balsa wood, and Styrofoam can be made, stored, and displayed in this area.

I. Office

Here are kept records, books, stationery, typewriters, telephones, adding machines, computers, and so forth. There should be a file of the instructions, parts lists, and guarantees for the equipment in the studio, and a directory of suppliers, services, and fabricators in the area.

J. The Viewing Room

Even in a small and far-from-ideal studio it is of great advantage to have a space set aside where work may be viewed in a neutral atmosphere, away from the distractions of the workshop. The ideal room is high and windowless, with bare white walls and a ceiling grid from which panels or objects can be hung and on which lighting fixtures can be mounted. The walls and floors can receive screws and nails without permanent damage. There are electrical outlets in flush-floor receptacles and at intervals along the walls, as well as in the ceiling grid.

Plate 15.11. Large floor vise. The 8″ jaws of this vise open to 12″. A welded steel stand places jaws 32″ above floor and allows access to vise from all sides.

Plate 15.12. Blacksmith anvil on dolly. The 175-lb. anvil and 8″ vise can be rolled on this dolly into position inside or outside the studio.

Although its main purpose is simply for looking at sculpture, the viewing room can also be used for photography, for showing films, and as a small gallery. It may also be used for setting up environmental experiments, where the entire space is transformed in various ways by the use of flats, drapery, and lighting. The viewing room can also be used as a studio for working with live models, and for dance presentations and other performances.

Plate 15.13. Viewing room. Note ventilation duct, overhead channels for lights and material fastening. Spotlights on stands: Berkey Colortran Mini P10, Lowel Quartzlight, Century Leicolight.

K. Pipes and Ducts

There are six separate exhaust stacks symmetrically placed around the studio, for the kiln, the furnace, spray and resin booths, and for wood dust and metal fumes. Care should be taken that these stacks are high enough to disperse their effluents so that they do not return to the courtyard areas. If there is a prevailing wind, the stacks may have to be rerouted so that there is no danger of fumes being pulled back into intake ducts. Due concern should be taken for the effects on neighbors of resin fumes and wax burnout smoke.

When a new building is being designed great care should be taken to make the proper provisions for pipes and electrical conduits to supply present and

Plate 15.14. Dust collection system at rest in Vasa's studio. Courtesy of Vasa Mihich, Venice, California. The centrifugal blower works like a giant vacuum cleaner to suck dust and chips from tools. Clean air is returned to studio through the filterbag, while dust drops to collection hopper on floor.

future needs. Adding these later can be expensive and difficult.

Pipes should be considered for hot and cold water, drains, air, gas, oxygen, and acetylene. The pipes should be color coded so they can be easily identified. In a large installation it is best to have the air compressor outside the building or in the basement. An automatic switch can start the compressor when the pressure in the supply tank falls below a preset level. Where there is considerable welding, it may be advisable to keep gas cylinders in a closet, connected via a manifold to welding stations in the studio. If possible the cylinder locker should have outside access for cylinder delivery.

The electrical power likely to be needed includes 115-volt single-phase for small tools and devices, 230-volt single-phase for arc welders, and 230-volt three-phase for larger motors driving stationary tools such as saws, grinders, and blowers. Switch boxes and breaker panels should be located in convenient

Plate 15.15. Dust collection system in operation at Vasa's studio. Courtesy of Vasa Mihich, Venice, California. The filter bag is inflated and dust is pulled into ducts by intake nozzles on band saw, grinders, and planer. Acrylic plastic sculptures are fabricated in this studio, but this system would be equally suitable for working with other plastics and with wood.

Plate 15.17. Air hose connectors. On the left, two styles of ½″ connectors; on the right, two styles of ⅜″ connectors. At each side are shown the crimped ferrules used to rejoin hoses after a damaged section has been removed.

Plate 15.16. Air regulator station for running pneumatic tools. From left to right: water trap, on-off valve, water separator and clean air connector, water separator, pressure regulator, oiler, ⅜″ connector, ½″ tool connector. The two tool connectors to the right of the oiler supply air mixed with lubricating oil.

Plate 15.18. 115-volt extension cords. Left to right: Heavy-duty #12 cord with detachable plugs and receptacle, twist-lock blades; heavy-duty #14 cord with molded ends; standard two-blade plug with grounding prong; light-duty #16 cord with molded ends (flat section goes under doors, tapes flat to floors); light-duty, general purpose #16 cord.

TABLE 15.1 Recommended Minimum Extension Cord Wire Size for Tools Based on 115 Volts Supply Drop is Approximately 6 Volts

Ampere Rating	Length of Cord in Feet							
	50	100	150	200	250	300	400	500
2	18	18	18	18	16	16	14	14
2.5	18	18	18	16	16	14	14	12
3	18	18	18	16	16	14	14	12
3.5	16	16	16	16	14	14	12	12
4	16	16	16	14	14	12	12	10
5	16	16	16	14	12	12	10	10
6	16	16	14	12	12	12	10	10
8	16	14	12	12	10	10	8	8
10	16	14	12	10	10	8	8	—
12	14	14	12	10	10	8	8	—
14	14	12	10	10	8	8	—	—
16	12	12	10	8	8	8	—	—

Plate 15.19. Styles of electric plugs and receptacles for 115-volt cables. Center top: stage light plug. Right: pig-tails for twist-lock to three-prong conversions.

Plate 15.20. Four-blade plug and wall receptacle for 230-volt, three-phase current. 230-volt plugs are made in several conformations, including twist-lock.

places. At every large power tool there must be a prominent switch enabling the operator of the tool to cut the power in case of accident or malfunction.

L. Floors, Foundations, Doors

Early in the design process is the time to plan furnace and sand pits, and any other concrete work that must be formed and poured along with the foundations of a building. In the foundry, it is much more convenient to have the furnace in a pit than standing on the floor, and the same holds true of the sand pit. If adequate drains are installed at the edges of work courts, these areas can be made level rather than sloped as they are in conventional architectural practice.

Since much equipment and work will be wheeled from place to place in the studio, it is a good idea to make all small changes of elevation ramped rather than stepped. Attention should be given to the design of weather stripping under doors. The doors themselves should be wide and high enough to admit the passage of large pieces of sculpture.

M. Access and Parking

Many otherwise fine studios make miserably inadequate provision for motor vehicles. Good work court space is often taken up by parked automobiles. It is usually a big chore to get the trash out of the studio, and, as often as not, the delivery of a load of materials precipitates a minor crisis. In the Ideal

studio, each work court has a double gate that will admit a delivery truck. Trash is put in rolling bins that are pushed out into the service alleys for pickup. Many kinds of materials, especially long items like pipe, rod, and bar, can be kept out-of-doors in racks and bins against the back walls of the studio, where access is easy.

Most sculptors and students prepare their own work for shipment. One corner of the woodshop and part of the service alley can be set aside for making and storing shipping crates. A set of banding tools can be used to reinforce the crates with steel straps.

THE BASIC STUDIO

While the Ideal studio provides maximum flexibility and allows work in all media to proceed simultaneously without interference, there are often limitations of space and budget which make some sharing of facilities necessary. Figure 15.2 shows a studio in which the viewing, drawing, and office areas are still separated from the workshop areas by a work court, as in the Ideal studio, but the wood and metal shops and the work courts are combined, since these areas can share many of the same tools. A pair of overhead rails carries a bridge crane from the furnace and kiln area to the work court. The kiln, furnace, spray booth, and resin booth are all in line so that they can be vented into one stack if necessary.

A tool room is provided in the center of the studio to serve all work areas. In the large Ideal studio there is a separate tool crib in each shop so that the metal, wood, and plastics shops are self-sufficient and serve their adjacent work courts. In an instructional situation, though many people are working, service is still rapid, but three assistants are required to check out tools. The Basic studio can be served by a standard crew of two persons: a foreman or instructor and his assistant.

THE MINIMUM STUDIO

The Minimum studio represents an even further reduction in size of the basic studio. This is about as compact as a studio can become and still provide workable access to a full range of equipment.

In the Minimum studio, the two shops of the Basic studio have been combined into one large area with clay, plaster, concrete, and plastics facilities

Plate 15.21. Receptacles for extension cords. The ends of extension cords may be equipped with many types of convenient multiple receptacles, or the receptacles can be made with short "pig-tails" which plug into a standard single receptacle.

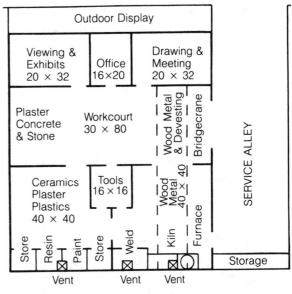

Figure 15.2. Basic studio. Shop unit is 5,600 sq. ft.; design unit is 1,600 sq. ft.; court area is 3,400 sq. ft.

occupying one side of the studio and wood, metal casting, and welding the other side. All the light tool processes are on one side and the heavy equipment is on the other. Part of the clay and plastics area is provided with stools, tables, blackboard, projection screen, and so forth, to provide a class meeting or discussion area. The office and tool room are combined in a central room with convenient access to the other areas.

If possible even the Minimum studio should have a work court served by a service alley. Here the trash bins are kept and bulky materials stored. There should be enough space for several large outdoor sculptures to be constructed. At the very least there must be an area where sculptures can be seen out-of-doors.

Overhead equipment is reduced to a single rail that runs the width of the studio, over the foundry area, and continues out into the work court. A pivot crane in the work court would be a welcome addition.

Ducts are provided over the kiln, furnace, and welding areas. The spray booth and the resin booth can be combined.

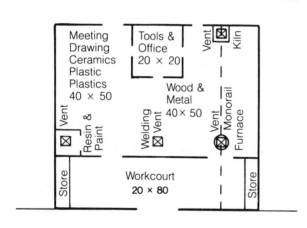

STREET

MINIMUM STUDIO Studio Area = 4000 Sq. Ft.
Scale: 1" = 20' Court Area = 1600 Sq. Ft.

Figure 15.3. Minimum studio. Studio area is 4,000 sq. ft.; court area is 1,600 sq. ft.; Total area is 9,600 sq. ft.

Like the Basic studio the Minimum studio is run by a foreman and an assistant, but one person can take charge for short periods of time. It is one possible arrangement for an individual studio, with the elimination of unnecessary equipment.

CAPACITIES AND OCCUPANCY

The three types of studios are presented here not as fixed plans, but as designs illustrating the issues to be considered in planning any studio. Combinations of features of the different plans might be desirable. The funds but not the space might be available to build the Ideal studio, so the drawing and viewing rooms might have to be attached directly to the shop building, or even inserted into the inner courtyard, making a more compact installation. Expenses may dictate a Minimum studio, but there may be a way to include a viewing room.

Where funds and space are both limited, it may be better planning to eliminate certain capabilities entirely in order to better serve a few. In that case immediate needs will have to be balanced against future expectations. If the studio is your own, perhaps you will never need to cast bronze or large blocks of resin, but you may need, instead, room to handle large sheets of plexiglass or plywood. If the studio is in a college or art school, perhaps it is better to postpone building a foundry until more funds are available, or perhaps it would be possible for students to build the foundry, while available cash is spent on equipment that cannot be homemade.

The three types of studios are all suitable with slight modifications for either institutional or professional use. For continuous production or for serving large numbers of students, the Ideal studio has great advantages because so many operations can go on simultaneously. It can accommodate, for instance, two concurrent classes of ten students each or one class of twenty with two instructors. There could be two morning classes and two afternoon classes with two sections for each class, one meeting Monday, Wednesday, and Friday, the other Tuesday, Thursday, and Saturday. The staff for such an operation would be four full-time teachers and six assistants. A total of about eighty students would be served by these courses, with not more than twenty students in the studio at any one time. Eighty to one hundred is the maximum number of students that can happily

work together, in shifts, in one sculpture studio complex.

Although the Basic studio is almost as well equipped as the Ideal studio, it cannot accommodate as many students, because there is less floor space, less overflow space into the courtyards, and because students have to wait to check out tools and have to take turns more often in using the large stationary equipment. The Basic studio handles one class at a time of fifteen to eighteen students, two four-hour classes a day, six days a week. Of course any combination of hours and students which adds up to the same use is possible.

In scheduling sculpture classes it should be remembered that there is another consideration in addition to the number of students per square foot per hour. When students leave the studio, most of their work stays behind taking up space. As the semester or quarter progresses, this problem becomes more and more acute. Work courts and service alleys are a big help in getting students to move their work out of the tool areas and finally to take it home or throw it out. The viewing room, too, makes this process easier, since it makes it possible to look at work as soon as it is finished and to discuss it and photograph it.

Plate 15.22. Small tool room. Hand tools, brooms, and cables are hung on the wall. A heavy table with vise is in the center for servicing and repairing tools. Out of view in the near side of the room are shelves for portable power tools.

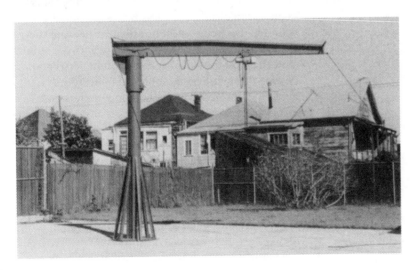

Plate 15.23. Bruce Beasley's pivot crane. Courtesy of Bruce Beasley, Oakland, California. The pivot crane serves the circle over which it swings. Mast must be securely mounted at base. Note electric chain hoist.

The Basic studio requires a staff of two full-time teachers and three or four assistants.

The Minimum studio has almost the same number of tools as the Basic studio, but there is less space. The same kinds of projects can be executed but on a smaller scale. Either the size of the classes or their number have to be reduced by about one-third from the capacity of the Basic studio.

The more compact arrangement of space in the Minimum studio might not be a disadvantage for the individual sculptor, or for a small group of sculptors. The Minimum studio might serve as a power-equipment center for a group of individual studios

Plate 15.24. Fire extinguisher. Dry chemical fire extinguishers must be inspected once a year to make sure pressure is adequate. Do not stack materials in front of extinguisher.

clustered around it, with as much equipment as possible mounted on rollers.

FIRE SAFETY

Fire extinguishers should be available near all potential fire areas, especially near welding areas. Frequent inspections should be made to ensure that flammable debris does not accumulate around welding, kiln, and furnace areas.

Metal lockers should be provided for paints and thinners. Spraying of paints or plastics must not take place near areas where there are open flames, or even burning pilot lights.

The most effective aid in putting out fires is to be ready for them before they happen. The primary source for fire information is the National Fire Protection Association, 470 Atlantic Avenue, Boston, Massachusetts 02210. The F.P.A. classifies fires in three categories.

Class A includes fires in combustible solids like wood, cloth, and paper. Water is the most effective agent for fighting these fires. Where the danger of fire is greatest, for instance in welding areas, there should always be a source of water nearby, such as a connected hose. Large installations can gain added protection by installing an overhead sprinkler system that can be both automatically and manually operated.

Class B includes fires in flammable petroleum products and other flammable liquids or greases. These fires tend to spatter and spread if water is poured on them. The best quenching agents are powders or gases dispensed from fire extinguishers. Foam extinguishers for Class B fires are no longer manufactured; they were not popular because they left a residue difficult to remove. The most common (and cheapest) powder agent is sodium bicarbonate. Newer extinguishers use potassium bicarbonate, potassium chloride, or monoammonium phosphate, all more effective, pound for pound, than sodium bicarbonate. Dry powder extinguishers depend on a gas propellant to send the powder from the nozzle to the fire, so they are equipped with a pressure gauge which must be inspected annually. Do not use pre-1965 gaugeless extinguishers.

While powder works well on exposed surface fires, it has less penetrating action than carbon dioxide, CO_2, which works by smothering the fire. CO_2 fire extinguishers must be checked annually by

TABLE 15.2 Fire Extinguishing Agents

	*Foam	Co$_2$	Dry	Halon 1211	Halon 1301	Water
Size B-I	1¼ gals.	4 lbs.	2 lbs.	2½ lbs.	no	
Size B-II	2¼ gals.	15 lbs.	10 lbs.	no	no	
Fixed					5–20 lbs.	sprinkler
Bucket						1–5 gals.
Hose						continuous
Class A fires	OK	OK	OK	yes	yes	yes
Class B fires	yes	yes	yes	yes	yes	no
Class C fires	OK	yes	yes	yes	yes	no

*Foam fire extinguishers are legal, but they are no longer manufactured.

weighing. Since the contents are highly pressurized, it is important to store CO$_2$ extinguishers in a dry place where rust won't start eating through the cannister.

A synthetic vapor for fire fighting is Halon, a colorless, odorless gas, heavier than air, which forms a vapor barrier over the fire, and is especially useful in enclosed areas that are difficult to reach with powder. Halon 1211 is supplied in portable cylinders for hand use. Halon 1301 is the agent for most stationary vapor systems in use today. In a stationary system, the extinguisher is mounted in a place where a fire might begin and is activated by heat.

Speed and accuracy are essential in using a powder or vapor extinguisher. Remember that portable extinguishers have a discharge time of from eight to twenty seconds. Powder and vapor extinguishers will work on small Class A fires, but water is better and more plentiful. This is why it is a good idea to have faucets and hoses in the welding and casting areas of a studio.

Class C includes fires in and around electrical equipment. The electrical conductivity of the extinguishing agent is the most important consideration here. Do not use water on electrical fires, because of the danger of shocks and short-circuits. Powder will work on these fires, but it is not as effective as vapor, because of its lack of penetrating action around wiring and complicated machinery. *Use it* if there is no vapor equipment available. The well-equipped studio will have Halon fire extinguishers prominently mounted near major items of electrical equipment.

One of the less-recognized hazards of electrical fires is the toxic nature of the fumes from burning electrical insulation. Halon itself is relatively, but not completely, nontoxic; humans can tolerate a 7 percent concentration. As we have more and more synthetic materials in our studios we should recognize the hazard presented by the toxic smoke from the combustion of these materials. People who are overcome by smoke cannot fight fires even if hoses and fire extinguishers are available.

The list at the end of this chapter will help you find fire-fighting equipment and information.

POWER TOOL SAFETY

The necessity of adequate ventilation for fume and dust removal has been stressed in the chapters on different materials with the need for goggles, respirators, and protective clothing. Accidents happen even in studios where this equipment exists, because precautions are not taken even though the equipment is available. This is a matter of supervision; studio staff and assistants must make sure that people working in the studio understand the necessity for safety measures and how to apply them.

When an accident does occur, there should be a preestablished first-aid procedure. First-aid kits should be available and there should be at least one telephone accessible at all times, with emergency numbers posted prominently near it.

All saws, blowers, pug mills, and other pieces of stationary power equipment should be inspected to

make sure that the operator can reach the shutoff switch in case of accident. Occupational Safety and Health Agency (OSHA) regulations should be consulted to make sure guards and shields conform to accepted practice. Essential tool instructions should be posted near the tool to which they apply.

It is dangerous to work alone with power equipment, especially late at night when you are tired and help may be miles away. All institutions should have two absolute rules about the use of the studio:

1. No one may work in the studio alone.
2. No one may work in the studio unless there is an authorized person in charge.

BIBLIOGRAPHY

A. Books and Articles on Safety

Art Hazard Information Center. Bulletins on arts and crafts materials, storage, protective equipment. A.H.I.C., 57 Pine St., New York, N.Y. 10005.

Barazini, Gail. *Hazards in the Arts* (newsletter). 530 N. Magnolia, Chicago, Ill. 60640.

Chicago Lung Association. Pamphlets on breathing hazards in arts and crafts. Chicago Lung Assn., 1441 W. Washington St., Chicago, Ill. 60607.

Garland, J. D. *National Electrical Code Reference Book.* Englewood Cliffs, N.J.: Prentice-Hall, 1977.

Goodfellow, Ann. *The Studio Guide to Safe Practice in the Arts and Crafts.* New York: College Art Association, 1979.

Grant, Mark N. *The Artists' Studio as a Toxic Mine Field. Los Angeles Times,* 19 February 1978, *Calendar* section, p. 80.

Institute of Electrical and Electronic Engineers, Inc. *National Electric Safety Code.* New York: N.E.E.E., 1977.

McCann, Michael. *Art Hazard News* (periodical). Center for Occupational Hazards, 56 Pine St., New York, N.Y. 10005.

———. *Health Hazards Manual for Artists,* 1975. Foundation for the Community of Artists, 220 Fifth Ave., New York, N.Y. 10001.

McKinnon, Gordon P., ed., and Keith Tower, assist. ed. *Fire Protection Handbook.* 14th ed. Boston: National Fire Protection Assn., 1976.

National Fire Protection Association. *Fire Protection Reference Directory.* Boston: National Fire Protection Assn, 1975.

Peterson, Dan. *The OSHA Compliance Manual.* New York: McGraw-Hill, 1975.

Redding, R. J. *Intrinsic Safety, the Safe Use of Electronics in Hazardous Locations.* New York: McGraw-Hill, 1972.

Sax, Irving N. *Dangerous Properties of Industrial Materials.* 3d ed. New York: Van Nostrand Reinhold, 1968.

Siedlecki, Jerome T. *The Silent Enemy, Potential Health Hazards of the Fine Artist and their Control.* Washington, D.C.: Artists Equity Assn., 1969.

Waller, Julian, and Lawrence Whitehead. "Health Issues," *Craft Horizons* 37, 5 (October 1977), 8.

B. Art and Law

Crawford, Tad. *Legal Guide for the Visual Artist.* New York: Hawthorne, 1977.

Dubroff, Leonard D. *The Deskbook of Art Law.* Washington, D.C.: Federal Publications, 1978.

Duffy, Robert E. *Art Law: Representing Artists, Dealers, and Collectors.* New York: Practicing Law Institute, 1977.

Plate 15.25. Respirators, goggles, and ear guards. On the left: double and single filter respirators should be fitted with correct filters for fumes, vapors, or dust. Center: plastic goggles, tempered glass goggles and eye glasses, flash goggles with tinted lenses and side shields. Right: full visor gives full face protection and unobstructed vision, ear guards protect against high-frequency noise of grinding.

Merryman, John Henry, and Albert Elsen. *Law, Ethics, and the Visual Arts.* New York: Matthew Bender, 1978.

C. General Information for Sculptors

Anderson, James, and Earl E. Tatro. *Shop Theory.* 6th ed. New York: McGraw-Hill, 1974.

Brady, George E., and Henry R. Clauser. *Materials Handbook.* 11th ed. New York: McGraw-Hill, 1977 (first published 1887).

Clarke, Geoffrey, and Stroud Cornock. *A Sculptor's Manual.* New York: Reinhold, 1968.

Mayer, Ralph, *The Artists' Handbook of Materials and Techniques.* 3d ed. New York: Viking Press, 1970; second printing with corrections, 1971.

Mills, John W. *The Technique of Sculpture.* New York: Watson-Guptill, 1976.

Rich, Jack C. *The Materials and Methods of Sculpture.* New York: Oxford University Press, 1947; 9th printing, 1973.

Schwartz, Paul Waldo. *The Hand and Eye of the Sculptor.* New York: Praeger, 1969.

Struppeck, Jules. *The Creation of Sculpture.* New York: Holt, Rinehart & Winston, 1952.

Verhelst, Wilbert. *Sculpture, Tools, Materials and Techniques.* Englewood Cliffs, N.J.: Prentice-Hall, 1973.

FIRE AND SAFETY EQUIPMENT

See also manufacturers and distributors listed after chapter eight and chapter twelve.

Alarm Device Mfg. Co., Div. Pittway Corp., 165 Eileen Way, Syosset, NY 11791.

W. O. Allen Mfg. Co., Inc., 2200 W. 16th St., Broadview, IL 60153.

All Fire Control Mfg. Co., Inc., 4500 E. District Blvd., Vernon, CA 90058.

Automatic Sprinkler Co. of America, Box 180, Cleveland, OH 44147.

Badger-Powhattan Div., American La France, Inc., Box 6159, Charlottesville, VA 22906.

Bel-Art Products, Pequannock, NJ 07440. Emergency eyewash stations.

Bernz-O-Matic Corp., 740 Driving Park Ave., Rochester, NY 14613.

Fire-End & Croker Corp., 7 Westchester Plaza, Elmsford, NY 10523.

Fire Metal Products Corp., 704 S. Tenth St., Blue Springs, MO 64015. Stationary Halon Systems.

Fyr-Fyter Co., Inc., Box 2752, Newark, NJ 07114.

General Fire Extinguisher Corp., 1685 Sherman Road, Northbrook, IL 60062.

Gillette Co., Appliance Div., Prudential Tower Bldg., 24th Floor, Boston, MA 02199.

Gillette of Canada, Ltd., 5450 Cote de Liesse Rd., Montreal, Quebec H4P1A7, Canada.

Walter Kidde & Co. Inc., 29 Main St., Bellenville, NJ 07109.

Levitt Safety Ltd., 33 Laird Dr., Toronto 17, Ontario, Canada.

Mike Green Fire Equipment Co., 8717 Venice Blvd., Los Angeles, CA 90034.

Pacific Coast Fire Extinguisher Service, 4276 E. Olympic Blvd., Los Angeles, CA 90023.

R. C. Industries, Inc., 320 Canter Ave., Linden, NJ 07036.

Safety First Products, Div. Chemetron Corp., 3684 Meadow Lane, Cornwells Height, PA 19020.

Stop Fire Inc., Box 9, Monmouth Junction, NJ 08852.

STUDIO EQUIPMENT

A. Cranes, Hoists, Dollies, Carts, Reels.

American Pulley Co., Div. Universal American Corp., 4200 Wissahickon Avenue, Philadelphia, PA 19129. Kwick-Stak portable lift trucks.

Appleton Electric Co., 1701 Wellington Ave., Chicago, IL 60613; 6450 E. Bandini Blvd., Los Angeles, CA 90040. Reelite automatic extension reels for electric and air lines.

Big Joe Mfg. Co., 7225 N. Kostner Ave., Chicago, IL 60646. Portable lift trucks.

Campbell Chain Co., York, PA 17400; Union City, CA 94587. Chain hooks, ratchets.

Chisholm Moore Hoist Div., Columbus McKinnon Corp., Fremont Ave., Tonawanda, NY 14150. Lodestar electric hoists.

Crane Hoist Engineering Corp., 6515 Salt Lake Ave., Bell, CA 95340. Hoists and cranes.

Crown Controls Corp., Materials Handling Div., New Bremen, OH 45869. Lift-stackers and pallet trucks.

Manning, Maxwell, and Moore, Division of Dresser Industries, Inc., Muskegon, MI; 15205 S. Main, Gardena, CA 90247. Cranes, hoists, chain blocks, and A-frame gantries.

Mifran-Bowman Corp., 8015 S. Alameda St., Los Angeles, CA 90001. Used forklifts and pallet jacks.

George M. Prescott Co., 825 S. Fremont Ave., Alhambra, CA 91803. All types of industrial material handling equipment.

Up-Right Scaffolds, 1013 Pardee St., Berkeley, CA 94700; Oshawa, Ontario, Canada. Portable aluminum scaffolds.

Valleycraft Products, Inc., 750 Jefferson St., Lake City, MN 55041. Platform trucks, barrel carts, and engine hoists.

West Bend Equipment Corp., West Bend, WI 53095. Weld-Bilt forklifts, lift tables, lift trucks, and skids.

Daniel Woodhead Co., 15 N. Jefferson St., Chicago, IL 60606. Protex electric cord reels.

B. Dust Collection Equipment

Acme Mfg. Co., 1400 E. Nine Mile Rd., Detroit, MI 48220.

Allis Chalmers Corp., P.O. Box 512, Milwaukee, WI 53201.

Lewis P. Batson Co., Box 3978, Greenville, SC 29608.

Beltran Associates Inc., 1133 E. 35th St., Brooklyn, NY 11210.

Buell Emission Control Div., Envirotech Corp., 200 N. Seventh St., Lebanon, PA 17042.

Canadian Plastics & Rubber Machinery, Ltd., 2446 Cawthra Rd. Units 7-8, Mississauga, Ontario, Canada L5A 3K6.

Cincinnati Fan & Ventilator Co., 5345 Creek Rd., Cincinnati, OH 45242.

Dustex Div., American Precision Industries, Inc., P.O. Box 900, Greenville, TN 37743.

Hammond Machinery Builders, Inc., 1600 Douglas Ave., Kalamazoo, MI 49007.

Kirk & Blum Mfg. Co., 3125 Farrer St., Cincinnati, OH 45209.

Process Control Corp., 6875 Mimms Dr., Atlanta, GA 30340.

Ube Industries, Ltd., 1 Rockefeller Plaza, New York, NY 10020.

Vacu-Blast Corp., P.O. Box 885, Belmont, CA 94002.

C. Special Lighting Equipment

Berkey Colortran Inc., 1015 Chestnut St., Burbank, CA 91502.

Century-Strand, Inc., 5432 W. 102nd St., Los Angeles, CA and 521 W. 43rd St., New York, NY 10036.

Four Star Stage Lighting, 3935 N. Mission Road, Los Angeles, CA 90031; 585 Gerard Ave., Bronx, NY 10451.

Lowell-Light Mfg. Co., Inc., 421 W. 54th St., New York, NY 10019.

Westinghouse Electric International Co., 200 Park Ave., New York, NY 10017.

Index